PERGAMON

The Telephos Frieze from the Great Altar

VOLUME 2

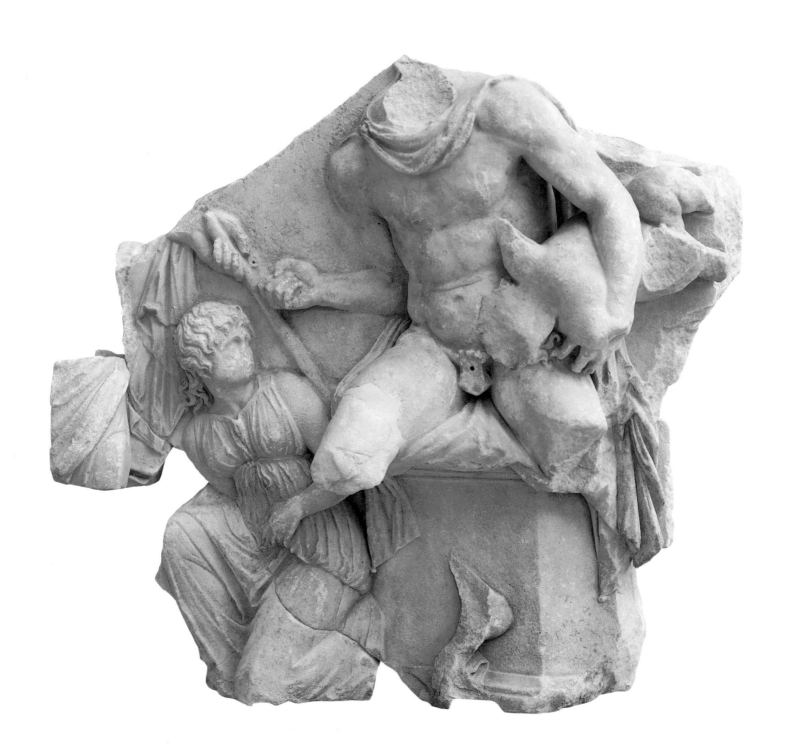

PERGAMON

The Telephos Frieze from the Great Altar

VOLUME 2

edited by

RENÉE DREYFUS

ELLEN SCHRAUDOLPH

Fine Arts Museums of San Francisco

PERGAMON: The Telephos Frieze from the Great Altar
Volume 2

This catalogue is published with the exhibition *PERGAMON: The Telephos Frieze from the Great Altar,* organized by the Fine Arts Museums of San Francisco and The Metropolitan Museum of Art in conjunction with the Staatliche Museen zu Berlin, Antikensammlung–Preussischer Kulturbesitz.

This exhibition and catalogue have been funded in part by the National Endowment for the Arts, a Federal agency. Both volumes 1 and 2 are published with the assistance of the Andrew W. Mellon Foundation Endowment for Publications.

The Metropolitan Museum of Art
New York, New York
16 January–14 April 1996

Fine Arts Museums of San Francisco
California Palace of the Legion of Honor
San Francisco, California
4 May–8 September 1996

Library of Congress Catalogue Card Number 95-083343
ISBN 0-88401-089-9

Distributed by the University of Texas Press, P.O. Box 7819, Austin, Texas, U.S.A. 78713–7819.

Catalogue numbers refer to illustrations in Volume 1. Telephos frieze panel numbers correspond to former placement; see drawing folded into front cover.

Front cover: *Carpenters Build the Boat in Which Auge is Cast out to Sea* (cat. nos. 2 and 3)
Frontispiece: *Telephos Threatens the Infant Orestes at Agamemnon's Altar* (cat. no. 11)
Page 10: *Head of Philetairos.* Eumenes I, tetradrachm (enlargement of cat. no. 44)
Back cover: *Herakles Discovers His Son Telephos* (cat. no. 5)

Unless otherwise noted in the captions, photographs are courtesy of the Staatliche Museen zu Berlin.

Printed and bound in Hong Kong

CONTENTS

PREFACE AND ACKNOWLEDGMENTS

RENÉE DREYFUS

It is one of the happy consequences of organizing a museum exhibition that the process can lead to a significant advancement in scholarship. Such was the case with *Pergamon: The Telephos Frieze from the Great Altar,* held at the California Palace of the Legion of Honor, of the Fine Arts Museums of San Francisco, and The Metropolitan Museum of Art in New York. The history and accomplishments of Pergamon, one of the greatest centers of Hellenistic civilization, were long overdue for reevaluation. The occasion of this exhibition has brought together both the pioneering and the more recent studies by scholars throughout the world in order to reassess them. In addition, so little of what had been recorded in these studies is in English. It has, therefore, been difficult for those who are not fluent in the German language to appreciate Pergamon and its great feats of artistic and cultural accomplishments in its heyday in the wake of Alexander the Great. We hope that the two volumes that comprise this catalogue will help to fill the void for the English-speaking audience.

The timing of this exhibition could not have been better for a number of significant reasons. Recent excavations at the site had led to a new understanding about the late Hellenistic architectural monuments that are Pergamon's hallmarks. No survey of Greek art and architecture leaves out the artistically adventurous Great Altar of Pergamon, one of the universally acknowledged wonders from the late Hellenistic age. Yet these references are, in large part, out of date and do not take into consideration the latest scholarship, discoveries, and excavation results. It is therefore the intention of the collaborators of this exhibition and the contributors to this catalogue to present the most complete information while focusing on the artistic significance of ancient Pergamon and its role in the development of Hellenistic art and culture. In this regard the exhibition and its catalogue express what is known and what is still to be learned about Pergamon, its art, architecture, and history; hence the catalogue attains an importance far beyond the exhibition itself.

This unparalleled exhibition, however, represents an international collaboration that goes beyond scholarship. It is also a good model of how museums working together can make a difference to world art, in that it has helped to preserve one of the greatest monuments from antiquity. With the opening up of the Eastern bloc countries and the unification of Germany, it was clear that this was the appropriate time to bring to America those treasures from the Pergamon Museum in former East Berlin. This world-famous museum was for most of the post–World War II years out of easy reach for most Americans and Western Europeans. Those who did visit were thrilled by room after room of astounding ancient works of sculpture and reconstructed architectural wonders. The question was not whether the Fine Arts Museums should request loans from this collection, but assuming it was indeed possible to organize such an exhibition, which of the works in this vast storehouse should be included. The Pergamon Altar is one of the glories of Berlin and we harbored hopes that it would be possible to borrow significant objects that relate to it. Our discussions with the directors and curators of the Staatliche Museen zu Berlin proved fruitful and, with additional support from The Metropolitan Museum,

6

we were able to focus on an exhibition concept that was beneficial for all.

The inspiration for this particular collaboration came from the drastic need for the relief panels of the Great Altar's interior frieze to be cleaned, conserved, and studied. The Telephos frieze, smaller and calmer, yet more realistic and less theatrical than the Gigantomachy frieze that writhes around the exterior of the monument, had often been overlooked in comparison with the tumultuous struggle of the gods and the Giants. Yet the Telephos frieze is in many ways even more important in its sophistication, sheer beauty, and narrative impact.

The Telephos frieze, like many objects in Berlin, went through difficult times—especially during World War II and its aftermath. The frieze was taken by Soviet forces in 1945 to Leningrad, where it remained until its return to Berlin in 1958. It was not worked on after its return, but was quickly reinstalled onto the walls of the museum without any repairs or careful conservation treatments. But, as is made evident in the essay by Ellen Schraudolph, my coeditor who documents the more recent history of the frieze, even earlier than this the Telephos frieze had not always received proper care. In her essay she describes how, even in its assembly in the last century when it was first brought to Berlin, the carved marble frieze had already been severely damaged.

It took two years for work on the fifty-one existing panels to be completed by the internationally renowned stone restorer Silvano Bertolin and his associates. In the course of this project the fragments were carefully disassembled, cement plaster and other adhesives were removed, and the surfaces were cleaned. The iron dowels used in the first restoration had caused rusting that penetrated into the marble, cracking it. These were removed and replaced by stainless steel dowels. The removal of the panels from the museum walls and their disassembly allowed scholars to reconsider their original order on the walls of the raised interior court of the Great Altar. New discoveries on the back, sides, top, and bottom of the panels have helped to determine a new placement of the works, which has led to a better understanding of the unfolding of the story of the birth of Telephos and the founding of Pergamon. In some cases, these new discoveries have required changing the traditional order of the panels.

The Telephos frieze, one of the most remarkable masterpieces from the ancient world, has now been given the attention it deserves. It was with a sense of international cooperation that we embarked on this project, and with a sense of pride that we greet its successful culmination. This complex project of conservation, documentation, and scholarship that has resulted in an international exhibition would never have been possible without the cooperation of a number of talented and dedicated individuals. It is with gratitude and appreciation that I acknowledge the following people:

I wish to thank Wolf-Dieter Dube, general director of the Staatliche Museen zu Berlin, and Wolf-Dieter Heilmeyer, director of the Antikensammlung, for making this exhibition possible. Primary impetus and responsibility rests with Max Kunze, former director of the Antikensammlung of the Pergamon Museum, and it is to his farsighted vision that we are all indebted. I am also grateful to Harry S. Parker III, director of the Fine Arts Museums of San Francisco, for his unwavering belief that this project was critical to Berlin and San Francisco.

It is with profound gratitude for their expertise and willingness to share that I mention the contributors to the catalogue: Ellen Schraudolph, who documented the conservation effort, organized the exhibition from Berlin's side, wrote the catalogue entries, and was a most conscientious coeditor; Wolfram Hoepfner and Volker Kästner, who shared their knowledge about the architecture of Pergamon and especially the Great Altar; Huberta Heres and Andrew Stewart, both experts in Greek sculpture and the development of narrative art, who contributed insightful essays on these subjects and provided vital information that added to the accuracy and completeness of this catalogue. I must also mention Ursula

Kästner and Wolf-Dieter Heilmeyer, whose historical essays add considerably to the understanding of how the Pergamene treasures came to Berlin and the early years of their display in the Berlin museums. Professor Heilmeyer also describes the new arrangement of the panels of the Telephos frieze, which have been beautifully and faithfully captured in the drawings of Marina Heilmeyer. The history of the kings of Pergamon has been ingeniously traced through the coinage of the Attalid Dynasty by Hans-Dietrich Schultz, and the difficult task of dating and describing the significance of the Telephos frieze has been undertaken by Bernard Andreae, who places the carved relief into a context by relating it to other Attalid dedications. I also thank Ulrike Wulf, who has made her topographical plan of Roman Pergamon available to us, and Josef Riederer, Thomas Cramer, Klaus Germann, and F. Johann Winkler, who have contributed the scientific analyses that add considerably to our understanding of the marble of the frieze and the artificial stone fills that were previously used in the assembly and repair of the relief carving.

As coeditor of *Pergamon: The Telephos Frieze from the Great Altar,* and on behalf of those who have worked with me to prepare the two volumes of this catalogue, I am especially indebted to Karen Kevorkian, managing editor, and Ann Karlstrom, director of publications and graphic design of the Fine Arts Museums, and to the exemplary copy editing of Fronia Simpson. Each has significantly improved the manuscript through her considerable skills. Ariel Herrmann and Frank and Maureen Kovaks also gave important assistance with their careful review of the essays. In some cases, slight emendations have been made to the essays and references to suit the American audience and the American academic community. I would especially like to express my gratitude to Louise Chu for her unfailing technical assistance through the many phases of this project and the tedious task of checking bibliographic information. I also thank Jane Nelson, who took over many of the tasks of my department and thus allowed me the freedom to focus on Pergamon. The collabora-

tion and encouragement of the Greek and Roman Department at The Metropolitan Museum of Art in New York is gratefully acknowledged, especially Carlos Picón, curator-in-charge, who has been supportive of the project since its inception, and Elizabeth Milleker, curator, who has been of great assistance in so many ways in the development of the exhibition and catalogue. I am especially indebted to Ed Marquand and his talented staff for their intelligent and beautiful design for the two volumes of this catalogue. On a personal note, I would like to thank my parents, Marc and Eve Glaser, who instilled in me at an early age a love of the ancient world.

A project of this complexity leaves almost no member of a museum staff untouched and I thank all involved at the Staatliche Museen zu Berlin, the Fine Arts Museums of San Francisco, and The Metropolitan Museum of Art in New York who have performed their function with great skill and style. To several people at the Fine Arts Museums I express special appreciation: William White, exhibition designer, and his mount-making and installation team; Kathe Hodgson, exhibition coordinator; Steven Nash, chief curator; William Huggins, lighting designer; Connie King of the graphic design department; Pamela Forbes, Victoria Alba, Paula March, and Linda Jablon of the departments of media relations and marketing and membership; and the registration departments of all three of the museums, especially Therese Chen of the Fine Arts Museums. I would like to single out the work of Elisabeth Cornu, who, as objects conservator in San Francisco, was of invaluable assistance with the technical aspects of the mount-making and packing of the exhibition, as well as caring for the objects when they were unpacked, installed, and displayed in the California Palace of the Legion of Honor. She was joined by her Berlin colleagues, Wolfgang Massmann and Stefan Geismeier, who traveled to New York and San Francisco to assist with the unpacking, installation, deinstallation, and repacking of the objects.

I am also grateful to Heide Van Doren Betz, who shared our vision for an exhibition from the Pergamon Museum and

who was a significant help in its early stages, and I thank those who helped to create the video presentations and audio tour of the exhibition. The orientation video was produced by Sender Freies Berlin, under the direction of the creative filmmakers Marina Bartsch-Rüdiger and Beate Moser. The San Francisco introductory video that brought the public behind the scenes of a museum installation was produced by Don Bright and Phillip Hofstetter with funds donated by DuPont. Finally, the innovative random-access audio tour was produced by Acoustiguide, under the talented direction of Antonia Bryan.

The Fine Arts Museums of San Francisco were fortunate to receive assistance from the National Endowment for the Arts. We are also grateful for the support for both volumes of the catalogue from The Andrew W. Mellon Foundation Endowment for Publications. Financial support has also come from The Justin Dart Family Foundation, Linda Zia, and Alice Chu, who provided funds toward the production of this catalogue in memory of Samuel K. T. Chu.

The team spirit and display of friendship exhibited by all the participants in this international venture throughout the seven years of its development attest that this was truly a unique undertaking. Friendships were made that will continue through time; an appreciation and mutual respect for technical and scholarly abilities was formed that has benefited all those involved in the project. It is through the combined efforts of these individuals that we were able to present what we hope will be a long-standing contribution to the knowledge of the art and culture of Pergamon.

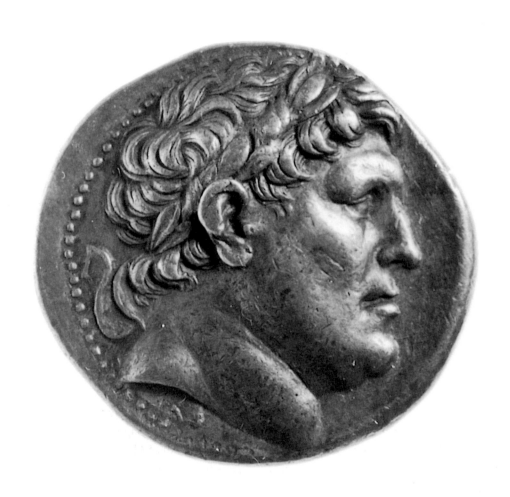

THE COINAGE OF PERGAMON UNTIL THE END OF THE ATTALID DYNASTY (133 B.C.)

HANS-DIETRICH SCHULTZ

When coins were first struck at Pergamon, in the second half of the fifth century B.C., the city was still of little importance. It, and several neighboring localities, was ruled by the family of Gongylos, an exile from Greece, whom the Persians had installed as a local dynast in the 470s. The head of a bearded man with a Persian tiara on the reverse of several Pergamene silver coins (fig. 1) is interpreted by some as a portrait of Gongylos, and by others as a Persian satrap. Whatever the identity of the portrait, the autonomy of the Greek city of Pergamon must have been rather limited. The obverses of the small silver and bronze coins from the time of the Gongylids show a head of Apollo, a motif that after this time disappears from the civic coinage of Pergamon. The initials of the so-called *ethnikon* on the reverses—to be read as "[coin of the] Perg[amenes]"—are the earliest evidence for the city's name.

It was not until many decades later that coins were again minted at Pergamon, this time in all three metals, gold, silver, and bronze. On an anepigraphic gold stater that survives in only a few examples, whose attribution to the city is secured by small silver coins of the same type bearing the legend PERGAM, one sees an archaistic figure of Athena in the form of a palladium (fig. 2). The goddess, standing frontally with feet close together, wears a calathus on her head instead of the usual helmet and is dressed in a girdled chiton and a mantle, with ends shaped like swallowtails. She holds a spear in her raised right hand and a shield on her left arm; notable is a taenia suspended from the shield and ending in a tassel, which must be imagined as being held in the left hand. The Corinthian helmet on the left side in the field does not belong

to the coin type but is the mark of the official responsible for the minting. This archaistic Athena is generally considered to be a depiction of the cult statue of the temple of Athena on the Pergamene acropolis. Given the role Athena was to play as the city's chief goddess under the Attalids, this early evidence for her cult in Pergamon is of vital importance. Unfortunately, the date of the coin's issue, which would provide us with a terminus ante quem for both the cult image and the temple, cannot be exactly determined. The head of the youthful Herakles wearing a lion skin, which appears on the obverses of the gold, silver, and most bronze coins, is certainly adopted from the tetradrachms of Alexander the Great. The year 334 B.C., when Alexander conquered Asia Minor, therefore has to be regarded as their terminus post quem. However, the coins are generally dated to about 300 B.C.

After the battle of Ipsos, in 301 B.C., Pergamon belonged to the realm of the Thracian King Lysimachos. About 287 B.C. at the latest Lysimachos made Pergamon one of his numerous royal mints, which were situated on both sides of the Dardanelles. For some years Pergamon took part in the minting of the king's magnificent tetradrachms, whose obverse shows the head of Alexander the Great with a diadem and the ram's horns of Zeus Ammon, while on the reverse is a seated Athena with spear and shield holding a statuette of Nike in her right hand (fig. 3). On the example shown here, the crescent moon in the exergue, the letter *N* on the left margin, and a small cult idol directly in front of Athena (which cannot be characterized any further) belong to a group of varying symbols used in different combinations, some which denote

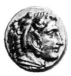
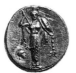

Enlargement

Fig. 1 (cat. no. 36). Pergamon, obol of Persian standard (or perhaps a Milesian three-quarter obol), second half 5th century B.C. OBVERSE: Head of Apollo; REVERSE: ΠΕΡΓ ([coin of the] Perg[amenes]). Bearded head with Persian tiara. Silver, 0.73 g; inv. 187/1877; Fritze, *Münzen von Pergamon*, 4; see Mørkholm, "Some Pergamene Coins," 181–82

Fig. 2 (cat. no. 37). Pergamon, gold stater, last quarter 4th century B.C. OBVERSE: Head of Herakles with lion skin; REVERSE: Archaistic cult image of Athena; on the left, Corinthian helmet. Gold, 8.51 g; from the Fox collection; Fritze, *Münzen von Pergamon*, 5

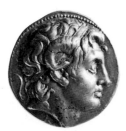
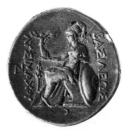

Fig. 3 (cat. no. 38). Lysimachos, tetradrachm, mint of Pergamon, ca. 287–282 B.C. OBVERSE: Head of Alexander the Great with horn of Ammon and diadem; under truncation of neck, K; REVERSE: ΒΑΣΙΛΕΩΣ ΛΥΣΙΜΑΧΟΥ ([coin] of King Lysimachos). Athena Nikephoros (bringing victory) with spear and shield enthroned facing left; in front of her, a small cult statue; left margin, N; in the exergue, crescent. Silver, 16.82 g; from the Prokesch-Osten collection; Thompson, "Mints of Lysimachus," no. 225

the mint, while others refer to the official responsible for the issue.

Philetairos, who was to enter history as the founder of the Attalid dynasty, was at that time phrourarchos (commander) of the citadel of Pergamon. Lysimachos had installed him in this position, with the special duty to guard a treasure that was reputed to be nine thousand talents (236 tons) of silver. There is no reason to doubt that Philetairos remained loyal to his king for years. But when he felt threatened by conflicts and intrigues at Lysimachos's court, which eventually led to the murder of the successor to the throne, Agathokles, he transferred his loyalty to King Seleukos I of Syria. Very soon this step proved providential. When Seleukos, around February 281 B.C., defeated his rival, Lysimachos, who lost both his kingdom and his life, Philetairos found himself backing the right side. His post as commander on the acropolis of Pergamon was confirmed by his new suzerain.

In the summer of 281 B.C. the mint at Pergamon, now under Seleucid control, issued one of the most remarkable series of tetradrachms of the time, in terms of typology and artistry (fig. 4). On the obverse appears the head of the king's horse, equipped with horns to indicate the animal's supernatural powers. The elephant on the reverse symbolizes the strength of the Seleucid army, which owed much to its Indian war elephants. The anchor in the exergue is the heraldic sign of Seleukos, who is also mentioned in the legend: "[coin] of King Seleukos." The bee in the field's upper margin indicates the official responsible for the series. Presumably tetradrachms of this type were meant to be produced in larger quantities, and perhaps other mints would subsequently have been involved in the issue. However, the unexpected murder of Seleukos in September 281 led to an untimely end of the issue, with the consequence that these tetradrachms are now among the most sought-after rarities (at present only about seven examples are known).

It is impossible to say whether or in what way Philetairos influenced the remarkable series of tetradrachms for

Seleukos I. More certain is the fact that it was he who determined the types and legends of the coins for the next three issues, which reveal that his politics were as cautious as they were purposeful. Following the death of Seleukos I, when the balance of power was still uncertain, Philetairos minted a small series of uncontroversial tetradrachms of the Alexander type, which bear on the obverse the head of the youthful Herakles wearing a lion skin, and on the reverse an enthroned Zeus with eagle and scepter together with the legend, "[coin] of King Alexander" (fig. 5). Tetradrachms of this type constituted the bulk of circulating silver coins in most of the states succeeding Alexander's empire; they were accepted everywhere and did not arouse suspicion. It should be mentioned that this discussion follows E. T. Newell's interpretation, to which we are indebted for the attribution to Pergamon of these and the two preceding tetradrachms, as well as for their dates.

The next series of tetradrachms is also of the Alexander type, but his name is replaced with that of Seleukos (fig. 6). The recourse to the late Seleukos's name is in itself not surprising, but one may be allowed to remark that tetradrachms in the name of Antiochos I would have made Philetairos's loyalty to his present sovereign more apparent.

Finally, the tetradrachms of the third series go so far as to show Seleukos's portrait on the obverse—one of the best royal portraits on coins of the time—and on the reverse an Athena similar to that of Lysimachos's tetradrachms, with slight variations. The legend reads, however, "[coin] of Philetairos" (fig. 7). The evidence of these coins is strangely contradictory: while on the obverse Seleucid suzerainty still seems to be acknowledged, on the reverse Philetairos states his independence. Philetairos's endeavor to disengage himself from Seleucid supremacy, without open conflict if possible, is obvious.

Eumenes I (r. 263–241 B.C.), the nephew and successor of Philetairos, after an initial successful military campaign against Antiochos I, then took the last step and presented the

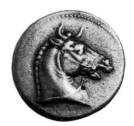
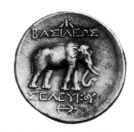

Fig. 4 (cat. no. 39). Seleukos I, tetradrachm, mint of Pergamon, 281 B.C. OBVERSE: Horned and bridled horse's head; REVERSE: ΒΑΣΙΛΕΩΣ ΣΕΛΕΥΚΟΥ ([coin] of King Seleukos). Elephant; above, bee; in the exergue, anchor. Silver, 16.57 g; inv. 218/1897; Newell, *Philetaerus*, no. 1 (II–2), and *Western Seleucid Mints*, no. 1528 B

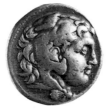
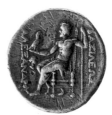

Fig. 5 (cat. no. 40). Posthumous tetradrachm of Alexander the Great, mint of Pergamon, ca. 280 B.C. OBVERSE: Head of Herakles with lion skin; REVERSE: ΒΑΣΙΛΕΩΣ ΑΛΕΞΑΝΔΡΟΥ ([coin] of King Alexander). Zeus Aetophoros (holding an eagle) enthroned facing left; on the left in the field, bust of Artemis; below throne, crescent. Silver, 17.00 g; from the Prokesch-Osten collection; Newell, *Philetaerus*, no. 3 (IV–4), and *Western Seleucid Mints*, no. 1530; Price, *Alexander the Great and Philip Arrhidaeus*, no. 1470

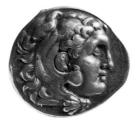
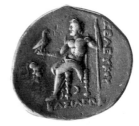

Fig. 6 (cat. no. 41). Posthumous tetradrachm of Seleukos I, mint of Pergamon, ca. 280–274 B.C. OBVERSE: Head of Herakles with lion skin; REVERSE: ΒΑΣΙΛΕΩΣ ΣΕΛΕΥΚΟΥ ([coin] of King Seleukos). Zeus Aetophoros (holding an eagle) enthroned facing left; on the left in the field, head of Athena; below throne, crescent. Silver, 16.82 g; from the Löbbecke collection; Newell, *Philetaerus*, no. 5 (VI–13), and *Western Seleucid Mints*, no. 1532

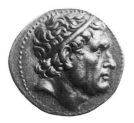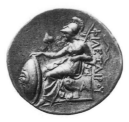

Fig. 7 (cat. no. 42). Philetairos, tetradrachm, ca. 274–263 B.C. OBVERSE: Head of Seleukos I with taenia; REVERSE: ΦΙΛΕΤΑΙΡΟΥ ([coin] of Philetairos). Athena enthroned facing left with shield (in front) and spear; above, ivy leaf; on the throne, A; on right side, bow. Silver, 17.14 g; from the Prokesch-Osten collection; Newell, *Philetaerus*, no. 15 (obv. XIX, rev. different die)

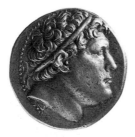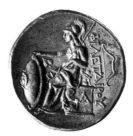

Fig. 8 (cat. no. 43). Eumenes I (r. 263–241 B.C.), tetradrachm. OBVERSE: Head of Philetairos with taenia; REVERSE: ΦΙΛΕΤΑΙΡΟΥ ([coin] of Philetairos). Athena enthroned facing left with shield (in front) and spear; under her right arm, ivy leaf; on throne, monogram; on the right side, bow. Silver, 17.04 g; from the Fox collection; Westermark, *Bildnis des Philetairos*, no. VIII 1a

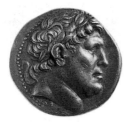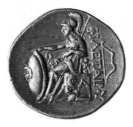

Fig. 9 (cat. no. 44). Eumenes I (r. 263–241 B.C.), tetradrachm. OBVERSE: Head of Philetairos with laurel wreath entwined with a diadem; REVERSE: as cat. no. 43. Silver, 17.12 g; inv. 297/1877; Westermark, *Bildnis des Philetairos*, no. XII 1a

portrait of Philetairos as that of the dynasty's founder on the tetradrachms (fig. 8). Recently, however, based on the evidence of the great coin hoard from Meydancikkale, Georges Le Rider has proposed that Philetairos himself had done this in his lifetime. A typological detail would fit well with this assumption: it is the rather unusual taenia *(strophion)*—to be distinguished from the broad royal diadem—that Seleukos wears and that is to be seen as well on the first portraits of Philetairos, here, however, complemented with the fillet ends hanging down his neck. Further discussion of the problem will, no doubt, ensue.

The portrait of Philetairos, characterized by a broad lower face and small eyes, remained the standard obverse type of the Attalid tetradrachms for more than one hundred years, as did the figure of Athena on the reverse. The Ptolemaic dynasty in Egypt proceeded in a similar, if less consequential, fashion, retaining the head of Ptolemy I as the standard tetradrachm design for nearly three hundred years. Regrettably, as a result of this practice in both cases, a number of royal portraits remain unknown. On the other hand, it is interesting to have the opportunity to watch different engravers shape the Pergamon dynasty founder's portrait over a long span of time. Some examples of Philetairos's portrait from different periods are grouped together here for comparison (figs. 9–12).

The problem of arranging the tetradrachms of the Attalids in chronological order, regardless of the unchanging nature of their types, and of attributing them to the various representatives of the dynasty was addressed in the late nineteenth century by Friedrich Imhoof-Blumer. He succeeded in distinguishing a number of different groups of coins and in establishing their sequence relative to one another. The decisive criteria for establishing a relative chronology were several details that underwent gradual alterations: the aforementioned taenia of Philetairos, which was soon replaced by a laurel wreath entwined with a diadem (figs. 9–12); the position of Athena's shield, which at first is held upright in front of her

(see figs. 7–9), and then shifts to the right behind her throne, while Athena herself now crowns with her right hand the name of Philetairos (see figs. 10–12); the manner in which the symbols, letters, and monograms are arranged in the field; the omission of the border of dots on the obverse (see figs. 11–12), and so on.

While Imhoof-Blumer's relative chronology proved itself trustworthy and is generally accepted, the absolute chronology of the Attalid tetradrachms remains controversial to this day. Opinion is divided especially concerning the end of the tetradrachm coinage. Any advance in the question of dating can only be made by interpreting coin hoards in which Attalid and other, better-dated coins are found together. Attempts to correlate changes in typological details with changes in government or with particular historical events were not very fruitful. Thus, one can no longer explain Athena's crowning of Philetairos's name, to take but one example, as a result of Attalos I's (r. 241–197 B.C.) adopting the title of king, which took place around 236 B.C. As Le Rider's interpretation of the Meydancikkale hoard mentioned above has shown, this typological innovation had already taken place under Eumenes I (r. 263–241 B.C.).

Toward the end of the third century B.C. for a period of ten to twenty years tetradrachms of the Alexander the Great type were once again minted at Pergamon (fig. 13). The symbols, letters, and monograms of these "Alexanders" are encountered in identical combinations to some extent on the common tetradrachms with the head of Philetairos, which proves that both series circulated concurrently. What led to the minting of the Alexander type coins—appreciated almost everywhere in the Hellenistic world—is not known; perhaps this class of coins was the preferred currency for paying mercenaries—for example, during the wars of Attalos I against Philip V of Macedonia (r. 222/21–179 B.C.). It is not yet possible to fix an exact date for the entire block of these coins.

To get a realistic picture of the coins circulating in the

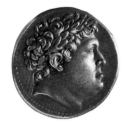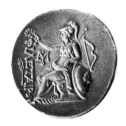

Fig. 10 (cat. no. 45). Attalos I, tetradrachm, ca. 240–235 B.C. OBVERSE: as cat. no. 44; REVERSE: ΦΙΛΕΤΑΙΡΟΥ ([coin] of Philetairos). Athena enthroned facing left with spear and shield (beside the throne) and crowning the name of Philetairos; on the left, palm branch; in the center, monogram; on the right, bow. Silver, 17.00 g; Old Museum collection; Westermark, *Bildnis des Philetairos,* no. XCIV 1

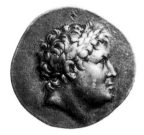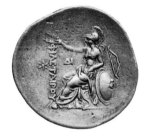

Fig. 11 (cat. no. 46). Attalos I (r. 241–197 B.C.), tetradrachm, end 3d century B.C. OBVERSE: as cat. no. 44; REVERSE: as cat. no. 45, but on the left, a star; monogram different. Silver, 16.65 g; from the Fox collection; Westermark, *Bildnis des Philetairos,* no. CXXIV 1

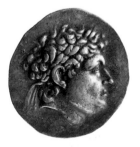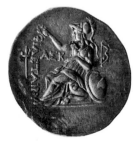

Fig. 12 (cat. no. 47). Eumenes II (r. 197–159 B.C.) or Attalos II (r. 159–139 B.C.), tetradrachm. OBVERSE: as cat. no. 44; REVERSE: as cat. no. 45, but on the left, a stylis; in the center, AΣK. Silver, 16.72 g; from the Imhoof-Blumer collection; Westermark, *Bildnis des Philetairos,* no. CLI 1

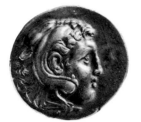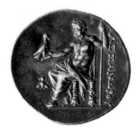

Fig. 13 (cat. no. 48). Posthumous tetradrachm of Alexander the Great, mint of Pergamon, end 3d–beginning 2d century B.C. OBVERSE: Head of Herakles with lion skin; REVERSE: ΑΛΕΞΑΝΔΡΟΥ ([coin] of Alexander). Zeus Aetophoros (holding an eagle) enthroned facing left; on the left, a bee. Silver, 16.95 g; inv. 10659; Kleiner, "Alexander Tetradrachms," series IV, E 11; Price, *Alexander the Great and Philip Arrhidaeus*, no. 1476

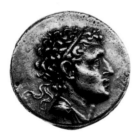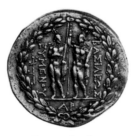

Fig. 14 (vol. 1, p. 108, fig. 12). Eumenes II, tetradrachm, ca. 170–160 B.C. OBVERSE: Head of the king with diadem; REVERSE: ΒΑΣΙΛΕΩΣ ΕΥΜΕΝΟΥ ([coin] of King Eumenes). Laurel wreath surrounding Dioscuri (Castor and Pollux) standing frontally with spears, the one on the right also holds a short sword; on the left, stylis; in the exergue, AP. Silver, 16.62 g; Nicolet-Pierre, "Monnaies de Pergame," 203–4. (Photo: Bibliothèque Nationale, Cab. des Médailles, Paris)

Pergamene kingdom up to the time of Eumenes II (r. 197–159 B.C.), one has to realize that the Pergamene kingdom was by no means restricted to a uniform currency. The Attalid tetradrachms of Attic weight standard mingled easily with coins belonging to the same weight standard from any other region, and they are, for their part, found even in countries as remote as Mesopotamia. On the other hand, the coinages of Alexander the Great and the principal Hellenistic states circulated in vast quantities and even dominated in the Pergamene kingdom. The supply was such that it proved unnecessary for the kings of Pergamon to issue gold coins and silver drachms in their own name. The situation was different only with respect to the bronze coins.

The long series of Philetairos-type coins, whose portrait heads had lost all original vigor and vitality after decades of repetition, was eventually supplemented, under the reign of Eumenes II, by a silver tetradrachm with the portrait of the reigning king. For a long time this coin was known only from a single example that in 1849 had found its way to the British Museum. Not until 1983 did a second example turn up; it was purchased by the Bibliothèque Nationale at Paris (fig. 14). The head of Eumenes II on the obverse wears a diadem with ends fluttering freely in the air; the neck, distinct from that of Philetairos, is draped. On the reverse appear the two Dioscuri, flanked by the vertical lines of the legend "[coin] of King Eumenes." They stand frontally and are each naked save for a chlamys and pilos (pointed hat), and they are armed with spears; the one standing on the right also holds, in his left hand, a short sword. There are stars above the heads of the Dioscuri. A laurel wreath encircles the image. If one looks for a historical situation that would present a suitable setting for the issue of the exceptional portrait coins, one might, as did Ulla Westermark, propose the years of 166–165 B.C. At this time Eumenes II, despite the obstructionist policies of the Romans, won a great victory over the Celtic tribe of the Gauls in Central Asia Minor and was honored as benefactor by the Greeks. But this date cannot yet be considered definitive.

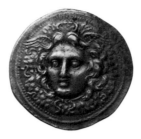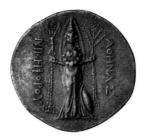

Fig. 15 (vol. 1, p. 108, fig. 13). Pergamon, festal coin (tetradrachm), 181 B.C. (?). OBVERSE: Gorgon's head frontally on a shield; REVERSE: ΑΘΗΝΑΣ ΝΙΚΗΦΟΡΟΥ ([coin] of Athena Nikephoros). Cult image of Athena Nikephoros (bringing victory) standing frontally with Nike and branch. Silver, 16.89 g; Mørkholm, "Some Pergamene Coins," 187–92. (Photo: National Museum, The Royal Collection of Coins and Medals, Copenhagen)

Another exceptional issue of tetradrachms from the time of Eumenes II has been known for only twenty-five years. The example reproduced here (fig. 15) is in the National Museum at Copenhagen. The obverse shows a winged Gorgon's head of the "fair type" on a round shield, while on the reverse, together with the legend "[coin] of Athena Nikephoros," appears a statue of the goddess, which doubtlessly represents the cult image of the famous Pergamene sanctuary that has yet to be discovered. Surely one would not have expected the mistress of this sanctuary to be anything other than purely Greek in appearance. In fact, however, we see that in a quite unusual way elements of a mother-goddess of Asia Minor were combined with those of a Greek Athena: the goddess stands frontally, wearing a polos on her head from which a veil hangs down her back; a peculiar ornament, consisting of seven globular objects, frames the upper part of her body forming a crescent that opens toward the top; her forearms are extended and strings with tassels hang from her hands; the left hand holds what may be an olive branch with new growth. The remaining elements of the figure are Greek: the unhindered fall of the garment; the rendering of the weight-bearing and relaxed legs; the round shield leaning against the left leg; and the Nike statuette held in the right hand. It is unanimously agreed that these exceptional tetradrachms were minted as commemorative coins on the occasion of a celebration of the festival of the Nikephoria. After the reorganization of the Nikephoria in 181 B.C. by Eumenes II, they took place every four years as a Panhellenic festival. A terminus ante quem for the coin is provided by the fact that two of the three examples of the coin currently known come from a hoard found near Larissa in Thessaly, which was buried around 165 B.C. Unusual, but not unparalleled is the fact that the sanctuary of Athena Nikephoros itself is noted as being responsible for the coin's issue.

The standard silver coin in the last decades of the Attalid reign was the cistophoric tetradrachm, a strange coin in every respect (fig. 16). Its images refer to Dionysos and Herakles. On the obverse, surrounded by an ivy wreath, a round box with open lid is shown, out of which crawls a serpent. The coin's name, *cistophoros,* refers to this Dionysiac cista (container). On the reverse one perceives, between two upright serpents with intertwined tails, a gorytos (decorated bow case) containing a bow, which is to be interpreted as a symbol of Herakles. The smaller pieces—drachm (fig. 17) and

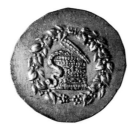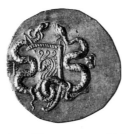

Fig. 16 (cat. no. 49). Cistophoros, mint of Pergamon, middle 2d century B.C. OBVERSE: Ivy wreath surrounding cista mystica with serpent; REVERSE: Two serpents surrounding a gorytos with bow; on the left, a monogram of the city name; on the right, head of Athena. Silver, 12.68 g; from the Löbbecke collection; Kleiner and Noe, *Early Cistophoric Coinage*, 28, series 17, 37–a

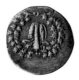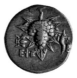

Fig. 17 (cat. no. 50). Cistophoric drachm, mint of Ephesos, 140–137 B.C. OBVERSE: Ivy wreath surrounding club and lion skin; REVERSE: Bunch of grapes on vine leaf; on the left, ΕΦΕ and bee; on the right, double cornucopiae. Silver, 2.73 g; inv. 319/1872; Kleiner and Noe, *Early Cistophoric Coinage*, 51, series 35, 7–a

didrachm—show on the obverse a club and a lion skin, common attributes of Herakles, surrounded by a wreath of vine leaves, and on the reverse, a bunch of grapes on a vine leaf.

Apart from Pergamon, cistophoric coins were also struck in a number of other mints of the Attalid kingdom, especially at Apamea, Ephesos, Sardis, and Tralles. The mints signed the coins at the left margin of the reverses with their initials, which are sometimes configured as monograms. To the constant types (of ivy wreath and Dionysiac cista on the obverse, serpents and bow case on the reverse) and signatures are added the varying symbols of the mint officials. In terms of their appearance, the cistophoric coins resemble the coinage of a federation of city-states rather than that of a kingdom. The absence of the ruler in type and legend on the coins remains difficult to understand. But the cistophoric coins differ radically from the tetradrachms of the Philetairos type not only in their appearance. They even follow a new weight standard, which is 25 percent less than the Attic standard used up to that time. As the places where the cistophoric coins are found indicate, only a small number of them has ever left the territory of the Attalid kingdom. Through their monetary policy the later Attalids had eventually succeeded in creating a coinage that corresponded to the demands of their kingdom and can be considered to have been its proper currency.

The date of the introduction of the cistophoric coinage has been much discussed recently. The proposals range from about 180 B.C. to 159 B.C., the year of accession to the throne of Attalos II. Though the exact date still remains controversial, it is generally agreed that the transition from the Attic standard to the standard of the cistophori did not take place all at once, but that both currencies existed side by side at least for some years.

The cistophoric tetradrachm was to survive the Pergamene kingdom for more than 250 years as the standard silver coin of the Roman province of Asia. This is not the place to discuss this later coinage. However, mention should be made of a small group of cistophoric coins issued only after the

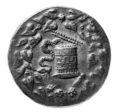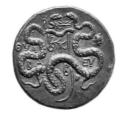

Fig. 18 (cat. no. 51). Cistophoros of the usurper Aristonikos, mint of Thyateira, 133–132 B.C. OBVERSE: Ivy wreath surrounding a cista mystica with serpent; REVERSE: Two serpents surrounding a gorytos with bow; on the left, ΘYA; on the right, head of Dionysos (?); below on the left, BA; on the right, EY; in the center, B. Silver, 12.56 g; inv. 34/1921; Kleiner and Noe, *Early Cistophoric Coinage,* 103, series 1, 3–h

death of Attalos III (r. 138–133 B.C.), which is of interest as an appendix to the royal coinage. Attalos III had bequeathed the Pergamene kingdom to the Romans at his death. Aristonikos, an illegitimate son of Eumenes II, claimed the inheritance for himself and instigated a revolt against the Romans. At first he had remarkable success and held his territories for four years. Under the dynastic name Eumenes [III] he issued cistophoric coins in several Lydian cities, first at Thyateira (fig. 18), then at Apollonis, and finally at Stratonikeia. The cistophoric coins of Aristonikos are the only ones on which the name of a king is mentioned together with the actual year of his reign (here, B, i.e., year 2 = 132–131 B.C.). The fact that ancient historians do not mention the dynastic name used by Aristonikos had for many years prevented a correct interpretation of this group of coins. The legend BA[SILEOS] EU[MENOU] was readily assigned to Eumenes II. As a result, not only was this group of coins dated half a century too early, but this led to the conclusion that the minting of cistophoric tetradrachms had already begun in the last third of the third century B.C. E. S. G. Robinson was the first to identify the Eumenes of the coin's legend with the usurper Aristonikos and thereby cleared the way for the correct integration of the cistophoric currency into the numismatic and monetary history of the Attalid kingdom.

The Pergamene silver coins minted from the time of Philetairos onward are complemented by bronze coins, which belong to various numismatic categories. The first category consists of the dynastic bronzes; as with the tetradrachms they bear the name of Philetairos, although in their case, unlike the silver coins, they were not introduced to function as a new standard. In addition to the dynastic coinage there is a civic coinage denoted by the legend "[coin] of the Pergamenes"; of course, other cities in the Pergamene kingdom also issued their own civic coinage. Eventually, if the legends on the coins may be taken literally, the important Pergamene sanctuaries of Athena Nikephoros and Asklepios Soter issued bronze coins in their own names. The sanctuary of Athena Nikephoros as a minting institution has already been mentioned above for the introduction of the exceptional new tetradrachm (see fig. 15). The coins in the names of these two deities are, of course, typologically devoted to them exclusively. Again, depictions of Athena and Asklepios are dominant in the imagery of the dynastic and civic bronze coins. Determining a precise chronology for the bronze coins is not yet possible. Nor is it possible to establish the sequence of their issue. Also, there are no criteria that would help to distinguish coins of the later period of the kingdom reliably from those of the time of the Roman rule. The end of the

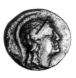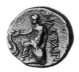

Fig. 19 (cat. no. 52). Attalid coin, end 3d century–first half 2d century B.C. OBVERSE: Head of Athena with Attic helmet; REVERSE: ΦΙΛΕΤΑΙΡΟΥ ([coin] of Philetairos). Asklepios seated facing left feeding a serpent. Bronze, 4.61 g; from the Imhoof-Blumer collection; Fritze, *Münzen von Pergamon,* 23; Boehringer, "Münzen," M 32

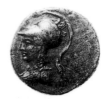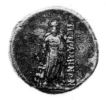

Fig. 20 (cat. no. 53). Pergamon, civic coin, 2d century B.C. OBVERSE: Head of Athena with Corinthian helmet; REVERSE: ΠΕΡΓΑΜΗΝΩΝ ([coin] of the Pergamenes). Asklepios standing frontally with staff entwined by a serpent. Bronze, 10.39 g; inv. 11112; Fritze, *Münzen von Pergamon,* 5; Boehringer, "Münzen," M 43

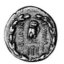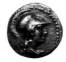

Fig. 21 (cat. no. 54). Pergamon, festal coin, 2d century B.C. OBVERSE: Head of Athena with Corinthian helmet; REVERSE: ΑΘΗΝΑΣ ΝΙΚΗΦΟΡΟΥ ([coin] of Athena Nikephoros). Owl shown frontally; below, monogram of the city's name; all in a laurel wreath. Bronze, 1.98 g; from the Fox collection

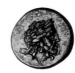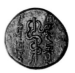

Fig. 22 (cat. no. 55). Pergamon, festal coin, 2d century B.C. OBVERSE: Head of Asklepios with laurel wreath; REVERSE: ΑΣΚΛΗΠΙΟΥ ΣΩΤΗΡ[ΟΣ] ([coin] of Asklepios Soter). Staff entwined by a serpent. Bronze, 4.01 g; from the Imhoof-Blumer collection; Fritze, *Münzen von Pergamon,* 29

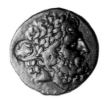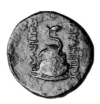

Fig. 23 (cat. no. 56). Pergamon, festal coin, 2d century B.C. OBVERSE: Head of Asklepios with laurel wreath; to left, countermark (head of Artemis); REVERSE: ΑΣΚΛΗΠΙΟΥ ΣΩΤΗΡΟΣ ([coin] of Asklepios Soter). Serpent coiling around an omphalos. Bronze, 8.52 g; from the Imhoof-Blumer collection; Fritze, *Münzen von Pergamon,* 5; Boehringer, "Münzen," M 49

kingdom provides a confirmed terminus ante quem only for the dynastic bronze coins.

In conclusion, some examples of the different categories of Pergamene bronze coins will be put forth: the obverse of a dynastic bronze (fig. 19) shows a head of Athena with an Attic helmet, the reverse a seated Asklepios feeding a serpent. On a civic bronze (fig. 20) a head of Athena wearing a Corinthian helmet is combined with Asklepios on the reverse, standing frontally and holding a staff entwined by a serpent. The types of a small bronze coin minted in the name of Athena Nikephoros (fig. 21) consist of a head of Athena wearing a Corinthian helmet and an owl within a laurel wreath. Below the owl is the monogram, known from the cistophoric tetradrachms, of the mint of Pergamon, which seems to have been commissioned by the sanctuary to strike its series of coins. The two coins of Asklepios Soter (figs. 22–23) bear on the obverse a head of the god and on the reverse a staff entwined by serpents or a serpent coiling around an omphalos. The head of Asklepios on the second, somewhat larger, coin, which almost completely fills the field, seems to have been influenced by the high Hellenistic style of the time of the Great Altar of Pergamon, which in general has left no traces on Pergamene coins.

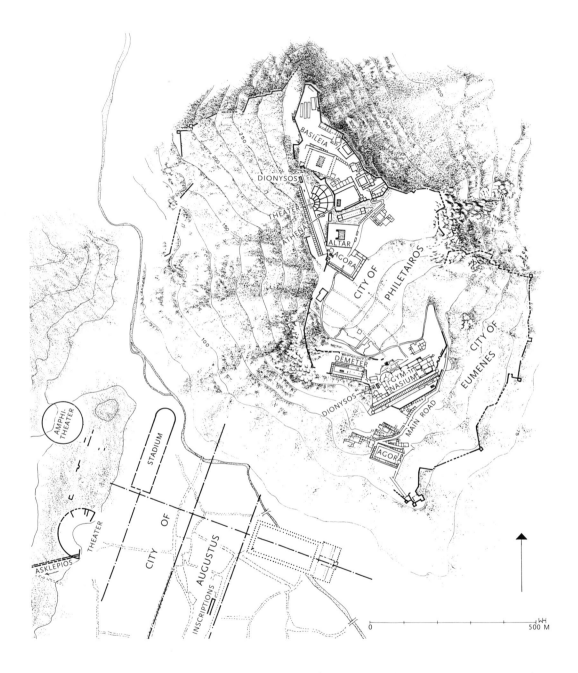

Fig. 1. Extension of the city of Pergamon: Philetairos built a small city covering the northern part of the hill, Eumenes II enlarged Pergamon, and Augustus extended it onto the plain below the citadel. (Drawing: Hoepfner)

THE ARCHITECTURE OF PERGAMON

WOLFRAM HOEPFNER

In a famous passage the historian Michael Rostovtzeff pointed out that the great building projects of the second century B.C. undertaken by the free cities in Asia Minor such as Miletus and Priene were the result of the area's general wealth, especially that of a very affluent middle class.[1] The buildings of Pergamon, however, existed because of its kings' devotion to culture. More than other rulers, they thought of themselves as custodians of the legacy of the high classical period, which they used as the basis for their legitimacy. Their function as representatives of their empire allowed them to act as innovators, evoking astonishment and admiration. Royal architecture had to be conservative and innovative at the same time. Three periods of construction can be clearly distinguished in Pergamon (fig. 1).[2] Of the three, the middle period, the era of Eumenes II, was a time of rich development, amalgamating the arts of architecture and sculpture on the highest level, as had been established in the classic period and which was reached again later in Europe under Augustus and then in the Renaissance.

HISTORY AND DEVELOPMENT OF THE CITY

From Xenophon we learn that the pro-Persian Greek Gongylos of Eretria had been appointed ruler over Pergamon and other places (470s B.C.).[3] One hundred years later Xenophon and his soldiers were welcomed by the wife of a younger Gongylos in Pergamon. She advised them to raid the camp in the plains of a wealthy Persian, since they could expect booty. Hence, in the fourth century B.C. Pergamon was nothing but a den of thieves,[4] hardly a city important to Greek culture.

It was to this place that Alexander sent his illegitimate son Herakles with the child's mother, the Persian princess Barsine, to hide.[5]

Where in Pergamon did the Gongylids live? On the highest point of the acropolis insignificant remains of a huge square tower can be seen. Each side measures 17.40 meters long and the walls 1.50 meters thick (fig. 2a–b).[6] Traces of the inner walls can be seen in the southeast. Thus, one can assume that next to the entrance facing the street were located smaller rooms as well as a staircase. Accordingly, this tower was not an isolated defense tower, water tower,[7] or altar,[8] but a residential tower,[9] such as were built on the islands and the mainland in the fourth century B.C. wherever farmers had to protect themselves against pirates and robbers.[10] Such isolated farms, which consisted of oikiai (buildings) and pyrgos (tower), are also mentioned in inscriptions.[11] The most impressive towers, of which many stories have survived, are to be seen on the islands of Naxos and Keos.[12] Robert Koldewey also saw such residential towers on Lesbos, an island close to Pergamon.[13] Thus, little doubt exists about the function of the Pergamene tower. With a height of more than 20 or even 30 meters, it must have been visible from afar and was later probably still a landmark of Pergamon. It should be noted that nothing has ever been built over it.

Exactly parallel to this tower lie the ruins of a building 9 meters deep, which probably served secular purposes. A small Doric temple, of which two building phases can be distinguished, is oriented toward this building. Xenophon made sacrifices on the altar that stood in front of it. At the corner of

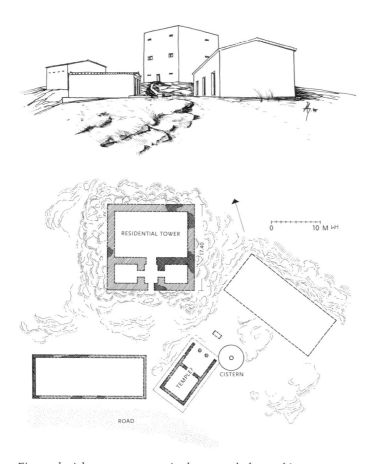

Fig. 2a–b. A large tower, seen in the ground plan and in a tentative reconstruction, seems to have been the fortified residential tower of the family of Gongylos in the 4th century B.C. (Drawings: Arvanitis and Hoepfner)

the temple is a large, well-preserved cistern 4.55 meters in diameter. It is 6.20 meters deep and has a round column in the middle on which the capstones rested. The cistern collected the water from the roofs of the surrounding buildings. The ensemble, which of course can only be reconstructed hypothetically (see fig. 2b), differed from other farms or country estates only because it incorporated a modest temple.

Philetairos of Tios on the Black Sea, son of a Greek father and a Paphlagonian mother, a high-ranking officer in the army of King Lysimachos and also his confidant, was the actual founder of Pergamon. There, at first, he guarded the substantial treasure of nine thousand talents belonging to the king that was hidden in an inconspicuous and unimportant place. Pergamon may have been chosen because the large dwelling tower, with its 1.50-meter-thick walls, provided a secure hiding place for the silver coins, worth fifty-four million drachmas. Lysimachos, pressed by his wife, Arsinoë, had his own son and successor to the throne, Agathokles, murdered, and as a result lost his prestige with all ruling families. Philetairos took advantage of the situation, broke with Lysimachos, and committed himself to the powerful King Seleukos.[14] This move proved astute, because soon after, in the battle near Korypedion (281 B.C.), Lysimachos lost his empire and his life, and Seleukos later fell victim to an assassin. In this unexpected power vacuum arose the opportunity to found the new state of Pergamon.

Philetairos ruled Pergamon independently for almost twenty years, until 263 B.C. His successors honored him as founder of the dynasty and put his portrait on their coins (see Schultz in this volume). Only by being internationally accepted could the small state hope to keep its independence. Philetairos believed in the effectiveness of cultural politics. He recognized that messages transmitted in this manner made it possible for him to maintain and gain further power. Unlike neighboring states such as Bithynia, Paphlagonia, and Pontos, which remained provincial even after they had become kingdoms, the Pergamenes considered themselves from the beginning part of the Greek community and established connections with the important international sanctuaries of Delphi, Olympia, and Delos.[15] Already in Philetairos's time, the building program began to turn Pergamon into an appropriate place for the ruling dynasty. The top of the hill had its own wall and was set apart from the town proper (see fig. 1). Philetairos's city wall encircles a large part of the hill that slopes to the south. Unfortunately, we still do not know what the network of roads servicing the residential

quarters looked like, nor is anything known about the early houses.

One generation later Pergamon was a great power: in 188 B.C., in the peace of Apamea, much of western Asia Minor came under Pergamene rule. Pergamon suddenly became a mighty capital like Alexandria and Antioch. The new self-confidence of Eumenes II, who now ruled an empire and, accordingly, had much money at his disposal, manifested itself in a spectacular building program for the metropolis. Under Philetairos and his successors the walled city encompassed only 20 hectares (1 hectare = approx. 2.5 acres). Eumenes II now ordered a new wall to be built, which in the south and southeast extended to the plain and in the west reached as far as the river Selinus, a tributary of the Kaikos (see fig. 1). Although the area of the city of about 90 hectares (approx. 225 acres) fell far short of other Hellenistic cities in size, Pergamon could now count itself among the major Hellenistic cities.

Under the Roman emperor Augustus, Pergamon, with the exception of Ephesos, became capital of the province of Asia. A further indication of the importance of the city is that Augustus almost doubled the size of its territory. In the plain, south of Eumenes' city, an extensive new district arose, which adhered to a strict grid system. Buildings meant for great numbers of people were built, among them a stadium and a theater. It is here that the search for the temple of Octavian, erected in 29 B.C. as the central sanctuary of the imperial cult in the province of Asia, should start.[16] The temple of the emperor Trajan, later erected on the citadel, seems to have been planned exactly at the end of the extension of the main road of the city of Augustus.[17]

BUILDING MATERIAL

Most Hellenistic cities are located in open country, making fast travel from point to point possible. Pergamon's rulers founded several cities that adhered to the established patterns of parallel insulae and dense networks of roads.[18] Pergamon, however, belongs to the type of archaic city that, for reasons of defense, is situated on a steep slope. The seat of a sovereign on the hill, which had been there from early times, had to be maintained when the city was founded in the early Hellenistic period. It did not take long for the Pergamene rulers to realize that they could make a virtue of necessity, and that the irregular construction of the city offered challenging possibilities for city planning.

The mountains in and around Pergamon do not offer good building material.[19] Volcanic rock is everywhere, and, as at Assos, red, yellow, and brown rocks dominate the landscape. Andesite (named after the Andes), a younger volcanic stone of porphyritic structure with high vitreous content, can take a lot of weight, but it breaks more easily than hard limestone and can be used for building only if the stones are medium in size. Like andesite, the related trachyte (*trachys* in Greek means "rough" and is the primary component of the hill on which the city of Pergamon sits), does not lend itself to large building projects and the fashioning of architectural details. The even harder, dense, and almost black volcanic basalt is subject to chipping and can be used only as building material for houses. Finally, tufa, solidified volcanic ash, is soft and prone to weathering and is therefore only suitable for foundations.

The architects of Pergamon, faced with these conditions, developed an architecture using small stones. Furthermore, they constructed walls with facings in which two narrow blocks were set upright, on top of which was placed a flat and continuous layer of binders. This form of construction was termed pseudo-isodomic (Vitruvius 2.8.6), and it arose from the need to use andesite as a building material. Marble was used only on very rare occasions in the third century B.C. It was very expensive and could be brought to Pergamon only with great difficulty. It was not until the end of the third century B.C., when the quarries of Prokonnesos[20] and its marble belonged to the city of Pergamon, that this stone was used in abundance in the capital. At this time it was obviously

cheap, because the quarries presumably were owned by the king, just as the marble quarries were later the property of the Roman emperors.[21]

TERRACES AND PERISTASES

For each building that was to sit on the steep slope of Pergamon, including private houses, a terrace had to be cut into the hard rock. The material wrested from the rock could be used on site for the front part of the terrace, which had to be artificially constructed. The steepness and narrowness of Pergamon's hill does not allow room for large terraces, yet public Hellenistic architecture called for large open spaces. The architectural layout of public squares was the important theme of city planning. To display a certain dignity the terraces had to have a depth of 60 to 70 meters. Thus, a unique method of building terraces and porticoes developed in Pergamon, which became the model for many similar constructions in other cities in Asia Minor.

Particular problems occurred on the terraces built on the slope. Here the earth was under greatest stress and threatened to collapse, especially during the winter rains and where the substratum consisted of tufa. The builders of Pergamon developed a special protective architectural device, called the peristasis. The word *peristasis,* or the colonnade encircling a peripteral temple, is used here to refer to the covered pathways. It derives from the alley surrounding early classical houses, which separated neighboring houses on all sides except the street front.[22] The typical Pergamene peristasis was a slab-covered pathway, and, as the excavations show, almost every house on the slope was provided with one. A law required them to be 1 cubit (approx. 50 cm) wide to provide enough space for a person to perform necessary cleaning and repair work (fig. 3a–c). In the famous inscription of the astynomoi, a legal text dating from the time of the Pergamene kings, the problems arising from these covered pathways are discussed. Punishment was inflicted on those who damaged or filled in a peristasis. They could not be used for stor-

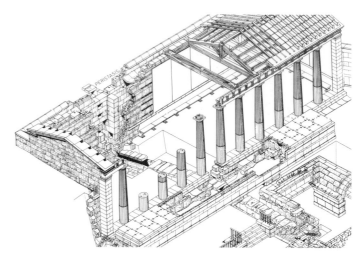

Fig. 3a. A one-storied Doric stoa, which Attalos I dedicated in the sanctuary of Apollo at Delphi. (Reconstruction and drawing: Roux and Callot)

age, and even trespassing was punished with a fine of five drachmas.[23]

The slab-covered pathways meant more construction work. In addition to the walls and foundations of the buildings, a second wall, the actual terrace wall, had to be built. If the soil exerted too much pressure, the wall on the hillside would bulge into the covered pathway, which allowed time to fix the problem without causing damage to the structure on the slope. The assumption that the function of the peristasis was to collect and drain off rainwater is incorrect. On the contrary, greatest care was taken to keep the peristasis and the walls of the building dry.[24] Rainwater was channeled above ground into the streets and collected in large drainage systems. Especially well preserved are the peristases at the gymnasium at the temple of Hera, behind the north stoa of the sanctuary of Athena, and by the walls of the houses from the period of Eumenes in the area below the agora. The entire city was linked with a network of these covered pathways. There were, however, disadvantages to them, in that they attracted vermin and served as good hiding places.

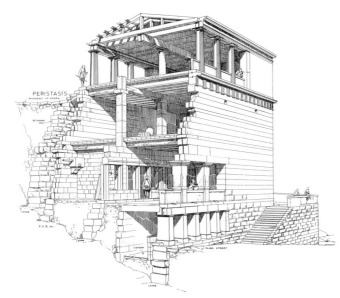

Fig. 3b. Stoa in the agora at Assos. (Reconstruction and drawing: Koldewey)

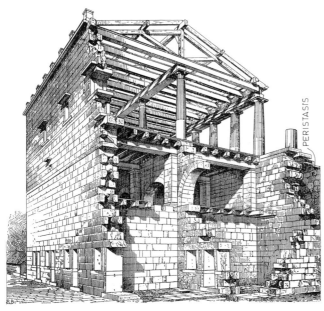

Fig. 3c. Stoa in the agora at Aigai. (Reconstruction and drawing: Bohn)

Toward the end of the third century B.C. large city squares were built in Magnesia on the Maeander, and, for the first time, these were completely enclosed by uniform stoas.[25] Such city squares so well answered the increased demand for ostentation that most later squares were built in this fashion. However, this meant that the type and function of the buildings behind the stoas could no longer be determined from the outside, as was the case with the prytaneion at Magnesia. Athens and Priene serve as examples to show that old agorai were frequently reconstructed to become modern squares. Like the famous gymnasia at Alexandria and Rhodes, the gymnasium at Pergamon also had a very large colonnaded court serving as a palaestra. However, giant peristyles remained an exception at Pergamon because such spacious squares could only be created on the steep hillside with great effort.

In Pergamon stoas as single monuments predominated, and some were of considerable length. The stoa on the theater terrace (see fig. 1), with a length of over 200 meters, is the longest in the Hellenistic world. The way in which the disadvantage of the steep incline was turned into an advantage makes this construction exceptional: tall basements, serving as storerooms and stables, were constructed on the side facing the valley (figs. 3a–c, 4).[26] These could be reached from below on the slope side. The main stories were adjusted to the hillside and were entered through a colonnade. Thus, four-storied buildings were often built that were more than 20 meters high. As they sometimes were more than 11 meters deep, an inner system of support was necessary. In the upper stories columns were erected, and in the basement a continuous center wall was built, sometimes constructed of large open arches. Such stoas were erected at Pergamon at the market, the gymnasium, the theater, and other places. The Pergamene stoas were famous. The kings gave stoas to Delphi (see fig. 3a) and to Athens, specifically the re-erected stoa of Attalos in the agora, which today serves as a museum, and the stoa of Eumenes by the theater. Their building elements

were prefabricated in Pergamon and transported to the site.[27] The stoa in the agora at Assos (see fig. 3b) and the stoas at Aigai (see fig. 3c), not far from Pergamon, were built in high Hellenistic times, presumably following the pattern of the stoas in the capital.

The Roman architect Vitruvius (4.2.2) describes the triglyphs of the Doric order as beam ends, which, in early times when columns and the entablature were entirely made of wood, were adorned with grooves. Because in the classical period the beams were always higher than the triglyphs, it is reasonable to doubt Vitruvius's explanation. It is noteworthy that in Pergamene Doric buildings, especially the stoas, the main beams are always situated at exactly the same height as the triglyph frieze (fig. 4). This is because the extremely graceful and light hall architecture, with its widely spaced slender columns and finely detailed cornices, was only made possible by firmly anchoring the thin facades to large beams and heavy ceilings of gravel or cement.[28] In the wooded countryside of Mysia surrounding Pergamon, trees to make large beams could easily be found. Above these crossbeams smaller beams were placed lengthwise to provide ventilation for protection against dampness. Thus were created the coffered ceilings so characteristic of Greek and Roman architecture.[29]

Unfortunately, the peristases that protected Pergamene halls were not always noticed by the excavators.[30] However, the hall and peristasis of the stoa that Attalos I dedicated at the sanctuary of Delphi, which also lies on a steep slope, are well preserved (see fig. 3a),[31] as are the stoas at Assos and Aigai.[32]

CITY STRUCTURE, CITY WALLS, AND STREETS

In Pergamon terraces followed in close sequence up the slope of the hill. In conforming to the incline they changed their orientation. Thus, many attractive and diverse urban spaces were created. The architects of Pergamon certainly knew that they were not following the rectilinear and symmetrical stoa and open-stairway architecture at Lindos and Kos. We may

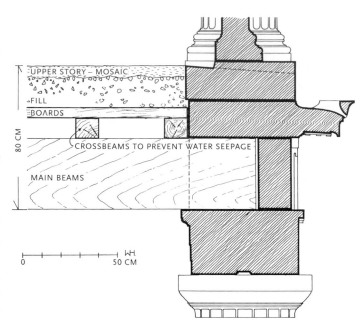

Fig. 4. Section through a Pergamene stoa. (Drawing: Hoepfner)

rest assured that they did not consider their manner of building, determined as it was by the hills, a disadvantage, but rather a particular advantage. Athens, the center of Greek classical art and architecture, with its gradually developed and informally arranged houses, was also a model for Pergamene urban architecture.

Hellenistic metropolises have main roads that are often more than 15 meters wide and run in straight lines from gate to gate. The main road in Pergamon also is the backbone of the city plan (see fig. 1). Because the slope is steep and irregular, a main road running up the hill could only have been realized in the form of steps. The basileia (royal district), however, had to have a winding, paved road connecting the most important terraces of the public buildings. Although the rural and military roads on Pergamene terrain legally had to be 20 cubits, or approximately 10 meters, wide,[33] the main boulevard in the inner city was only 5 meters wide. This relatively narrow street doubtless originated early and was enlarged

and paved only later. The crossroads run at right angles to the main street. Therefore, the buildings followed the course of the main road, which often changed direction. Unfortunately, we still do not know whether the residential settlement built under Eumenes differed in its layout from the older city. The latest results of the new excavations in the housing area within Philetairos's city seem to show that the residential streets turn off the main road at almost equal intervals of 50 to 70 meters. A house placed ingeniously within the triangular space between the sanctuary of Demeter and the sanctuary of Hera[34] shows that by the time of Philetairos, at the latest, a practical solution that the government could accept must have existed for dividing the city into lots, despite the adverse terrain and previously allotted plots. Whether small houses existed in addition to the peristyle houses, as on Delos and in Hellenistic Priene, is still not known. It is certain that many poor people did not have their own living quarters but lived in large houses as servants. But how did the middle-class citizens of Pergamon live?

The large main road was researched in detail by Wilhelm Dörpfeld.[35] The rural road coming from the south, from the harbor of Elaia, reached the largest city gate at the foot of the town. The gate consisted of a square court protected by towers (see fig. 1). The road then passed the lower market, turned sharply up to the large terrace of the gymnasia, and reached the old city farther to the north. Taking a sharp turn and passing the residential houses, the road crossed the upper market and led to the basileia, which had its own wall. Behind the gate of the citadel it passed the sanctuary of Athena and the palaces and reached the arsenals. The road was 570 meters long and ascended 63 meters, a gradient of more than 10 percent. It was entirely paved with slabs of trachyte. Underneath lay large sewage channels and clay conduits for freshwater. The conduits were of limited durability and had to be replaced every so often by new pipes. At various points the excavators found up to eleven different pipes side by side.

Just as the Acropolis at Athens is set apart from the living quarters, so the basileia in Pergamon with its wall and the steep sloping hill are separated from the public section (see fig. 1). In both instances the sanctuary of Athena Polias is situated in the center of the acropolis. It does not seem to be mere coincidence that at the foot of the southern citadel wall in Pergamon are niches and exedrai comparable to the cliff sanctuaries at the edge of the Acropolis at Athens. In one of these caves or depressions in the rocky terrain below the sanctuary of Athena at Pergamon may have stood the Prometheus group (cat. no. 21) showing the freeing of the hero who had been chained to the rock. Recently the sculptural group has been convincingly attributed to Eumenes II in connection with his final victory over the Gauls in 166 B.C.[36] A path below the citadel wall that corresponds to the Athenian peripatos (covered walk) must have provided access to these exedrai and cult places. A building discovered below the ruins of the Pergamon Altar farther down the slope must also have belonged to these sanctuaries. It was most likely a sanctuary of the Nymphs.[37]

The late classical period marks the zenith of Greek fortification building. With immense effort walls up to 8.50 meters thick and mighty turrets were erected.[38] In the Hellenistic period individual cities no longer fought and besieged one another. Rather, large empires battled each other with gigantic, swiftly operating armies of mercenaries. Entire provinces could be conquered or lost, and the resistance of individual cities was of little importance, as their surrender was inevitable. It therefore comes as no surprise that the city walls in Pergamon do not belong to the most sophisticated fortification systems and for long stretches are only 2 meters thick.

In Pergamon a theater must have existed in early times, because that is where the people's assembly convened. An older phase of the theater can clearly be detected on the site.[39] The agora, named the "Upper Market" by the excavators, was surrounded by houses and was the heart of civic life. Later

this was also remodeled and more elaborately developed, like other public squares. At the time of Eumenes II, at the latest, the upper agora was an administrative, religious, and social center, accessible to all citizens, while the new lower market, a large square also surrounded by colonnades, became the city's market.[40]

No city of culture could do without gymnasia, which in early Hellenistic times had already developed into general educational institutions similar to our universities. It is still not known where the old gymnasia of the third century B.C. were located in Pergamon. The large gymnasium extending over three terraces is said to have been built in one campaign during the reign of Eumenes II.[41] However, the question arises whether this largest construction in Pergamon did not have a predecessor, because spacious educational and athletic sites were usually built outside the city walls.

No running spring existed on the citadel. The people depended on old-fashioned, large, pear-shaped cisterns installed in their houses to collect and hold rainwater. The list containing all cisterns in the city was constantly checked by an astynomos. Damaging or filling in a cistern could result in a fine of one hundred drachmas, a large sum.[42] The famous pressure pipeline of Pergamon built under Eumenes II, which consisted of huge cast-lead pipes (fig. 5), went through

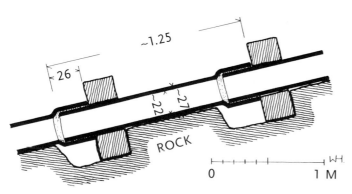

Fig. 5. Section through the famous pressure pipeline for freshwater. (Drawing: Hoepfner)

a valley and led up to the basileia. Obviously, it supplied only this royal precinct with water, but it may also have serviced the public fountains that existed in several places in the city. Doing laundry and watering animals were prohibited at these fountains. If a slave was caught at a fountain, acting on his own accord, he could be punished with one hundred lashes in the stocks, be put in the stocks for ten days and given repeated floggings with a kyphon (curved wooden stick).[43] Great emphasis was put on cleanliness and hygiene.

<div align="center">EARLY TEMPLES AND SANCTUARIES</div>

The dating of the Doric peripteral temple for the city goddess Athena Polias in the basileia of Pergamon is disputed. It is agreed, however, that the building is among the oldest in the city. The most likely interpretation was put forward by Erwin Ohlemutz, who proposed that Philetairos, the founder of the dynasty and the city, established the cult of Athena, programmatically selecting the city of Athens as his model.[44] The temple, facing south, lies at the edge of the terrace of the city sanctuary, which is approximately 60 meters deep (see fig. 1) and is not quite parallel to the old citadel wall.[45] Made of andesite like the temple of Demeter, the temple therefore differs from the marble buildings from the time of the Pergamene kings.

Only a few stones of the substructure were discovered in situ. But in the surrounding area, so many building elements were found that the ground plan as well as the superstructure of the little peripteros could be reconstructed on paper (figs. 6–8; foldout 1). The two-stepped substructure (13.02 × 22.52 m) shows such a regular distribution of stylobate slabs that it is certain there were six columns for the front and ten for the sides. The cella with its pronaos and opisthodomos is canonically placed within the peripteros. Noteworthy is the fact that the peripteros is no deeper on the front than on the sides. With no emphasis on the facade, the temple looks old-fashioned. On the other hand, when looking at the plan one detects a certain progressiveness in the almost

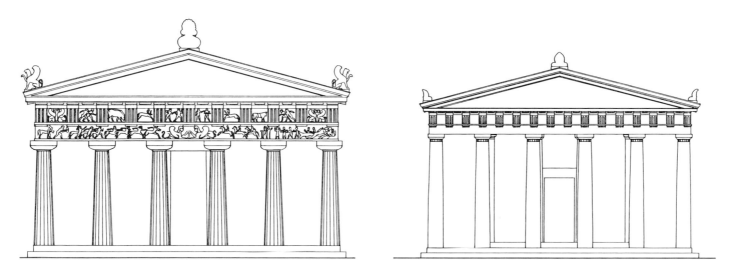

Fig. 6. The temple of Athena at Pergamon (right) depended on the venerable temple of Athena in nearby Assos (left), the only Doric peripteros in Asia Minor until the beginning of the Hellenistic period. (Drawing: Arvanitis)

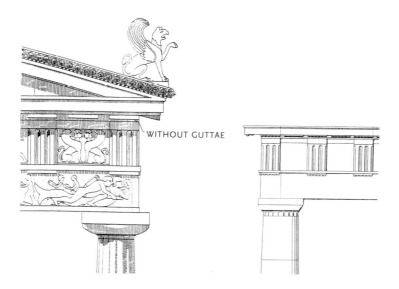

WITHOUT GUTTAE

Fig. 7. Details as dovetail clamps lying bare, round-glyph closing, and a geison without guttae show the dependence of the Pergamene building (right) on that at Assos (left). (Drawing: Arvanitis)

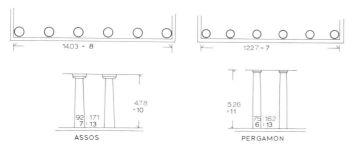

Fig. 8. Measurements and proportions of the front columns of the temple of Athena at Assos and the temple of Athena at Pergamon. (Drawing: Arvanitis)

Ionic lightness expressed by the widely spaced columns (see fig. 8; foldout 1). There are two and two half triglyphs and three metopes to a span instead of the usual one and two (see fig. 6). For practical reasons this three-metope system was used in the classical period on gate constructions and stoas with broad passageways. Aesthetic reasons must have determined the use of this system on a temple. In the course of the fourth century B.C., the Doric columns had already become more slender and their entablature lighter. However, in the Doric order a really wide spacing of columns can only be achieved with a span of three or even four metopes.

The temple of Athena shows very well how columns of unusual slenderness (height = 7.3 × lower diameter) set far apart can be combined with a low entablature, giving the Doric order an Ionic character. This was to remain a characteristic of Pergamene architecture.

One often notices unfinished columns on the buildings at Pergamon. As usual the capitals are completely finished, but the column drums are only blocked out and are thus unfinished. The evidence of the lowest drums shows that we are dealing here with an intentional state: the completed fluted band on the foot of the column, which is necessary if the entire column is to be fluted, is missing. Completing this section of the column later would have been impossible from a practical standpoint. Thus, we may conclude that the columns on the temple of Athena were never intended to be completed.[46] This unusual contrast between the light architecture and the unfinished columns was probably of importance to the architect. It cannot be a coincidence that some details of almost all buildings from this time remained unfinished. This also applies to the funerary monument of King Lysimachos near Ephesos, where, contrary to all previous practice, even unfinished capitals were used.[47] This intentional lack of finish may be surprising, but we should remember that it was also a favorite practice of Renaissance architects.

King Lysimachos gave the venerable city of Troy an important role in his empire and erected a marble temple to Athena there, a Doric peripteros with six columns by twelve columns and carved metopes. One gets the impression that in many ways Philetairos modeled himself on his former master. By comparison, the Pergamene temple of Athena is much smaller, of plain local stone, and without the sculptural adornment that would have required at least partial use of better material. The coins of Philetairos after 281 B.C. show a portrait of the deified Seleukos I, a concession to Seleucid power, and on the reverse side Athena Nikephoros in the tradition of the Lysimachos tetradrachm (see Schultz in this volume).[48]

In the archaic period Aeolis and, therefore, Assos as well made use of architectural forms based on plants. Most common are wreaths made of leaves and the Aeolic capitals.[49] The temple of Athena on the acropolis of Assos, however, is impressive evidence that buildings of the Doric order also existed early in northwestern Asia Minor.[50] This peripteros, erected in the middle of the sixth century B.C., is in many ways surprisingly close to the Hellenistic temple of Athena at Pergamon. The unusual lightness of the effect at Assos resulted from the graceful, slender columns that, thanks to the elongated metopes, could be set far apart (figs. 6, 8). A certain debt to the Ionic order can be detected in the sculptural decoration on the architrave and in the absence of the usual corner contraction. All spans on the front and sides are of equal size, with the result that the metopes become noticeably wider

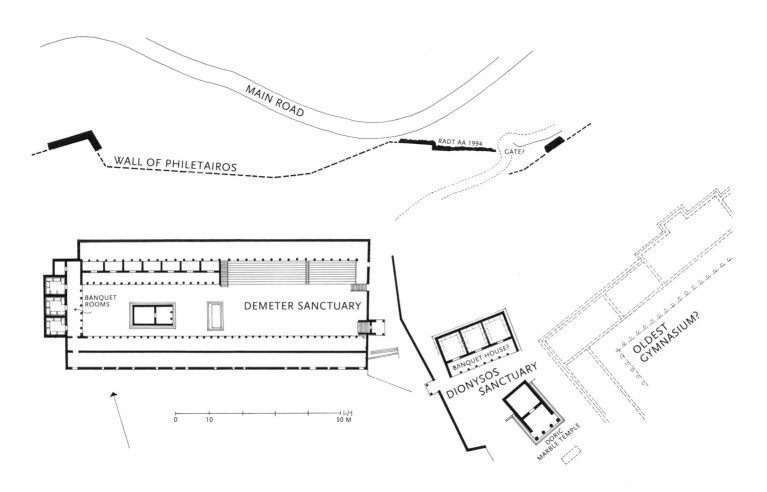

MAIN ROAD

WALL OF PHILETAIROS

RADT AA 1994

GATE?

BANQUET ROOMS

DEMETER SANCTUARY

0 10 50 M

BANQUET HOUSE?

DIONYSOS SANCTUARY

DORIC MARBLE TEMPLE

OLDEST GYMNASIUM?

Fig. 9. The old sanctuary of Dionysos and the sanctuary of Demeter were situated outside the old city. (Drawing: Hoepfner)

toward the corners. At Pergamon the ground plan is canonically Doric, and the lightness is achieved by means of the three-metope system. Both temples stand on two instead of the usual three steps. In the architecture at Pergamon the guttae on the regula and geison are frequently missing (e.g., Meter temple; stoa of Attalos); this is also true for the temple at Assos, which also served as a model for the roundish glyphs of the frieze. The architect not only closely inspected the archaic temple but obviously also measured it, since the proportions of the two temples are related (fig. 8): the ratio of the width of the stylobates of the two buildings is 8:7; the ratio of their lower diameters is 11:9; the ratio of their column heights is 10:11; and the ratio of the column diameter to the intercolumniation at Assos is 7:13 and at Pergamon, 6:13. Finally, both buildings exhibit a noteworthy technical peculiarity: contrary to Greek building practices, the slabs of the stylobate are joined by dovetailed clamps that are visible on the surface.[51] Philetairos, who had no money problems, obviously engaged builders from Assos who introduced these light Doric shapes, which then prevailed at Pergamon for decades.

Of the numerous buildings excavated at Pergamon only one, because of an inscription on the architrave, can be dated securely to the time of Philetairos's rule. In honor of his mother, Boa, he and his brother enlarged an ancient sanctuary of Demeter just outside the city wall to the south to form a theaterlike ensemble for cult festivities (figs. 1, 9). On a long terrace were built a deep temple in antis, stoas, and steps to sit on. From these one could follow the activities around the altars.[52] This impressive arrangement can be compared to the most important Demeter precinct of the Greek world, the one at Eleusis.

The long temple in antis (14.14 × 7.97 m) with a particularly deep porch (fig. 9; foldout 1) was built of the local brittle andesite. The temple rises from a two-stepped substructure. The walls with their unusually profiled socle are of pseudo-isodomic masonry, as the building material at Pergamon allows only small stones to be used. Above the unfluted

columns (no bases and capitals were found)[53] sits a low architrave, and on top of this as a special adornment, a high frieze of white marble (fig. 10). It shows beautifully executed bucrania with garlands and libation bowls. The usual entablature of dentil pattern, geison, and sima follows. Hans-Joachim Schalles has emphasized the dependence of this frieze on the slightly older buildings at the sanctuary of the Great Gods on Samothrake.[54] The architect of the temple of Demeter was obviously influenced by the famous sanctuary of the mysteries not far away.

In the Asklepieion at Pergamon, the famous cult place of the god of healing located in the hills southwest of the acropolis, were found many marble fragments of a bull-skull-and-garland frieze belonging to one of the earliest temples in the temenos.[55] The early dating, probably to the time of Philetairos, derives from its striking similarity to the frieze on the temple of Demeter. It is uncertain where in the sanctuary the temple stood.

In the small sanctuary of the mother goddess Meter in the hills near the city, a place now called Mamurt Kale, there is an important Doric temple surrounded by stoas.[56] The architrave bears an inscription naming Philetairos, the son of Attalos, as the one who commissioned the building.[57] The building material again is andesite, and, as on the temple of Athena, the fluting on the columns of the prostyle is missing (figs. 6, 11). Another common feature is the three metopes and two and two half triglyphs in each span. Because the architrave and frieze are especially low, the columns here are not noticeably far apart. The elements of the Doric order may actually have become decorative, because the columns are enormous in proportion to the delicate triglyphs. The entablature actually could be replaced by an Ionic one. All spans are the same size, and instead of the corner column being contracted, here the metopes have been considerably broadened toward the corners.

Great lightness, unfinished details, angular fillets, a very low architrave, and unusual decoration are characteris-

tics of the early architecture at Pergamon. The brittle and hard-to-work volcanic stone did not allow the fashioning of rich ornamentation or even the fluting of columns. Hardly any development or change seems to have taken place in this striking provincial architecture up to the time of the Pergamene kings. When Philetairos came to Pergamon he doubtless did not find sophisticated craftsmanship. If he intended to change the rural conditions to urban ones, he had to bring masons and architects to Pergamon. Not only masons but also experts in many different fields left the coastal towns and moved to the new capital.

Fig. 10. The temple of Demeter was built of reddish andesite. White marble was used for contrast only for the frieze with garlands. (Photo taken after excavation)

NEW PALACES OF EUMENES II

The royal precinct on the top of the citadel (fig. 12) was encircled by its own wall and was approximately 3 hectares in size. The palaces and living quarters of the royal household were not the only buildings located in the Hellenistic basilcia. Since King Eumenes II was in continuous correspondence not only with all cities of his empire but also with nearly all the cities in the Greek world, his administration and state archives required a large area. The city sanctuary of Athena also belonged to the royal precinct. The library—its two hundred thousand scrolls made it one of the largest in antiquity—was integrated into the sanctuary and attests to the presence of scholarly and scientific institutions in the basileia.

Conforming to the crest of the hill, this oblong district was crossed by the large paved road. Buildings were located on both sides. To the east, next to the citadel gate, were irregular buildings, which doubtless served the military. The somatophylakes, the king's bodyguards, were probably stationed here. To the north were arsenals. Theodor Wiegand named the ruins east of the paved road building complexes I to V.[58] The palaces must have been located here. Unfortunately, the buildings were not only altered several times but also ransacked, so the most important building phase of the monarchy can be reconstructed only hypothetically.

At the highest point of building complex I there was

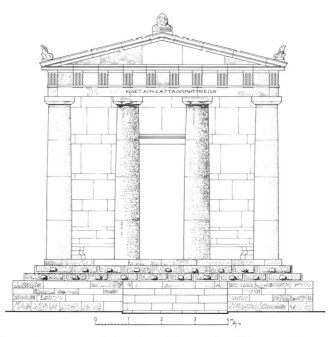

Fig. 11. Reconstructed elevation of the temple of Meter at Mamurt Kale from the time of Philetairos. (Drawing: Arvanitis)

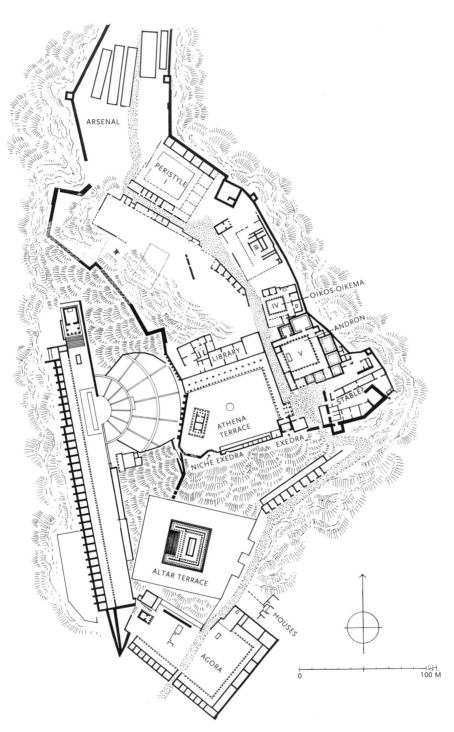

ARSENAL

PERISTYLE I

OIKOS·OIKEMA

IV

ANDRON

LIBRARY

V

STABLE

ATHENA TERRACE

EXEDRA

NICHE EXEDRA

ALTAR TERRACE

HOUSES

AGORA

0 100 M

Fig. 12. The basileia, the royal district on
the top of the citadel, was encircled by its
own wall like a city inside the city. In the
center lay the royal palaces, the sacred
precinct of Athena with the famous library,
and buildings for the administration and
the military. (Drawing: Hoepfner)

a large peristyle surrounded by halls and rooms approximately 30 meters long. We may assume that the official andron was located here, built by King Attalos I at the latest (r. 241–197 B.C.). According to the most recent studies, this official andron in Hellenistic palaces must be distinguished from the private rooms simply called oikos.[59] They are separate but adjacent buildings or a group of buildings most often in the form of a peristyle. The older royal oikos was presumably on the other side of the road. Later the Trajaneum, with its facade facing the imperial lower city, was erected there, and so the older buildings on this higher level had to be demolished.[60]

On the highest point of the citadel is building complex II, with a square tower, small temple, large cistern, and new buildings. As mentioned above, it must have been the living and commercial center of the Gongylids. Building complex III has several parallel and right-angled walls and also larger rooms, but a convincing ground plan cannot be reconstructed.[61] A large peristyle does not seem to have existed here, where it is quite possible that the archives and administration were located.

The area farther south was originally reserved for the military, because older walls found among the remains of building complexes IV and V have been interpreted as belonging to barracks. Only under Eumenes II (r. 197–159 B.C.) were additional palaces built on this site. The peristyles in IV and V were discovered by the excavators to have been pillaged and so greatly altered architecturally that a reconstruction hardly seemed possible. When the smaller ensemble of building complex IV is compared with what we now know of Hellenistic palaces, it appears that the oikos, or family room with a hearth, was still the most important room (fig. 13).[62] Whereas in classical times living rooms were furnished rather modestly, luxury had now entered the private quarters. The floors have elaborate mosaics, and the walls are decorated with colored stucco, some with stripes imitating colored marble. Columns and capitals made of plaster of paris have been found

that speak of a facadelike interior architecture on the walls. The luxurious furnishings of the large living room can, unfortunately, be documented only fragmentarily. The mosaic on the floor shows fish; the hearth, the symbol of family unity, consists of marble slabs. Additional private rooms of the royal family are grouped around the colonnaded court in such a way that the space between the main road and the citadel wall was used to best advantage.

Peristyle V, with its colonnaded court more than 20 meters long, was the royal andron and therefore the actual palace used for official banquets and royal receptions. In the typical dining and banqueting halls klinai, or couches on which the guests ate and drank while reclining, were placed along the wall in traditional fashion. The center of the sometimes large rooms remained empty and was often used for entertainment. Since palace V was also ransacked and robbed of its art treasures in the Byzantine period, the excavators considered themselves fortunate to find relatively complete mosaics in rooms H and K. Among these is the mosaic with extremely delicate intertwining tendrils signed by the artist Hephaistion.[63] Fifteen klinai stood on the mosaic's 1-meter-wide white border. The large room of the complex, with its door off-center by 1 meter, has also been recognized as a banqueting room with dining couches along the walls. There was space for exactly twenty-two klinai. The doors in the other rooms have not survived, but the size and the similarity of these rooms to those in the palace at Aigai suggest that they were also used as banqueting rooms. Thus a total of one hundred klinai were placed in andron V. The king of Pergamon obviously wanted to emulate Alexander's famous pavilion for festive occasions, which had room for the same number of klinai. It is most probable that the basileia of Alexandria and Antioch had larger androues, but at Pergamon the interior with its fine mosaics and richly stuccoed walls was no less splendid. The new androues at Pergamon must have been very well known because it seems that Augustus used this building of Eumenes II as a model when he built his own

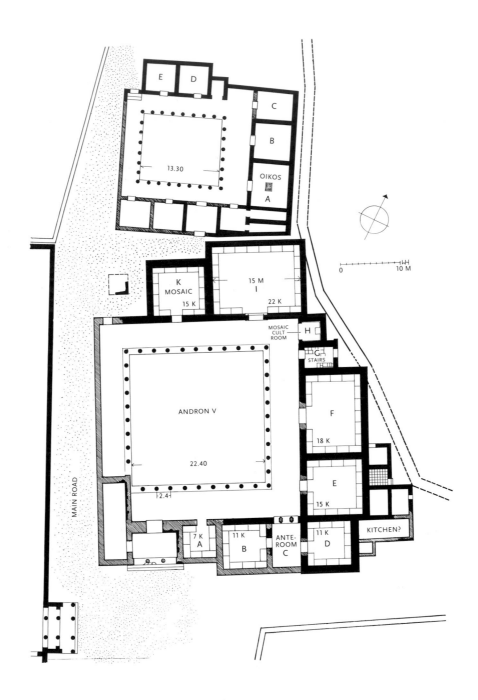

Fig. 13. The new palace of Eumenes II consisted of two
peristyles with adjoining rooms and luxurious furnishings.
(Drawing: Hoepfner)

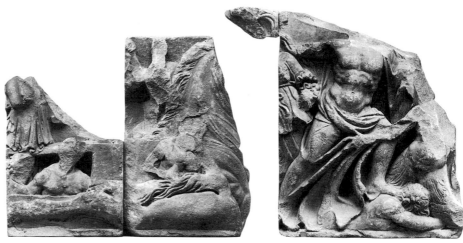

Fig. 14a–c. Marble relief panels were installed between the columns of the upper story of andron V. Preserved are panels with three different subjects: the hero Telephos (a), the Trojan War (here the Trojan Horse) (b), and the Gigantomachy (c).

house on the Palatine Hill in Rome. It is striking that the ruler of the world contented himself with a modest peristyle, but the building complex nevertheless included a temple and a library.[64]

Andron V can be dated because a stone discarded from the Pergamon Altar was found in its foundations, showing that the Great Altar and palace V were under construction at the same time. That a relationship existed between these buildings is made explicit by the similar subject matter of the sculptured friezes. The frieze on the podium of the Great Altar shows the battle of the gods against the Giants, and the Telephos frieze illustrates the origin of the dynasty. Both themes are also found on marble panels with reliefs that are 86 centimeters high. These were most likely placed between the columns of the upper story of andron V (figs. 14a–c, 15). The length of the frieze on each side of the peristyle, not counting the columns, is 14 meters. A third subject that has

survived on the reliefs is the Trojan War, a story connected with the history of the Pergamene dynasty. The surviving panel depicts the moment when the conquerors climb out of the wooden horse. Presumably, one theme was chosen for each of the four sides facing the court. Apart from the images in the sanctuaries, the scenes in the royal androues were among the most important disseminators of official pictorial propaganda.[65]

On the north and east sides of the adjacent precinct of Athena, Eumenes II built two-storied stoas that turned the modest sanctuary into a magnificent complex (fig. 16). The modesty of the little peripteral temple built of humble andesite stands in striking contrast to the splendid marble of the surrounding stoas. The temple built one hundred years earlier under Philetairos had obviously become a historic monument, with an aura and patina comparable to the Parthenon in Athens.

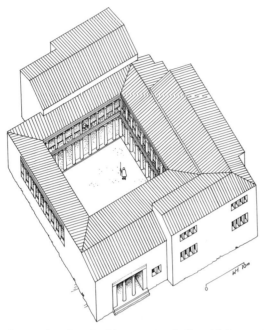

Fig. 15. The royal andron had banqueting halls with large windows in the lower story. (Drawing: Hoepfner)

Giving the architecture of stoas a formal resemblance to palace architecture allowed them to be seen as part of a coherent concept. The clear spans of the palace and the stoas in the sanctuary are almost the same. The reliefs of the balustrade of the upper story of the stoas, which are 86 centimeters high, represent a still life of weapons, scattered as if they had been left in disarray on the battlefield.

The gateway to the precinct of Athena is an ingenious creation of Pergamene art (fig. 17). For the first time in Greek architecture a gate was made by adding a pediment to a section of a two-storied stoa. In the small space available no monumental expansion was possible. Instead, an architecture with several stories was chosen, whose widely spaced columns and low cornice gave it the appearance of lightness. On both the architrave of the gate and the east side of the Great Altar, Eumenes II had an inscription added naming himself as the donor.[66]

Shortly after the excavation Alexander Conze recognized in a series of rooms behind the northern stoa on the terrace of Athena the famous library (figs. 12, 18).[67] Although three small rooms are badly preserved and no distinguishing features are noticeable, the large main room of 200 square meters contained a socle of squared stone blocks 1.05 meters wide, 90 centimeters high, and placed 50 centimeters from the wall (foldout 2). Conze assumed that wooden bookshelves stood on this base. There are holes 2.20 meters from the floor in the wall at regular intervals for the metal dowels that held the shelves. In the middle of the north side of the room the socle projects, forming a pedestal, on which stood the large statue of Athena found nearby, a copy of the famous Athena Parthenos in the Parthenon at Athens. Conze concluded that Athena, as goddess of wisdom, was honored in many libraries.

Karl Dziatzko, however, attacked this theory.[68] He disagreed with the premise that the scrolls had been kept in this room, because the socles are unnecessarily high and are placed too far from the wall, and no traces of fastenings for the shelves are visible on the wall. He called this hall the oikos, which in Pergamon could be analogous to the mouseion of the library at Alexandria. Works of art like the many small statues found in the precinct of Athena supposedly stood on the bases. The members of the library presumably ate in this room, which served as a banqueting hall. Although there is no precedent for a banqueting hall in which the klinai would have stood in the middle of the room, this opinion has met with approval and has even become generally accepted.[69] Dziatzko and more recent experts on libraries assume that the scrolls were kept in three small side rooms.

Historical sources prove that these highly esteemed treasures of knowledge mainly served the prestige of the rulers. Therefore, there had to be a way to display the scrolls that would be understood by all as testimony to Pergamon's culture, knowledge, and science. A room that only provided

Fig. 16. Eumenes II added splendid marble stoas decorated with weapons reliefs to create an elaborate architectural frame for the old, modest temple of Athena. (Drawing: Bohn)

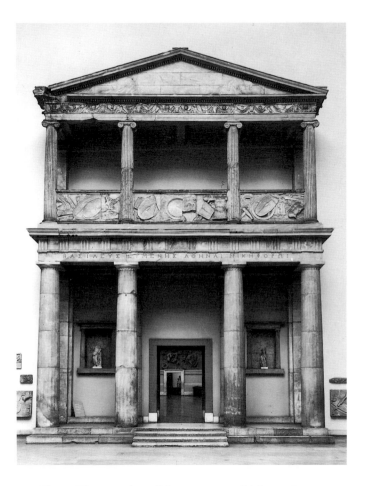

Fig. 17. The propylon of the sanctuary of Athena, the two-storied gate facing the main street; as reconstructed in the Pergamon Museum, Berlin. (Photo: Petersen)

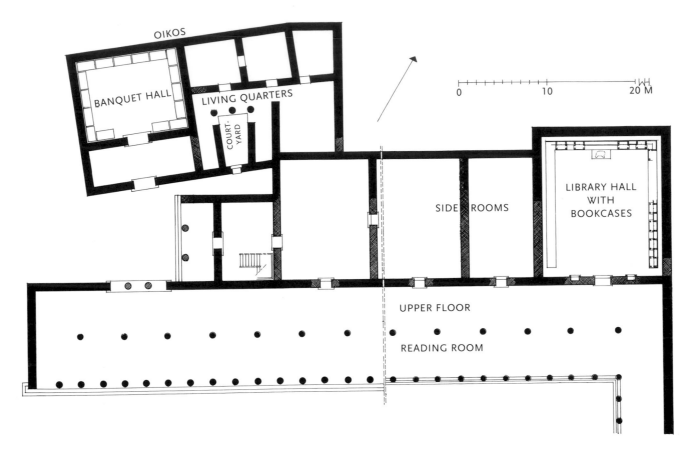

Fig. 18. Library in the sanctuary of Athena at Pergamon. To the east the room with bookcases, to the south the hall serving as a reading room, and to the west a banqueting hall containing sixteen klinai. (Drawing: Hoepfner)

storage for the shelves and scrolls would have been inadequate. The later Roman imperial libraries, such as the library of Celsus at Ephesos, the library of Hadrian at Athens, the libraries at Rome, and the nearby library in the Pergamene Asklepieion are all buildings of great splendor with luxurious interior furnishings. They can perhaps be compared with the princely libraries of the baroque. Accordingly, the Hellenistic models for imperial libraries could not have been storage rooms. The large hall in the precinct of Athena meets all the requirements of an elaborate library, and the arguments of Dziatzko can easily be refuted. The architect of the Pergamene library had obviously considered the convenience of the librarians when he raised the shelves or bookcases on a socle 90 centimeters high. Also found in both ancient and modern libraries are the unanchored shelves. Shelves were fastened to the upper part of the wall, secured not against moving sideways but against tilting over.[70] The space of 50 centimeters between shelves and wall corresponds to the Pergamene peri-

stasis between the retaining wall and the building proper. Thus, one might agree with Bohn and Conze, who thought that dampness from the earth penetrating the wall should be kept away from the scrolls.[71] But this was only a secondary consideration.

Vitruvius (1.2.7 and 6.4.1) twice prescribes the orientation of libraries to the east to have good light. As oil lamps are not very effective and might even have been forbidden because of the danger of fire, large windows must have been provided. But until glass windows were invented in the first century b.c., rain coming in through these high, open window frames also posed a risk. Although wooden shutters doubtless existed, a rainstorm could come faster than the servants or slaves would be able to close the shutters. Accordingly, the peristasis for the main hall was an aisle used for handling the mechanisms (tackle line or rods) with which the windows could be closed.[72] Roman imperial libraries no longer needed such an aisle because scrolls were kept in bookcases placed in niches in the outer wall, and these walls no longer had windows. Light was provided by large windows in the wall containing the door. This wall was protected against water coming in by freestanding columns and a projecting roof. When it was necessary to have windows above the bookcases, they could be filled with glass panes. One such example is the library in the Asklepieion at Pergamon (fig. 19).[73] It should be mentioned that Augustus, in imitation of the basileia of the kings of Pergamon, had a library built next to his house and the temple of Apollo on the Palatine, which already incorporated the modern installation of inset bookcases to contain the scrolls.[74]

In the precinct of Athena Bohn discovered openings 2.76 meters high, which he identified as passageways between the stoa of Athena and the hall of the library.[75] These consist of antae on both sides and at least two pillars with attached Doric half-columns placed in between. The height of 2.76 meters and the width of 1.12 meters would be large enough for a passageway. However, the threshold belonging

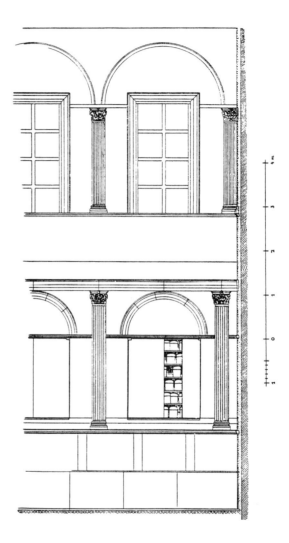

Fig. 19. Library from the Roman imperial period in the Asklepieion of Pergamon. The bookcases were inset into the wall; the windows above must have had glass panes. (Reconstruction: Deubner)

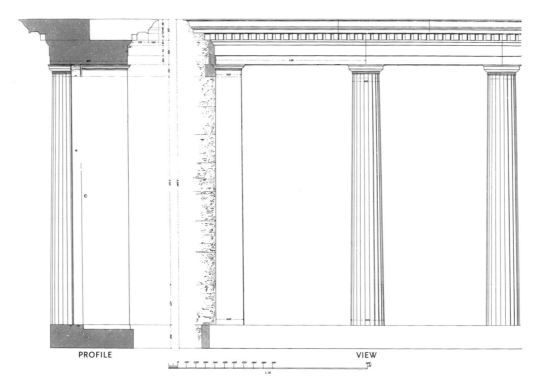

PROFILE VIEW

Fig. 20. Large window with sill found in the area of
the library. (Drawing: Bohn)

to the construction that Bohn published is not a threshold at all but rather the windowsill against which the wooden shutters would close (fig. 20). The pieces that were found belong to elaborate window frames that were required for the libraries and also for the large androns of nearby palace V. In light of these or similar windows, a very large space above the bookcases of the library must be reconstructed (see foldout 2).

Fragments of two small graceful niches were found nearby, framed by Doric and Ionic columns with a canonical entablature (fig. 21). Bohn had identified these as niches or bookcases set into the rear wall of the hall and thought that they had contained statuettes. This arrangement, however, is not known from other halls. Most likely they were cases for scrolls, since their dimensions (1.34 m high, 82 cm wide, and

33 cm deep) are well suited for them. They seem to be forerunners of the cases for scrolls of imperial times, which, judging by surviving niches, were the same size. Presumably, the two Pergamene niches, supplied with wooden paneling and doors, were located within the large hall on each side of the door (see fig. 18). Because this wall had no windows, it was protected against rain and therefore suited for cases holding scrolls. On the other hand, the wall was not entirely protected from rising dampness, which might explain why the architecture framing the cases was made not of wood but of stone.[76]

Archaeologists and architects, familiar with contemporary Bauhaus cubes, pictured the bookshelves of the royal library in Pergamon as made of simple wooden boards. This is certainly completely wrong, since the scrolls had to be

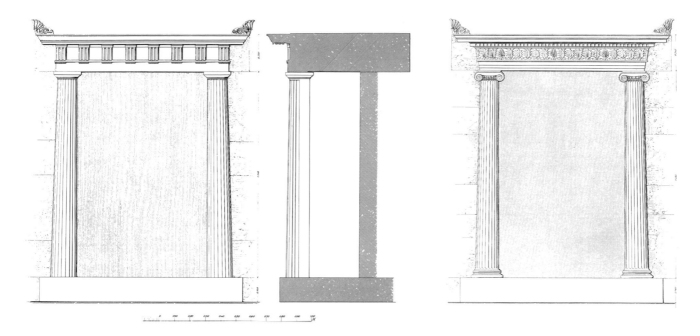

Fig. 21. Wall cases with columns of Doric and Ionic order, most probably intended to contain book scrolls in the great hall of the library. (Drawing: Bohn)

protected from dampness—one has only to think of the winter season in Pergamon. Even though today the standards of cabinetmaking and interior architecture have degenerated to a low level, and although any evidence for woodworking is missing, we should not ignore the fact that already in the fifth century B.C. it reached a standard comparable to that of stoneworking.[77] In the Hellenistic era of luxury at the royal courts interior architecture and the art of woodworking had entered into competition with exterior architecture. The finest and most graceful architectural details could only be fashioned for interiors, as the above-mentioned niches show, where details one would have expected in wood were realized in stone. We can therefore picture the inset bookcases on the socle in the large hall of the library being on the same level as the stone niches and, so to speak, as their continuation. Each one of these bookcases was probably fashioned with a complete frame, similar to Renaissance interiors with their magnificent built-in furniture. Judging from the stone niches, the architectural orders alternated. A case of the Doric order was followed by one of the Ionic order, and so on. The columns and entablatures are the same size, and the architraves are also identical. Since the socles are 1 meter deep and the bookcases for the scrolls only 33 centimeters deep, it is likely that the socles were furnished with freestanding columns. The bookcases were made in the form of an aedicula, something like a shrine, to highlight the invaluable contents. Between the bookcases a recessed wooden screen and architrave ran to the next case. The holes in the walls for the metal rods to fasten the cases correspond exactly to the width of the cases, which we have reconstructed after the stone model (see fig. 21). It is thanks to this single technical detail that a reconstruction can be made.

The large hall contained only a few magnificent cases for selected scrolls. Here the highly valued manuscripts, among them perhaps originals of Plato and Aristotle, were stored. Only the best wood, maybe cedar, was good enough to serve as a case for these scrolls. The doors surely were rabbeted several times to keep dampness out.

The miniature aedicula wall case is of the greatest importance for the development of architecture. Similar cases had already existed in the older library at Alexandria. Perhaps it is correct to assume that such interiors with bookcases in different locations showed for the first time variations of small pediments. Arcuated or Syrian pediments, broken pediments, and pediments of two quarter-pyramids, as are shown on the facadelike architecture facing the court of the villa at Ptolemais from the first century B.C.,[78] may have their origin in this wood-and-stucco interior architecture.

The large hall served as a storage space for the books. Here the librarians, who obviously had ladders, could retrieve the requested scrolls. As has always been assumed, the entire upper story of the stoa was used as a reading and study hall. Bohn had observed that curtains that could be opened or closed as needed were put up between the columns of the stoa.

If the mouseion and library at Alexandria had an oikos, such a room can also be assumed for Pergamon. While the rooms to the west of the large hall were most likely used as storage areas and workshops or by copyists and conservators, the adjoining building to the northwest, which Bohn had already tentatively identified as living quarters, is undoubtedly the oikos. Although the alignment varies slightly, the oikos is cleverly joined to the library by two diverging walls with antae on either side of the entrance, each parallel to its neighboring wall (see fig. 18). Three unfluted columns border a small court to the north, and the three small adjacent rooms were possibly used as lounges by the directors of the library. The large room with an anteroom farther to the west was doubtless a banqueting room, for sixteen klinai, each 2 meters long,

stood against the wall. The door, 2.03 meters wide, is slightly off-center to accommodate the characteristic arrangement of klinai. Nothing has survived of the interior to hint at the festive use of this andron.[79]

Strabo (13, 4, 2) rightly praised Eumenes II as the great builder and innovator of Pergamon: "He built monuments and libraries and beautified his home city of Pergamon until it was the splendid city it is today."[80] New palaces served as showplaces, libraries promoted learning, the Great Altar celebrated victories over the barbarians, and the remodeling of the sanctuary of Athena showed the piety of the ruler. The building program of Eumenes II for the basileia is the most significant of its time. It seems as if the kings were competing in the development and decoration of their residences. Antiochos IV, contemporaneous with Eumenes II, had enlarged and beautified his capital Antioch on the Orontes,[81] and great building activities are also documented for the royal district of Alexandria.[82]

NEW TEMPLES FOR DIONYSOS: HERMOGENES AT PERGAMON
The existence of a large Doric marble temple at Pergamon can only be conjectured from fragments of building components that were reused in the Ionic temple R in the gymnasium (see foldout 1).[83] Doric details can be seen on the Ionic building in the areas that do not face outward. These stones must have been used in an earlier time (fig. 22). Obviously, marble was a sought-after and expensive building material, so that reworking it was a common occurrence. Ernst-Ludwig Schwandner reexamined this older building and, after taking new measurements, found that the building was slightly larger than Dörpfeld and Schazmann had thought.[84]

We may assume that the Doric architecture of the late classical and early Hellenistic periods was constructed like a grid system of equal parts. Thus, an entire facade can be reconstructed from a few remaining parts. The smallest unit is the width of the via, the sloping path left between the mutules on the geison. Four units make up the width of one triglyph;

six, the width of one metope; and twenty account for a span. In the early marble temple of Pergamon the width of the via measures 15 centimeters and the width of the span, twenty times 15 centimeters, or 3 meters. In this monumental architecture one can expect the canonical span with one and two half triglyphs and two metopes each.

Closely related to this oldest Pergamene marble architecture is the temple of Athena at Troy mentioned above. In this peripteral temple with six columns by twelve columns,[85] the via is 14.4 centimeters wide and the span 2.88 meters wide. The two buildings are similar not only in size but also in individual details. However, the important question is whether the Pergamene building was a peripteros, as its size suggests. With six columns at the front the temple would have had a width of 17 meters and would have been the largest in Pergamon. But no terrace would have been large enough to accommodate this building, as Schwandner had pointed out.[86] It is also unlikely that its blocks, previously used in another building, would have been transported over a long distance. Therefore, we should expect a smaller building with four columns in the front or a facade in antis. At the frieze this building would have measured exactly 9.60 meters across. This would have been an impressively large building (fig. 23), since the span of 3 meters was far greater than that of the other rather delicate Doric buildings in Pergamon.

At this point we must refer to a text in Vitruvius (4.3.1–2) that deals with a curious incident.[87] It says that the highly praised and famous architect Hermogenes once took building elements that had been prepared for a Doric temple and, without hesitation, reworked them for use in an Ionic temple to Dionysos. Vitruvius explains that Hermogenes considered the Doric order not as perfect as the Ionic.

During the course of excavation, Dörpfeld had realized that temple R in the gymnasium of Pergamon could have been this building mentioned by Vitruvius. Schwandner disagreed and pointed out that the foundation was too small. But this is doubtful. The euthynteria of the temple, or the layer

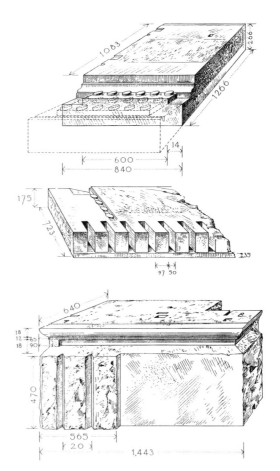

Fig. 22. Reused structural elements of a marble temple—originally Doric and later Ionic—near the sanctuary of Demeter. (Drawing: Bohn)

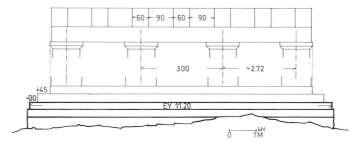

Fig. 23. The Doric marble temple stood on the foundation later used for an Ionic marble temple. (Drawing: Hoepfner)

above the foundation, is made of trachyte and measures 11.20 meters across. The marble steps would be inset approximately 30 centimeters from the corner and should have been about 45 centimeters deep. One broad step must have extended on each side below the stylobate, but this does not correspond to the classical canon, which called for two steps beneath the stylobate. This arrangement does correspond, however, to many Pergamene buildings and, among others, to the temple of Athena at Troy. From the 11.20 meters we must therefore deduct 1.50 meters, leaving 9.70 meters for the width of the stylobate. If we now start in reverse from the remains of the superstructure, we get a width of 9.60 meters at the height of the frieze. This corresponds as a rule to the building's width at the foot of the columns, but to make up the full width of the stylobate we have to add 5 centimeters on each side, for a total of 9.70 meters. It cannot be a coincidence that this calculation corresponds exactly to the width of the foundation.[88]

Confirmation can be found in the foundation grid of the later Ionic building (fig. 24a–c). These square sections are half a span long on a side, corresponding to the length of the plinth under the column base. Following the late classical architect Pytheos, these grids were also applied to the walls. On our Ionic temple R, however, there is a difference in the depth of 30 centimeters from the earlier Doric structure, for which the architect compensated by using a particularly thick wall for the door front.

Thus, there is hardly any doubt that the temple's foundation reused that of its Doric predecessor. This realization has far-reaching consequences. Because temples were rarely rededicated to other gods, both the Doric building and its successor must have been dedicated to Dionysos. In view of carefully executed individual details the Doric temple can be dated to the third century B.C., when the city was still very small. Accordingly, the temple must have stood outside the city wall in the vicinity of the sanctuary of Demeter. Such suburban cult centers were not as rare as one might think. Sanc-

tuaries in the area of the Ilissos river southeast of Athens come to mind. Erwin Ohlemutz learned from inscriptions that Demeter and Dionysos as gods of the mysteries were jointly honored in Pergamon.[89] Therefore, it is not surprising that Dionysiac symbols such as vine tendrils and kraters are found on the balustrade slabs in the precinct of Demeter, and that even a statue interpreted as Dionysos was found there.[90] Finally, it is safe to conclude that building H, located just behind the temple of Dionysos and consisting of a room 20 meters long with a columned anteroom, was the locus of the cult of Dionysos (see fig. 9).[91]

The old temple of Dionysos, together with all the other suburban sanctuaries, was obviously destroyed in 201 B.C. when Philip V besieged the city. This catastrophe called for an extension of the city and the erection of numerous new buildings. The new gymnasium, extending over three terraces, was built under the reign of Eumenes II and followed the course of the old Doric temple. The reerection of the temple and the construction of the gymnasium took place at the same time.

Hermogenes is the only architect mentioned four times in Vitruvius's textbook on architecture. He must have been one of the most famous architects of his time. In the third century B.C. he was commissioned to build a very large temple to Artemis near the Ionian city of Magnesia, which, because of its location on the edge of the large and fertile plain of the Maeander, was very wealthy. Hermogenes designed an Ionic building with an eight-columned front, an enlarged middle span, and fifteen columns on the long sides (fig. 25). The antae and the walls of the cella are in alignment with the third column to allow for a canonic dipteros. Hermogenes, however, omitted the inner row of columns and thus created a new type, the pseudodipteral temple with very deep porticoes, which from then on would play a part in the construction of new sanctuaries. For the Ionian city of Teos, Hermogenes also designed an Ionic temple, a peripteros with columns spaced unusually far apart. This eustyle, characterized by well-spaced columns, also became famous. After Pergamon had

TEMPLE OF ATHENA

TEMPLE OF D
CA. 280

IONIC TEMPLE OF
ASKLEPIOS

TEMPLE NEAI
GYMNASIU

Foldout 1. A list of the temples at Pergamon shows that small, prostyle buildings were dominant. The temple of Dionysos next to the theater was the biggest of this type in the Greek world. (Drawing: Hoepfner)

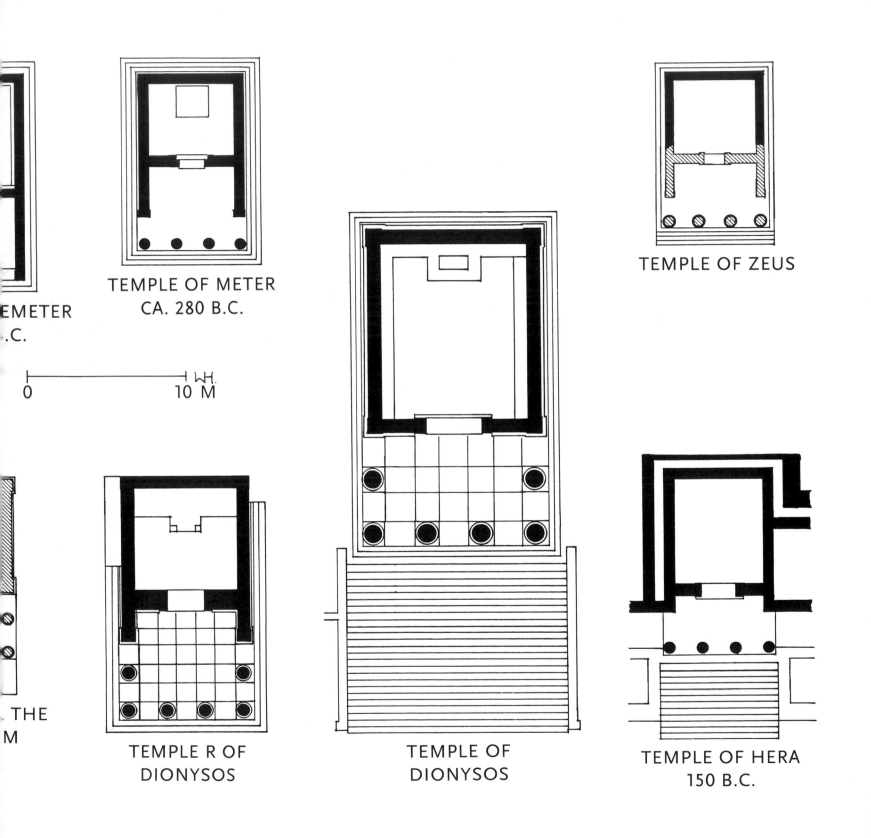

EMETER
.C.

TEMPLE OF METER
CA. 280 B.C.

0 10 M

THE
M

TEMPLE R OF
DIONYSOS

TEMPLE OF
DIONYSOS

TEMPLE OF ZEUS

TEMPLE OF HERA
150 B.C.

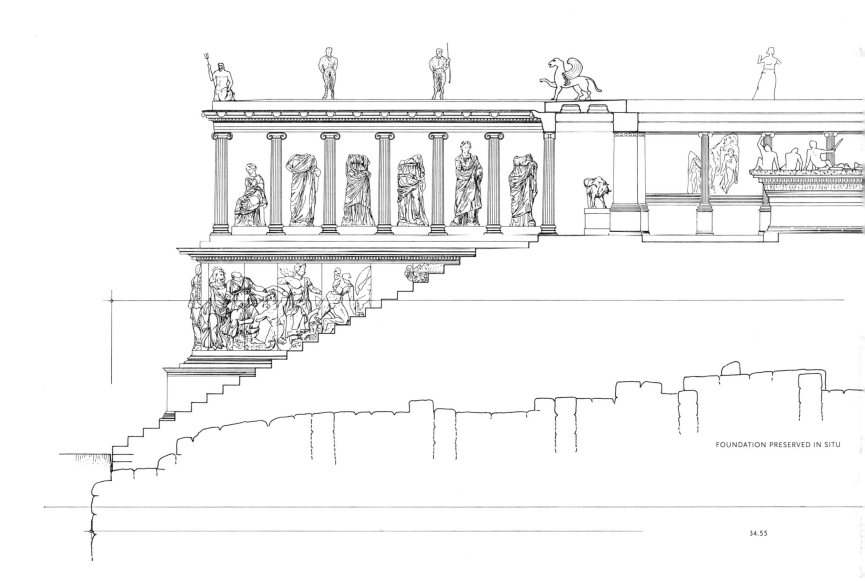

FOUNDATION PRESERVED IN SITU

34.55

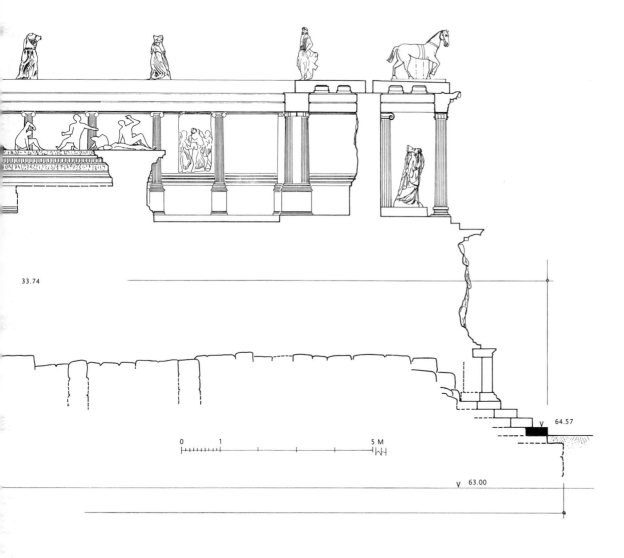

33.74

0 1 5 M

64.57

63.00

Foldout 4. New reconstruction
of the Pergamon Altar, a section.
(Drawing: Hoepfner)

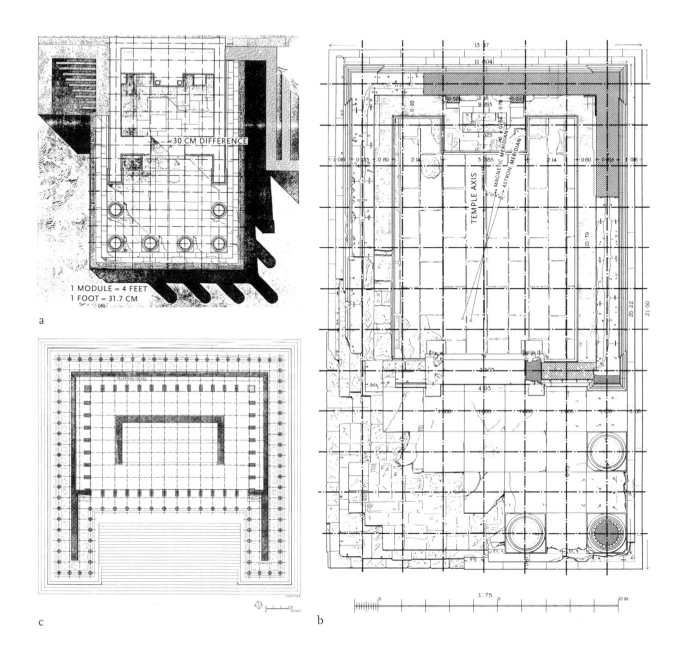

Fig. 24a–c. Buildings of the high Hellenistic period at Pergamon were designed on a grid. Here the Ionic temples of Dionysos next to the gymnasium (a) and at the theater (b) and the Pergamon Altar (c). (Drawings: Schazmann, Bohn, and Hoepfner)

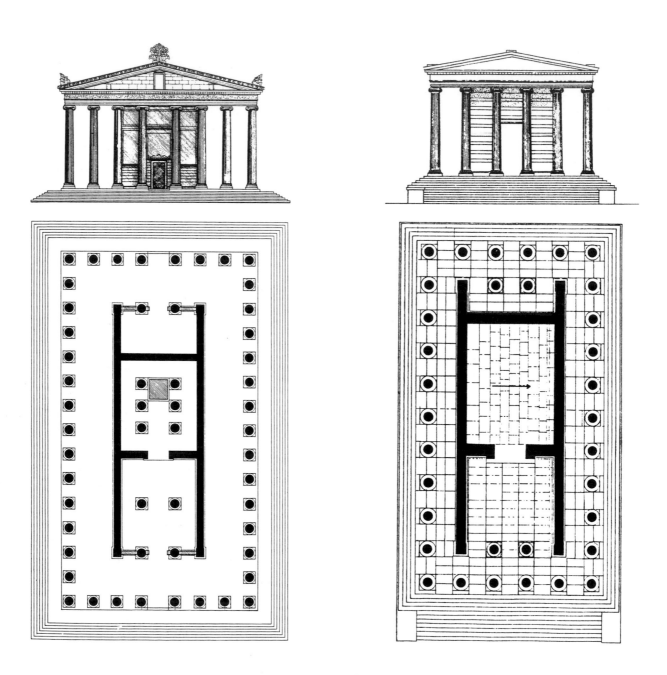

Fig. 25. Grid-based buildings by the architect Hermogenes: left, the temple of Artemis at Magnesia (a pseudodipteros with deep porches), and right, the temple of Dionysos at Teos (a eustyle with widely spaced columns). (Drawings: Hoepfner)

become the capital of a large empire in 188 B.C., Eumenes II called upon Hermogenes to reerect the temple of Dionysos next to the gymnasium. In this case the master decided to reconstruct the destroyed building not in the Doric but in the Ionic order, which he preferred. His decision might have been influenced by the fact that Pergamon was no longer just a city in Mysia but the capital of Ionia and other areas of Asia Minor. The extant ruins of the older temple could almost all be reused as building material.[92]

This new type of Ionic marble building shows four columns on the front, but in the second row there are no columns in the middle. This feature resembles the pseudo-dipteros of Hermogenes, where the inner row of a dipteros-like temple was eliminated in order to have spacious halls. In Pergamon no expansive building was possible and therefore a smaller temple with a deep porch on the front was created. However, the newly erected building dedicated to Dionysos can be called a "pseudodipteral prostyle." It is not surprising that the new type spread rapidly.[93] The temple of the Augustan period in Antioch in Pisidia has the same form,[94] and deep porches with columns at the sides can also be seen on the imperial temples in the west. Old Etruscan temples may have influenced the temple of Mars-Ultor, the temple of the Dioscuri, and the temple of Castor and Pollux in Rome, but earlier Greek-Hellenistic forms also played a role, as Vitruvius states (4.8.5).

Temple R is not the only one of this particular type in Pergamon. The temple of Dionysos on the theater terrace, also a high Hellenistic marble building, shows the same basic form of a pseudodipteral prostyle with a deep, columned porch (figs. 24b, 26; foldout 1).[95] Antae were omitted, and only slightly projecting pilasters accentuated the corner of the cella. Its close resemblance to temple R suggests that this building too was designed by Hermogenes.[96] The fairly wide spacing of columns preferred by him is found on both temples: the ratio of the lower diameter of the column to the

intercolumniation is 1:2. This corresponds with the systylos type mentioned in Vitruvius 3.36.[97]

Viewed from the Athena terrace, the temple of Dionysos on the theater terrace appears small; its huge size is apparent only from close up. No other building in Pergamon has columns that are 1.13 meters across. They reach a height of more than 11 meters (fig. 26). With a length of 21.60 meters and a width of 13.17 meters, this is the largest prostyle temple of Hellenistic times, worthy of being dedicated by a king. A peripteros could not have been erected on its small terrace. It is typical of the later Hellenistic period to emphasize the facade by means of high terraces and large open stairways. The stagelike character of such buildings, like the temple of Hera high above the gymnasium at Pergamon, dated to the reign of Attalos I, is evident. In other places such as the sanctuary of Athena at Lindos on the island of Rhodes and the Asklepieion on the island of Kos we find similar arrangements of gigantic open stairways from the same period. This form of stagelike architecture set a precedent and was popular in the first century B.C. and in the imperial period.[98]

Neither temple of Dionysos was ever entirely finished. The large frieze, in particular, was only blocked out. The sculptors were most likely completely occupied for years with the gigantic figural friezes of the Great Altar, so that work on the two new temples of Dionysos had to be postponed. The building technique with dowel and clamp joints used on the temples is the same as on all buildings of the time of Eumenes II. On the better-preserved temple of Dionysos in the theater as well as on the Great Altar a logical and carefully applied system of masons' marks can be observed.

In Greek antiquity no project was repeated elsewhere once it had been executed. On the contrary, each building had to be unmistakably unique. Since the range of Greek architecture was limited, and since each architect and artist wanted to work in his own style, a noticeable dilemma resulted. There are surprisingly few formal differences between the temples

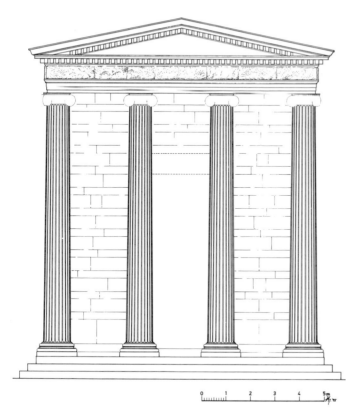

Fig. 26. Reconstruction of the front of the large temple of Dionysos next to the theater, presumably a work by Hermogenes. (Drawing: Arvanitis)

the exception. The profile of the bases has been repeated on the foot of the antae on both temples of Dionysos, and on the larger Dionysos temple it has also been used at the base of the wall. The capitals of the antae of both temples of Dionysos are almost identical in the sequence of the cymae and cavetti. Hermogenes used a small cavetto with lotus and palmette leaves for the upper border of the architrave on the Artemision at Magnesia. A similar small frieze is found on the Ionic marble temple in the Pergamene Asklepieion. Although surviving in only fragmentary condition, it may also be one of Hermogenes' works in Pergamon.[100] Fragments of the capitals of the small temple of Dionysos have survived that suggest the volute was in a ratio of 1:2:3. Hermogenes borrowed these proportions from the late classical architect Pytheos and applied them at Magnesia.[101] The buildings in Pergamon, like all the buildings of Hermogenes, also have a high frieze with a dentil pattern above.[102] On the large temple to Dionysos this dentil pattern is also found on the tympanum as part of the geison, a curious addition later taken up by architects of the imperial period.[103]

Hermogenes was the most successful architect of the Hellenistic period, and Vitruvius's particularly high opinion of him was justified. Hermogenes would not have enjoyed this status if he had not been in the employ of Eumenes II, who intended to turn Pergamon into the grand capital of Asia Minor and drew the best artists to his court.[104] Hermogenes, for his part, came from Alabanda, at the edge of the Pergamene kingdom.

In the city of Pergamon proper there were the two temples dedicated to Dionysos of surprisingly similar form. Dionysos was one of the main gods of Pergamon, along with Zeus, Athena, and Asklepios. Therefore, Eumenes' two temples to the god meant that the king must have been an important supporter of the cult of Dionysos. This corresponds with the historical accounts compiled and interpreted by H. von Prott and Ohlemutz.[105]

of Dionysos, so that the characteristic features of Hermogenes' architecture as described by Vitruvius can be readily discerned. The concept of a homogeneous architecture that uses a grid seems to be fundamental: all Hermogenes' buildings are of the Ionic order and have standardized spans. The grammar of the Ionic order is mostly that of the late classical period.[99] The bases have plinths; the plain Attic base is more common. The more intricate Asiatic base used on the small temple of Dionysos and on the temple of Zeus at Magnesia is

The Attalids considered Dionysos Kathegemon to be their progenitor. On the Telephos frieze of the Great Altar, Dionysos—in addition to Herakles—plays an important part.[106] The priests of Dionysos, together with the king, made their offerings at the large festivals.[107] Several inscriptions tell of the close connection between Pergamon and Teos, where Hermogenes had erected the often-praised peripteral temple to Dionysos. A group of itinerant actors was based at Teos, and they were in association with a similar group in Pergamon that served the court theater and whose director was Kraton. From the time of the treaty of Apamea, Pergamon was the capital of Asia Minor, and the court was also the principal authority. In Pergamon Dionysos was the god who legitimized the rule of the Attalids, patron of actors, and, although not well attested, the god of the mysteries. As Kathegemon, that is, "God who leads," Dionysos was revered by the entire populace as benefactor of the world and as bringer of salvation.[108]

THE GREAT ALTAR: A VICTORY MONUMENT

In the middle of the fourth century B.C. King Maussolos of Karia gathered at his court the most famous sculptors and architects of the time. They were to build a funerary monument for him, which was to be larger and more magnificent than anything built before but which would still bear witness to Greek culture.[109] The monument, 140 feet, or 42 meters high, created not only the new building type of the mausoleum but also the model for spectacular architecture. Its podium surmounted by a colonnade, steplike roof, rich sculptural decoration with friezes, and figures between and behind the columns and along the cornice are all found seventy years later on the funerary monument of King Lysimachos at Belevi near Ephesos. But this is by no means a copy.[110] The architects were given the task of creating a new and original monument but one that was still clearly part of a tradition. It is to this sequence of royal monuments that the Pergamon Altar

belongs. The altar of Artemis in Magnesia from the late third century B.C. (presumably a work of the architect Hermogenes)[111] was a close model for the altar, as was the earlier altar in the temple of Athena at Priene, which was designed by Pytheos (who had worked on the Mausoleum).[112]

Of all the buildings in Pergamon, maybe even of all the buildings of the high Hellenistic period, the Great Altar is the most splendid creation.[113] It was larger than all the temples in Pergamon, and, given its 170-meter-long frieze, it conveyed a message of unequaled impact.[114] It is likely that the altar surpassed all monuments of its type, if not in venerability, then certainly in splendor. It is clear that the altar is a royal dedication that was erected in particular historical circumstances. The basileia was not large enough to allow for a new terrace bigger than the one for Athena's sanctuary. The terrace for the Great Altar was constructed along the main road above the agora and below the Athena terrace. The old city wall had to be relocated down the slope to attain a depth for the terrace of at least 70 meters, or 200 feet (1 foot = 35.2 cm) (see fig. 12). Several houses and a rectangular apsidal building embedded in the rock, probably the old nymphaion,[115] had to be razed. Measured at the lowest steps, the altar is 35.37 meters wide and, therefore, is to be considered a hekatompedos (100 footer; fig. 27; foldouts 3–4).[116] Since it was customary for priests to make sacrifices facing east, into the rising sun, the stairway had to be located to the west, and something worth looking at had to be placed opposite the entrance gate to the precinct.

The impressive large frieze depicting the battle of the gods against the Giants has always been the focal point of the altar. However, it is imperative to consider the monument in its entirety, as a *Gesamtkunstwerk* on which nothing is accidental or supplementary.[117] Therefore the architecture also deserves attention, although in this instance it functions mainly as a vehicle for the sculptures that proclaimed the victories of the Greeks over their enemies.[118]

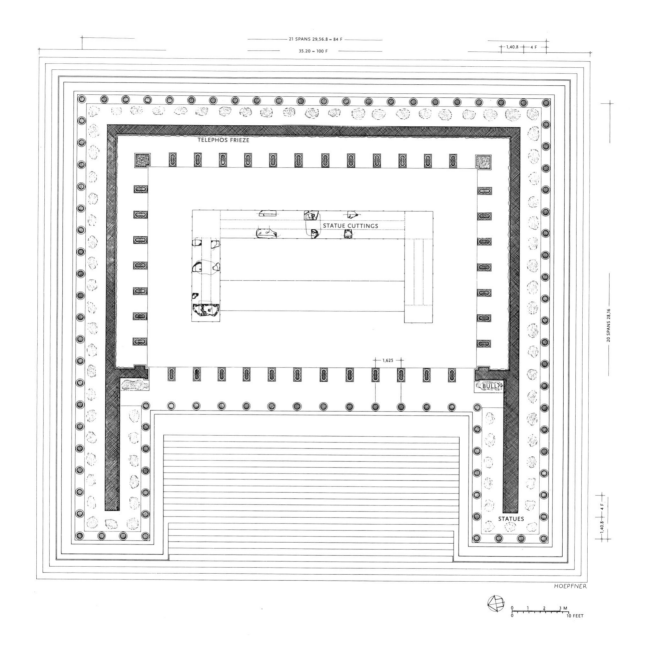

Fig. 27. New reconstruction of the Pergamon Altar,
ground plan. (Drawing: Hoepfner)

Ascending a large open stairway the visitor reached the peristyle of the inner court. The peristyle consisted of typical small double half-columns, which are also found on the windows of the north stoa in the sanctuary of Athena and on the upper story of the Attalos stoa at Athens. These half-columns stand on unusually high pedestals, which were to set a precedent in architectural history. Here they were to be understood as part of a wall. The small Ionic columns were meant to correspond to the row of windows in the royal andron of the palace. This interpretation is supported by the Telephos frieze, which thematically puts us in the house of a king. In a pointedly classical relief style the frieze shows the mythical descent of the Pergamene kings from Herakles, and the way that Telephos, son of Herakles, came to Pergamon.[119] The altar court, too, if we consider it as a peristyle, points to the domain of the palace, because there such columned courts were a part of the official plan.

The actual sacrificial altar was located in the middle of the court. Unfortunately, only about sixty fragments of it have survived, and important questions can be answered only hypothetically. But it is certain that it had the usual shape of a common trapeza, surrounded on three sides by a wall (figs. 27–28). Not one stone of the base molding has been found, nor can a set of marble ashlars be attributed to the 86-centimeter-thick wall. One of the architraves of the wall, very well executed with a double cyma and cavetto (a profile calling Hermogenes to mind) has survived with the cornice above it. In contrast to the exterior architecture, here we find a finely worked anthemion followed by a dentil pattern, geison, and sima with lions' heads and acanthus scrolls (cat. no. 34).

The Great Altar of Pergamon was filled with sculpture to do justice to its claim to being a hekatompedos. The narrative elements dominate the architecture, and juxtapositions were meant to astound and fascinate the viewer. Turbulent scenes alternate with tranquil ones: the "snapshot" of the great battle on the Gigantomachy frieze is followed in the

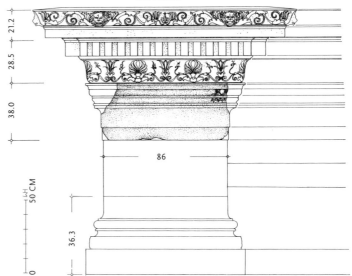

STATUES

Fig. 28. Pergamon Altar. Elevation of a projecting front of the sacrificial altar. Architectural details are unfinished. (Drawing: Hoepfner)

"andron" by the epic narrative of the legendary origin of the Pergamene kings. The climax is reached with the gods in action, who must have circled the top of the roof and from there triumphed over their broken enemies on the walls of the altar. Viewed from the outside, the ferocious battle dominates the entire monument. On the Mausoleum, small-scale battle friezes were placed high up, as were friezes on temples of the classical period. Here, on the altar, the viewer is addressed more directly than before and seems to participate. Enlarged to superhuman size, the battle has been brought down to ground level. The main story, with its stately colonnades and over-life-size statues of women behind the columns, creates a zone of tranquility. On the edge of the roof fabulous creatures laden with symbolic meaning—horses, lions, and griffins in full motion—seem to dash toward the viewer.

Marble sculptures were placed close together on the altar in the court. It is unthinkable that a fire was ever made

a

b

c

Fig. 29a–c. Leaf scroll (Lesbian cyma) from
the temple of Dionysos next to the gymnasium
(a), from the Pergamon Altar (b), and from the
Ionic temple in the Asklepieion (c). (Photos:
Deutsches Archäologisches Institut, Athens,
Hoepfner, and Pergamon-Grabung)

on this altar. Since not the slightest trace of burning can be found here, this altar must have been used for unburned sacrifices, or perhaps as a victory monument that was not actually meant for religious ceremonies. The latter is more probable; the theory that the altar belongs to the sanctuary of Athena is thus to be rejected.

In spite of heterogeneous forms and a varying figurative language, the Great Altar is a uniform whole. A dating based on stylistic evidence is especially difficult because during that time it was quite common to use older forms. Schwandner compared the Lesbian cyma on temple R to the one on the Great Altar (fig. 29a–c) and pointed out the surprising correspondence of the two.[120] The question arises whether the Great Altar was designed and built by Hermogenes or by one of his students. It would be surprising if the most imposing royal monument of its time had not been executed by a famous architect.

An affinity with Hermogenes is suggested by the Ionic order, which he favored. It is quite striking that the Doric order, so often found earlier in Pergamon, is totally absent on the Great Altar and was not even used on the lower part of the building, as was customary. The gridlike execution of the ground plan of the foundation is also typical for the buildings of Hermogenes. It is found on both temples of Dionysos at Pergamon and on the Great Altar.[121] The altar has the wide diastyle spacing of columns preferred by Hermogenes; the Ionic capitals are of Hermogenic proportions;[122] and the varying pictorial devices on the cushions are rare but used by Hermogenes on the Artemision at Magnesia. At this point the following statement must suffice: since the altar, temples, and other marble buildings from the reign of Eumenes share the high quality of their execution we may speak of a school of architects that was active over several decades.[123] The high level of planning and building in Pergamon at the time of Eumenes II can be compared to the great building programs of other periods in European history.

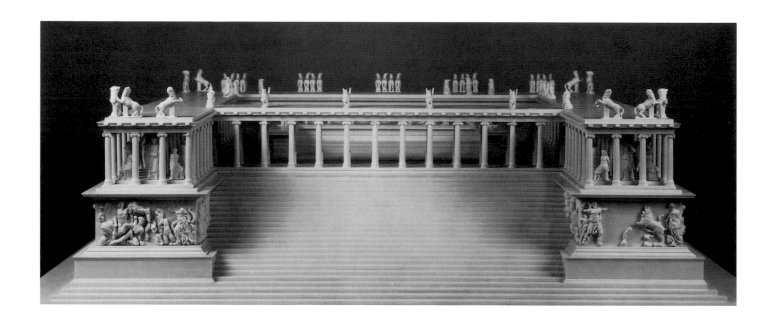

Fig. 1. Model of the Pergamon Altar after Hoepfner. (Photo: The Metropolitan Museum of Art, New York; Kellen, The Photograph Studio)

MODEL OF THE PERGAMON ALTAR (1:20)

WOLFRAM HOEPFNER

DIMENSIONS: 35.1 × 175.5 × 168.7 cm, including the socle
MATERIAL: Corian by DuPont and a synthetic material consisting of acrylic and powdered marble. Its fineness allows variances of as little as 1/100 mm.
RECONSTRUCTION: Wolfram Hoepfner
EXECUTION OF THE MODEL DRAWINGS: Jacek Kościuk
PREPARATORY WORK: Jürgen Giese
COORDINATION: Jerzy Jasienko
EXECUTION OF ARCHITECTURAL ELEMENTS: Kazimierz Szydekko
EXECUTION OF FRIEZES AND SCULPTURES: Janusc Kucharski, Grazyna Jasxkierska, and Maciej Albrzykowski (Academy of the Arts Wroclaw/Breslau)

All architectural components were individually sawed and milled from slabs of Corian, a synthetic material. More than thirty specialized blades were manufactured to cut the profiles. Socles, steps, columns, and cornices were joined with a special glue designed by DuPont; the joints are not visible. Friezes and sculptures were modeled in wax. Similar to the ancient process for bronze casting, negative molds of silicon were made and the wax was then melted. For the casting of the figures, liquid acrylic with marble dust was used. The model is held together with screws and can be disassembled into individual parts. Fabrication took ten months.

Hans Schleif made a smaller model in the 1930s, presumably on a scale of 1:50. Although the model itself no longer exists, photographs of it are kept at the Winckelmann Institute in Berlin's Humboldt University. This earlier model is a copy of the reconstructed altar in the Pergamon Museum. Since no sculptures were placed on the roof and between the columns, the altar is oddly (and wrongly) severe, a quality that was embraced by the architects of the Third Reich.[1]

When the Pergamon Altar was being reconstructed in Berlin in the 1920s, it became obvious that the first reconstruction, done by Jakob Schrammen in 1904, was inconsistent in some details. Similarly, the assembled altar in the Pergamon Museum shows building details that have nothing to do with the actual architecture of the Hellenistic period. Therefore, in 1988 the area of the altar in Pergamon was surveyed again, and a new reconstruction resulted, on which this model is based (fig. 1). The recent measurements revealed that important buildings of the Hellenistic period, without exception, are based on a fascinating clarity in both plan and execution, and the new model follows this principle. Deviations from the plan do not occur. This means that the widths of the spans cannot vary. Discrepancies in the spans can be explained by the fact that the altar is built using two ingeniously interwoven grids, one for the outer porticoes and one for the inner porticoes.

Most of the foundation has survived in Pergamon in situ. The middle part consists of uniform right-angled walls that form a gridlike system of chambers. This core is encircled by a broad zone of massive tufa ashlars. The porticoes and krepis were placed on these heavy walls. In its time this was an innovative foundation platform, in which the entire substructure formed a massive core whose walls did not connect directly to the walls of the altar. Above this substructure was placed a regular layer of hard trachyte ashlars, joined with dowels.[2] Above this layer rose the outer walls of white marble, its panels fastened to one another and to the layer below by dowels and clamps.

The only elements of the marble building that have survived in situ are two marble steps on the east side. They belong to the lowest of four encircling rows of steps. The height of the steps is just under 20 centimeters and forms a module that determines the scale of the whole (see Hoepfner, p. 54, fig. 27; foldouts 3–4).[3] Thus, the superimposed orthostat socle (including one base profile and one crown profile) is six steps high. The podium wall proper should have followed. However, the altar presents a curious feature: instead of a small figural frieze, which would normally take up only a section of the wall, the entire wall is transformed into a gigantic frieze. Including the intricate and deeply projecting cornices it is the equivalent of fourteen steps. The upper story features a graceful, encircling colonnade, which provided a roof for statues. A monument whose function was to give form to Greek culture had to have colonnades, even if they were only decorative. Two low steps, an Ionic-Asiatic base with a round plinth, a fluted monolithic shaft with an Ionic capital, and the architrave and cornice with dentil but without a frieze together were the equivalent of sixteen steps.[4] The total height of the monument up to the edge of the roof thus amounts to forty steps. In ancient measurements it corresponds to 25 feet, or 200 eighths-of-a-foot.

The lower diameter of the columns is 35 centimeters (1 Greek foot) and is in a 1:3 ratio to the intercolumniation, which corresponds to the diastyle proportional system, an extremely wide spacing of columns discussed by Vitruvius (3.3.4). The small scale of the altar allows this ratio to be used, since the standard rule calls for smaller columns to be spaced farther apart than larger ones.[5] According to Vitruvius, on a diastyle the height of a column has to be 8½ times its lower diameter, but because of the small dimensions of the altar, the columns are exactly 7½ times the lower diameter. The Ionic capitals are ½ foot high, 1 foot deep, and 1½ foot wide, measured at the volutes (fig. 2a–c). They are clearly planned with a sixteenth-of-a-foot module and exactly demonstrate the numbers with which Vitruvius (3.5.5–9) describes his Ionic

capital.[6] The capitals correspond to Vitruvius's even to the turning of the volutes, reconstructed from quarter circles. A short time after the Great Altar was constructed, its low egg-and-dart band and projecting cyma were repeated on the stoa of Attalos at Athens.[7] The quality of the stone masonry should be noted, the capitals having been worked by the best craftsmen. This style, with its millimeter-thick fillets on the Ionic cyma, reflects the prevailing trend.[8]

While large buildings, such as the Mausoleum at Halikarnassos, the temple of Athena at Priene, and the mausoleum at Belevi, developed a new and rich architecture for the ceilings of their colonnades, the ceilings of the Pergamon Altar are strangely plain, even coarse. The frames of the coffers are set off by simple fillets, the cyma at the base is only roughly worked, and the actual cap is unadorned (fig. 3; foldout 4). Noticeable is the construction of the ceiling. One row of beams has been omitted, and the coffers are arranged in panels of two sections each. At the edge of the roof these coffers appear above the sima as a high step, similar to those found on the Mausoleum and on the mausoleum at Belevi as supports of statues.

Today more than fifty fragments of ceiling slabs still lie in the vicinity of the altar. Since the dimensions vary within a recognizable group, reconstruction efforts, though intensive, have not proven successful thus far. To accommodate the short pieces, Schrammen proposed moving the center wall of the side colonnades 15 centimeters to the outside.[9] This very simple solution will be explained below.

During the excavations over-life-size statues were found in the area of the altar.[10] Twenty-eight or more female statues were found, most dressed in a peplos and standing upright. They stood on a low step behind the columns of the upper story, as Hans Schrader and Heinz Kähler proposed (fig. 4).[11] Paul Zanker has suggested that these statues, which originally numbered seventy-one, might have represented the cities of the Pergamene empire.[12] Their serene postures provide a pronounced contrast to the battle scene on the

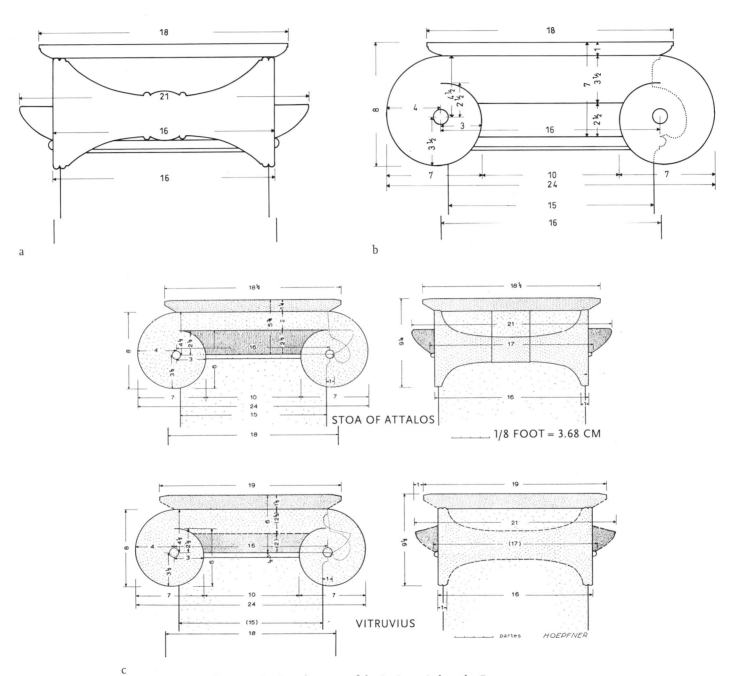

a

b

STOA OF ATTALOS

____ 1/8 FOOT = 3.68 CM

VITRUVIUS

____ partes *HOEPFNER*

c

Fig. 2a–c. Design elements of the Ionic capital on the Perga-
mon Altar. They correspond with the specifications given by
Vitruvius for the Ionic capital. (Drawings: Hoepfner)

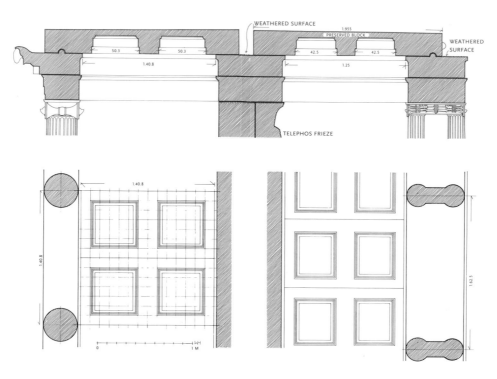

Fig. 3. Reconstructed ground plan and section through the outer and inner porticoes of the Pergamon Altar. The coffered ceilings were designed on the basis of a square field divided into strips. (Drawing: Hoepfner)

Gigantomachy frieze. However, there was a connection between the upper and lower sections: the figures of the Gigantomachy frieze are the same size as those in the upper portico and are by no means arbitrarily placed. On the contrary, the figures of the combatants are placed at roughly four-foot intervals, producing a loose rhythm. It was not by accident that the architect chose this measure for the spans of the columns above the frieze and thus achieved a harmony between the two elements of the altar.

Low socles stood to either side of the enlarged walkways in the colonnade (fig. 5). Although they appear to have been added later, they must have been part of the original construction as one of the stones of the outer layer is connected to a

block of the anta.[13] Perhaps equestrian statues of the royal donors stood here. Or could the statues have been bulls, as are shown on the famous coin with the depiction of the altar (see Kästner, p. 73, fig. 2)?

The outer colonnades, with twenty-one spans of four feet each (1.41 m) on the east and west and twenty spans on the north and south, form a uniform grid, which also determines the six spans on the inside of the projecting wings (see fig. 3).[14] To make passage easier, the spans are wider in the large open staircase. Instead of fifteen spans of normal width, there are thirteen enlarged spans. This larger measure of 1.63 meters makes up a second grid that also determines the plan of the altar court. The interconnection of the two systems is a

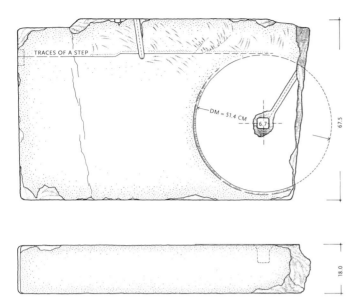

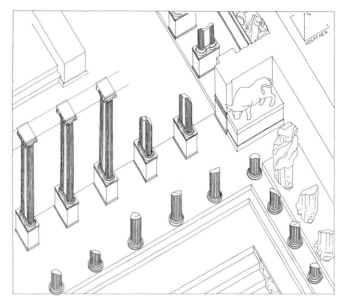

Fig. 4. Stylobate slab of the external portico of the Pergamon Altar with support traces of a column and a step immediately behind for the erection of statues. (Drawing: Brunner and Seidensticker)

Fig. 5. Axonometric rendering of the Pergamon Altar, showing the staircase and passage to the court, with sacrificial altar. (Drawing: Hoepfner)

geometric work of art, because the spans had to be strictly uniform, the porticoes had to have the same depth, and the colonnade at the walkway had to make the transition between the two rectangles. Today the ground plan of the altar can be reconstructed to the centimeter because, contrary to all expectations, it has become apparent that the work was carried out with the utmost precision. The crucial point is the preserved anta pillar, from which the exact position of the columns in the altar court can be determined. The pillar also shows the exact depth of the court and points to a minimal deviation from the mathematically exact regularity of both systems: the eastern rear wall had to be built 6 centimeters thicker than the other walls so that the colonnade would have the correct depth.

The problem of establishing the form of the entablature of the double half-columns in the altar court seemed insoluble to the excavators because they found no fragments of

an appropriate cornice. It was not possible that the projecting entablature of the larger outer columns was also used in the court, so Schrammen assumed that for the most part the court had remained unfinished. Blocks that project slightly at the top, which must be a wall crowning, seemed to support this theory. Half of the upper side must have been exposed to the elements because rain and hail have damaged the surface.[15] Although this lack of finish seemed strange to Schrammen, he held firm to his opinion. His views have prevailed and to this day the Pergamon Altar is thought to be essentially unfinished, even though there is no obvious reason for work to have ceased. On the contrary, the brotherly and parental love of the Pergamene kings was well known. Why then should this great prestigious monument, the victory altar in particular, have been neglected by Attalos II when he succeeded Eumenes II?[16]

The stones themselves testify that the monument was

indeed completed. Blocks have been found that form the top of the wall and that are weathered only in a narrow strip along the middle. Accordingly, coffers must have rested on each of the nonweathered sides. In addition, eight socles of the double half-columns of the court have been found. We must ask whether the blocks discussed by Schrammen could not have been fitted above the architrave of the double half-columns as a cornice (see fig. 3). The coffer blocks rested on the blocks forming the wall crowning, but they covered only half the crowning blocks, leaving the other half exposed to weathering. A cornice with such a plain form, which simply carried the profile of the wall to the outside, should not be surprising because the entire architecture of the court was supposed to represent the royal palace. This is proven by the existence of the Telephos frieze, which calls to mind the kings' banqueting hall.[17] A cornice as a wall crown was therefore appropriate.

It should be mentioned, nevertheless, that some parts of the altar remained unfinished. For instance, the lions' heads on the edge of the roof were left rough-hewn, and some ornamental details on elements of the sacrificial altar are not finished, as are areas of the Telephos frieze. However, incomplete details can be found on almost all Greek buildings, so it is possible that the builders actually chose not to finish all aspects of the altar.

Accordingly, if we postulate that the Pergamon Altar—including the colonnades in the court—was finished, we must look for the appropriate coffer panels. The depth of the inner colonnade can be calculated to be 1.25 meters from the antae blocks and the double half-columns. The only preserved coffer panel, with coffers 50 centimeters wide and 42.5 centimeters deep, must have been placed here.[18] Nineteen blocks of the same width rested on the narrow side, followed in the corners by four identical coffers 42.5 centimeters square.

The depth of the outer porticoes corresponds exactly to the span of 1.41 meters. Square fields were thus created, for which models existed in late classical architecture, on the

Mausoleum and the temple of Athena at Priene. The architect divided each side of this field into fourteen equal strips of 10.04 centimeters (see fig. 3). He needed five strips for each coffer (50 cm) and one strip on each side for the frame. One block drawn by Schrammen may have belonged to these standard coffers of the outer porticoes.[19] On the outer corners the coffers had to be of the same width but of lesser depth.[20] Schrammen had previously correctly attributed the 58-centimeter-wide coffers to the enlarged spans in the area of the walkways. These coffers are 50 centimeters deep, corresponding to the 1.41-meter-deep porticoes in this section. Four square fields are arranged in each span. No special forms were used at the corners.

Let us return to the inner court with its sacrificial altar. Cuttings are found located 20 to 23 centimeters from the edge of the upper surface of the fifteen preserved sima blocks from the wall of the altar (fig. 6; see Hoepfner, p. 54, fig. 27; foldout 4; cat. no. 34).[21] Dowels frequently are found together with pouring channels leading to the edge. Only statues could have been placed here, and they must have been marble since bronze statues do not require such large plinths. The plinths were set in a bed of lead. The presence of dowels can be explained as a special precaution against robbery. Stealing works of art was a common crime in late Hellenistic times, and altar statues were particularly valuable originals.

The cuttings for the plinths of the statues for the most part have irregular edges, which seem to follow the outlines of the figure. However, straight edges are also occasionally found, and the one preserved corner block has a rectangular cutting 80 centimeters wide. It can safely be stated that for the other pieces the irregular plinths of the sculptures stretched from the front of the upper surface to the back, even though the center blocks have thus far not been identified. The plinths must have measured 1.30 to 1.35 meters across.

As it happens, under-life-size statues were found at the altar, among them Apollo, Athena, and Poseidon (cat. nos. 17–18). The figures are shown striding, their garments billowing

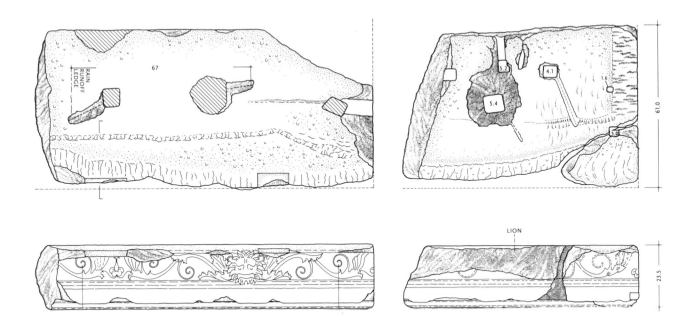

Fig. 6. Cornice of the frame of the sacrificial altar with lions'
heads as water spouts on the sima. On the upper surface
are cuttings for statues, which were fastened with dowels.
(Drawing: Brunner and Seidensticker)

behind. Since the marble surface is weathered and damaged by hail, the statues must have been erected outdoors. The excavators had already assumed that these figures stood on the ledge of the roof of the Great Altar because they had found an appropriate block with the impression of a similar plinth. It is quite possible that the statues of the gods stood on the inner ledge facing the court and could be seen from inside it.

The statues on the sacrificial altar were probably also under life-size. The small gods and the figures on the neighboring Telephos frieze are 1.25 meters high. Given the configurations of the cuttings for their plinths, the sacrificial altar statues must have been shown in a reclining position. Although as many as twenty-five such reclining statues may have existed, not even the smallest traces were found during the excavations, either at the altar itself or in other areas in Pergamon. Here the question arises whether a group of sculptures meeting these unusual requirements exists outside Pergamon.

In fact, museums in Naples, Rome, and Venice contain statues that are under life-size, approximately 1.25 meters high, which have a common theme: the enemies of the Greeks. In addition to mythical enemies such as Giants and Amazons, historic enemies such as Persians and Gauls are also depicted.[22] Although enemies are usually shown in battle, as can be seen on the Gigantomachy frieze and the statues in the Italian museums, they are dead or dying. The battle is over, and the defeated have collapsed or are pleading for mercy. The Lesser Gauls and the others are not originals but copies of the Roman imperial period. The original group after which the copies were made must have stood in

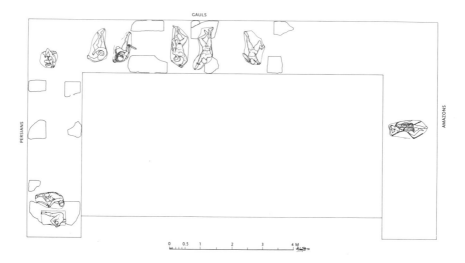

Fig. 7. Upper surface of the framing architecture of the sacrificial altar. The Lesser Gauls could have originally been placed in the irregular cuttings. Hypothetical arrangement of Gauls on the long side, Persians on the north, and Giants and Amazons on the south. (Drawing: Arvanitis)

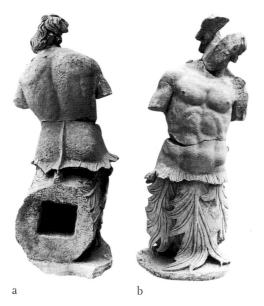

a b

Fig. 8a–b. Triton from the roof of the Pergamon Altar. Staatliche Museum zu Berlin, Antikensammlung.

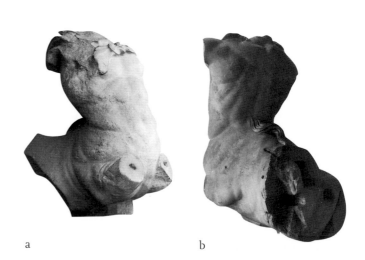

a b

Fig. 9a–b. Centaurs from the roof of the Pergamon Altar. Bergama Museum, Bergama. (Photos: Hoepfner)

Pergamon, because following the victory of Attalos I the theme of the defeated Gauls was given priority in the official art of the court. Most of the statues of the vanquished enemies have flat plinths that follow the irregular outline of the body and are on average 1.30 meters long. The remains of the cuttings on the sacrificial altar seem to correspond to the plinths of the Lesser Gauls. In addition, a cutting corresponding to the rectangular plinth of the collapsing Persian seems to have existed on the cornice of the altar. A block from the front of the projecting side wing has survived that shows a cutting for a plinth 80 centimeters wide (fig. 7; see Hoepfner, p. 54, fig. 27; foldout 4).

Whereas the reliefs on the balustrade of the stoas in the precinct of Athena show weapons piled in disarray, we may expect order in the depiction of the enemies on the altar. The Gauls formed the largest group and therefore perhaps occupied the long west side. The Persians may have been placed on one of the short sides, and the Amazons and Giants may have shared the other short side. The sacrificial altar must have been so low that visitors in the court could look down on the reclining sculptural groups or at least be on the same level with them (see foldout 4).[23]

Based on this hypothetical reconstruction, the figural sculptures and reliefs of the altar can be seen in a new light. In a direct way they were intended to glorify the victories of the Pergamenes over the wild Gauls. These events are equated with the battles against the Persians and also the great myths of the Amazonomachy and Gigantomachy. The rendering is quite unusual. The victorious gods stand on the edge of the roof, as if on Olympus. The defeated enemy writhes on the altar and begs for mercy; in a figurative way the enemy is sacrificed on the altar.[24] Such a scene, in which two groups interact across a distance, may have its sources on late classical vases. Theatrical stagings of artworks, in general, were not uncommon at the beginning of the late Hellenistic period, such as when the Nike of Samothrake is depicted at the moment she glides down a bow into a large water basin with an artificial rock.[25]

In Pergamon figures also stood on the outer edge of the roof. Fragments of sixteen horses have been found on the east side. Because the heads of the horses turn sideways, Huberta Heres was able to prove that they were grouped together in fours, as parts of quadrigas (see foldouts 3–4). Lions and griffins also belong to the roof decoration.[26] As royal animals they were most likely placed on the side opposite the staircase. Lions and griffins had already become a tradition on royal monuments, such as the Mausoleum at Halikarnassos and the early Hellenistic mausoleum at Belevi. However, at Pergamon the range of roof figures is complemented by Tritons, who were well disposed toward people (fig. 8a–b).[27] They were joined by centaurs, those demons of the woods who were part-horse, part-man (fig. 9a–b).[28] Centaurs were not necessarily included among the enemies of the Greeks, as Chiron and Pholos exemplify. Thus the roof was densely occupied by an illustrious company. The quadrigas may be understood as the triumph and victory of the Pergamene kings, each quadriga representing a specific battle with the Gauls. In addition to the other royal animals—horses, lions, and griffins—the gods stand with their assistants, the Tritons and centaurs. All figures are shown in vigorous motion, and the garments of the gods billow in the wind. They are all working for a good cause, for Pergamon.

THE ARCHITECTURE OF THE GREAT ALTAR AND THE TELEPHOS FRIEZE

VOLKER KÄSTNER

DISCOVERY AND RECONSTRUCTION

The excavations at Pergamon conducted by the Berlin Museums during 1878–1886 yielded not only extensive remains of relief decorations and sculptures from the large altar building but also numerous architectural fragments. They formed the basis for the first attempts to reconstruct the monument, together with the unearthed remains of the tufa foundation grid, upon which only two stepped slabs of the marble superstructure were found in situ on the east side. Thus Richard Bohn, the excavation architect, could present an essentially correct plan for restoration in the preliminary reports published in 1880 and 1888, shortly after the work was completed. Bohn's records—with Otto Puchstein's studies of the arrangement of the Gigantomachy frieze (1888–89) and Hans Schrader's investigations of the sacrificial altar (1899) and the Telephos frieze including its architectural integration into the altar structure (1900)—constituted the groundwork for the first museum reconstruction of the building with its Gigantomachy frieze in the old Pergamon Museum.

After Bohn's early death, Jakob Schrammen undertook the conclusive publication of the altar's architecture in the series *Altertümer von Pergamon*. His presentation, published in 1906, summarized the results of research at that time supplemented by his own observations based on subsequent investigations, particularly on the west slope of the acropolis in 1902 and 1903. Schrammen's conclusions also resulted in further modifications of ideas for the altar's reconstruction, as set forth in an unpublished manuscript by Wilhelm Dörpfeld in 1919, and in the plans that Armin von Gerkan produced to reerect the altar in the new building of the Pergamon Museum, which was opened in 1930.

The removal of the altar friezes for safekeeping during World War II to a limited degree offered further opportunities for Friedrich Krauss to make technical observations. This material was also used by Heinz Kähler for his significant doctoral dissertation on the Gigantomachy frieze, submitted in 1942 and published in 1948. But when the altar friezes were again installed, an operation that was carried out in great haste in 1958 after their return to Berlin, scientific research was hardly possible, and so the west front of the altar was restored following the earlier specifications.[1]

But even Gerkan, in an article written in 1963 and published posthumously in 1972, pointed out once again that the impressive altar construction as realized in the museum was not possible without hypothetical reconstructions of important sections (a staircase, court wall, and western portico), and that therefore a renewed, critical examination of the remains of the building at the site and in the museum would be necessary. Only such a detailed examination of the excavated remains could provide a solid understanding of the architectural features of the Great Altar.[2] This need for a detailed study was confirmed by the first results of current investigations at Bergama and Berlin, which will be referred to below, particularly in relation to the Telephos frieze and its architectural context.

The area on the southern slope of the acropolis below

the venerable sanctuary of the city-goddess Athena had already held a building before the erecting of the Great Altar. Remains of an apsidal building (which most probably served cultic purposes) inside the altar's foundation and the walls of a Hellenistic house had already been unearthed in the course of the excavations led by Carl Humann.[3] For the construction of the altar the terrain was leveled into a spacious terrace by cutting down the bedrock on the north side, moving the citadel wall and its substructure to the west, and filling in the ground to the south and enclosing it with a new retaining wall. In the east the temenos followed the old course of the road to the citadel, from which a short ramp apparently branched off to form the main entrance. Architectural remains of a gate or propylon could not be detected. But on the north side below the rocky slope it was possible to unearth the core masonry of an elongated podium, to which are attached, to the northwest, further remains of buildings that cannot as yet be interpreted. A flagstone pavement like that in the sanctuary of Athena was not found.[4] The marble steps of the altar are placed, however, on a layer of andesite ashlars, which rises above the surrounding terrain. One may assume therefore that the temenos was originally to have been paved but that construction came to a premature end.

Apart from the tufa foundation grid (36.80 × 34.20 m) that rises about two meters above the slabs of the lowest marble step, numerous relief panels and architectural fragments from the marble superstructure of the altar are preserved. When in A.D. 716 an Arab army commanded by General Maslama marched against Constantinople, the Byzantine garrison tried to defend Pergamon by hastily constructing a new rampart on a level with the Upper Market. The material for this Byzantine wall was obtained by pulling down the ancient buildings on the acropolis. Later, the marble debris that remained in the vicinity of the ruined altar was used for building houses on the altar terrace and in the area of the late Byzantine residential quarter covering the

slope of the acropolis.[5] Thus, the building materials of the altar were to a large extent preserved, until in modern times lime burners began to exploit the ruins of the Pergamene citadel.

The demolition of the rest of the Byzantine wall and the unearthing of the altar foundation brought to light such large quantities of the marble architecture that soon an essentially consolidated reconstruction of the monument could be worked out. The discovery that the ancient dressed blocks of the altar had been supplied with masons' marks in the form of Greek letters played an important part in the reconstruction. The lack of suitable marble in the immediate vicinity of Pergamon made necessary its transportation over long distances to the site. Therefore the use of the marble was apparently planned in detail and economically employed, just as dressed blocks from demolished older buildings frequently were reused. By marking the structural components, the materials required could be calculated more accurately. In addition, the blocks could be prepared in advance and the amount to be transported commensurately reduced. Finally, the masons' marks ensured the correct placement of the individual parts at the building site. Thus it was possible, for example in the case of a large stoa dedicated by Eumenes II in Athens, to prepare the structural components in Asia Minor. After transporting them to Athens, the blocks were assembled on the south side of the Acropolis.[6]

In order to increase the stock of available masons' marks, a combination of letters was used, the first for counting and the second for indicating location. This system of marking can be observed on nearly all marble buildings on the Pergamene acropolis, but is most visible on the Ionic temple on the theater terrace, ascribed to Eumenes II, and on the Great Altar. With the aid of these masons' marks, Puchstein was able to reconstruct the arrangement of the upper cornice slabs above the Gigantomachy frieze. The names of deities inscribed on the cornice provided essential clues for

the arrangement of the frieze itself. Thus the lower structure of the altar—consisting of a krepis with four or five steps, a low molded socle, and the Gigantomachy frieze between a richly profiled base molding and a widely projecting Ionic geison, amounting to a total height of 5.92 meters—could be reconstructed with certainty.

In addition, the excavators discovered that on the western side a monumental staircase, about 20 meters wide, cutting into the lower structure and flanked by narrow risalite wings, led up to the altar's raised court. Above the upper cornice slabs of the Gigantomachy frieze, but set back by 62.5 centimeters, rose the upper structure on top of the two-stepped krepis. It consisted of a three-sided court, surrounded by an Ionic colonnade (cat. nos. 29–31). On the western side the court walls continued to the front of the risalites and were enclosed by the colonnade on three sides. Finally, at the top of the monumental staircase a transverse portico completed the external colonnade. A row of piers set behind it between spur walls ending in pilasters in antis gave access to the inner court of the altar platform (cat. nos. 32–33). The pilasters indicate that an encircling inner ring of piers was also planned for the inside of the court. The walls of the inner court were decorated with the Telephos frieze. Finally, within the court stood the sacrificial altar, which was surmounted by a richly decorated entablature (cat. no. 34).

The external colonnades had an Ionic entablature without a frieze and a coffered ceiling of marble slabs. The upper surfaces of the coffers, sloping slightly outward, at the same time formed the roof of the altar. The roof carried acroteria, according to the still-recognizable cuttings on some of these slabs. Numerous fragments of under-life-size statues—mythical creatures such as griffins and centaurs, divinities such as Apollo and Athena (cat. no. 17), and especially parts of horses that can be connected to chariots—were recovered during the excavation north and east of the altar foundation.

When demolishing the towers of the medieval gate to the acropolis, fragments of the architrave with remains of a dedicatory inscription were found (cat. no. 35). It probably was situated on the east side of the building and can only be completed hypothetically. Therefore at this time the name of the dedicator, the occasion of the dedication, and the deities to whom this altar was consecrated unfortunately cannot be decisively determined.

THE COLONNADES OF THE GREAT ALTAR

While the general appearance of the altar can be described in a satisfactory way, numerous questions concerning the details are still to be resolved (fig. 1). For example, up to now no blocks could be assigned to the bottom step of the external colonnade. But its form and position can be deduced by comparing the setting lines on top of the upper cornice slabs of the Gigantomachy frieze with the reconstructed dimensions of the colonnade, including the stylobate. According to the traces left on the slabs of the stylobate, round bases of the traditional Asiatic-Ephesian type, with circular, flat plinths, a spira with double scotia, and a convex torus, are ascribed to the Ionic columns (cat. no. 29). However, a second type of base with simpler moldings exists, whose upper diameter would also fit the shafts of the columns. It is about 10 centimeters lower and consists of a square, flat plinth and a reverse cavetto with a smooth, reverse Lesbian cyma.[7]

Variants of capitals exist as well. Most frequent are examples of a type known in Ionia since the archaic period (A) with a quadruple-fluted cushion. A second type (B) is influenced by Attic models, which affected architecture in Asia Minor beginning in the fourth century B.C. (cat. no. 30). On these capitals the gorges are exchanged for a cushion, which is bound together in the center by a band of scales. Laterally out of this band grow short acanthus leaves, under which concave leaf-tongues spread outward.[8] On one example (C), the decoration is replaced by stylized thunderbolts, the attributes of the weather god Zeus (cat. no. 31). The external corner capitals had four diagonally arranged volutes, of which several fragments have been found. They have left concave support

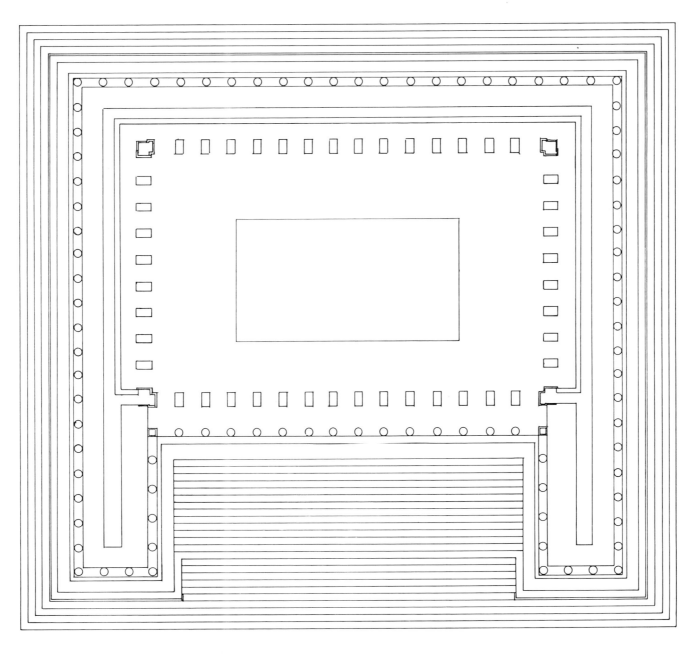

Fig. 1. Ground plan of the Great Altar. (Drawing: Kästner)

cuttings on the corner architraves.[9] For the supports of the reentrant corners between the western colonnade and the risalites, on the other hand, straight-lined support cuttings are confirmed on a matching fragment of the architrave. But since here, as well, a special corner capital must be assumed (i.e., not a normal Ionic capital), there must have been at this point either a type of capital as yet unknown or, as in the reconstruction in the Pergamon Museum, a square pillar.

The attempt to enliven the monotonous sequence of columns by modifying the appearance of the details apparently affected the intercolumniations as well. Marks on the crown molding blocks of the Gigantomachy frieze on the east side, which belong to the plan of the colonnades, and two architraves, which according to their find spot must be assigned to the southeast corner of the altar, exhibit an axial intercolumniation of 1.44 meters.[10] The majority of the other completely preserved architraves show only 1.40 meters. Several other architraves, which are 3 centimeters narrower, are 1.62 meters long. The two shorter and wider examples of architraves can now be joined with portico cornices of corresponding dimensions and with coffered ceiling panels measuring 69 to 72 centimeters in width (clear span between the cuttings, 1.22–1.27 m), which spanned one intercolumniation of the portico two at a time. Likewise, cornices with corresponding dimensions and coffer panels that are 79 to 81 centimeters wide, but about 30 centimeters deeper in the clear space, can be arranged on top of the longer and narrower architraves. Schrammen had deduced earlier from the specially trimmed panels that were recovered at the northeast and southeast corners of the altar, together with matching pieces of entablature,[11] that the colonnades with the smaller clear span and the shorter intercolumniations had framed the altar podium on the north, east, and south. Taking into account the dimensions of the foundation, this evidence allows us to determine that there were twenty-one axial intercolumniations on the east side and twenty on the north and south sides.

The fronts of the risalites projecting on the west side were correspondingly deep as well; based on the attributable ceiling coffers, a clear span of about 1.29 meters between the support cuttings can be determined. (Given the known width of the podium on the northern risalite, the fronts should be reconstructed with three shorter axial intercolumniations.) According to the blocks of their crown molding that are known, the spur walls of the risalites were 98 centimeters wide, much narrower than one axial intercolumniation. Therefore it must be assumed—as Schrammen did when he published the altar—that a correspondingly deeper portico ran along the inner flanks of the risalites. The large coffer panels correspond to this larger clear span and at the same time imply a greater axial spacing of the matching row of columns. Consequently, apart from a narrow axial intercolumniation at the corner, at least four wide axial spans have to be arranged on the inner flanks of the risalites so that the transverse colonnade at the top of the monumental staircase can be connected. The ledge between the crown molding of the lower structure and the stepped structure of the external colonnades would then also interrupt, in equal width, the rise of the flight of stairs.

One would expect the wide spans of the columns to continue in the western screen colonnade above the stairs. Yet this was apparently not the case, according to the fragments of corner panels found during the examination of the building in recent years (which can only have come from the reentrant corners of the porticoes on the western side). On the transverse colonnade, with a calculable clear span of 1.28 meters, the smaller type of coffer panels measuring about 70 centimeters wide appeared again. That means that the western colonnade duplicated the short axial spacing of the eastern colonnade. Through the row of piers behind it, this spacing would have been repeated in the colonnades of the court as well. However, these were never completed.

This assumption is, incidentally, substantiated by another observation. Coffer panels that were already trimmed but not assembled because of the interruption of work on the

altar were later used for other buildings. Several remodeled coffer fragments and a complete ceiling panel were found in palace V and in the area of the gymnasium terrace.

This complete panel, measuring 72.70 meters wide, as well as other reused pieces that can be attributed more accurately, have small coffers and therefore must have been produced for the narrow intercolumniations.[12] These blocks might have been intended either for the unfinished colonnades of the court or for the western colonnade, which probably would have been left open until all the materials had been transported onto the altar podium. Thus, no pieces of entablature have been found so far that can be combined with the piers behind the external western screen-colonnade. Finally, and remarkably, the western colonnade is also missing on a coin from the time of the Roman emperor Septimius Severus (r. A.D. 193–211), which otherwise conveys to us a very detailed representation of the altar front with a direct view onto the sacrificial altar in the interior court (fig. 2).

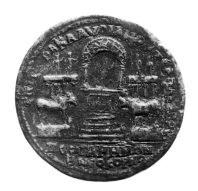

Fig. 2. Bronze coin from the time of Septimius Severus, reverse, with representation of the Pergamon Altar. Staatliche Museen zu Berlin, Münzkabinett.

THE COURT WITH THE TELEPHOS FRIEZE

From the proportions of the external colonnades as noted above, it is now possible to determine the dimensions of the court wall and hence the length of the Telephos frieze that ran around the walls. According to these proportions, the length of the frieze at the level of its crown molding was 26 meters on the east side, 15.50 meters on the north and south sides, and 1.30 meters on each of the internal western spur walls. Above the frieze the walls were crowned with capping blocks on a level with the cornices of the external colonnades. These blocks, including the simple concave moldings carried around the inner and outer faces, measured 65 to 68 centimeters wide on the north, east, and south sides and on the spur walls on the west side; on the risalites to the west, however, they were 98 centimeters wide. As can be deduced by the masons' marks, about fifty-six such capping blocks that were up to 2.50 meters long must have formed the top of the wall. The wider blocks of the risalites show traces of weathering

and tooling for the ceiling slabs lying on top of them on two or three sides; the narrower blocks of the court, however, generally show such traces only on the outer face. From this one can conclude that only the external colonnades and the porticoes of the risalites had been finished up to the roof. Judging by a groove in their center caused by weathering, some of the capping blocks from the northern wall of the court may also have carried ceiling slabs on the side facing the court. Below this course of wall-capping blocks, a plain wall architrave with a thin crown molding (smooth Lesbian cyma and flange) ran along the outer face. The same simple upper profile molding also ran along the inner side of the column architraves and as an upper terminus on the panels of the Telephos frieze. From this evidence and from the miters of the Telephos frieze panels preserved for at least three inner corners, Schrader drew the correct conclusion: the Telephos frieze with its upper profile molding covered the walls of the inner court up to the level of the external architraves.[13] Since no external frieze corners have been found, but at least three external corners of the wall architrave are known—two of them can be assigned to the northeast and southeast corners of the outer face based on where they were found, their doweling, and their masons' marks—the Telephos frieze cannot have extended onto the external wall of the altar.

Fig. 3. Reverse side of panel 20 from the Telephos frieze. (Photo: Laurentius)

Fig. 4. Top surface of panel 10 from the Telephos frieze. (Photo: Laurentius)

Fig. 5. Top surface of panel 43 from the Telephos frieze. (Photo: Kästner)

The Telephos frieze consisted of marble panels measuring 1.58 meters high and 0.67 to 1.06 meters wide.[14] About seventy-four relief panels altogether (north frieze, twenty panels; east frieze, thirty-one panels; south frieze, nineteen panels; and two panels on each of the spur walls) would correspond with the wall measurements given above. Of these there are forty-seven panels completely or partly preserved. Also taking into account the large number of fragments that certainly belong to the frieze but cannot be integrated and the scenes that are crucial to the Telephos myth and that must have been included, it is obvious that any attempt at a reconstruction is, properly speaking, rather circumscribed.

The reverse sides of the individual relief panels are coarsely stippled (fig. 3). Their lower surfaces were smoothed with a toothed chisel and generally have two square dowel holes each. A dowel on the edge is visible only on the beveled lower edge of panel 48, and another rectangular dowel hole is visible on the lower, mitered edge of panel 36; a dowel in this position would further stabilize the corner joins. In addition, one can observe places where a lever could be inserted on the lower right joining edge of panel 40 from the south wall and on the lower left joining edges of panels 38, 39, 44, 45, and 46 also from the south wall; the corner panel 34 from the east wall; and panels 5, 6, 10, and 11 from the north wall; and in some cases also on the lower edges on the rear. Based on this evidence, the frieze panels were apparently assembled primarily counterclockwise from right to left, or from the rear, using a mark to adjust the front edge. Except for the right side of panel 49, the joined faces are smoothly abraded over their entire surfaces to create an exact seam. On the finely stippled top surface one usually sees a hole for a lewis (missing on panel 6), on the sides beddings for clamps to connect adjoining panels, and sometimes also dowel holes for the wall-capping blocks as well as clamps on the rear. The outer edge of the upper molding was slightly beveled to prevent the cyma from being chipped when the wall-capping block was mounted on top (fig. 4). Only on the right side of panel frag-

ment 43 is the bedding for the clamp to an adjoining panel missing. Instead, there is an oblique cut for the purpose of clamping this panel to the rear wall (fig. 5). This shows that no further frieze panel was to be clamped on the right side and that this fragment brought the frieze to an end against the southern anta pier of the west colonnade. Hence this panel must have formed the last scene on the inner face of the southern spur wall together with corner panel 48, which would be congruent with the reconstructed length of the panel.

The individual panels were assembled with the aid of a lewis [15] and then carved so that about half of the panels, which were originally 35 to 40 centimeters thick, remained as a solid background. On panels 7 and 11 one can see that the sculptured relief projected 7 to 9 centimeters below the upper molding. The wall socle on which the panels rested must therefore have been thicker than the top of the wall by at least that dimension, to ensure full support.

Further evidence concerning the construction of the wall is found when the frieze panels are turned around. Several well-preserved panels (numbers 4, 17, 18, 21, 36, 38, 42, 47, and 51) have a cutting on their reverse sides, 88 to 94 centimeters above the bottom. This sometimes dovetailed in diagonally from the top, where a flat clamp up to 4 centimeters wide could attach a panel to the outer wall (fig. 3). Sometimes these cuttings even preserve remains of lead. On corner panel 8 this cut occurs about 47 centimeters above the bottom.

These clamp cuttings must, at least approximately, have corresponded to the horizontal joins of the external ashlar masonry, and thus the question arises whether similarly trimmed blocks can be found among the material in the area around the altar. During examination of the marble fragments on the altar terrace, the west slope, and in the area of the Upper Market along the course of the former Byzantine wall, numerous ashlars of gray-blue marble have indeed been found, which, together with the wall architraves and the frieze panels, permit the reconstruction of the ashlar masonry in the

dimensions required (fig. 6). The ashlar's outer face is smoothed; the inner surface coarsely stippled. In addition, they have a continuous system of masons' marks, which contain signs for each of the corresponding ashlar courses as well.

The ashlars of course A are 38 to 39 centimeters high (24–33 cm deep), most still having an upper bossed edge; they must be placed immediately below the wall architraves that measure 26 centimeters high. An ashlar for the corner with the masons' marks ωB can be inserted into the northeast corner of the court wall. Some ashlars measuring 42 to 44 centimeters high (28–33 cm deep), which are partly provided with clamp beddings on the rear corresponding to the clamp cuttings on the reverse sides of the frieze panels mentioned above, belong to course B immediately below. The remaining gap between this course and the base of the frieze panels was eventually filled by ashlars measuring 51 to 52 centimeters high (26–31 cm deep) with the course mark Γ. Deeper slabs (44–65 cm) that are only 24 to 25 centimeters thick, carrying the mark Δ, form the course of trusses, to which the outer wall and the Telephos frieze were doweled. Most of these dressed blocks are severely damaged, probably as a result of the violent destruction of the masonry in late antiquity. Finally, there are some thinner slabs, 59 centimeters high (24–36 cm deep), with the course mark E, which probably belong to the outer wall socle under course Δ. Then, since the columns are 2.67 meters high, there remains about 48 to 52 centimeters for the wall footing, which perhaps was filled with a 36-centimeter-high course of white marble ashlars, and a low step that, according to the support cuttings left on the fragments of the stylobate, began immediately behind the column bases. Only a few fragments of these ashlars are known, however, among them an example with the mark Z.

Several thin blue-gray marble ashlars (24–32 cm deep) of varying length (1.18 m to 0.67 m), with continuous assembly marks, can be attributed for the present to the wall socle facing the court. They correspond to the height of the course of trusses Δ and are stippled only on the top surface, which

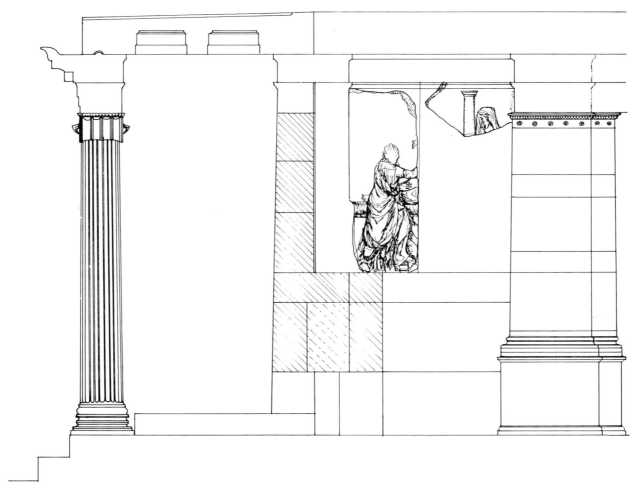

Fig. 6. Section through the southern wall of the Great Altar
court. (Drawing: Kästner)

reveals no traces for doweling to another course of ashlars, while a narrow strip along the front edge is far more weathered. These slabs can placed directly below the Telephos panels, projecting about 10 centimeters. In this case they form the top of a third course of ashlars; with them the court wall in the zone of the socle reaches the thickness of the spur walls of the risalites (approx. 93 cm). Below that there should be added, to correspond to the outer wall, a layer of blue-gray orthostats measuring about 59 to 60 centimeters and a 48-centimeter-high base consisting of white marble. Ashlars with the same dimensions are also present among the dressed blocks on the altar terrace. Finally, the core of the pedestal might have been filled with crudely trimmed stones. The attachment of the Telephos frieze above a projecting pedestal explains the reduced thickness of the main zone of the court wall in comparison with the walls of the risalites. These would have maintained the wall thickness of the socle zone up to the top, which would have prevented the Telephos frieze from extending across the flanks of the risalites facing the stairway.[16]

The discovery of six panels of the Telephos frieze with miter joints (panels 8, 9, 35, 36, 47, and 48), which can be combined with at least three reentrant corners, proved that the western side of the court above the monumental stairway was also at least partially enclosed by walls. With this information Schrammen could attribute to the altar itself a group of closely related dressed blocks from anta pillars and pillars with attached half-columns, whose fragments had been found during the excavation of the altar and the west slope. Here again each anta is composed of a square pillar, to which pilasters are attached at a right angle on two sides. These antae formed the corners of a peristyle, which also was composed of Ionic pillars with engaged double half-columns that stood on square molded socles like the antae pilasters (cat. nos. 32–33). Short spur walls joined the separately constructed anta pillars to the risalites on the west side. The shafts of the antae were composed of numerous segments, which frequently

were reworked pieces of older dressed blocks. In contrast to the outer wall, which above the socle zone consisted of ashlars in layers of decreasing height, the anta shafts were composed of alternating courses of thick and thin ashlars. This resulted in a pseudo-isodomic wall structure with three thick and two thin zones of ashlars between the Attic base and the capital, the neck of which was decorated with rosettes.

Although none of these anta pillars can be completely reassembled thus far, it is obvious that the addition of a block with a thickness of 10 centimeters, which Schrammen had inserted between the base of the pilaster and the socle, is not necessary for the elevation. This is also true for a base attached to the anta spur walls facing the stairway. The dressed blocks assigned for this element, when their arrangement is accordingly modified, can also be interpreted as the socle of the anta core. Meanwhile, from the number of fragments known, particularly those belonging to the anta shafts, one may, after all, conclude that not only the pillars of the western facade but also those in front of the east side of the court had been at least partially erected when work on the building was stopped.

The inner court of the altar was certainly paved with marble slabs. Schrammen attributed to this pavement fragments of slabs measuring 17 centimeters thick that show some support cuttings for the superstructure. In addition, one may certainly expect to find in the open court arrangements for draining rainwater. Bohn found, for example, remains of marble gutters—apparently in a secondary use—in the north stoa of the sanctuary of Athena, and a fragment of a similar gutter was recently uncovered in a Byzantine cistern near the altar foundation.[17] Finally, the older cistern on the south side of the altar grid may have collected the rainwater.

THE SACRIFICIAL ALTAR INSIDE THE COURT

It is generally assumed that a sacrificial place where offerings were made stood in the center of the paved court. The interpretation of the whole structure as an altar is confirmed by

ancient literary tradition. Lucius Ampelius, who presumably used sources datable at the latest to the time of the emperor Trajan (r. A.D. 98–117) (though the language of his *liber memoralis* probably is that of the fourth century A.D.), no doubt meant the altar of Pergamon when he spoke of the *ara marmorea*. In his description of Greece written between A.D. 160 and 180 Pausanias compared the altar of Zeus at Olympia, which consisted of the ashes of sacrificial animal thighs, with an altar at Pergamon, as well as with the altar of Hera at Samos and ash altars in Attika in general.[18] Certainly he based his observations on his personal knowledge of Asia Minor. Finally, we have the bronze coin from the time of the emperor Septimius Severus (r. A.D. 193–211), whose reverse represents the western front of the Pergamon Altar (see fig. 2). Between the risalites and above the monumental stairway one sees a low, block-shaped altar with a strongly emphasized cornice surmounted by a canopy supported by columns.[19] That this baldachin was not a symbolic addition made by the engraver of the coin die can be concluded from the detailed rendering of the supporting columns and the gridlike internal structure of the canopy, which is clearly visible, particularly on the example of the coin in Berlin. In spite of its somewhat clumsy execution, the coin recalls representations of wooden-arch constructions such as the famous bridge across the Danube on Trajan's Column; it therefore certainly depicts a great moment in technical engineering.[20]

Bohn had already related dressed blocks of a lavishly decorated tripartite entablature, which had been found on the altar terrace, on the western terrace, and in the Byzantine wall (cat. no. 34), to the sacrificial altar in the court. Schrader and Schrammen developed from that the construction of a large sacrificial hearth that rose above the columned hall.[21] With regard to more recent research and discoveries, particularly the increased understanding of Greek altar types and older reconstructions with their overly large dimensions, the coin from the Roman imperial period apparently depicts an altar podium of more modest dimensions. Clearly, renewed attention to the archaeological evidence seems essential. Thus Gerkan proposed as early as about 1926 the well-attested type of a rectangular stepped altar with lateral projections.[22] The richly articulated entablature should make the type of a sacrificial podium flanked by projecting wings—as it were, a repetition of the architectural motif that characterizes the whole structure—more plausible. Other Hellenistic structures it could be compared with, for example, are the altar at Tenos or the altar of Dionysos at Kos and the altars at Knidos.[23] The ladder-shaped grid of the foundation, consisting of walls about 1 meter wide running from north to south and walls about 50 centimeters wide running from east to west, could provide further evidence. From this the external walls of the sacrificial altar could be envisioned as either a larger rectangle of about 12 by 7 meters or a smaller quadrangle of about 7 meters on a side.

This general information must now be compared with the fragments of the sacrificial altar's "fine entablature" (fig. 7). According to data given by Schrammen, twelve pieces of a wall architrave 38 centimeters high belong to the entablature. The architrave has two fasciae and a richly articulated upper molding, of which 9.60 running meters, including three outer corners and an end slab, are preserved. Above an apophyge, the upper molding of the architrave consists of a string of beads, a Lesbian cyma, an Ionic cyma (egg-and-dart) set off by a thin ridge, and a cavetto decorated with alternating cross-shaped and lotus flowers. So far this lavish decoration can only be compared with a dressed block that is, however, much older, from the sanctuary of Athena Alea at Tegea, where it has been ascribed to the altar of Athena.[24]

The underside of the end slab of the architrave is 85.6 centimeters wide; this dimension helps determine the thickness of the projecting walls. Its upper molding, however, follows only the basic shape and is carved on the right corner to a depth of just a few centimeters. Thus the cyma ended in

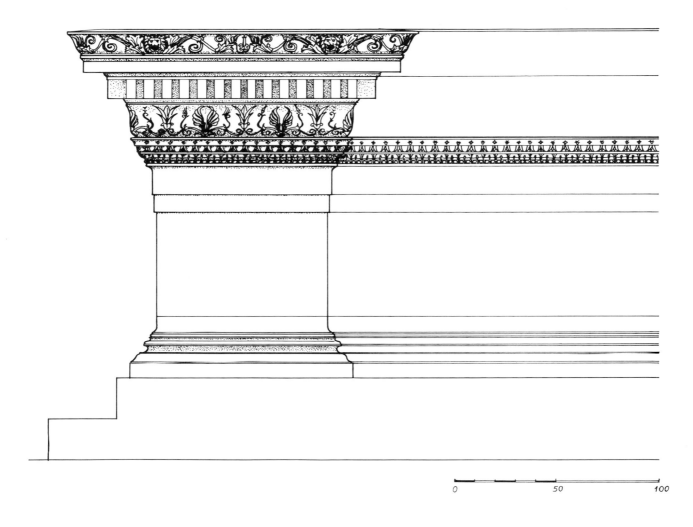

0 50 100

Fig. 7. Projecting front of the sacrificial altar.
(Drawing: Kästner)

graduated half-palmettes. Such a finish can only indicate a reentrant corner with corner palmettes. The simplest explanation for this corner reentrant by about 9 centimeters would be a pillarlike ressaut of the projecting end. A symmetrical arrangement would allow the thickness of the adjoining projecting wall to be reduced by 18, to 67.6 centimeters. In addition to the architrave slabs known so far, during the excavation in Pergamon in 1992 another fragment of an interior corner with miter cut was found. From this it can be deduced that the architrave with its profiled crowning was carried around the interior face of the sacrificial altar podium as well.

The second course of the entablature, measuring 29 centimeters high, consists of a bulging anthemion frieze and a dentil. Of this, sixteen pieces were found, which together add up to a length of 14.50 meters. Among them are two large corner slabs and an end slab. On the reverse side of the end slab a section up to 43 centimeters deep with a joggle and clamp bedding on the left rear was unfortunately chiseled off before the slab was transported to Berlin. Besides, its anthemion frieze is bossed only on the left corner. Among Bohn's records is a sketch of an apparently similarly trimmed block, which was, however, only 31 centimeters long. These bossed frieze corners can also indicate the presence of the ressaut of the wall crowns suggested above. Furthermore, masons' marks are recognizable on two frieze panels (a Δ on a corner slab and an H on the underside of a fragment; both in Berlin), which otherwise are completely missing on this structural group.

The anthemion relief of the frieze, with its lateral scrolls framing split flame palmettes, is a late Hellenistic descendant of an ornament that can be traced back to the classical Attic architecture of the Erechtheion. Following an attractive hypothesis put forth by Hans Möbius, the altar of Athena next to the Erechtheion was also decorated with such an anthemion frieze.[25] Thus the famous sanctuary on the Athenian Acropolis—recalling the good relations of the Attalids with

Athens—could well have been the model for an ornamentation that was unusual in Asia Minor. Further, as Frank Rumscheid has noticed, several hands can be distinguished in the execution of the frieze fragments from the Pergamene sacrificial altar.[26] On eight blocks—among them the short sides of the large corner slabs—the side leaves of the palmettes bend very far outward, thus increasing the axial spacing between the ornaments from 40 to 44.5 centimeters. Taken together and restored to an average length of 1.50 meters, these slabs yield a frieze length of at least 10 meters. The other fragments and the longer sides of the corner slabs have a smaller axial dimension of 35 to 37 centimeters, with the lateral scrolls nestling closer against the palmettes and curling in toward them. From these another group consisting of five frieze pieces can be separated out—including the end slab and a dressed block in Berlin preserved in full length—in which the palmette leaves have a ridge in the middle instead of the usual notch. These slabs can be assigned to the sides of the altar.

The top of the entablature was formed by a crown molding with a sima with a scroll pattern and lions' heads; these were not pierced as waterspouts but merely had a decorative function. Schrammen knew of twenty-four fragments of the severely damaged crown molding, among them an end slab and four corner pieces. The fragments that are still traceable today add up to an ornament of about 15 meters long. Among them are two corner pieces, whose sima ornament was completely or partly unfinished and only bossed. As on all other parts of the entablature, the backs of these slabs were only coarsely stippled. From these Schrammen deduced that there must have been a core masonry of tufa or andesite, which would indeed seem likely for the sacrificial altar podium. But while in the lower zones structural components for rear clamps occur very rarely, they can be regularly found on the slabs of the sima. In addition, on the top there are stippled cuttings 1 to 4 centimeters deep of rectangular or irregular shape, and cuttings that are not very carefully stippled. On two slabs these cuttings, about 80 centimeters

deep, are provided with at least one pair of dowels; on a third slab this cutting measures about 70 centimeters. On the end slab, which is more difficult to interpret because of its severe weathering, as well as on another fragment in Bergama, one can observe that in the course of a repair further dowel holes were cut into it. While the fragments with the dowel holes are appropriate for fastening large slabs, a simple cutting seems to point to the attachment of a flat piece of metal. Schrammen already considered these traces to be provisions for erecting sculpture, while Gerkan rejected the idea of "smoke-blackened deities" on the sacrificial altar podium. Further, taking into account that the acroteria on the altar colonnades were, as can be proved, mounted without additional doweling or clamping, it seems strange indeed that for sculptures on the low sacrificial altar in the sheltered court of the building such a massive system of fastening and later equally massive repairs were deemed necessary. However, if one connects the traces of doweling to the plinths of columns that carried statues or a canopy, as is suggested by the Severan coin, these provisions would have an acceptable reason. In the case of the other flat cuttings of a more irregular shape, attaching a seal made of metal or packed earth as protection against weathering and fire would offer a sensible explanation.[27] If one insisted on a sculptural decoration on the sacrificial altar, the addition would result in a very tight sequence of elements, which would have conveyed an odd impression on the low podium with its crown moldings projecting about 44.5 centimeters.

Just as difficult as the reconstruction of the altar cornice is the attempt to determine the wall ashlars and the lower structure. A white marble slab lying south of the altar terrace, 83 centimeters wide and 52 centimeters high, is appropriate for a wall facing. The face of the left side of the slab is not preserved, but it could well be restored to a total width of about 86 centimeters based on the pairs of dowel holes in the bedding surfaces and the rear joins. This ashlar could be combined with a base molding, which in the old reconstruc-

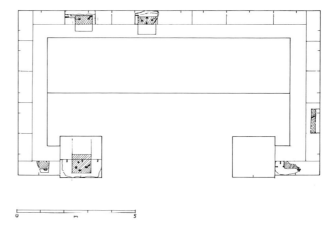

Fig. 8. The sacrificial altar in the court of the Great Altar. Proposed reconstruction plan of the upper surface. (Drawing: Kästner)

tion had been interpreted as the foot of the altar court walls. The altar cornice renders in smaller scale (30 cm high) the same combination of cyma recta, cavetto, and Lesbian cyma that occurs as the base molding on the Gigantomachy frieze.

Otherwise, such a molding is known in Pergamon only from a round socle for a statue of Apollonis, which her son Attalos II consecrated before he assumed the title of king.[28] Of this molding only four fragments have been found so far, two outer corners and two dressed blocks with interior corners, which would suggest that they belonged to a rather small, exedralike building similar to the presumed structure of the sacrificial altar. Also important is a complete slab with two miter cuts 1.13 meters apart. This slab could have formed the inner base molding of the free projecting wall behind the risalite with a ressaut. If so, the spur walls would have been rather short. Therefore, the dimensions of the whole structure could not be expected to have been very large. Based on the measurement of the scroll pattern of the crowning sima profile—87.5 or 97.5 centimeters for a complete section with central lion's head—and taking into consideration the foundation grid, one could reconstruct a rectangular, narrow altar with projecting wings with a length of at least 10 meters according to the frieze fragments (fig. 8).[29]

With the cuttings described above, the sacrificial podium would eventually have risen to a height of about 1.20 meters (the top edge of the wall architrave), which should still have been within comfortable reach for the priest and would relate to the usual dimensions of altars for sacrifices. Finally, the usual two-stepped krepis, consisting of the stepped slabs measuring 23 centimeters high mentioned by Schrammen, has to be added as the base below the structure. The sacrificial altar would then achieve a total height of 2.18 meters (see fig. 7) and—if the height given by Ampelius (40 Roman feet equals 11.84 m [the length of a Roman foot = 29.6 cm]) was correct—it could be crowned by a 3.74-meter-high canopy supported by columns. But thus far it has not been possible to identify with certainty elements of such a structure.[30]

The attempt to reconstruct the Pergamon Altar from its numerous remains clearly shows that this is an exceptionally complex structure. Its appearance melded different ideas derived from architecturally lavish altars and monumental funerary buildings to form a unique monument of a dynasty that self-confidently conceived of itself as the political pioneer of Hellenism. In this altar, idea and execution represent in their totality the climax of Hellenistic culture in Asia Minor.

THE MYTH OF TELEPHOS IN PERGAMON

HUBERTA HERES

Telephos, the son of Herakles and the Arkadian princess Auge, was born in Arkadia on the Peloponnesos and later set out for Asia Minor, there to rediscover his mother and become king of the Mysians. According to the ancient literary tradition, he was the mythical founder of Pergamon. The Attalids, the ruling dynasty of Pergamon, regarded him as the ancestor of their line.[1] The earliest extant evidence by a Greek city acknowledging Herakles as an ancestor is an Athenian inscription for Attalos I (r. 241–197 B.C.) from about 200 B.C. This descent from the hero Telephos, the son of Herakles and grandson of Zeus, secured the legitimacy of the Attalids' claim to sovereignty.

To be sure, for the same reason other Hellenistic dynasties also traced their descent back to a divine origin.[2] But the population of Pergamon also was included in this mythical descent: a Milesian inscription from after 129 B.C. and an oracle of Apollo at Klaros, written down in the second century A.D., call these people Telephidai, descendants of Telephos, and Pausanias (*Description of Greece* 1.4.6) reports in the second century A.D. that they were descendants of the Arkadians who had accompanied Telephos to Mysia. Mutual honors, recorded in inscriptions, confirm the bond between Pergamon and the Arkadian city of Tegea. From there Auge, Telephos's mother, was said to have conveyed the cult of Athena to Pergamon, which was the most important cult of the city. The connection of Pergamon and its dynasty with the legend of Telephos was promoted in particular under the reign of Eumenes II (r. 197–159 B.C.) in order to establish in the myth the relations of the eastern empire to Greece.

In the frieze in the inner court of the Great Altar of Pergamon, which depicts the life of Telephos from the events preceding his birth in Arkadia to the late years of his life, perhaps to his death and heroizing, the ruling family and population of Pergamon recognized their mythic prehistory. Furthermore, contemporary cult and history, traced back to mythic times, created an immediate link between the legend and the present for the ancient spectator. This close relation to Pergamene cults as well as the frieze's fragmentary state make understanding some of its parts difficult. Even today, more than a century after its discovery, the interpretation of individual scenes and the arrangement of the panels are uncertain.

The legend of Telephos was the subject of Greek literature and art long before the Attalids made the hero the ancestor of their dynasty. This literary tradition and ancient representations of the myth provided the basis for the interpretation of the extant relief fragments and the reconstruction of the sequence of frieze panels. Shortly after the discovery of the altar, Carl Robert offered the first conclusions in three admirable articles, which later were corrected only partially by Hans Schrader and Hermann Winnefeld in the basic publication of the altar.[3] All three authors still assumed that the frieze extended beyond the inner court onto that side of the spur walls in the wings that faced the stairway, particularly because of the scenes that have to be added and the great number of preserved fragments to be included. More recently, Christa Bauchhenss-Thüriedl proposed a new interpretation.[4] Also, she was the first to attempt—though with the

omission of important fragments—to fit the remains of the frieze in the inner court of the altar, as the architectural context apparently demands. The studies concerning the interpretation of the frieze fragments have concluded that the version of the Telephos myth as depicted in the frieze represents significant elements from various and partly contradictory literary traditions.[5] The concept for the narrative of the frieze that served the sculptors as their immediate model was therefore probably created at Pergamon.[6]

THE MYTH OF TELEPHOS IN THE FRIEZE VERSION[7]
(See inside front cover insert)

The beginning of the frieze relates the events preceding the birth of the hero in Arkadia. The first two panels on the northern spur wall are not preserved. Presumably represented was King Aleos of Arkadia, who receives the oracle from Apollo in which his sons are threatened with death by a descendant of his daughter Auge. To avoid this fate he consecrates Auge a priestess of Athena. Herakles then arrives at Tegea. Separated from each other by a pillar, panels 2–3 (fig. 1) show the remains of the welcoming of the guest in the house of Aleos and of the encounter of Herakles with Auge in an oak grove (cat. no. 1). The figure of Queen Neaira is preserved in the welcoming scene, sitting raised on a throne and grasping the hem of her mantle with a gesture that means "polite uncovering of the face of veiled women."[8] By way of comparison, Robert has pointed to Arete, queen of the Phaiakians, in the *Odyssey* (7.139–47), who, while welcoming Odysseus, sits "in the depths of the hall."[9] In front of Neaira two members of the retinue of King Aleos are recognizable. Auge has to be assumed at the right of the figure of Herakles. Bauchhenss suggested the placement here of panel 11 (fig. 2), which shows several women busying themselves with a statue of Athena.[10] In this case the love affair between the two main characters would only be decorously hinted at by the bare breast of the central female figure, who is understood to be Auge. The plane tree under whose branches the group of women stands,

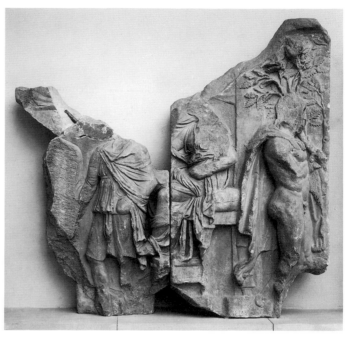

Fig. 1. Herakles welcomed at the court of Aleos at Tegea. At the right Queen Neaira is enthroned. At the left Aleos and Herakles are to be assumed. Beyond the pillar Herakles watches Auge in the sacred grove of Athena (panels 2–3).

however, according to the conventions employed in the frieze, represents a different place, making doubtful the association of this panel with the figure of Herakles in the oak grove. Nevertheless, it is possible that in the frieze the meeting between Herakles and Auge was reduced to a tranquil encounter.

The myth continues with Auge giving birth to a child by Herakles, the infant Telephos. Once again Aleos attempts to avert the doom awaiting his sons by surrendering mother and child to certain death. Telephos is left exposed in the Parthenion Mountains: panel 4, the carved fragments of a man and a woman under a plane tree, may have belonged to this scene. Auge is set adrift on the sea in a nutshell-like skiff, which four carpenters are building on panels 5–6 (cat. nos. 2–3). But both Telephos and Auge are miraculously rescued.

The skiff with Auge drifts toward the shore of Mysia, and King Teuthras of Mysia receives the abandoned woman. On panel 10 (cat. no. 4) one may recognize the king with his retinue approaching in haste to inspect the marvelous flotsam. All wear long-sleeved garments and boots with flaps (Greek embades), which in the frieze characterize the inhabitants of Asia Minor: the Greeks wear high-laced boots (Greek krepides).[11] The left part of the scene with Auge's skiff is lost save for a fragment with a piece of the vessel's edge, carried by a dolphin, and a fragment with a woman's garment.[12]

Auge founds the cult of her goddess Athena at Pergamon. Thus panel 11 (fig. 2), with women under a plane tree who appear before the statue of Athena with sacred fillets and a cult vessel—busying themselves with the statue, perhaps dressing the cult image—has long been connected to that event, for good reason. Since the cult of Athena at Pergamon was officially regarded as Auge's foundation, this event was certainly depicted in the frieze.[13]

Auge's exposed child, too, is rescued. Herakles finds Telephos in the Parthenion mountains being suckled by a lioness (panel 12, cat. no. 5). Panel 8 (fig. 3), on which a girl kneels before a tripod cauldron and kindles a fire for warming water in the presence of a mountain goddess, is perhaps part of a scene in which nymphs bathed and cared for the child, much as, according to tradition, the infant Dionysos was nurtured. This panel belongs to a corner because of the miter-cut joining edge. In terms of its subject, it must belong to the northeast corner of the altar court. On the east side of the court fits the severely damaged panel 9 (fig. 4), with its fragments of men in a mountainous region, which cannot be explained. How the childhood of the thus miraculously rescued hero was represented in the frieze cannot be reconstructed from the fragments. In the literary tradition he grows up with herdsmen and comes to the court of Aleos. We do not find him again in the preserved parts of the frieze until he is an adult, and we do not know whether he was shown killing his uncles, thereby fulfilling his grandfather's oracle.

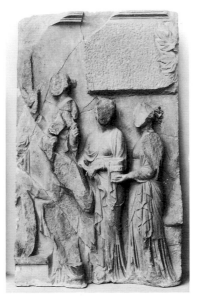 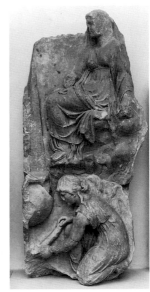

Fig. 2. Auge, attended by her maid-servants, in front of the cult image of Athena (panel 11).

Fig. 3. Nymphs prepare a bath for the infant Telephos (?) (panel 8).

Fig. 4. Mountainous scenery with remains of male figures (panel 9). (Photo: Laurentius)

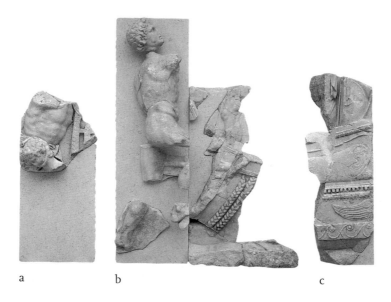

a b c

Fig. 5 a–c. Remains of representations of ships from the voyage of Telephos to Mysia (?). A man clasps his arms around the stern ornament of the ship lying ashore, while another, bent toward the ground, is probably engaged in mooring the ship (panel 13). A Greek boards a ship. Fragments of the stern, rudder, the ship's stairs, and the tackle around the hull are preserved (panels 32–33). A richly decorated bow of a ship with remains of two figures on board (panel 14b). (Photo: Laurentius)

Another oracle directs him to Mysia, where he is to find his mother. Remains of ships (panels 13, 32–33, 14b; figs. 5a–c)[14] probably belong to this voyage, in which some Arkadians perhaps also emigrated to Mysia in the company of Telephos.

Panel 16 (cat. no. 6) shows on its left margin just the far-right end of the welcoming scene in Mysia with members of the retinue of Teuthras, again characterized as inhabitants of Asia Minor by their Phrygian caps and boots with flaps. A separately preserved head of a dignified bearded man wearing a Phrygian cap may represent Teuthras.

Telephos is seen being equipped to go into battle on behalf of the Mysians (panels 16–17, fig. 6; cat. no. 6). His own mother, still unrecognized and followed by a maidservant, brings his weapons. The adjacent severely damaged scene seems to depict Telephos's departure (panels 17–18,

fig. 7). After Telephos is victorious in battle, Teuthras wants to give his adopted daughter Auge to him in marriage. Panel 20 (cat. no. 7) shows the king leading Auge to the cult image of her goddess. This scene must be associated with the fateful wedding, for in the next scene, which is separated from the previous one by a pillar, the nuptial bed is represented with a serpent coiling up between Telephos and Auge, thus bringing about the recognition of mother and son. The outline of the serpent's body and Telephos's torso are still preserved (fig. 8).

Telephos becomes king of Mysia. He sees the Greeks landing first on the Mysian shore on their way to Troy. In a battle in the Kaikos river valley he defeats the intruders (panels 22–33; the exact sequence of the scenes can no longer be reconstructed). He is aided by his wife, the Amazon-like

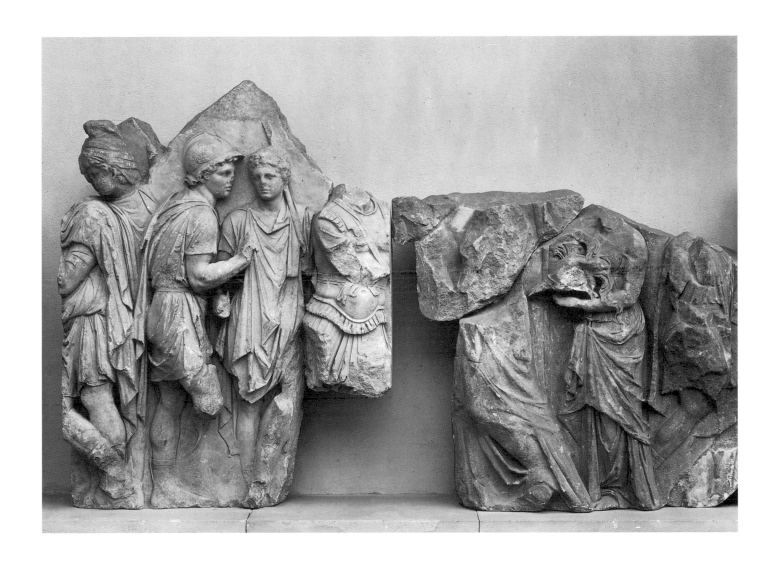

Fig. 6. Telephos being welcomed in Mysia (fragments at the
left margin). Auge equips Telephos with arms (panels 16–17).

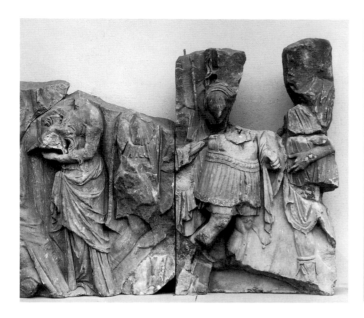

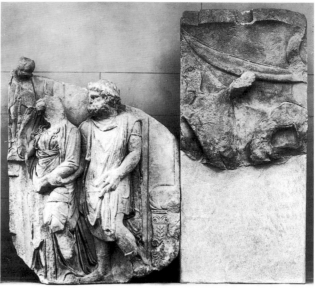

Fig. 7. Telephos and Teuthras (panels 17–18).

Fig. 8. Teuthras leads Auge to the cult image of Athena. In the nuptial chamber Telephos is startled by the serpent (panels 20–21).

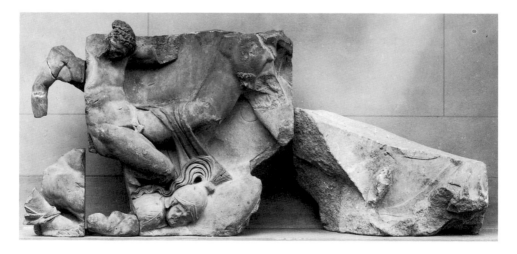

Fig. 9. Scenes from the battle against the Greeks on the Kaikos plain. In front of the warriors two reclining river gods face each other (panels 27–29).

Hiera, who rides into battle at the head of the Mysian women (panels 22–24), and by Heloros and Aktaios, the sons of the River Ister—that is, the Danube—whose Scythian armor points to their origin (panel 25, cat. no. 8). Two deities, personifications of the region and its rivers, whose feet alone are preserved, recline peacefully in the midst of the turmoil of fighting. Without intervening they are present at the battle. Between them combatants endeavor to recover someone who has been wounded or slain (panels 27–29, fig. 9). The allusion to the familiar river landscape as well as the representation referring to the cult of Athena on panel 11 probably linked the mythical events with the present in the eyes of the viewer. The depictions of the battles would have recalled the bitter decades-long struggles of the Pergamenes against their enemies. Furthermore, the region around the headwaters of the Kaikos river was the site of one of the decisive battles of the third century B.C. against the Gauls, and victories over the Gauls had been celebrated by the erection of monumental battle memorials.[15]

The Mysians succeed in repelling the Greeks. Telephos, however, is wounded by Achilles. The enraged Dionysos, to whom Telephos had denied offerings, makes a vine sprout up, in which Telephos gets entangled (panels 30–31, fig. 10). Only fragments of the two heroes' bodies in front of rocky scenery are preserved, Telephos with a richly decorated shield helplessly presenting his unprotected flank to the spear of Achilles and probably the torso of Dionysos as well (cat. no. 9).

Telephos was wounded in his thigh and since the wound did not heal, he consulted the oracle of the Lykian Apollo and received the answer, "He who caused the wound will heal it." This oracle was so famous in antiquity that the scene was certainly represented in the frieze. Perhaps panel 1, with the king in a long-sleeved garment like that worn by the kings of Asia Minor in the frieze (see panel 10, cat. no. 4) and what appears to be the royal fillet in his hair, belongs

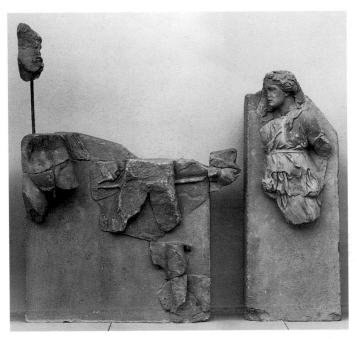

Fig. 10. In the battle Telephos is wounded in the thigh by Achilles' spear. From the right Dionysos appears. By means of a vine he entangles Telephos and prevents him from fleeing (panels 30–31).

here. The king stands in front of a column-shaped pedestal on which the feet of a small statue of a deity are preserved (panel 1, fig. 11). Laurel branches tower above the image and indicate a sanctuary of Apollo. The king raises his hand in prayer toward the image of the god. Telephos then travels by ship to the Greeks, who have returned to Argos, to ask Achilles to heal him. The arrival and the unloading of the ship are depicted on the extant panels (panels 34–35, fig. 12). This arrival and the welcome at Argos form the southeast corner of the frieze. The wounded Telephos as well as the man who greets him are accompanied by a retinue (panels 36–38, fig. 13; cat. no. 10). The princes entertain him at a banquet, in the course of which Telephos discloses his identity (fig. 14). He flees the Argives' wrath and takes refuge at the house altar. As if fearing that his rights of asylum would not be respected, he

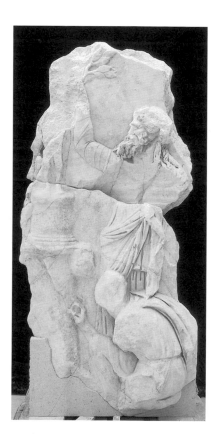

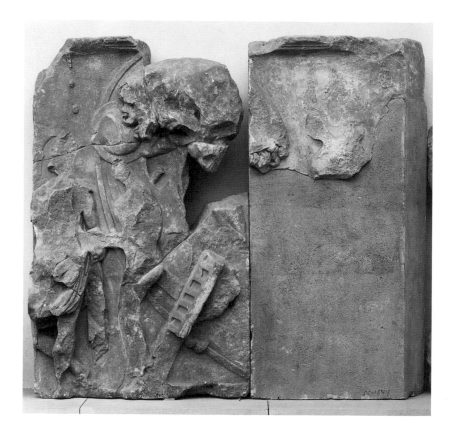

Fig. 11. A man with the royal fillet in his hair and wearing the costume of Asia Minor in front of the image of Apollo. The wounded Telephos receives the oracle, "He who caused the wound will heal it" (panel 1). (Photo: Laurentius)

Fig. 12. Telephos lands at Argos. A man climbs down the stairs of the ship, of which the stern ornament and a part of the hull are still extant. On board another man is bowed under a burden, wrapped in an animal's skin turned inside out. At the right edge a man lays down the mast (panels 34–35).

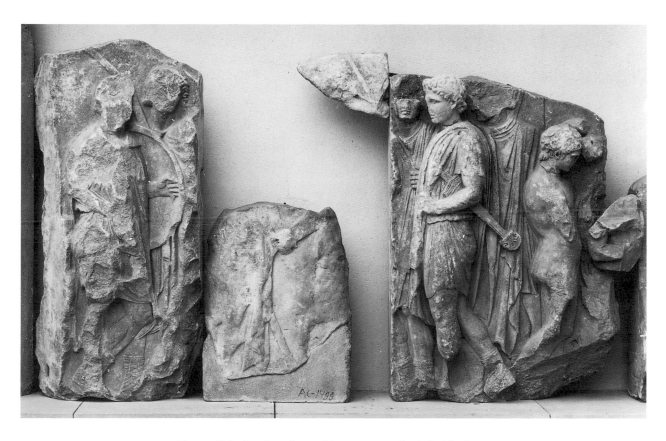

Fig. 13. Telephos is welcomed in Argos. On the left Telephos
leans heavily on a staff; from the right Agamemnon comes to
receive him. Both are attended by a retinue (panels 36–38).

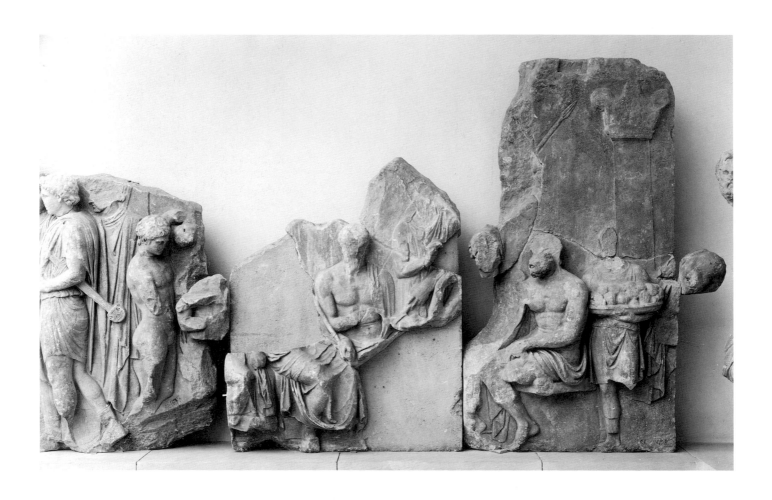

Fig. 14. Banquet of the Argive princes for Telephos. On the right side of the semicircle of the princes Telephos is seated, uncovering the wound on his thigh (panels 38–40).

has seized the infant Orestes, the son of Agamemnon, as a hostage (panel 42, cat. no. 11). Again an important scene is lost, the healing of Telephos, by which the oracle is fulfilled. Achilles scrapes rust splinters off his spear into the wound, which is thereby healed.

In the current arrangement of the frieze, scenes follow that are related to Pergamene cults (panels 44–50, figs. 15–17). One may assume that the most important cults of the city are referred to, either because they were connected with the myth of Telephos or because they were prompted by the Attalids. On panels 49–50 (fig. 17) an altar is being erected in front of a naiskos and apparently at the feet of a goddess sending out a bird as an omen. Two men, one dressed in a chiton and mantle, move the capstone of the altar into the right position, surely a symbolic procedure denoting its consecration. The presence of reclining river gods shows that a sanctuary of great importance is concerned. Yet the scene is rendered without any ceremonial character and is instead filled with the liveliness and activity of the building site, where half-naked laborers work. Labor and craft are depicted with an interest similar to that expressed on panels 5–6, where the carpenters build Auge's skiff (cat. nos. 2–3).

Panel 51 (cat. no. 12), with the remains of a prothesis, was for a long time taken to represent the laying out of Telephos on his deathbed and therefore was placed at the end of the frieze. On the basis of the curly hair of the deceased, it was recently determined that, not the aged Telephos, but a youth or a woman is being laid out here. It is said that Hiera was slain in battle and that her beauty even when dead moved the enemies: a truce was concluded so that Hiera could be buried.[16] If this scene is meant to be the laying out of Hiera, it would have to be placed in the center of the battle of the Kaikos river or immediately at its end. But this is made difficult given the remains at the left margin of the panel, which belong to a figure dressed in a long garment, facing left toward the previous scene. Instead, one might think that this represents the laying out of Auge, whose life occupies such a

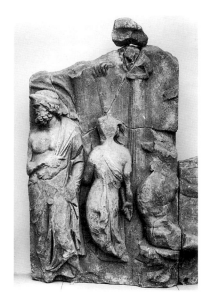

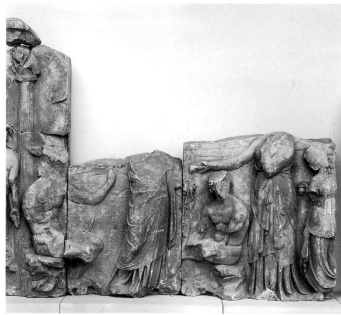

Figs. 15–16. Scenes of the cult of Dionysos (?). Left of the column, on the capital of which sits a small lion, stands a man dressed in a cloak with a wide wreath and a fillet, followed by a female torchbearer. On the right, a mountainous scene with satyrs flanking a female figure, who welcomes a richly dressed woman followed by a small maidservant with a box in her hand (panels 44–46).

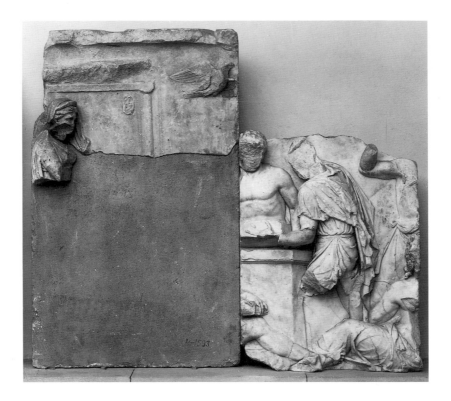

Fig. 17. Founding of a sanctuary. In front of the naiskos of a goddess a capstone is being placed on an altar by two men, one of whom is a laborer wearing a loincloth, the other one perhaps Telephos. From the right another laborer approaches, carrying a load on his head. In the foreground recline two river gods (panels 49–50).

prominent place in the frieze. The information about her burial mound in the marketplace of Pergamon, furnished with stones and a statue, however, dates only from the time of Pausanias (8.4.9). Only a heroine could have a tomb within the city limits. If this scene does indeed depict Auge, that would explain why, instead of warriors, men dressed in civilian clothes, and among them perhaps her son Telephos, stand at the head of the kline with offerings for the deceased.

Bauchhenss places at the end of the frieze the panel sequence 47–48 (figs. 18–19), which shows Telephos reclining on a kline, heroized after his death. The excitement of the two women hurrying toward the reclining Telephos from both sides of the southwest corner of the court must then refer to the preceding scene. The representations on panels 44–46 (figs. 15–16) are related to Dionysos in a broader sense. One should like to imagine the epiphany of the god himself, who fills the women with such horror and at whom the hero Telephos points with outstretched finger. In battle, the wrathful god imperiled Telephos; at the end of the latter's life, his appearance would indicate a reconciliation. The Attalids felt particularly attached to Dionysos Kathegemon,[17] and his cult occupied a large space at Pergamon.

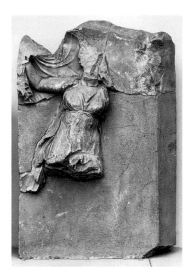

Fig. 18. A woman hurries to the right. Her mantle, the hem of which she grasps with her right hand, swells behind her like a sail (panel 47).

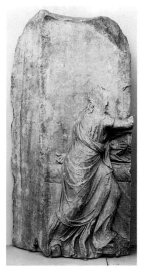

Fig. 19. A woman hurries toward a kline on which reclines a man, the heroized Telephos. She turns her head as the man points his finger to an event that must take place on the preceding panel. This panel (panel 48), together with the one that has to be assumed on the right, completed the frieze at the southern spur wall of the altar court.

Considering the extent of the literary tradition of the Telephos myth[18] and comparing it with the iconographic tradition, which Matthias Strauss has so thoroughly compiled and discussed,[19] one realizes that the same small selected number of episodes from the life of Telephos was depicted time and again—the encounter of Herakles and Auge, the discovery of the infant Telephos by Herakles, the hero's fight with Achilles on the Kaikos plain, Telephos with Orestes on the altar, and Achilles' healing of the wound. We know no models for the continuous representation of the hero's life story with the numerous pictures that chronologically and geographically connect his deeds and the stages of his life. The frieze is the only extant comprehensive representation of this story.[20] It is possible that the artists of the frieze found models in book illustrations or in picture books.[21] This genre, however, is entirely lost and can be approached only with difficulty in terms of its aftereffects on art. The question as to what extent the representations of the Telephos myth in the frieze used earlier models and where the Telephos masters went their own ways must therefore start with what exists and probably can only approach the truth. Limits are set not only by the gaps in the tradition but also by the fragmentary state of the frieze itself and the uncertainty in interpreting some of the scenes.

The meeting between Herakles and Auge at Tegea in the frieze was possibly restricted to a tranquil encounter, only indicating the love affair, to respect the dignity of the protagonists. This is in contrast to the dramatic version with the drunken Herakles, conveyed to us by the reliefs on Greek case-mirrors and the silver bowl from Rogozen as well as by Pompeian wall paintings.[22] Herakles finds his son in the Parthenion mountains (panel 12, cat. no. 5), but not, as is shown in every single pictorial representation, being suckled by a hind. Here the child huddles against the teats of a lioness. With this modification the leonine strength of Herakles'

son and the founder of the dynasty of Pergamon is antici- pated. As Theun-Matthias Schmidt suggests,[23] the depiction of the lioness instead of a hind also signals a deliberate, po- litically motivated break in the iconographic tradition, thus indicating the breach in the friendly relations between Rome and Pergamon. For the figure of Herakles the artist turned to a famous statue that was often copied and must have been recognizable by everyone familiar with earlier Greek art, per- haps even for a larger circle—the resting Herakles, leaning on his club, by Lysippos.[24] Apart from the leaning motif, the figure's heavy, broad-shouldered body and animated, bulky form recalls this famous statue. The movement of the right arm toward the left shoulder and the motif of the crossed legs that constitute the opposed movement of Herakles' body on the frieze deviate from the original. Above all, his head is raised and turned toward another figure, perhaps a mountain goddess. (For comparison see the dominating figure of Ar- kadia on the Roman wall painting from the basilica of Hercu- laneum.[25]) In this case the movement of Herakles' hand, which is perhaps raised in a gesture of speech,[26] might refer to the mountain goddess.

The battle of the Mysians against the Greeks and the wounding of Telephos by Achilles was the subject of the west pediment of the temple of Athena Alea at Tegea, the home city of Auge.[27] Only fragments of the pedimental sculptures are preserved. One reconstruction places the two heroes, Telephos and Achilles, in the center of the pediment standing upright and facing each other, similar to their representation in the Telephos frieze (see fig. 10).[28] In the pediment, how- ever, Telephos seems to have worn the lion skin of his father, Herakles, instead of a helmet. Achilles lunges at him. Hence, the representation in the frieze follows the model of the pedi- ment only for the heroes' postures, if at all. The helmet worn by Telephos in the frieze is of the old Corinthian type, dating to the late eighth century B.C.[29] The Corinthian helmet was still represented on Hellenistic monuments, but more com- mon in the Hellenistic period are other helmet types, like the

pseudo-Attic helmet with the wavelike neckpiece, which is worn by Telephos's companion on panel 16 (cat. no. 6). The helmet kept ready for Telephos by the maidservant represents another Hellenistic type, the konos helmet, which here, adorned with three crests, figures as a particularly stately ex- ample distinguishing the receiver.[30] In other Hellenistic battle scenes, too, mythical heroes bear contemporary arms.[31] So the Corinthian helmet with its very long tradition can be conceived of as a heroic attribute. Telephos wears it only in this battle, which is so significant for the Mysians and for his own fate.

It can be said with some certainty that panel 42 (cat. no. 11) showing Telephos at the altar does not refer precisely to any of the traditional strands of iconography.[32] As in vase paintings of the fifth century B.C., Telephos is represented sit- ting on the altar, here with his cloak used as a cushion. His legs are spread, so that the overall impression is of the strongly animated pictures of the fourth century B.C. in which Telephos rests one knee on the altar while spreading wide the other leg (fig. 20). The spatial effect of the image is enhanced through this unusual sitting motif. The dramatic movement of the scene in the frieze is further increased, when con- trasted with earlier renditions, by the ruthless manner in which Telephos presses the infant Orestes head downward against himself, threatening him with his clenched fist. Such a threat to Orestes occurs only rarely elsewhere.[33] Agamem- non and a frightened maidservant are included in the scene of the frieze, as in the vase paintings of the fourth century, and perhaps Clytemnestra was present as well: the attribution of fragment 43 proposed earlier, with the remains of a female figure watching the scene from a portico, is justified at least for reasons of subject matter. Because of a hole used for tech- nical reasons, however, Volker Kästner takes it to be the panel concluding the frieze at the southern spur wall court (see Kästner in this volume).

The healing of Telephos was, according to tradition, represented in a painting by Parrhasios, which is perhaps

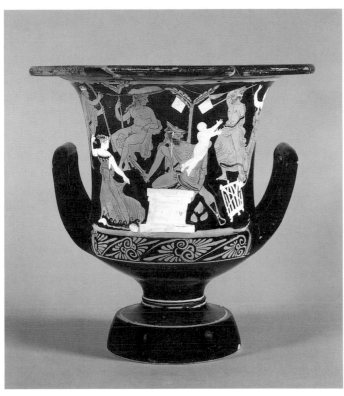

Fig. 20. Telephos takes refuge on the altar with Orestes. The scene takes place in the sanctuary of Apollo. From the right Agamemnon approaches hurriedly. Two terrified women flee. Red-figure krater, ca. 400 B.C. Staatliche Museen zu Berlin, Antikensammlung inv. V.I. 3974. (Photo: Stenzel)

Fig. 21. Achilles heals the wound of Telephos with rust splinters from his spear. Engraving on the reverse of an Etruscan bronze mirror, second half 4th century B.C. Staatliche Museen zu Berlin, Antikensammlung inv. Fr. 35. (Drawing: Peckskamp-Lürssen)

Fig. 22. The wounded Telephos. Telephos sits on a rock. A younger man bends over the bandage on his thigh. Light blue glass intaglio, last third of the 1st century B.C. Staatliche Museen zu Berlin, Antikensammlung inv. FG 678. (Photo: Laurentius)

echoed in an Etruscan mirror (fig. 21). The motif is also known from a glass intaglio in Berlin (fig. 22). Such a scene is not found among the remains of the Telephos frieze, but it must surely have formed part of the cycle.

Only panels 12 and 42 (cat. nos. 5, 11) are preserved well enough to permit a comparison with the iconographic tradition, in the course of which can be observed how the version in the frieze was changed thematically as well as formally. Although no model exists in the iconographic tradition of the Telephos myth for the construction of Auge's skiff, the panel

sequence 5–6 (cat. nos. 2–3) may be added on here. Its particular mood is due to the contrast between the mourners in the upper part and the men busily working in the lower zone of the picture, with the detailed rendering of the carpenter's tools.[34] In mythology Auge has a sister in fate in Danae, who was also locked up in a container—in her case, in a chest. Vase paintings depicting the scene render the work of the craftsmen with fewer figures.[35] In the frieze Auge, is left exposed in a craft consisting of two oval shells. However, on a coin dating from the Roman imperial period from Elaia, the seaport of Pergamon, representing the arrival of Auge at the Mysian court, Auge is welcomed by the astonished fishermen as she alights from a chest-shaped container (fig. 23).[36] May one conclude from this that the version of the frieze had no effect on later representations of the legend in the environs of Pergamon? The coin types from Asia Minor dating from the second century A.D. that represent the discovery of Telephos by Herakles always show the infant being suckled by a hind and not, as in the frieze, by a lioness.[37] As stated above, this can be explained by political reasons. However, it is remarkable that this theme does not seem to appear in later versions of the myth of Telephos.

THE EMPLOYMENT OF TRADITIONAL MOTIFS
FROM OTHER CONTEXTS

In several images figural types and the formal vocabulary from the tradition of Greek art are employed and included in new contexts. In his investigation into the fundamentals and models of the Telephos frieze, Arnold von Salis has pointed out in detail the influence of funerary and votive art of the fifth and fourth centuries B.C.[38] The group of women on panels 5–6 (cat. nos. 2–3) has its predecessors here. The posture of Auge sitting on the rock, huddled up and entirely enveloped by her mantle, resting her cheek on her hand, is a pictorial formula for silent grief in Greek funerary art.[39] These withdrawn, seated figures are as common a motif as the two maidservants with the open casket, whose intimate unity as

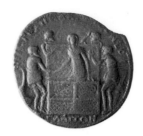

Fig. 23. Arrival of Auge in Mysia. Fishermen have pulled the larnax ashore in a net and marvel at Auge alighting from the open chest. Bronze coin from Elaia, the seaport of Pergamon, reign of Marcus Aurelius (r. A.D. 161–180). Vienna, Kunsthistorisches Museum. (Photo: Laurentius)

they bend toward each other conveys the mood of Greek grave reliefs. Accordingly, familiar formulas were chosen for the representation of those doomed to death. The motif of the woman absorbed in grief and the maidservant with a casket belongs to the figural repertoire of Hellenistic grave reliefs as well. There, however, the difference in height between the mistress heroized by death and the maidservants is more significant and makes the distance between them correspondingly greater. The servant figures have a purely attributive character, as do the other objects represented from the surroundings of the deceased.[40] In contrast, the proportions in the Auge scene reduce the difference to a human scale. Like the clothing of the girls—chiton and mantle—these proportions remain closely related to the Attic grave reliefs of the fourth century B.C.

The motif of offering the hand (in Greek, dexiosis)[41] can in the frieze be deduced in two places from the thematic context and the scant remains. On panel 18 Telephos, equipped with cuirass (breastplate), helmet, spear, and shield, offers his hand to a person standing opposite him. The scene must be viewed in context with the preceding panels 16–17 (figs. 6–7, cat. no. 6), on which Auge, followed by a maidservant, brings helmet and spear to her still-unrecognized son. This scene stands, not formally but thematically, in the tradition of departure scenes on vases from the archaic and classical peri-

ods, on which the departing warrior faces a woman bringing him weapons or holding his helmet.[42] Because in this case the mother equips her departing son, the parallel with Thetis suggests itself, who, attended by the Nereids, in the *Iliad* hands the new arms forged by Hephaistos to her son, Achilles.[43] Yet in contrast to the departure scenes of restrained mood from the classical period, the figure of Telephos is filled with vehement motion. He stands with legs spread wide, his head turned out of the picture after his companions, who are also apparently filled with excitement. At least one bends forward and raises his hand in a gesture of speech. We do not know whether the excitement is due to the sight of the woman dressed in long, trailing garments approaching from the other side. The following scene (panel 18, fig. 7) must then depict the actual departure or a promise that might already refer to the marriage with Auge. In both cases the offering of the hand is the external sign, as in the pictures of a warrior's departure or on Attic document reliefs of the fifth century B.C., on which the partners to a contract shake hands. However, the offering of the hand on panels 36–37 (fig. 13) clearly signals the welcome of Telephos at Argos. The figure of the guest who, wrapped in a heavy cloak, supports himself leaning on a gnarled staff under his left arm again has its models in Attic art of the fifth and fourth centuries B.C. in the representation of elderly "mantled men" supported by staffs.[44] It is Telephos, as it were, who has come to Argos, suffering gravely. The welcoming of the guest has, "as in Homer, an official character referring to the nature of the xenia (hospitality)."[45] The voyage and the scene change connected with it would be sufficiently represented by the landing and unloading of the ship. The ceremonial welcome evokes, however, additional ancient rites of hospitality.

Both parties are attended by a retinue, as befits a hero in the Homeric epic, which grants his person authority and high rank.[46] Even the young Telephos on panel 16 (cat. no. 6), when he receives the arms from Auge, is attended by companions, while Auge as a noblewoman has a maidservant

with her; the men on the left margin of panel 16 are also members of a retinue belonging to the preceding scene. An archaizing intention invoking epic models is also evident in the banquet of the princes (panels 38–40, fig. 14). The princes sit, rather than recline, in a semicircle. For the grouping as well as the clothing of the seated figures there are also models in classical relief sculpture.[47] Each figure wears only a cloak, which is wrapped round the hips and laid across the shoulder, while the upper part of the body remains naked. The spearbearer closing the semicircle in the background is, in contrast to the others, represented wearing a chiton and chlamys. Both sides of the scene are flanked by pillars. The completely preserved one carries a capital whose meaning has not yet been determined with certainty.[48] Servants stand in front of the pillars—on the left a cupbearer, on the right a boy with a tray full of what may be fruit and cake. Their appearance resembles that of the paides, or the servants on the reliefs of funerary banquets;[49] and their scale as compared to the princes corresponds with those of the maidservants on panels 5–6 (cat. nos. 2–3). In comparison with these youths the higher rank of the companions of Telephos on panel 16 (cat. no. 6) is obvious.

So, a meal is represented, the peace of which will soon be disturbed by Telephos, for he is already pulling back the cloak on his thigh to reveal his wound. The princes, again, are not reclining for the meal, as has been the custom since the archaic period and as is also represented on hundreds of Hellenistic reliefs with funerary banquets, but instead sit on chairs like Homeric heroes.[50] The leg type of the chair on which Telephos sits imitates models of the fifth and fourth centuries B.C.[51] Queen Neaira sits on a throne without back and armrests of a similar "archaic" type at the welcoming of Herakles at Tegea (panels 2–3, fig. 1; cat. no. 1).

As far as the remains allow a judgment, the scenes of the battle in the Kaikos plain essentially follow traditional pictorial motifs, but they are clearly distinct in the way those motifs are depicted. Thus, in panel sequence 27–29 (fig. 9),

with the recovery of dead or wounded warriors we find a loose arrangement of the combatants broadly drawn out against the relief ground as on battle friezes of the fifth and fourth centuries B.C.[52] The figure of Hiera attacked by two enemies turns in the saddle, wielding the battleax above her head against the person attacking from behind. The second assailant, seizing the reins of the rearing horse (panels 22–24), stands in a long tradition of groups of fighting Amazons.[53] Yet on panels 25 and 27–28 (fig. 9; cat. no. 8) one also observes a tendency to heap up the dead and wounded on the ground, a rendering from Hellenistic imagery, which we find in the Gigantomachy frieze of the altar.[54] On panel 25 from the Telephos frieze (cat. no. 8) all the figures are closely crowded. Philostratos (*Heroikos* 2.15), who apparently used the same source as the frieze, reports in his description of the battle that Aias frightened the team of horses of the two Scythian fighters. Leaping from their chariot, the warriors were killed by Aias. The sons of Ister falling backward across a horse lying on the ground and the victors thrusting in from both sides, seizing the fallen arms, form a concentrated mass of people in a small space. It seems that the appearance of classical battle friezes was achieved or attempted only from time to time. The motif of the recovery group, like the Amazon group, has a long tradition.[55] There presentation of a slain figure also recalls the models of the later classical period in the way the contour is emphasized. From the thematic point of view episodes like the recovery (or the robbing) of the corpse and the stealing of the weapons of slain enemies are ancient battle motifs.[56]

With the representation of the prothesis on panel 51 (cat. no. 12), whoever the dead may be, a pictorial tradition has been resumed that was an important subject of painting from the Geometric period to the end of the fifth century B.C.[57] In the Hellenistic period the laying out of the dead is still an element of the funeral rites but no longer belongs to the prevalent themes of funeral art. On individual Hellenistic grave reliefs the laid-out body is only visible on a very small scale, in the lower fields.[58] Accordingly, the representation of the prothesis in the Telephos frieze refers to earlier pictorial subjects no longer common in art.

The shape of the kline resembles contemporaneous furniture, which continues a tradition already several hundred years old.[59] From the extant remains a curved head support is still discernible on which the cushion lies, as is a leg of the kline, richly arrayed with well-turned cylindrical and sharp-edged disk-shaped elements. The lower end of the kline of the nuptial bed on panel 20 (cat. no. 7) is preserved. The type of rectangular furniture legs with carved-out incisions had developed in the sixth century B.C. On costly examples the ornaments were inlaid with marquetry. In Macedonian chamber tombs and on East Greek grave reliefs the type can be found in an altered form down to the second century B.C.[60] We may assume that the examples in the frieze are to be seen as particularly luxurious pieces of furniture. The various shapes of the beds can be interpreted as the artists taking delight in a variety of representations. The extant fragments of the ships also show a great variety in the rendering of types with their individual details.[61]

In the scene preceding the nuptial chamber (panel 20, cat. no. 7) Auge stands in front of a naiskos with a small cult image of Athena, which is rendered in the archaic type of the palladium, a form that passed on to us for the cult image in the temple of Athena at Pergamon, too.[62] The cult image stands on a pillar base, which widens at its upper edge toward the abacus of the statue. This type resembles bases common at the beginning of the fifth century B.C. and does not occur later.[63] Not only the image of the goddess but thus also its mounting and therefore the establishment of the cult seems characterized as very old. By contrast, the cylindrical, molded base of the archaic statue of Apollo on panel 1, which is addressed by Telephos (fig. 11), is a type that was common at the time of the Telephos frieze.[64] In order to raise the cult image high enough, the round base is additionally placed on a column with a molding at the upper edge. Even if one is willing to ascribe some of these motifs, such as the choice of differ-

ent types of furniture, merely to a desire for variety, there are still images like the banquet of the princes and the prothesis that are distinct examples of archaizing tendencies in the frieze.

The artists of the Telephos frieze did not restrict their borrowing of motifs to models of classical Attic art of the fifth and fourth centuries B.C. but included the East Greek tradition as well.[65] It is likely that Attic artists working at Pergamon conveyed the tradition of Attic models. The adopted motifs and figural types were incorporated into a new formal and thematic context, which shows the artists of the frieze to be active in the still-living creative tradition of Greek art; the relief style and the plastic rendering of the frieze testify to that.

On a second level, ideas are embraced whose tradition reaches back beyond the classical period to the epics of Homer. The poetry of Euripides, whose drama *Telephos* partially determines the narrative of the frieze,[66] and the epics of Homer were widely read in the Hellenistic period. At Pergamon the famous library and a school of philosophy provided conditions for the knowledge of literary tradition. The chief work of Krates of Mallos, who was the head of the school in the second century B.C., were commentaries on Homer.[67] Among the sculptures found at Pergamon was a relief from about the same time as the Telephos frieze depicting the construction of the Trojan Horse; it demonstrates the interest in the myths concerning Troy.[68] Among examples of the reception of the epic and tragic tradition in the centers of the Hellenistic world are the "Homeric" bowls from Macedonia, whose decoration leads us to assume they refer to the current political situation at the Macedonian court.[69] In the Telephos frieze the traditions are used to surround the life of the forefather with the aura of "ancient times," reaching back to the Trojan War. In the restrained and moody, rather intimate atmosphere of the frieze, these quotations from a bygone heroic world produce, of course, a rather antiquated effect, which was probably perceptible only to the knowledgeable spectator.

DATING THE FRIEZE

The frieze's dates of execution can be only approximated.[70] From the trimming of the panels it can be concluded that the reliefs were executed after the panels were erected in the inner court of the altar (for the following, see Kästner and Schraudolph in this volume). Work on the Telephos frieze was therefore among the last to be done on the altar. For the beginning of the construction of the altar two dates have been proposed—the period after 183 and the years after 165 B.C. The untimely end of this construction affected the Telephos frieze as well. This is demonstrated by numerous panels that remained unfinished (e.g., 5–6, 11, 17, and 20). The cessation of work has been seen as related to the death of Eumenes II in 159 B.C. But it is also possible that the invasion by Prousias of Bithynia, who in 156 B.C. besieged Pergamon, brought an interruption in building. However Attalos II (r. 159–138 B.C.), the brother and successor of Eumenes II, continued a program of extended building, and it seems at least strange that he should have ceased work on so important a building as the Great Altar. The version of the Telephos myth chosen for the frieze, drawn from the rich tradition of the story, excluded the relations of the hero to Troy and therefore to Rome, thus apparently reflecting the diplomatic alienation between Pergamon and Rome in the mid-160s. The introduction of the lioness in the frieze as foster mother to the infant Telephos (panel 12, cat. no. 5) and several other political considerations point to a date of creation after 166/65 B.C. (see Andreae in this volume). Thus the frieze could have been executed between 165 and 159 B.C., or later.

THE RELIEF STYLE

The rendering of reliefs is determined by the relation of the figures to each other and to the relief ground as well as to the elements of the setting, such as trees, rocks, pillars, and curtains. The role of the frieze in the development of Greek relief has frequently been discussed, since some images, especially panels 10, 25, 38–40, and 42 (fig. 14; cat. nos. 4,

8, 10, and 11), exhibit spatial recession and scenic atmosphere. These devices extended the existing possibilities of rendering space in Greek relief and might have influenced further development in an essential way.[71] Hence it has repeatedly been asked until very recently whether the sequence of images in the frieze as well as the rendering of individual scenes can be explained by the influence of lost Hellenistic paintings.[72] Spatial recession is represented to a varying degree in the images of the frieze,[73] but is not, however, affected by the elements of landscape and architecture and the space defined by them. Trees, pillars, and columns separate the scenes one from the other. Sometimes, as on the left margin of panel 51 (cat. no. 12) and between panels 15–16 and 17–18 (figs. 6–7), they are hard to see in their present state. One may assume, however, that being topped by a crown molding—as for example on the pillar on panel 40 (fig. 14)—they originally had a greater visual weight. These elements not only separate the scenes from each other, but they also more closely locate the place of action. In this respect the differentiation of several species of trees—oak, plane, and laurel—is relevant, too. Like the landscape elements on classical Greek reliefs they have an attributive character; like them they do not create spatial recession. However, compared to earlier representations, trees, curtains, and rocks in the Telephos frieze have more sculptural qualities. The trees have thick, leafy crowns with rich foliage in which birds are fluttering, and they spread their branches above the figures, like the oak tree under which Herakles stands (panel 3, cat. no. 1), or the plane tree in the shadow of which the infant Telephos was perhaps exposed (panel 4). The curtains inside the rooms are of heavy cloth, as the thick, hanging folds indicate, and they would probably have received a rich pattern with colorful paint that was never applied, for Pergamon was renowned throughout the ancient world for the manufacture of precious textiles, especially curtains and carpets.[74] Rock formations are indicated by recesses and outcroppings. They form a cave for the lioness and the infant Telephos (panel 12, cat. no. 5) and

projecting seats for the satyrs (panels 44–46, fig. 16). Thus an atmosphere is created that goes beyond information provided by foreshortened landscape elements in classical and early Hellenistic relief art, to be paralleled only in the rocky scenery of the later classical nymph reliefs with their rocky grottoes.[75]

Despite the conception of the Telephos frieze as a sequence of self-contained images, the appearance of a continuous frieze is preserved. The figures in the foreground share the same ground line that spans the break between the scenes and are in many places lined up closely side by side (panels 16–18, 36–40, figs. 6–7, 13–14). Only the elements separating the scenes reach to the upper border of the field. In some scenes the figures form a dense unit; in others the composition extends toward the upper border of the scene by the action of the figures or by the introduction of a second, higher level of representation, so that the frieze must have offered a varied aspect.

Apparently, personifications of the mountains are represented in the second, higher level (panels 8, 44, figs. 3, 16), in contrast to the personifications of rivers reclining on the ground (panels 27–29, 49–50, figs. 9, 17). In both cases, as uninvolved spectators of the events, "with their abiding presence [they] testify to mythical reality."[76] A self-contained compositional combination of the two levels is, so far as we can see, attempted only in panels 5–6 (cat. nos. 2–3) with the construction of the skiff for Auge. This scene has always been the subject of discussion about the possibility of rendering perspective in Greek relief. It is divided into two zones by a feature of the terrain, a rock wall that slopes toward the middle. In the lower zone the craftsmen turning toward the boat from both sides are arranged in two successive planes. This staggered effect has forerunners in classical reliefs, for example in the representation of the hunt of Meleager on a classical clay relief from Melos (fig. 24).[77] The two figures in the background are at the same time moved closer together. They are rendered in low relief, so that in this zone the space of the

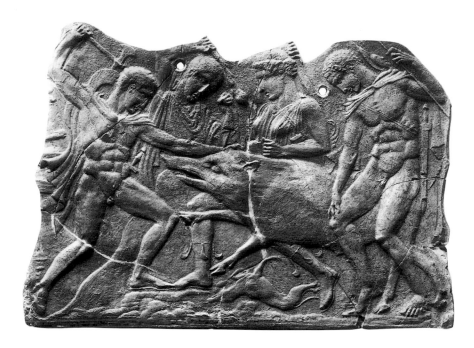

Fig. 24. The Kalydonian Boar hunt. The arrangement of the
figures in two planes on panels 5–6 of the Telephos frieze depends
on classical pictorial compositions such as the Meleagros terra-
cotta relief, from Melos, ca. 440 B.C. Staatliche Museen zu Berlin,
Antikensammlung inv. TC 5783.

relief is deepened. The movement of the background figures arranged parallel to the relief plane terminates the pictorial space at the back. This is so in the upper zone of the picture as well. Auge sits in profile at the upper border of the line indicating the terrain, but the girls—only slightly turned toward each other—stand nearly frontally behind the rock wall so that their feet are hidden. Auge's foot touches the drill of one of the carpenters. Accordingly, the figures are pushed close together. Nevertheless, the impression of receding space exceeds the actual staggering of spatial planes. The women are rendered smaller than the craftsmen and the guard in the foreground, and therefore seem to be farther away. The structure of the entire group, which moves gradually closer together toward the top, also contributes to this

effect. Here an attempt at rendering perspective is made,[78] which can also be observed in the Prometheus group (cat. no. 21), which was created much later: the figure of Prometheus chained to the rock, who consequently has to be imagined in a raised position and rather distant, is distinctly smaller than the reclining Caucasus and Herakles, who establish the scene in the foreground.

A self-contained group of figures with spatial recession is also rendered in the banquet of the princes (panels 38–40, fig. 14). Proceeding from the servants in profile or in frontal view flanking the group, the scene seems to develop into a gradually receding semicircle. The figures sitting sideways are set at a slight diagonal against the ground of the relief and are rendered nearly in the round. The depth of the relief is

more shallow in the area of the figures sitting toward the center. The almost frontal posture of these figures carries over to the spearbearer in the background, who is also depicted nearly frontally. Thus a nearly semicircular figural space is created that opens toward the spectator, while in the back the space is created by overlapping the figures, with a single figure being taller than the others. A similar principle can be observed on panels 5–6 (cat. nos. 2–3). Here, too, older pictorial types are used, in this case votive reliefs of the fourth century B.C., referred to by the two princes sitting next to each other at the left margin and for the figure of Telephos.[79] Votive reliefs provided the models for spatial recession through their gradual staggering of figures into the background. A few nymph reliefs of the fourth century employ a figure standing frontally to indicate the closure of the pictorial space in the background.[80] The consistently closed circle of figures, however, can be found only on the Telephos frieze.

On panel 10 (cat. no. 4) the arrangement of the figures creates a different spatial effect. The group of the king and his attendants hurrying to the left is modeled after the rows of hurrying figures on the friezes of Lykian tombs of the fifth century B.C. (fig. 25).[81] Just as on these friezes, parallel movement and repeated drapery folds dominate the image and the figures seem to be inserted into a structure of lines. As the depth of the relief increases from the figure of the king toward the attendant in the relief ground of the scene, the fan-shaped arrangement of the bodies creates a movement of the whole group to the left front and thereby extends the space. The head of the attendant gazing diagonally out of the picture toward the right behind the king extends the pictorial space toward the rear as well. The placement of the figures together with the high, open zone above the group, which does not have an exactly defined boundary because of the groove at the crown molding, creates the impression of atmospheric spaciousness.

A similar spatial effect is created by the bodies of the

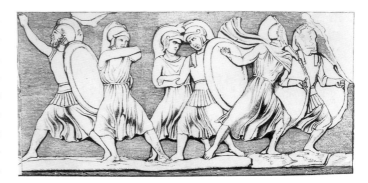

Fig. 25. Battle scene from the small frieze of the Nereid Monument at Xanthos. The overlapping of the figures and the parallel arrangement of movement and garments are adapted on panel 10 of the Telephos frieze. Marble, ca. 420 B.C. London, British Museum.

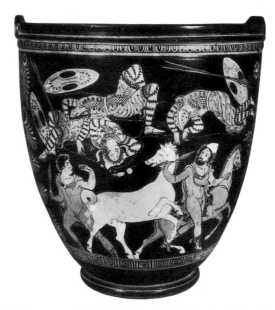

Fig. 26. Odysseus steals the steeds of the Thracian king Rhesos. Motifs like that of the sleeping or killed Thracians lying on top of each other in the upper part of the image are adopted in panel 25 of the Telephos frieze and rendered with an enhanced spatial effect. Red-figure situla of the Lykourgos Painter, ca. 350 B.C. Naples, Museo Nazionale inv. 81863. (After Schmidt, *Dariusmaler und seine Umkreis*)

Scythians falling diagonally to the picture plane on panel 25 (cat. no. 8). The one falling backward with outspread arms across his horse seems to tip out of the relief toward the spectator. The lower part of his body and his right thigh develop from shallow relief to increasing three dimensionality, so that here, too, perspective is implied. The second warrior, whose upper body is raised to the left, enhances this impression by his diagonal turn and his upflung arms. But apparently only with the instances of fallen figures is spatial recession effected, and this was rendered only occasionally. The despoilers thrusting in from both sides were presumably moving parallel to the background. The spatial recession is particularly impressive in comparison with a similarly arranged group on a late classical vase painting, on which the bodies of the sleeping or slain Thracians are placed parallel to the background (fig. 26).[82]

The pictorial space in panel 42 (cat. no. 11) is likewise extended by the movement of the figures in a V shape toward the front. The altar at which Telephos takes refuge is set diagonally to the picture plane. The hero's body also turns diagonally to the left front, while his outstretched left leg and the infant's upturned body create an opposite thrust toward the right back. The figure of Agamemnon approaching hurriedly from the left was apparently placed slightly toward the right front, out of the background. This is indicated by the left knee detached from the relief ground. Thus it is clear that the scene was determined by several divergent axes.

It is easy to think that scenes whose space is created in such specific ways were inspired by painting. However, the space rendered in the frieze reliefs is, in contrast to that in painting, determined by the corporeality and the movement of the figures, which, like sculpture in the round in the middle of the second century B.C., develops spatiality by the construction of opposed movement.[83] In contrast to the early Hellenistic reliefs in which the relief ground represents a solid wall in front of which the figures act, here it is an indefi-

nite area that becomes a pictorial space only through the arrangement and movement of the figures.[84] Thus, the relief ground can be almost hidden by the figures, as on panel 11 (fig. 2), where the women in a procession-like manner approach the cult image under the plane tree. On the other hand, on panels 36–38 (fig. 13; cat. no. 10), the densely crowded attendants of the princes are rendered in two levels of relief with a man in the background at the right edge who seems to turn freely in the relief ground so that he is seen from the back. Yet the background can also be a rock wall, in front of which, for instance, the mighty figure of Herakles can emerge. The indefinite character of the picture plane is also evident in that architectural elements—pillars and columns with their crownings—end below the groove of the panel's upper edge, without a clear connection to the edge of the relief and, consequently, to what supports the representation. Neoclassic elements, which are seen everywhere on the Telephos frieze, appear in retrospect to be prototypes from the fifth and fourth centuries B.C. Some of the scenes were assembled nearly completely from traditional types, such as the princes' banquet (panels 38–40, fig. 14; cat. no. 10) and the Auge group (panels 5–6, cat. nos. 2–3). The princes' banquet should resemble Attic reliefs of the fourth century B.C., even through the relief style. But in composing the scenes of the frieze the older schemes of composition were handled as freely and creatively as were the older motifs.[85]

GARMENTS, FIGURES, AND HEADS IN THE FRIEZE

The detailed manner in which the figures in the frieze are rendered contributes much to its charm. There are parts that form graceful motifs, like the hand of the woman grasping a corner of her garment on panels 45–46 (see fig. 16). Delicacy and elegance of line characterize the garments in many scenes.

The well-balanced relation between body and movement on the one hand and the garment's drapery on the other

in classical art has in the early Hellenistic period already given way to a tension between the moving figure and the garment. In the case of several figures in the Telephos frieze, thick layers of cloth now conceal the body, or the fabric displays an inherent decorative movement by playfully covering bodies and limbs.[86] Thus on panel 10 (cat. no. 4) the bodies of Teuthras and his attendant to the left are outlined under the chiton in gently animated curves. The hem of the cloak, however, overlaps the upper parts of the bodies in sharp, diagonally pointed folds, directed toward the bend of Teuthras's left arm; the chitons beneath the legs, which are clearly outlined under the garment, swing back in S-shaped curves. A distinction evolves between bodies and clothes, which makes possible the garment's own ornamental life. Arranged in a similarly decorative manner are the folds of the cloak covering Auge's head and body on panels 5–6 (cat. nos. 2–3). Drapery folds embrace the back and gather near the elbow: below the hem of the cloak, beneath the foot, for no apparent reason, the dramatic sweep of drapery is similar to those accompanying the movement of the men on panel 10 (cat. no. 4). The bodies of the women on panels 11 (fig. 2) and 46 (fig. 16) are concealed by their chitons of ample fabric hanging down in dense folds. The stance of the figures is not discernible under the cloth, and the weight-bearing leg is indicated only by a broad fold. Long folds seem to support the figure at the sides. The body appears as a roundish volume embraced by the cloak, which forms curved folds; the edges of the cloak below the elbows fall in decorative, cascading folds. Where decorative elements come together, the figures thus establish a visual focus. The charm of the gently rounded surface covered with delicate folds is more enhanced by the effect created by the transparent folds of the chiton. The most appealing figure of the frieze, the small maidservant who follows the stately woman on panel 46 (fig. 16) with a pyxis in her hand, is entirely dominated by the fall of her thin chiton. As it flows down it models the tender form and swings in wide curves of

folds across the weight-bearing leg to the foot which is set back, thus concealing its supporting function.

Figure types such as the Auge on panel 20 (cat. no. 7), which follow late classical models, very clearly show the difference between the classical and Hellenistic conceptions of drapery. From the late classical models come the stance and the draping of the cloak and even the movement of the right hand grasping the hem of the cloak beneath the face.[87] The clear, rectangular structure of the classical figures here becomes a rounded shape through the thickness of the cloth and the diagonal arrangement of the folds of the cloak across the legs. Diagonal folds turning outward on both sides of the legs seem to support the figure and broaden its volume at the bottom. The cloak gathered high on the figure makes the lower part of the body seem very long, as compared to the torso. Not only the arrangement but also the proportions of the figure are altered according to the contemporary style and counter to the classical model: one might say they have been "modernized."

The nude bodies allow us to observe a surface anatomy that neglects the structure of the body in a way similar to that of the clothed figures, which makes a clear delineation of the bodies impossible.[88] The enormous body of Herakles on panel 12 (cat. no. 5) is covered with strongly animated, softly defined flesh and muscles in which the upper right arm is embedded and the rising and falling of which create smooth transitions. The body of the Herakles on panel 3 (cat. no. 1) is rendered differently. The figure backed by the lion skin stands upright, forming an impressive contrast to the image of the leaning hero on panel 12. The structure of the body, with the sharp incisions and the compact pectoral muscles and arch of the ribs protruding from them, seems ossified and is perhaps meant to evoke the impression of classical clarity and regularity. In contrast, the heavy body of Telephos on panel 42 (cat. no. 11) is modeled with soft, compact features, which are subdivided by almost horizontal incisions

and appear gently animated. The possibilities for different characterizations provided by this physical concept is shown on panel sequence 38–40 (fig. 14) with the banquet of the princes, in which the youthful body of the cupbearer, the still-solid frame of Telephos, and the body of the aging prince in the background are differentiated from each other.

Only a few heads on the relief panels have survived undamaged. Some have been found separated from the frieze panels and can no longer be attached. Together they provide an amazing picture of various characterizations of old age and youth, calmness and excitement, Hellenistic modeling and modeling after classical patterns.[89] All of them possess grace and intimacy. Using as an example the head of a youth (cat. no. 13), which shows just the first hint of a beard, Doris Pinkwart speaks of the "childlike" impression of the heads of youths in the frieze.[90]

The broad face of Teuthras on panel 10 (fig. 27; cat. no. 4) is framed by long hair bristling above his forehead and falling onto his temples in wavy strands. Despite the damage, one can still perceive his slightly protuberant forehead and the animated modeling of his cheeks. His eyebrows apparently arched expressively, and his mouth, encircled by a fluffy beard, is slightly opened with excitement. The animation of the features is restrained, however, and the plastic coherence is maintained. In contrast, the face of Agamemnon from panel 42 (fig. 28), with its strongly animated surface, shows the hollow features of an old man. The narrow, dull, aged eyes lie deep below the knitted brows. The even drawing of the eyelids, the delicately curved hairline encircling the forehead, and the decoratively curled locks nonetheless give the head regularity and grace. The modeling of mouth and beard and the curve of the eyelids recall late classical bearded heads. The predilection for graceful features is more obvious in the heads of the youths on panel 16 (fig. 29; cat. no. 6) and the head of Dionysos on panel 31 (fig. 30; cat. no. 9). The slightly protruding lower part of the forehead, similar to that of late

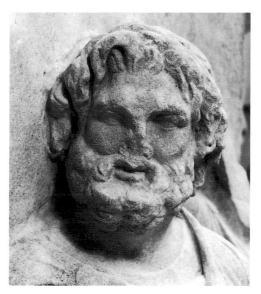

Fig. 27. Head of Teuthras. Detail of panel 10, cat. no. 4. (Photo: Laurentius)

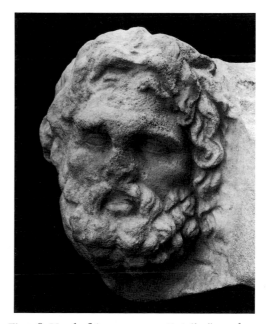

Fig. 28. Head of Agamemnon. Detail of panel 42. (Photo: Laurentius)

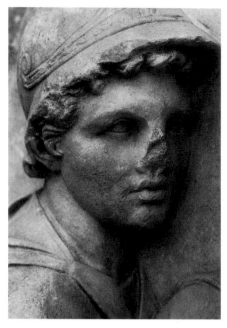 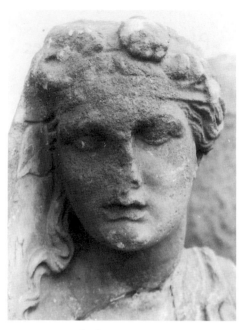 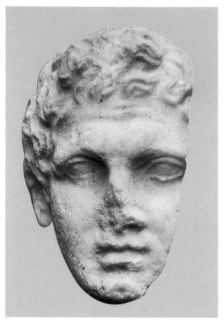

Fig. 29. Head of the companion of Telephos. Detail of panel 16, cat. no. 6. (Photo: Heres)

Fig. 30. Head of Dionysos. Detail of panel 31, cat. no. 9. (Photo: Heres)

Fig. 31. Head of a Greek. Detail of panel 32. (Photo: Laurentius)

classical youthful heads, imparts only a little depth to the regular, oval faces. The cheeks are hardly animated: the mouth is only superficially carved. The faces are classicizing in the sense of the calmness and harmony of features. The separately preserved head of a youth wreathed with laurel (cat. no. 14) shows these traits in a rather rigid manner. In the otherwise quite regularly composed head of a youth (fig. 31), which was associated with panel sequence 32–33, momentary excitement is expressed only by the knitted brows and a soft wrinkling of the forehead.

The Telephos frieze stands on the threshold of the late Hellenistic period. The decline of the ornate, extremely tense, and high Hellenistic features that are enhanced with pathos and the tendency toward calmness and decorative modeling is already prefigured in some parts of the Gigantomachy frieze on the altar's podium and in contemporary sculpture in

the round. In the Telephos frieze the adoption of classical motifs and relief features and their incorporation into a new creation can be found, as well as, occasionally, a predilection for classicizing modeling. The extension of space in the scenes, to be sure, is one of the greatest achievements of the Telephos masters. Both tendencies continue within late Hellenistic art in a formal copying of classical features in several refractions and in an enhanced contrariness and spatial opening of the structure of the moving figure. This leads to the isolation of the figure and makes coherence of action impossible between figures in a relief, as is still the case in the narrative scenes of the Telephos frieze.

TELEPHOS/TELEPINU AND DIONYSOS: A DISTANT LIGHT ON AN ANCIENT MYTH

ANDREW STEWART

Because the Telephos frieze presents by far the most extensive and complete account of the hero's life that survives, it is easy to forget that its particular version of the story had not always been the canonical one. Of course, the designer's concern with establishing Telephos's impeccably Greek credentials—from his birth and upbringing in Arkadia through his voyage to Argos to his foundation of cults of Greek gods at Pergamon—is self-evident and suggests a local agenda at work. Yet while this preoccupation hints at Pergamene unease with their own upstart status—Pergamon had never been a true Greek colony and had no proper mother-city—it was not, in fact, particularly new. Here, the myth's earlier history is most revealing and casts a new light on the frieze's agenda and achievement. This history can be divided, roughly speaking, into two phases: the epic and archaic, down to about 500 B.C.; and the classical, from the early fifth century onward.

FROM TEUTHRANIA TO TEGEA

Though the evidence for the first phase of the legend's development—before the early fifth-century Milesian historian Hekataios and the Attic tragedians took up the theme—can be assembled on the back of an envelope, it turns out to be unexpectedly revealing. For the archaic Greeks evidently believed that Telephos was not conceived and born in Arkadia at all, indeed not even in Greece, but in northwestern Asia Minor—specifically, in Teuthrania/Mysia, the region that was later to become the Pergamene kingdom.

The testimonia[1] are as follows:

8TH CENTURY B.C.

(T1) *Odyssey* 11.516–21. Persuaded by "a woman's gifts,"[2] Eurypylos "the Telephid" leads a host of "Keteioi" to Troy, all of whom are killed by Neoptolemos, son of Achilles. This happened at the end of the war, between Achilles' death and the ruse of the Trojan Horse.

7TH/6TH CENTURY B.C.

(T2) *Kypria* (ap. Proclus p. 32, 47–54 Davies = Arg. 36–42 Bernabé; frr. 20 and 22 Bernabé). The Achaians land in Teuthrania, mistaking it for Troy, and ravage it. Telephos kills Thersandros and [another Achaian] but is wounded by Achilles. The Achaians sail away and are scattered by a storm; Achilles lands on Skyros and marries Lykomedes' daughter Deidameia. An oracle directs Telephos to Argos, where Achilles heals him on condition that he will lead the Achaians to Troy.

(T3) *Little Iliad* (ap. Proclus p. 52, 14–15 Davies and frr. 4 and 7 Davies = Arg. 1, 12–13 and 2, 10 Bernabé; fr. 30 Bernabé). Just before the Achaians build the Wooden Horse, Eurypylos, son of Telephos, arrives to aid the Trojans and kills Machaon, but while fighting valorously he is killed by Neoptolemos.

(T4) Semonides fr. 37 West (= Demosthenes 18.72). "Mysian spoil." Demosthenes is arguing that if the Athenians had not stood firm during the Persian Wars, Greece would have become "Mysian spoil." According to Aristotle and others, this proverb refers to the depredation of Mysia "while Telephos was away."[3]

(T5) Ps.-Hesiod, *Catalogue of Women* fr. 165 Merkelbach-West (= *POxy* 1359 fr. 1). The gods appear to Teuthras. [Apparently after some hesitation] he heeds their wishes, takes in Auge (who is not named in the extant text), and honors her like his own daughters. Herakles drops in on his way to attack Troy and seduces her. She bears Telephos, "the Arkasid," who becomes king of the Mysians, routs the invading Achaians, and drives them onto their ships; but after killing many of them, he is laid low.

CA. 500 B.C.

(T6a) Fragmentary red-figure calyx-krater by Phintias, St. Petersburg (Hermitage inv. 1843: *ARV²* 23/5).[4] Patroklos and Diomedes (names inscribed) defend a fallen warrior (Thersandros?); Dionysos (name inscribed) brandishes a thyrsos above another fallen warrior (Telephos?) with his hand on a rock.

(T6b) Red-figure cup attributed to the Sosias Painter, Berlin (Staatliche Museen inv. F2278: *ARV²* 21/1).[5] Achilles binds the arm of the wounded Patroklos.

With these, compare the following:

CA. 490–480 B.C.

(T7) Hekataios fr. 29 Jacoby (= Pausanias 8.4.9). Auge, daughter of King Aleos of Tegea, is seduced and made pregnant by Herakles when he visits the city. Aleos, discovering that she has borne a child, puts mother and child in a chest and casts it out to sea. They come to Teuthras, lord of the Kaikos plain, who falls in love with Auge and marries her. Pausanias adds that her tomb can still be seen at Pergamon: a stone-ringed tumulus topped by a naked woman in bronze.

So the earliest Greek poets (T1–T4; perhaps also T5) knew of a Mysian chieftain called Telephos ("Farlight") who had once fought the invading Achaians; had been wounded by Achilles; had traveled to Greece to get healed, leaving Mysia in chaos; and had guided the Greeks back to Troy; ten years later, just before the sack of Troy, his son Eurypylos ("Broadgate") had come to help the Trojans but Neoptolemos killed him. This tradition, embracing both Homer and the so-called Cyclic Epics, was essentially a unified one, for as Gregory Nagy has argued, the Trojan legends form a complex whose crystallization into individual epic poems occurred at different times and under different circumstances. In his words: "Paradoxically, the textual fixation of the Homeric poems is older than that of the *Cycle,* in that the overall narrative of the *Cycle* is built around the *Iliad* and the *Odyssey,* and yet the inherited themes of the *Cycle* appear consistently older than those of the Homeric poems."[6]

The Hesiodic *Catalogue* (T5) is generally accepted as an outgrowth of Hesiod's own *Theogony;* and Martin West has argued that its Arkadian genealogies are relatively late formations within the complex of traditions that it treats, perhaps dating to the eighth century B.C. or even the seventh. Yet his further conclusion, that the *Catalogue*'s Telephos narrative "is parasitic on the Troy saga," tends to support the notion that the poem's explicit location of Telephos's conception and birth in Asia is original to the myth—as the principle of *lectio difficilior* would in any case suggest.[7] What of the hero's Heraklid paternity?

The *Catalogue* and Hekataios (T5, T7) show that Telephos was Hellenized in two stages. First, he was given a Greek father, Herakles, and a Greek mother, the exiled Tegean princess Auge ("Sunbeam"); and then his conception and birth were actually relocated from Mysia to Tegea. Concerning the first stage, it is frustrating that the damage to the Hesiodic papyrus (T5) has left the reasons for Auge's departure from Tegea and the gods' epiphany to Teuthras unclear—for she obviously cannot have fled or been expelled from the city because she was pregnant with Telephos, as stated in the classical and later versions of the myth. Yet this enigma should not obscure the main issue, which is that the poet of the *Catalogue* certainly related that Auge's tryst with

Herakles took place in Mysia, and that Telephos was actually born there (T5). But did he invent the tale, or did he inherit it along with much of his other material?

The answer lies in the basic plot of the Telephos myth itself, for it seeks to reconcile two separate traditions: first, that the Achaians, unable to find Troy, were devastatingly defeated by the Mysians and went home in disarray; and second, that they crossed directly to the Troad soon afterward and eventually won the war. Telephos's impeccable Hellenic paternity was essential to dovetailing these two stories, for it was only when Achilles and his other former enemies realized who his true father was that they came to trust him enough to set off into the unknown once more, this time with him as guide (T2). Thus, Herakles' seduction of Auge (T5) must have been an integral part of the vast and intricate Trojan complex inherited by Homer (T1) and the Cyclic poets (T2, T3).

On the other hand, Hekataios's relocation of Telephos's conception and birth to Tegea (T7) was his own invention. Indeed, Paul Friedländer boldly suggested as early as 1907 that Hekataios had modeled it on the adventures of the Spartan king Demaratos. Demaratos (like Telephos, a Heraklid) was exiled from Sparta in 491 and fled to the Persian king, Darius, who gave him Teuthrania/Mysia for his fief. Demaratos returned to Greece with Xerxes and his army in 480, but their defeat put an end to his hopes of reinstatement. Back in Mysia after 479, he founded a dynasty which still ruled the area a century later.[8]

Whether one accepts Friedländer's theory or not, the heterodox nature of Hekataios's tale is betrayed by the fact that by about 450 two competing versions of it were in circulation: Hekataios's own, in which Auge and her son were nailed up in the box together, and another (first known from a fragment of Sophokles' *Aleadai* and an early classical engraved gemstone), in which she alone was cast adrift and Telephos was left to die of exposure in the Arkadian mountains. Miraculously suckled by a horned deer, he crossed to Asia only much later, in early adulthood. This adaptation had the satisfying consequence of turning his life into a double quest (see the author's essay in volume 1): first to find his mother in Mysia and then to get his wound healed at Argos. This was probably why it swiftly became canonical—as on the Telephos frieze (panels 12–21), by which time the story had developed into a fully fledged colonizing narrative.[9]

The *Aleadai* was part of a trilogy on the Telephos legend. The fragments of this trilogy, together with those of plays on the same theme by Aischylos and Euripides, show that by the end of the fifth century B.C. the three tragedians had dramatized most of the episodes later selected for the Telephos frieze, from his conception and birth in Arkadia to his acceptance on this score as the Achaians' guide to Troy, and including his visit to Argos, his seizure of the boy Orestes, and his healing by means of shavings from Achilles' spear (a typical like-banishes-like ritual). And from their contemporary, the lyric poet Pindar, we learn that the battle "on the vine-clad plain of Mysia" (a hint at Dionysos's intervention?) actually took place on the banks of the river Kaikos and that Achilles and Patroklos were the only two Achaians to withstand Telephos's assault.[10]

An essay by the fourth-century B.C. orator Alkidamas, together with contemporary red-figured vases, embossed metalwork (figs. 1–2), and the pitiful remains of Skopas's metopes and pediments for the temple of Alea Athena at Tegea also help to enrich the picture.[11] Yet it is not until the second century B.C., the time of the Telephos frieze itself, that any more hard information appears about the centerpiece of the entire myth: the hero's disastrous duel with Achilles.

Our informants are Lykophron's *Alexandra* and a Delphic inscription purporting to record an oracle to Agamemnon. These relate that the Achaians only prevailed because the Achaian king, forewarned by Apollo of the mistaken landfall and encounter with "a barbarian-speaking Greek," took the god's advice to propitiate Dionysos Sphaleotas ("he who trips") of Mysia in advance. Since Telephos was afforded no

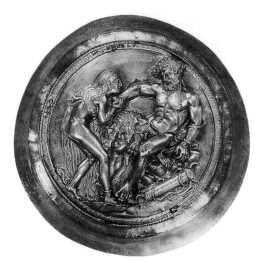

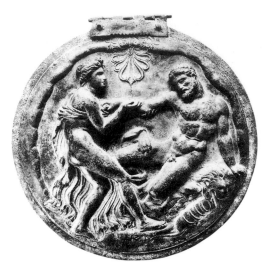

Fig. 1. Silver bowl from Rogozen, Bulgaria, ca. 400–350 B.C. Auge and the drunken Herakles. (Inscribed "You-Know-Who"!) (After A. Fol, *The Rogozen Treasure* [Sofia: Bulgarian Academy of Sciences, 1989], no. 4)

Fig. 2. Bronze mirror case from Elis, ca. 325 B.C. Auge and the drunken Herakles. Athens National Museum Stathatou 312. (Photo: TAP Service)

such warning and failed to do likewise, Dionysos tripped him in a vine root, stopping his onslaught in its tracks and giving Achilles his opportunity to reverse the Achaian rout.

The Telephos frieze preserves a fragmentary but vivid rendering of this scene on panels 30–31, with the bearded Telephos at left, Achilles spearing him in the thigh at center, and Dionysos rushing in at right. Much is lost, but the vine is clearly visible between the two heroes. Given the wretched condition of the early sources on Telephos (the *Catalogue* [T5] and Euripides' prologue to his *Telephos* break off at the crucial point; Phintias's krater [T6a] is similarly damaged; and from the Tegea pediment only heads and limbs survive), this tradition may well be much older. Not only are the three Hellenistic accounts of it independent of each other, but Dionysos's appearance on the sixth-century B.C. Phintias krater (T6a) and Pindar's reference to "the vine-clad plain of Mysia" as the battle site are certainly suggestive.[12]

The Telephos frieze adds many other details, and later writers more still, but the essentials of the myth hardly change from this period on. In particular, these later sources never doubt that Telephos was born in Greece, not Asia Minor, and that it was the revelation of his unquestionable Hellenic descent that persuaded Achilles to heal him and the Achaians to accept his leadership across the Aegean to Troy. The only significant variations are either blatant rationalizations, such as Apollodoros's assertion that Telephos was already in flight when Dionysos intervened, or pure fantasy, such as Dares Phrygios's fifth-century A.D. account.[13] Yet what does the entire story mean? In particular, why was Dionysos included at all, and why (not to mention how) did Telephos escape?

TELEPINU/TELEPHOS

Euripides' tragedy is the earliest extant work to offer an etymology of Telephos's name:

Men call me Telephos in the towns of Mysia, since **far from home** [*tele-*] my life was settled.[14]
(emphasis added)

Yet despite this brave conjecture, it seems clear that Telephos is a Greek version of the Hittite and later the Etruscan nature god Telepinu ("Strongchild"), the notoriously bad-tempered son of the all-powerful Weather God. For not only are the two names phonetically similar, but Telepinu's cult spread from the Hittite heartland to both northwestern and southern Anatolia. Though the northwest is Telephos country proper, Lykian Patara in the deep south also boasted a "fountain of Telephos" and a "Telephian deme," where the stricken, wandering hero washed his wound and Apollo reportedly gave him the fateful oracle, "your assailant will heal you"; suggestively, the cognate "Telebehihe" appears as the name of a ruler on the coins and inscriptions of nearby Tlos. Furthermore, the baby Telephos's suckling and discovery are featured on an array of Roman imperial coins of Asia, from Pontic Sebastopolis through Bithynian Nikaia to Cilician Tarsos.

This strong presence in several widely separated areas of Anatolia is powerful evidence that we are indeed dealing with the mortal avatar of an originally pan-Anatolian figure. Hittite history itself offers a parallel, for the last great king of the Hittite Old Kingdom, who reigned between about 1525 and about 1500 B.C., was actually named Telepinu, as was a son of Shuppiluliumash I (r. ca. 1380–1336 B.C.). Finally, Telephos's own son Tarchon, founder of Etruscan Tarquinia, was evidently yet another Hittite god in disguise, namely, Tarhun(t). Tarhun(t) was a native Anatolian divinity whom the Hittites gradually merged with the Weather God, Telepinu's father, closing the circle of mythical filiation.[15]

According to the Hittite texts, Telepinu's domain included all living and growing things, but vines, grapes, and wine were especially dear to him, and drinking cups and rhyta feature prominently among his sacred possessions. In this respect, then, he was the Hittite Dionysos. Terrible when angered, he was also invoked in battle hymns and cited as a guarantor of treaties. He was a "disappearing god" who left Hatti for a long period in a rage at some injury, plunging the country into chaos, and returned only when a bee was sent to sting him. The goddess Kamrushepa then healed him with spells and salves. Though his Greek counterpart in this particular regard is obviously Demeter,[16] the parallel with Telephos is remarkable, from his Anatolian birth (T5) to the chaos into which the country fell when he left (T4). It even—ironically—to some extent supports Euripides' fictitious etymology.

Provisionally, then, one might follow those nineteenth-century German scholars who saw the original Telephos myth as a Greek account of local Anatolian resistance to their colonizing incursions into coastal Asia Minor, and his Hellenization as an attempt to represent these ventures as divinely sanctioned.[17] By co-opting Telepinu/Telephos to their side, the Greeks justify their aggression and shrug off their defeats. And once they have secured his support and he leads them safely to Troy, the eventual success of the entire venture is all but assured. Yet because this future role as a guide entails that Telephos must escape from Achilles, the links between Telepinu and Dionysos make the latter's intervention *against* him even more puzzling. Why did Dionysos trip Telephos, if they were essentially the same entity?

ACHILLES, TELEPHOS, AND DIONYSOS

It is time to turn to Achilles for help. Walter Burkert has noted that in the *Iliad* Achilles is virtually the double of his mortal enemy and eventual destroyer, Apollo.[18] Since, as Burkert remarks, the worlds of gods and men stand juxtaposed, separated by the ritual of sacrifice yet related as mirror images of each other, it is fitting that in certain special cases (Artemis-Iphigeneia; Apollo-Achilles/Neoptolemos; Apollo-Hyakinthos; Athena-Iodama; Poseidon-Erechtheus) the divinity's mortal alter ego should fall in sacrifice to that divinity. "Myth has separated into two figures what in the sacrificial ritual is present as a tension."

Gregory Nagy has applied this insight to Pindar's account of the deaths of Achilles and Neoptolemos in *Paean* 6. "Since *Paean* 6 was composed specifically for a Delphic

setting and in honor of Apollo, we should be especially mindful of the central role of its hero as the ritual antagonist of the god. For here we see a striking illustration of a fundamental principle in Hellenic religion: antagonism between god and hero in myth corresponds to the ritual requirements of symbiosis between hero and god in cult."[19]

It has not been generally noticed that the combat between Achilles and Telephos furnishes what seems to be a powerful prima facie confirmation of this principle, acting out on the plain of the Kaikos the ancient polarity between Apollo and Dionysos. For just as Apollo was the ritual antagonist of Achilles, filled with spite, or phthonos, against him, could Dionysos have been the ritual antagonist of Telephos, who certainly suffered the god's phthonos on the vine-clad plain of Mysia? Furthermore, at Delphi Dionysos was worshiped as Sphaleotas in a sanctuary strategically located just outside Apollo's temenos to the east, and quite distinct from the chthonic cult of Dionysos, situated in Apollo's temple itself, next to the Pythian oracle.[20] And finally, the antagonism between the two families of heroes did not end when Achilles healed Telephos and the latter guided the Greeks to Troy, for when Telephos's son Eurypylos appeared to aid the Trojans just before the sack of the city, he was killed by none other than Neoptolemos, Achilles' son (T1, T3).

So on the levels of myth and cult, we arrive at the following schemes:

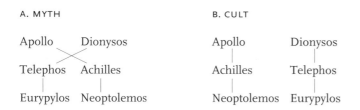

A. MYTH

Apollo — Dionysos
Telephos — Achilles
Eurypylos — Neoptolemos

B. CULT

Apollo — Dionysos
Achilles — Telephos
Neoptolemos — Eurypylos

A single glance at scheme A will suggest that one might look for confirmation of the pattern in myths that record details of a relationship between Apollo and Telephos on the one hand, and Dionysos and Achilles on the other. Fortunately, one does not have to go far to find them. Although some are only attested in "late" sources (which often quote early epic poetry without attribution), as a body they are remarkably coherent. Without sustaining the extreme view that a myth is the sum of all its variants, as orthodox structuralism insists, they offer striking confirmation of the principle that nothing incompatible with that myth's basic meaning and function can be added to it within the context of the culture that created it. Of course, this does not mean that the myth itself is inflexible and unresponsive to history (the classic structuralist dilemma), only that in normal circumstances the tradition itself sets limits to change. Hekataios's deft reworking of the Telephos legend itself (T7) is proof enough.

Apollo seems to have been particularly open to appeals from the Tegean dynasty. First Aleos, Telephos's grandfather, was told by the Pytho that if his daughter Auge bore a son, the boy would grow up to kill Aleos's own sons. Despite this warning, the oracle was later fulfilled by Telephos himself, who did indeed kill them, albeit unwittingly; on learning his true identity and recognizing the enormity of his crime he then went to Delphi to seek purification and to learn where his real mother was. The Pytho promptly told him to "sail to farthest Mysia," where he was reunited with her as described above. Next, after his wound at the Kaikos, he asked Apollo how he could be healed, and received the famous reply, ὁ τρώσας ἰάσεται ("your assailant will heal you"), upon which he went to Argos to seek Achilles. Two fourth-century-B.C. vases that depict him seizing the baby Orestes at the altar show Apollo just above (see Heres, p. 97, fig. 20), and, as it happens, cults of Apollo Lykeios and Apollo Pythios are independently attested at Argos by Sophokles. Finally, it was an oracle from Apollo that revealed to the Achaians that only Telephos could lead them to Troy.[21]

As for Dionysos and Achilles, there is to my knowledge only one piece of evidence, but this is very significant indeed. As Nagy remarks:

From Stesichoros fr. 234P we know of a tradition that Dionysos had given a golden amphora, made by Hephaistos, to the goddess Thetis, in compensation for her having preserved him after he fled from Lykourgos by plunging into the sea (cf. *Iliad* 6.130–40). It is into this same golden amphora that the bones of Achilles were placed, together with those of his surrogate Patroklos, on the occasion of his funeral (*Odyssey* 24.72–76; cf. *Iliad* 23.91–92). From what we know about the symbolic function of bones in general and about regeneration in particular, we may see in this formal token the promise of an ultimate immortality in store for the hero of the *Iliad*.[22]

This amphora may appear, or be alluded to, on the main frieze of the magnificent early-sixth-century-B.C. François Vase, where on the exact center of side A, Dionysos carries a two-handled wine jar to the wedding of Peleus and Thetis (fig. 3).[23] The François Vase is much concerned with the deeds of Hephaistos, Dionysos, and particularly Achilles; it can therefore hardly be coincidental that Achilles appears to pursue Troilos (with Thetis and an angry Apollo looking on; fig. 4) immediately below this scene and superintends the funeral games of Patroklos on the neck frieze immediately above it. Finally, the entire presentation is framed by pictures on the handles of the dead Achilles himself, being carried out of battle by Aias (fig. 4): the left-hand one is directly above the angry Apollo.

To turn to cult (scheme B), here Burkert has sketched the physical and (if one may describe it thus) spiritual identity of Achilles with Apollo, and Nagy has discussed their continuing antagonism. To clinch the relationship, Apollo later kills Achilles' son Neoptolemos, who promptly becomes Hero of Delphi.[24] Yet when we turn to Dionysos and Telephos the parallel is immediately—and somewhat unexpectedly—seen to be inexact.

To begin with, Dionysos's hostility to Telephos was far from continuous. First, the baby hero's exposure on the Parthenion mountains was ended happily by the appearance of the deer, abetted by none other than Dionysos Mystes, whose sanctuary lay nearby. In panel 12 of the Telephos frieze, he lies under a plane tree, which is sacred to Dionysos, while on a Roman neoclassical relief in the Vatican his discovery by Herakles is watched benignly by Dionysos himself. His bucolic upbringing was then entrusted to the Tegean shepherds (boukoloi) of King Korythos, the eponymous monarch of the deme Korytheis within whose boundaries the sanctuary of Dionysos Mystes lay, and was superintended by Pan, the nymphs, and satyrs. All these were companions of Dionysos, whose Mystai in the Pergamene Dionysiac cult were also called boukoloi. This upbringing may be shown on the enigmatic panel 9 of the Telephos frieze.[25]

After this, Dionysos's revenge on Telephos at the Kaikos is a distinct surprise and is not, to my mind, sufficiently explained by the mere fact of Agamemnon's advance propitiation of him—but more of this later. Then comes another about-face, for after Telephos's eventual return to Mysia, he founds the cult of Dionysos Kathegemon ("Leader") at Pergamon. This was destined—as its name suggests—to be the leading cult of the city under the Attalids, Telephos's descendants, who considered themselves to be under this god's special protection. On the Telephos frieze, this foundation is represented on panels 44–46, and Telephos's own death and heroization follow shortly thereafter, on panels 47–48.[26]

Furthermore, whereas Achilles was physically Apollo's double, Telephos bore little or no resemblance to Dionysos, either at Tegea or elsewhere; instead, we are told, he resembled Herakles more closely than all that hero's numerous other sons. And finally, he was not killed by Dionysos or at his behest but survived to die peacefully in bed. At Pergamon, where his bones lay, his cult was apparently not associated with that of Dionysos Kathegemon. Although we do not know the location of his heroon, if it is indeed to be identified with the Great Altar as some have suggested, it may be significant that this monument was situated far away from the Dionysion, but just below and in line with the temple of Telephos's divine protectress, Athena.[27]

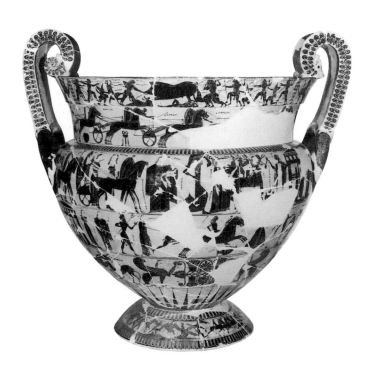 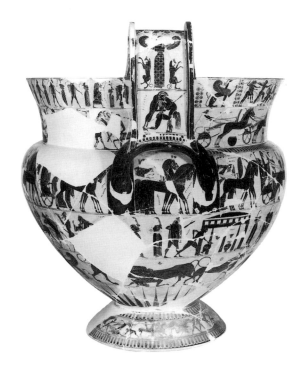

Fig. 3. Attic black-figure volute krater from Chiusi (the François Vase), signed by Kleitias and Ergotimos, ca. 560 B.C. Florence, Museo Archeologico 4209. In the middle of the third frieze from the top, Dionysos attends the wedding of Peleus and Thetis: he faces the spectator and carries his amphora. Above, Peleus and others hunt the Kalydonian Boar, and chariots race at the funeral of Patroklos; below, Achilles (only his legs preserved) chases Troilos. (Photo: Soprintendenza alle Antichità d'Etruria)

Fig. 4. Side view of the François Vase. Note the angry, gesticulating Apollo in the center of the lowest figure frieze (the pursuit of Troilos) and Aias carrying Achilles' body out of battle on the handle above. (Photo: Soprintendenza alle Antichità d'Etruria)

On this evidence, it is clear that Dionysos's antagonism was only temporary, and that the Greek tradition, at least, did not accept Telephos as his true heroic avatar. We should therefore emend our preliminary scheme as follows.

A. MYTH

Apollo Dionysos

Telephos Achilles

Eurypylos Neoptolemos

B. CULT

Apollo Dionysos

Achilles Telephos

Neoptolemos Eurypylos

DIVINE PROVIDENCE?

It is now possible to hazard an explanation for Dionysos's intervention. For it will be apparent that he only moved against Telephos when the hero had defeated the Achaian army and was actually threatening the life of Achilles himself. Yet Achilles had been preordained by Fate to die in glory at Troy and to be venerated in epic as the Best of the Achaians, and in cult as Lord of the Pontos (Pontarches) at his tomb at the entrance to the Hellespont.[28] Dionysos, it will be remembered, intervened to trip Telephos *only when the latter was winning*—that is, about to thwart this destiny. With the exception of Apollodoros's blatantly rationalizing account, mentioned earlier, both texts and images are united on this point; here, for example, is Pindar, writing in praise of Patroklos:

The son [of Menoitios] went with the Atreidai
To the plain of Teuthras, and stood beside Achilles
Alone, when Telephos turned the valiant Danaoi to flight
And made onslaught on their ships by the sea.[29]
(emphasis added)

Clearly both Achilles and his surrogate, Patroklos, are in mortal danger, a situation whose implications are further considered by Pindar at *Isthmian Ode* 8.47–60. Here the theme of Telephos's wounding "on the vine-clad plains of Mysia" is said to "bridge the return of the Atreidai" to Greece and is linked in the same sentence with Achilles' rescue of Helen [*sic*] and the fall of Troy. After this overture, the poet then immediately turns to the subject of Achilles' death and the unfailing glory he will have through the medium of song, delivered at his Hellespontine tomb by none other than Apollo's handmaids, the Muses.[30]

So Dionysos intervened on the Kaikos when and only when Telephos looked likely to force the hand of Fate[31] by wiping out Achilles and Patroklos and so denying them their deeds of glory (aristeia) at Troy and the Atreidai their return from the war. Had this occurred, Apollo would have been deprived of his twin sacrifices—Achilles and Neoptolemos (to say nothing of Patroklos)—and the two Achaian heroes of their own twin rewards of the undying honor (timē) of cult and the unfailing glory (kleos) of epic.[32] *Iliad* 20 offers a close parallel: this time it is Achilles who is thwarted by Poseidon, who envelops him in mist to prevent him from killing the helpless Aeneas. Homer states the reason explicitly: it would be "beyond destiny" (*hyper Moiran:* 20.336)—or, as the modern critic would say, untraditional[33]—for Achilles to kill Aeneas. For just as on the Mysian plain it would have been "beyond destiny" for Achilles himself to die before his time, his deeds of glory unperformed, Aeneas too has aristeia to accomplish that will eventually bring him both timē and kleos as well.

The gods, it will be noted, resolved the crisis in a neat, even ironical way. In the course of Agamemnon's obligatory visit to Delphi to ask about the future of the planned expedition to Troy, Apollo (Telephos's protector and Achilles' *enemy*, remember) took the occasion to slip him a warning—as he would not, presumably, have warned Achilles himself—that if he landed in Mysia he would be met by a barbarian-speaking Greek whom he could not defeat unless he sacrificed to Dionysos Sphaleotas of Mysia. The unsuspecting Telephos, given no such warning, of course failed to make the necessary countersacrifice and so predictably aroused the god's spite (phthonos), with devastating results.

So the entire incident was a blatant setup by Apollo, who used Dionysos as his tool to accomplish his own goals and those of Fate, but by so doing also allowed Dionysos in his turn to keep the promise inherent in his own gift of the golden amphora to Achilles. Tradition was upheld; both heroes were preserved for further aristeia; and (as explained in the author's essay in volume I) their characters and achievements duly expanded to fill the space that the gods had allotted them. Eventually, Telephos would establish the cult of Dionysos Kathegemon as the leading cult of Mysia and the proper successor to that of Telepinu and become Hero of Mysia himself, while Achilles would fall in sacrifice to Apollo and become Hero of the Hellespont. This area was already recognized to be Apollo's territory, with his two main cults at Smintheion and Thymbra.[34]

MYTH, HISTORY, AND FATE

If one accepts that the myth coheres in this way, then its original plot (T1–T4) should have gelled either during or shortly after the period of Mycenaean penetration of northwestern Asia Minor, from the fourteenth through the twelfth centuries B.C., or when the Greeks began to become interested in that area again, in the ninth and eighth centuries. For, as mentioned earlier, this most ancient version of the myth seeks to reconcile two traditions about the Achaean expedition to Troy: one that told of their failure to find the city and to defeat those whom they did encounter, and another that proclaimed their signal success in both departments.

Here archaeology, history, and literature may come to our aid. Mycenaean pottery is rare in the area, even at sites that have been quite thoroughly excavated, and according to the latest surveys "does not imply more than sporadic contact." Yet the Greeks' early-first-millennium colonization of Mysia was highly successful—and had nothing to do with either Tegea or the Arkadians. Furthermore, as we have seen, Telephos's Arkadian origin and, with it, the evolution of his legend into a colonizing myth are relatively late develop-

ments, not predating the fifth century B.C. In reality, it was not the Arkadians but the Aeolians from Thessaly who established the colony of Pitane near the mouth of the Kaikos in the tenth or ninth century (verified by the discovery of Protogeometric pottery in its tombs). At Pergamon itself, the earliest Greek pottery is late Geometric and Protocorinthian, beginning only in the eighth century.[35]

So the Greeks' legends of an invasion of Mysia and of their star-crossed encounter with Telepinu/Telephos are more likely to be Mycenaean in origin than a reminiscence of a (failed) early Iron Age colonizing expedition. This leaves us with two possibilities, which are not mutually exclusive. Either the original Telephos myth was generated by one single, traumatic historical event, such as the supposed defeat of the Ahhiyawa (Achaians?) by the Hittite king Tudhaliyas IV (Teuthras?) at the Seha river around 1250 B.C. (a perennial favorite among Hittite scholars), or it developed from a continuing standoff in the area. In both cases the intent would have been to prove inter alia that once the Mysian crown had passed from Teuthras to Telephos, now miraculously recognized as Herakles' son (T5), the area was really Greek-ruled anyway.[36]

Yet regardless of how one reconstructs the exact historical circumstances that produced Telephos and his story, three main facts emerge. First, there is the myth's extraordinary self-awareness, represented by Apollo's recognition of the central tradition of the Trojan War and the need to preserve it at all costs. Greek culture instinctively represented itself in mythical terms and was able not merely to project its values in myth but actually to reflect upon them in this way. Second, there is the myth's extraordinary flexibility. When new personalities and experiences were introduced as it developed into a (totally fictitious) colonizing narrative, it readjusted itself to accommodate them as far as possible while preserving its own coherence and historical validity. And third, there is the myth's root conviction that true heroes are born, not made, and must be Greek through and through.

At its most fundamental level, then, the story of Tele-

phos affirms a deep-seated belief in a cosmic order where every individual gets his or her fated portion (Moira) in the end, an order whose center and commanding heights are occupied by the Greeks and their gods.[37] Nurtured in the highly structured society of Mycenaean Greece, and powerfully reinforced by the chaos of the Dark Age that followed the Mycenaean collapse in the twelfth century B.C., these beliefs stand at the very core of Hellenism. In this respect, and for all their gaps and obscurities, the Telephos legend and its most monumental and sophisticated formulation, the Telephos frieze, represent the quintessence of the Greek worldview, not to mention (for better or worse) the Greeks' own legacy to the West.

Fig. 1. Portrait bust from Herculaneum. Bronze, H. 56 cm. Naples, Museo Nazionale inv. 5588. Reconstructed upper body. (Photo: Deutsches Archäologisches Institut, Rome)

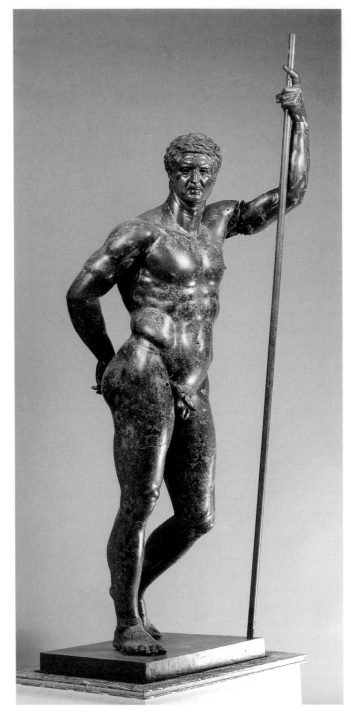

Fig. 2. The "Hellenistic Ruler." Bronze, H. 2.37 m. Rome, Museo Nazionale inv. 1049. (Photo: Deutsches Archäologisches Institut, Rome)

DATING AND SIGNIFICANCE OF THE TELEPHOS FRIEZE IN RELATION TO THE OTHER DEDICATIONS OF THE ATTALIDS OF PERGAMON

BERNARD ANDREAE

The Telephos frieze represents the core of the cultural activities of the Attalids of Pergamon. Eumenes II (r. 197–159 B.C.) and Attalos II (r. 159–138 B.C.), his brother, coregent, and successor—the sons of Attalos I (r. 241–197 B.C.) and Apollonis of Kyzikos—memorialized their enterprises by commissioning works of art that would convey a political message.

Although these two Attalids led the state of Pergamon to its zenith, their portraits have only recently been identified. The portrait of Eumenes appears on a coin that has survived in only two examples—one in the British Museum in London, and the other in the Cabinet des Médailles in the Bibliothèque Nationale in Paris (see Schultz, p. 16, fig. 14). These coins, in turn, contributed to the recognition of a bronze bust from Herculaneum, now in the Museo Nazionale in Naples, as a portrait of Eumenes II (fig. 1). This identification confirmed the title Attalos II, which had been proposed earlier for the famous Hellenistic Ruler in the Museo Nazionale in Rome (fig. 2). These two portraits were most likely commissioned on the occasion of Eumenes II's accession in 197 B.C. Considering the ages of the brothers, who at that time were respectively twenty-five and twenty-four years old, the date of the portraits, possibly the work of Nikeratos, son of Euktemon of Athens, cannot be far from the year 197 B.C. The pictures clearly show the family resemblance of the two Attalids and also the difference in personality: the elder is sophisticated and wise; the younger, strong and vital. The greatest monument of the combined accomplishments of these two men is the Great Altar of Pergamon.

The message and importance of the Great Altar, which includes the Telephos frieze, can only be understood in light of a number of key events that determined the cultural-political actions of both rulers. This means that it is necessary to pay attention not only to the important historical events but also to a few circumstances that influenced the thinking of the kings when they commissioned artworks. In this connection, it is important to recognize that the rulers' parents played a role and to understand that what the kings experienced personally determined the message they wanted to convey through the works of art they sponsored. The Pergamon Altar is not to be viewed in isolation; it is the culmination of a series of large dedicatory monuments that interrelate and that all focus on the altar.

The importance of genealogy, the tracing back of one's family to great ancestors, is impressively illustrated on the Telephos frieze by the myth of the founding of Pergamon. Since Telephos, the first mythical king of Pergamon, was a son of Herakles and thus a descendant of the highest god, Zeus, the royal house of Pergamon was descended from this god. The altar may have been dedicated to him and his daughter Athena, the bringer of victory. Strangely, Eumenes does not name a victory as the reason for the dedication but rather ta agatha, the favors the gods granted him.

Identifying the specific favors of ta agatha relates to the fundamental problem of dating the Great Altar. Much controversy has arisen lately concerning a date for the altar that can be based on incontrovertible historical evidence. Until recently, the two decades from 180 to 160 B.C. were unanimously accepted as the period during which the monument

with its rich sculptural adornment was constructed, following the victory over the Gallic tribe of the Tolistoagii and their leader, Ortiagon, in 184 B.C. If this is the relevant date, the favors the gods granted King Eumenes II cannot precisely be named, and the only information we have is that they granted him victory. Then why does the dedicatory inscription not mention a victory but only briefly and precisely give thanks for particular favors (ta agatha) (cat. no. 35)? This is hard to understand if the Pergamon Altar were built shortly after 184 B.C., as has been assumed until now. It can be comprehended if the altar were commissioned two decades later, after the final victory over the Gauls in the year 166 B.C. The war started because the Romans incited the Gauls—who were once the archenemies of the Pergamenes, but who had been appeased since 184 B.C.—against the people of Pergamon. Not only did the gods grant Eumenes II the victory, but they also bestowed favors on him that saved his life. These he might well have seen as ta agatha and taken as a reason to dedicate the altar. The dedicatory inscription, although brief, shows another peculiarity that one would like to have explained: King Eumenes succinctly calls himself son of Apollonis. He thereby honors his mother, the daughter of a citizen of Kyzikos, in a very unusual way and shows at the same time that the altar is a personal dedication by the son of a great mother.

Apollonis was famous for her sense of family and for the successful education and upbringing of her four sons, the two eldest receiving the royal crown without the usual accession disputes so common among all other Hellenistic ruling families. Eumenes and his brother Attalos dedicated a temple to their mother, Apollonis, in Kyzikos, where she was born. She was thus raised to godly honors.

This temple had nineteen columns adorned with pictorial reliefs, so-called stylopinakia, which have been described in the same number of Greek epigrams. These reliefs depict famous mythical examples of sons who demonstrated a spe-

cial love for their mothers. The last of these nineteen stylopinakia is of special interest for the political message of the Telephos frieze. In the words of the introduction to the epigram, it shows "Remus and Romulus depicted freeing their mother, Servilia, from the cruelty of Amulius. Ares had seduced her and she had given birth to two children. They were abandoned and nursed by a she-wolf. When they reached adulthood, they freed their mother from bondage, founded Rome, and reinstated Numitor to the throne" (*Greek Anthology* 3.1.19).

This last relief, the only one illustrating a Roman myth and indeed the one of the founding of Rome, must have been commissioned at a time when Pergamon was on friendly terms with Rome—that is, before the third Macedonian war (172–168 B.C.). The traditionally good relationship between Pergamon and Rome, which had existed since the time of Titus Quinctius Flamininus and the battle of Kynoskephalai in 197 B.C., became more and more strained until in 168 the Romans provoked the Gauls who had settled in the interior of Asia Minor to rise against Pergamon. This forced the state, which the Romans had supported and made powerful, into mortal combat. Contrary to all expectations, and after many military upsets, the Pergamenes were at last the victors and able to defeat the Gauls in the battle at Mount Tmolos near Sardis in 166 B.C.

It is important to understand a few things about the Gauls. After migrating from France through Europe, they crossed the Bosporus and in 287 B.C. settled in Asia Minor around Ankara and Pessinous. From there they intimidated the peoples of Asia Minor with their raids. In order to appear even more frightening, the Gauls rubbed plaster mixed with water into their hair and brushed it so that it would stand straight up in heavy locks. This gave them the terrifying appearance seen in the famous large sculptures of Gauls in the Capitoline Museum in Rome and in the Ludovisi collection. These are Roman copies after the monument commemorat-

ing a victory of Attalos I in about 220 B.C. Because plaster in Greek is called "titanos," the Alexandrian poet Kallimachos, who saw Gallic mercenaries in the service of Ptolemy II in Egypt, was the first to compare them in a hymn to Apollo to the Titans (*Hymn* 4.173–87). In Hellenistic times the Titans were often put on the same level as the Giants, although, in mythological terms, they belong to an older generation. On the Great Altar no distinction is made between the battling Titans and Giants. There, a nonspecific battle takes place in which Zeus is joined by the other eleven Olympian gods, Herakles, and other gods fighting monstrous beings of various forms. These figures can be distinguished as Titans or Giants only where the inscriptions giving their names have survived. The play on the Greek word "titanos" brought about the equating of the powerfully built Gauls with the mythic enemies of the gods. This leads to the conclusion that the Pergamon Altar is a memorial to the victory over the Gauls.

The unusual depiction in the Pergamon Altar's Telephos frieze of Herakles' finding the infant Telephos, who had been abandoned in the woods of the Parthenion mountains, plays an important role in the recent controversy over whether the altar is actually a monument celebrating the victory over Gallic troops in 184 B.C. The depiction of this mythic episode differs from the common iconography in a very significant way. Whereas on all other representations of the myth, and especially on the most famous one—the copy of a Pergamene royal painting from the basilica in Herculaneum, now in the Museo Nazionale of Naples—the child is nursed by a hind, it is a lioness who saves the child on the Telephos frieze. This obviously refers to the nineteenth stylopinakion on the temple of Apollonis in Kyzikos, where the founders of Rome are nursed by a she-wolf. If the first mythological king of Rome is nursed by a she-wolf and the first king of Pergamon is nursed by a lioness, then Telephos is stronger than Romulus. The language of the pictures cannot be misunderstood and the message conveyed only makes sense at a time

when Pergamon had to stand against Rome. This was the case after the third Macedonian war when, in the course of the disputes between Rome and Macedonia, King Eumenes changed from a devoted ally to a cautiously watched powerful king, falling out of favor with the Romans. More and more the Romans came to see the eastern Mediterranean peoples as either their dependents or their enemies, whom they expected to make subjects of the Roman people. Later, they even called this process "leading them home." King Eumenes, however, insisted on his sovereignty and, by his victory over the Gauls, proved this against all Roman expectations.

In the course of the disputes that were forced on him by the Romans, Eumenes' life was twice critically endangered, and he was saved only by miracles. The first incident happened in 172 B.C., when he had decided to stop at the sanctuary of Apollo at Delphi on his return home from a futile visit to Italy, where he had not even been permitted to appear before the Roman Senate. At Delphi he wanted either to make sacrifices to Apollo, who was honored by all Greeks, or to consult the oracle about his future political life. On his ascent to Delphi, henchmen of King Perseus of Macedonia were lying in wait for Eumenes and rolled boulders down on him; they left him there for dead. His loyal subjects took him to the island of Aegina and nursed him back to health (Livy 42.15.3). As far as the rest of the world was concerned, however, he was dead. When he returned to Pergamon, his remarkable recovery was commemorated by a silver coin. The obverse shows a portrait of the king, the only coin portrait we have of him; the reverse shows the divine twins Castor and Pollux (the Dioscuri), represented by the inseparable brothers Eumenes and Attalos (see Schultz, p. 16, fig. 14). The picture is framed by the laurel wreath of the healing god Asklepios, who had saved the mortally wounded king.

The second miraculous intervention occurred a few years later in the war with the Gauls, who had been incited by the Romans; Eumenes was so severely wounded in the attack

at Delphi that he was no longer able to ride a horse and had to be carried in a litter to the battleground. From there he directed the operations while his brother Attalos, as general of the cavalry, commanded from the front line. On one occasion during the war, which lasted from 168 to 166 B.C., the Pergamenes were overrun and the litter could not be moved fast enough to safety. Eumenes ordered that he, in his litter, be set on a hill by the roadside where he would await his fate. He saw the Gauls move closer. Suddenly they retreated because they feared a trap and believed that the enemy was hiding nearby, ready to ambush them as soon as they approached the litter (Polyaenus 4.8.1). At this moment, King Eumenes must have been aware of the aid of the gods.

In his youth Eumenes saw the gods depicted on the west pediment of the Parthenon, and perhaps at that moment of intense danger those images appeared before him. For the second time, then, the gods, to whom he dedicated the altar, showed him their favor. The master sculptor of the east frieze of the Pergamon Altar chose the figures of the goddess Athena and the father-god Poseidon from the west pediment of the Parthenon as models for his mighty representation of Zeus and Athena as leaders of the Olympians in the battle with the Giants. This intentional quotation was meant to show that the Pergamenes were also Greeks who revered the same gods as the Athenians, and it was to the Pergamenes that the gods, seen on the east metopes of the Parthenon fighting the Giants, granted aid.

The metopes of the Parthenon show that the Greeks, from mythical times on, withstood attacks by barbarians, just as the Olympian gods of ancient times repelled attacks by the Giants. The kings of Pergamon also dedicated an impressive monument on the Acropolis in Athens (Pausanias 1.25.2) with the booty they plundered from the Gauls, an act that embodied this analogy. More than one hundred bronze statues, each the size of the figures on the Parthenon metopes, were erected on the southern wall of the Acropolis at the foot of the Parthenon, representing the battles the Greeks fought against barbaric powers from ancient times down through the era of the Attalids. In four groups, each comprising about thirty fighters, gods were represented in close combat with the Giants, the Athenians with the Amazons, the Greeks with the Persians, and the Pergamenes with the Gauls. An experiment with wooden silhouettes of copies of the originals that have survived has taught us that the sculptures, although they were only two-thirds life-size, did not appear small but rather full-size when seen from below and from within the Acropolis looking out at the horizon. The impression must have been of a ferocious battle taking place on the Acropolis, of which only the front row of combatants could be seen.

The most famous artist at the royal court of Pergamon, the sculptor and painter Phyromachos of Athens, worked on this monument (Pliny *Naturalis Historia* 34.84) that was to show the entire world how the Pergamenes, against the will of Rome, defeated the Gauls. According to the oldest surviving list of artists from a Hellenistic papyrus of the late second century B.C., Phyromachos is named as the seventh of the outstanding Greek sculptors, after Myron, Polykleitos, Phidias, Skopas, Praxiteles, and Lysippos. There are good reasons to attribute the design of the Great Altar to Phyromachos. If this is true, it is especially interesting that he was not only commissioned to build the largest victory monument in the capital of the Pergamene state but was also assigned to work on the most important monument in Athens, the capital of the Greek world. Phyromachos may be considered a kind of Hellenistic Michelangelo, and one can show that his new baroque style for the Athena-Alkyoneus group on the east frieze of the Pergamon Altar influenced the Laokoön group, which, in turn, influenced Michelangelo and his style.

The Pergamenes did not confine the building of monuments glorifying their victory over the Gauls to Athens and their home city. Claiming that Dionysos had granted them victory over the Gauls at Mount Tmolos, they therefore placed

him fighting in the front line, before the other gods, on the projecting south wing of the Great Altar, which is what one sees first when ascending the huge stairway. They also built a sanctuary for the liberator Dionysos Lyseios on Mount Tmolos near Sardis at the battle site and, as the preserved dedicatory inscription tells us, additionally carried the cult to the city where the god was born, Thebes.

Eumenes and Attalos went with their father, Attalos I, to the battlefield of Kynoskephalai in 197 B.C. as confederates of the Romans under Titus Quinctius Flamininus, who had promised the liberation of the Greeks in case of a victory. While giving a speech proclaiming this liberation, Attalos, the seventy-year-old husband of Apollonis, became so excited that he was felled by a stroke, leaving his sons to succeed him (Livy 33.2).

Eumenes and Attalos, who traced their lineage back to Zeus through Telephos and Herakles, could therefore compare themselves to Amphion and Zethos, the two sons of Zeus and Antiope, who came to power in Thebes and who erected its mighty city wall. Before they were able to do that, however, they had to save their mother from Queen Dirke, who had imprisoned her and planned to tie her to the horns of the bull of Dionysos to be dragged to death. Amphion and Zethos in turn condemned Dirke to that same fate. The Attalids, therefore, chose this myth with which to announce their victory on one of their large monuments. They commissioned the two sculptors Apollonius and Tauriscus from the Pergamene city of Tralles in Lydia to carve a colossal marble group for the island of Rhodes that would show the Theban brothers throwing Queen Dirke under the rearing bull. This group from Rhodes is known from many small replicas and also in a famous full-scale marble copy from the Claudian period known as the Farnese Bull, in the Museo Nazionale in Naples. In the best replicas Dirke is shown with the full head of hair of a Gallic woman. This detail embedded the message clearly in the image: Amphion and Zethos had the bull of Dionysos drag to death the enemy of Antiope their mother; in this way the Attalids, who were also descendants of Zeus (like those twins Amphion and Zethos), came to power in Pergamon and defeated the Gauls with the help of Dionysos Lyseios. They now considered the Rhodians as their friends and presented them with this monument.

On the island of Kos the Attalids built a temple to Asklepios, whose colossal dedicatory statue was made at Pergamon by Phyromachos (Polybios 32.15 [25]). In other cities statues of King Eumenes were erected, and in Athens and Delphi the Attalids sponsored large stoas. The two kings of Pergamon were included among the phyle heroes in Athens; in Delphi their statues were added to the bronze group of the phyle heroes that Phidias had made.

This great political program, conveyed to all Greeks through various works of art, was a message that used no words, only images. Not only were the Pergamenes made aware through the Great Altar how terrible the life-and-death battle had been, but they also saw that the immeasurable spoils the Pergamenes had seized from the Gauls were used to erect works of art in numerous Greek cities, which would then win sympathy for the Pergamene cause. From the founding myth of the kingdom of Pergamon in the inner court of the Great Altar, an ever-increasing circle of works of art encompassing the entire Greek world tells of the crucial event—the victory of the Pergamenes over the Gauls, which they had won against the will of Rome and which had decided the future of Pergamon. The Pergamenes intended thereby to assert political influence over the destiny of all Greece. This message, however, faded away, and one generation later, at the death of Attalos III (r. 138–133 B.C.), Pergamon was able to save herself only by voluntarily submitting to the Romans. At the time the Pergamon Altar was built, this development was not foreseen; on the contrary, Pergamon had once more powerfully established her autonomy.

But when was the Great Altar of Pergamon built? It is

clear that its core, the Telephos frieze, was carved only after the conflicts with Rome—that is, after the third Macedonian war. This is shown by the lioness nursing Telephos, the lioness who is stronger than the she-wolf. The work on the Telephos frieze was suddenly interrupted in 156 B.C., when King Prousias of Bithynia invaded Pergamon and the Pergamenes once again turned to Rome for help. Earlier scholars thought they could detect a clear stylistic difference between the Telephos frieze and the Gigantomachy, which could only be explained by an interval of a generation. In this reading, the Telephos frieze was carved during the second decade of work on the Great Altar, and the purpose of erecting the altar was to commemorate the battle with the Gauls in 184 B.C. These Gauls, however, did not fight on their own behalf but were under the command of Ortiagon as auxiliary troops of King Prousias. A war against this king could hardly have been depicted as a battle between the gods and the Giants. In the meantime we have learned that older and younger stonemasons worked side by side on the Pergamon Altar, so any difference in style cannot be used as absolute chronological evidence. The style of the Telephos frieze is also identifiable in certain places on the Gigantomachy frieze. It is likely that the two friezes were carved at more or less the same time, probably after 166 B.C., when all the other dedications mentioned above were made.

A conclusive criterion for the dating of the Great Altar is given by the following sequence: In 172–171 B.C., on the coin that commemorates the homecoming of King Eumenes, the Dioscuri are shown surrounded by the wreath of Asklepios, who had saved the king. The people of Pergamon responded to this by applying this unusual wreath to their clay wine cups as a symbol of good fortune. A fragment of such a vessel was found in the foundation of the altar, which therefore must have been built after 172–171 B.C. The key events for understanding the Great Altar are most likely the decisive battles in 168–166 B.C., which ended in the annihilation of the Gauls. The booty from this war gave the Pergamenes the enormous funds with which they could realize their cultural-political program throughout Greece. Knowledge of these historical events sheds a different light on the Pergamon Altar. For the people who commissioned these horrifying images as well as for the artists who carved them, the terrors of the battle that exterminated the Gauls lay behind them, not in the future. The Gigantomachy frieze of the Great Altar of Pergamon does not offer a triumphal prediction of future victories, but rather deals with the past struggles of a fight to the death against gigantic and brutal opponents.

NEW ARRANGEMENT AND INTERPRETATION OF THE TELEPHOS FRIEZE FROM THE PERGAMON ALTAR

WOLF-DIETER HEILMEYER

The graphic reconstruction of the Telephos frieze from the Pergamon Altar summarizes decades of discussion between Huberta Heres, Christa Bauchhenss-Thüriedl, and others about the frieze's subject matter. This reconstruction is based on the new drawings of the panels by Marina Heilmeyer and the preparatory work for the new model of the Pergamon Altar by Wolfram Hoepfner. Of special importance is the observation by Silvano Bertolin that panel 2, as it shows traces of a miter joint, belongs to a corner, and that because of the narrative subject, it must be the northwest corner.

In our reconstruction, a few very poorly preserved or indistinct panels, such as those numbered between 25 and 28, have not been drawn but were nevertheless counted. It was doubtful whether two fragments (panel 14a) belonged to the frieze at all or, if so, where they belonged and how they should be interpreted. For this reason they were eliminated.

The new arrangement was based on the principles that the frieze should be read from left to right (compare panels 20–21, cat. no. 7) and that the scenes did not end at the edges of the panels. Consequently even a main figure such as Herakles can be located on the extreme edge of a panel (panel 3, cat. no. 1). On the four preserved corners of the frieze, figures relate around the corner in two cases, the northwest and the southwest. On the two other corners, the northeast and the southeast, the scenes are quite separate.

Of course, the frieze could not have been conceived without considering the colonnade that surrounded the altar court and contained the frieze. Since the space between the columns and the walls was only 1.20 to 1.25 meters wide, groups of viewers would normally see the frieze through the colonnade. The scenes that are still preserved are 1.50 to 1.70 meters wide, and those that can be reconstructed are about 1.40 to 1.80 meters wide; the axial distance between two double-columns, as a rule, is 1.63 meters. Yet the double-columns did not rigidly frame the scenes; the viewer could see beyond and around the columns. Therefore, some scenes are one or two figures wider than the normal intercolumniation, and other scenes fall short of the usual intercolumniation by the same distance. Only the scenes in the northeast and southeast corners, where pillars 85 centimeters square hampered the view, seem to be structured in a different way. Our arrangement places longer scenes there: panel 12 with two side panels; the fragments 13, 32, 33, 14b; panel 1 with two side panels; and the very broad panels 39 and 40, with one-half of panel 38.

The total length of the frieze is determined by the reconstruction of the architecture of the court by Hoepfner (see essay in this volume). According to this, the north and south sides are 15.18 meters, and the east side 25.14 meters long: the total frieze, thus, was shorter than had been previously assumed, that is, 58 meters long including the spur walls. If the preserved panels are arranged according to the most plausible narrative sequence, as seen in our reconstruction (compare to the essay by Heres in this volume), an equal number of lost panels and scenes will result by following the rhythm

Drawing folded into front cover.

of the columns. Accordingly, 10 scenes seem to exist on both the north and the south sides including the spur walls, and 15 on the east side, amounting to 35. On the north and south sides, where the center lines up with a double-column, 19 panels can be counted on each side (and 2 more on each spur wall), and 33 panels on the east side, where the center lines up with the open space of an intercolumniation; thus there are 75 relief panels in all. Panel 36 at 51 centimeters wide is the narrowest. The widest of the measurable panels is number 17, which at 105.5 centimeters measures more than double the width of any other panel. Presumably, each scene essentially occupied two panels, with the exception of those behind the pillars.

However, because of the subject matter, there are exceptions. For instance, Herakles seeing Auge for the first time is separated from her not only by a tree in the relief but also by a double-column, and stands on the neighboring panel 3 (cat. no. 1). And Hiera's enemy on panel 23 behind another double-column seems to approach her from the adjacent panel 24. The battle of the Amazons, which is depicted in an extraordinarily broad scene of about 2 meters wide, is now placed at the center intercolumniation of the east side. This locates it between the recognition scene of Telephos with his mother, Auge (panel 21), and the presumed order for truce on the occasion of the lying-in-state of the dead Hiera (panel 51, cat. no. 12). This arrangement, taken from Bauchhenss-Thüriedl, however, presents major difficulties as far as the measurements are concerned, even after taking into account the observations of Heres (especially regarding fragments 26–27 and 29). Other questions can be settled by considering the context: thus the two frontal figures on the right edge of the long scene depicting the altar building (panel 50) are separated from the main scene by the double-column in front of it. They might have belonged to the "miracle" scene on panel 47, which remains unexplained.

Regarding the contents in their entirety, we have on the north side the story of the parents and the early childhood of Telephos; on the east side his heroism as an immigrant and warrior in Asia Minor; on the south side we learn about his healing and, in this context, his relationship to the mainland Greeks and his pious rule in Pergamon. An abrupt change of scene interrupts the continuity of the narrative on each side: on the north, to panel 11, we can follow the fate of Telephos's mother until Asia Minor, when the story of the abandoned infant in Arkadia is resumed. On the east side, to panel 21, the adventures of Telephos until his dramatic encounter with his mother are depicted, after which the frieze addresses the struggles between the invading Greeks and the inhabitants of Asia Minor on the banks of the river Kaikos. On the south side, to panel 43, the "foreign policy" of Telephos is shown, and from there on, so to speak, his "domestic policy" as ruler: first his activities in Argos, and then his achievements in Pergamon.

It is now apparent that in antiquity, as one approached the frieze from the entrance to the altar court, the second scene on the southern wall revealed the construction of an altar, perhaps an indication of the cult of Zeus in Pergamon. The opposite scene on the northern wall must have shown Auge as priestess of Athena (though nothing of it seems to be preserved). This reinforces the presence of Zeus and Athena as the main gods on the Gigantomachy frieze. In all probability, Telephos was presented on the spur wall immediately to the right of the entrance at the southern end, lying as a hero on a bed. Therefore, I would suggest that his father, Herakles, who swayed the Gigantomachy in favor of the gods, in the same way be placed on the spur wall immediately to the left of the entrance at the northern end. This arrangement not only relates the story of the origin and achievements of Telephos to the architecture of the altar structure, but also impressively selects and groups scenes and sequences of scenes. This leads to the conclusion that guiding the spectator through the narrative must have been the main requirement and objective of the art of the Telephos frieze of the Pergamon Altar.

TOPOGRAPHICAL PLAN OF ROMAN PERGAMON (1:2500)

ULRIKE WULF

The excavations and investigations in the area of the ancient residential town on the south slope of the acropolis of Pergamon, conducted by the German Archaeological Institute (Deutsches Archäologisches Institut) from 1973 to 1993, yielded many new insights into the development of the city and the structure of ancient Pergamon. At the time of Philetairos (d. 263 B.C.), a comprehensive, nearly orthogonal road system was attempted as far as possible in the residential town east of the main road, which formed a large loop. The extensive new buildings in the Upper Market and the Great Altar under Eumenes II probably necessitated a partial restructuring of the road system within the small building plots in the very irregularly built residential town. This led to many deviations in the plan. With the extension of the royal district and the new arrangement of the improved road system in the city of Philetairos under Eumenes II, the town-planning concept of the buildings on the acropolis was laid out. These conditions determined the extension and remodeling of the city down to the Roman imperial period, when with the last great new building—the temple of Trajan—the residential town on the acropolis reached the end point of its development.

Plan folded into back cover.

RESTORATION OF THE TELEPHOS FRIEZE

ELLEN SCHRAUDOLPH

The restoration of important public monuments such as the Sistine Chapel in Rome and the Parthenon in Athens have in the last twenty years yielded a significant increase in the documentation of these activities. Not only have methods and techniques been greatly improved, but awareness has grown of the importance of systematic documentation of major monuments. The restoration of an ancient work of art can sometimes be compared to an archaeological excavation in terms of its context: by examining its fragments it is possible to explore the more recent history of the piece and reconsider a meaningful reconstruction. Just as in an excavation, the paradoxical element of destruction in a reconstruction effort makes meticulous documentation essential.

Large restoration projects of ancient monuments were carried out during the last fifteen years, especially in Italy, and the results have been clearly and comprehensively published. Many publications resulting from these projects are today considered benchmarks: the Ara Pacis of Rome (1983),[1] the Charioteer of the Esquiline (1987),[2] the Dying Gaul (1987),[3] and the Farnese Bull (1991).[4] The latest volume of *Bullettino comunale* under the section "Relazioni su scavi, trovamenti, restauri in Roma e Suburbio," which has been published for a number of years, for the first time reports on the ongoing stone restorations in the museums of Rome,[5] which will be continued in subsequent volumes. Publications summarizing the state of research and technology also primarily issue from Italian institutions, such as the work of Lorenzo Lazzarini and Marisa Laurenzi Tabasso[6] or the two supplementary volumes of the *Bollettino d'arte* of 1987, "Ma-teriali Lapidei."[7] In the preface to the latter, Agostino Bureca and Giorgio Palandri suggest a central database for all of Italy, to store current information on the state of the preservation of monuments and any restoration measures, keeping them accessible for comparison and evaluation. They admit that there is not yet an officially recognized theoretical model for performing restorations and that at the moment the focus is on methodology. Bureca and Palandri deal with both outdoor and indoor stone restorations, as the same techniques often were used for both forms of restoration and thus led to similar problems. This analysis of the state of the methodology was made public in an exemplary way for the restoration of the buildings of the Athenian Acropolis. In 1993 the fourth conference on this subject took place.[8] Hans Rupprecht Goette offers a clear summary of work through 1991 in his short report illustrating the important results of this restoration, even for purely archaeological questions.[9] Recently, a volume on this topic has been published in English.[10]

The effect of climatic changes on monuments brought indoors (into museums) is of less importance to this discussion than questions of reconstruction. A good example in Germany is provided by the pedimental figures of the Aphaia Temple of Aegina, the Aeginetes, in the Glyptothek in Munich. Their new positioning in 1971, stripped of Bertel Thorwaldsen's additions of 1816–18, evoked a broad discussion around the fundamental question of reconstructing eroded stone, which Michael Maass took up again in a comprehensive commentary in 1984.[11] Since then this controversy has subsided and there is no longer any call for justifying the con-

servation of the reconstructed state of an ancient sculpture. As far as the friezes of the Pergamon Altar are concerned, the altar was found so late in the last century that the responsible parties at that time had not considered any major sculptural additions to complete the works.[12] And yet there is a close connection between the early postwar project in Munich and the restoration of friezes of the Pergamon Altar: Silvano Bertolin had been in charge of the operation of the Aeginetan marbles, following which he went on to important restoration projects throughout Europe. He was subsequently engaged by the Staatliche Museen zu Berlin to restore the Telephos frieze, a task begun with four coworkers in March 1994 and completed, after frequent interruptions, in October 1995.

STATE OF PRESERVATION OF THE TELEPHOS FRIEZE
Circumstances of Its Find

The present state of preservation is primarily due to the fate of the frieze in medieval as well as modern times in Pergamon. Since Byzantine times the panels had been partly reused or burned for lime. No single piece of the Telephos frieze was found in its original place or where it had directly fallen from the platform of the altar. This was because the inner court of the altar had been leveled by more than half in the course of time. Thus the sequence of the panels cannot be determined according to the location in which they were found.[13] All information pertaining to the find spots was compiled in the comprehensive catalogue of Hermann Winnefeld. Although he refers to the preliminary report of Carl Humann,[14] Winnefeld evidently also used his diaries of the excavation.[15] Based on the map Humann drew on 1 May 1879, recording with Roman numerals all the locations of the find spots of the Telephos frieze,[16] Winnefeld marked all major fragments of the Telephos frieze by *T* and the relevant number of the panel on a schematic map of excavated remains.[17] These numbers can be found again on the individual drawings of the panels that were also made in 1879 by Humann (see Kästner, vol. 1, p. 20, figs. 2–5).[18] At least one later plan of

excavated works had to exist, according to remarks in Humann's report. But the earlier plan with twenty-three entries relating to the Telephos panels mentioned above is the only one still available. Thus, all other statements by Winnefeld, which partly refer to the very terse list of Carl Robert, can no longer be checked.[19]

The following picture emerges: ten reliefs were recovered from the Byzantine wall.[20] Among these at least six panels are striking for their unusually good state of preservation as they were hardly broken and comparatively complete (panels 6, 12, 16, 48, 50, 51; cat. nos. 3, 5, 6, 12). Obviously, when used in later constructions they were kept in their entirety, as far as possible. In the case of panel 16 (cat. no. 6), the figure of Telephos had broken off and was found a short distance away. The surface of the marble in all the panels mentioned above is almost unaffected. Before the last restoration, in contrast to the others,[21] the marble gleamed brightly, partly showing its gray, streaked structure. This difference in surface quality is especially notable in panel 16, on which the head of a follower wearing a Phrygian cap (found during the second campaign in 1881)[22] is covered by a stark reddish stain, attesting that it was not reused in the Byzantine wall. The marble of the head probably reacted with the iron-rich earth. Also, the scene showing the building of Auge's boat illustrates the way preservation is affected by find spot: while panel 6 (cat. no. 3) shows only isolated reddish stains, panel 5 (cat. no. 2), originally adjacent but found between the market and the base of the altar, is heavily corroded and covered by an uneven layer of stain.

Many pieces were found in the northeastern and southeastern corners of the altar.[23] The two groups exhibit distinct degrees of damage. All specimens from the southeast (in the area of the cistern) are badly broken and often show no relief ground. Obviously, they had been smashed. The pieces from the northeast, in contrast, with the exception of two specimens, are relatively complete. Quite often, however, the heads are missing. Especially striking is the state of preservation of

panel 10 (cat. no. 4). The surface with the fine pattern of drapery has remained beautifully intact, and, as an exception, the almost three-dimensional head of Teuthras is still in place on the relief, with hardly any damage or crack. The comparatively better condition is the result of the panels being used for building simple residential structures in medieval times.[24] Humann refers to this in his excavation report in the following way: "[P]eople have built artless masonry for their use surrounding living quarters and courts. As no lime was used but only earth as a binder, they preferred big pieces that were placed on edge."[25] Some of the panels show very extensive staining.[26] They seem to have been in direct contact with the soil or the earth that was used as a binder.

A major part of the relief was carried off as far as the Upper Market.[27] These pieces probably come from very different locations because the condition of their preservation differs greatly. Unfortunately no detailed information is available from the excavations. Among the relatively complete panels, notable is panel 5, mentioned above. Also a major part of the scene of Telephos with the baby Orestes on the house altar has survived virtually intact (panel 42, cat. no. 11). Spatters of gray paint on the lower part are from a much later date, as they are not visible in old photographs.[28] The lower fragment of the woman is especially corroded. Reddish stain covers the body of Telephos and the garment of the kneeling woman. In the case of panels 2 and 9, figures have fallen off; they were not separated in recent times as there are no traces of modern tools whatsoever. This phenomenon occurs often on the Telephos frieze and is due to the layering of the stone that runs parallel to the relief and promotes the exfoliation of relief pieces.[29] In other cases figures that have fallen off have survived without their relief backgrounds, as for example the Dionysos panel (panel 31, cat. no. 9), whose find spot is unknown. Panel 45, from the scene in the sanctuary of Dionysos, shows conspicuously few traces of stain and a remarkable gray coloring. The remaining parts of the frieze, of which the find locations are more or less known,[30] are spread over the area already described (the southern rim of the altar terrace,[31] the southwestern corner of the altar terrace,[32] and the northern side of the altar base and western slope[33]). Panel 44 was found under the road to the fortress. The deep dents on the back and the various discolorations on the front of the panel fit this location very well, as they most probably stem from its second use as pavement.

Ancient Restorations

The condition of the Telephos frieze after excavation includes ancient repairs and attachments. Ancient dowels are recognizable because of the finely drilled holes in areas where small pieces are missing, for example, in the place where the penis was often attached with an iron pin.[34] Ancient dowels such as these survived on five panels. On panel 3 (cat. no. 1) on Herakles' chest, a small end of a corroded iron post remains in the topmost hole, while the lower one is now empty. Probably the holes held attachment posts for the hero's lion skin, which most likely exceeded the depth of the original block of marble. Another ancient dowel hole is in the branches of the oak tree, where it held either another branch or a bird similar to the one higher in the tree. On panel 10 (cat. no. 4), a broad corroded iron lump emerges at Teuthras's right forearm, where it was broken off. It can be identified as the remains of an ancient iron dowel used to position the forearm diagonally across his chest, the form still visible from traces of the carving.[35] Evidently the arm broke off in ancient times and was reattached with the now-blunted iron post. A small, smoothed flat area with traces from a fine pick in the area of the crack supports this assumption.

Some additions were fastened without dowels—that is, they were held only by glue.[36] A good example of this is Dionysos, panel 31 (cat. no. 9), whose garment is missing a large piece below the left arm. The surface of this cleanly cut rectangular area is very smooth and finely stippled. It represents a portion of the girdle consisting of the panther skin and small drapery pleats welling out underneath it. This flat, rect-

angular addition can only be explained as a correction of a carving mistake. The two other pieces that have been glued are a result of their positioning at the joint edges of the panels: the head of the figure to the left in the scene of the founding of the city (panel 50, fig. 1) as well as the one of the river god reclining to the right did not completely fit on the panel and, therefore, had to be pieced. We also find glued additions on the portrait of a Hellenistic ruler (cat. no. 19).

When considering ancient repairs, the question is whether they were necessary because of damage caused after the relief was carved or because of the sculptor's mistakes. For Dionysos we have answered this question. For the remaining examples it is also likely that repairs were part of the initial work because some areas of the frieze lack the final finish. This suggests that the frieze may not have been totally completed; refer to panels 1, 5, 6, 8, 11, and 20 (cat. nos. 2–3, 7). This possibility is apparent on panels 5 and 6, which depict the building of the boat for Auge (cat. nos. 2–3), where evidence of various stonemasons' tools are recognizable. Parallel grooves of the toothed chisel are notably visible, especially in the lower part of panel 6 and in the vicinity of the boat; a flat chisel made the deep, long furrows on the arm of the craftsman who swings the hammer, and tool marks from the pointed chisel can be observed on the left side of the scene, near the boat. It is remarkable that the clothing on both panels appears to have been worked out to the finest detail, whereas the bodies and open spaces such as the boat interior show traces of much rougher work.

In this connection, the question debated among scholars is whether the frieze was completed before the panels were mounted onto the socle of the altar court walls or whether they were erected as roughly cut blocks and carved in place. Although some indications may point to the carving of the block before it was mounted, the preponderance of the evidence is in favor of the panels having been finished on the structure. The indications that point to the former conclusion are based on the several joint edges running through carved

Fig. 1. Panel 50: ancient surface with fine chiseling marks for piecing onto the joint edge. (Photo: Laurentius)

figures from panel to panel, yet closer examination reveals discrepancies in the sculptural execution. For example, the figure of the small girl along the upper left edge of panel 6 (cat. no. 3) does not continue correctly on panel 5 (cat. no. 2). The girl's right leg appears too flat on panel 5; her shoulder is too wide, as if the carver did not have the two panels side by side. This would indicate that the panels were carved in a workshop. However, in 1910 Winnefeld raised striking arguments in favor of the panels' completion on the walls.[37] He refers first to the unfinished areas, but these could also have resulted from insufficient time to finish the frieze before its installation. Second, he points to the mounting holes at the upper edges of the panels, which are located more or less along the plane of the relief ground and are frequently broken

Fig. 2. Panel 4: cement filling with cracks and fissures. The fragment above and to the right does not fit and was omitted in the latest restoration. (Photo: Laurentius)

Fig. 3. Panel 1: part of the filling from the back of the panel made from bricks and cement had already separated before the restoration in 1994. (Photo: Laurentius)

(as, for example, in panels 21, 40, and 49). Originally they must have been located in the center of the raw block to facilitate the mounting process. As the relief was carved, the surface was thinned, so that the wall surrounding the hole broke easily. The mounting of these panels by means of such fragile holes would not have been possible.

The same holds true for the doweling holes used for mounting the panels to the base. They also are located in the middle of the original depth of the block and, after the relief was hewn, came close to the front surface so that in time they frequently broke through (for example, panels 38, 44–46, cat. no. 10, drawings). It is therefore indisputable that the reliefs were completed after the panels were in place.

CONDITION BEFORE THE RECENT RESTORATION

The urgent necessity for a complete restoration in 1994 was a consequence of the handling of the panels during the restoration in the nineteenth century. Before discussing the process in detail, it is necessary to describe the alarming condition of the various panels prior to the recent restoration. The glue joins showed cracks and fissures; the adhesive was so brittle that extensive breaks occurred between the marble and the adhesive material (fig. 2). The mortar fill began to break off in sizable chunks (fig. 3), and in several areas dowels protruded from the relief where fragments had formerly existed—for example, on the Herakles panel 12 (cat. no. 5) in the area where the lion's paw had previously been located. A cause of special concern were the unprotected iron dowels that had begun to rust and affect the marble. They threatened to burst the stone and had already caused cracks or gaps (figs. 4–7). Especially destructive were the large iron clamps, embedded in gypsum, that ruptured the gypsum layer and were visibly rusting underneath (figs. 8a–b).

How could such damage have come about? Closer observation explains the deterioration in the following manner: the mortar for the attachment of the dowels should have been applied in a thick enough layer to isolate the metal from air.

Fig. 4. Panel 2: the rectangular iron dowel in the panel, above left, had burst the marble. Several fragments were already missing so that the dowel was exposed. (Photo: Laurentius)

Fig. 5. Panels 17–18: the rusted dowel had burst the marble and emerged through the mass of cement fill tempered by marble splinters. (Photo: Laurentius)

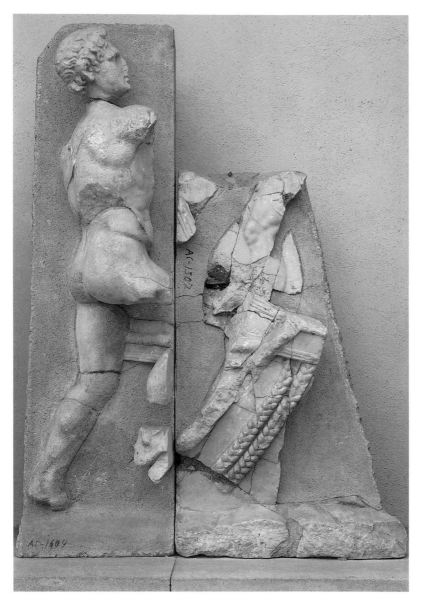

Fig. 6. Panels 32–33: before restoration in 1994 (for after restoration in 1995 see fig. 5b in Heres in this volume). The knee and left half of the buttocks were added to the figure with cement. The rust from the exposed iron dowel had discolored the marble. Many cracks in the ship fragment are caused by dowels in the marble. (Photo: Laurentius)

Fig. 7. Panel 33: details of damage caused by dowels. (Photo: Sender Freies Berlin, Küchle)

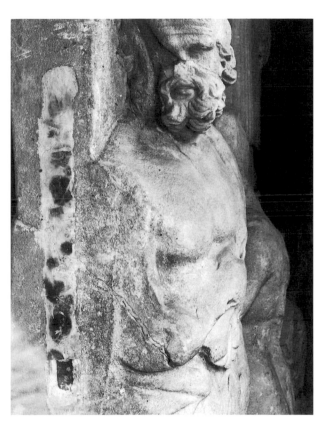

Fig. 8a. Panel 44: the iron clamp in the right joint edge reveals rust underneath its bedding of gypsum. (Photo: Laurentius)

Fig. 8b. Panel 44: the iron clamp in the left joint edge had partially broken from its bedding of gypsum. (Photo: Sender Freies Berlin, Küchle)

Such thick application, in theory, would prevent rusting. However, in many cases total isolation was not possible. Furthermore, the addition of water caused the mortar to shrink and crack because it dried too quickly. Subsequently, moisture entered the cracks. In addition, thick layers of mortar between the fragments prevented a tight fit of the broken surfaces. When the panels were moved, the adhesive material developed cracks due to the vibration caused by movement. Moisture entered and caused the iron dowels to rust. The rusted dowels expanded until they broke the marble. When gypsum was used as a material for anchoring iron dowels, the process was speeded up because gypsum is more hygroscopic than mortar. The conclusion to be drawn therefore is that most iron dowels inside the panels, even if not visible, were affected by moisture and contributed to the deterioration of the frieze panels. This process could not be stopped without rapid intervention.

HISTORY OF RESTORATION

Late Nineteenth- and Early Twentieth-Century Restorations
It is difficult to evaluate the effect of each restoration campaign because in the past no careful records were kept. It is only through documents such as invoices, orders, letters, and old photographs that a restoration history was compiled. During the most recent restoration, the documentation of all previous dowel holes and adhesives, combined with the historical information of the frieze since its discovery, resulted in a more complete picture.[38] Publications concerning the reassembly of sculptural finds from Pergamon mention the names of two Italian sculptors—Temistocle Possenti and Antonio Freres; Freres supervised the work. The minutes of a meeting of the Skulpturensammlung of 14 January 1880 reported that Freres described his working methods to a high-ranking committee of sculptors and professors of the Berliner Akademie der Künste and after this examination was commissioned to carry out the restoration work.[39] Vouchers in the cash accounts of the general administration attest to

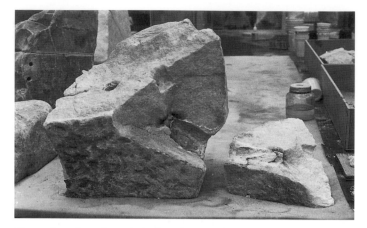

Fig. 9. Panel 39: large hole for a bronze dowel with dark traces of rust below the gypsum. (Photo: Schraudolph)

payment to Freres for sculpting work dating from October 1880, and to his assistant Stille dating from January 1881.[40] In April 1882 payments to Possenti are shown for the first time, at first as daily wage, and then as monthly salary, but distinctly lower than that of Freres.[41] There is no reference to the two sculptors, however, in leading publications on nineteenth-century Italian sculpture. The only written evidence of their work, apart from invoices and receipts, is a short inventory of boxes drawn up by Possenti on unpacking in September 1884.[42]

To assemble the frieze panels, the two sculptors used iron rods and concrete. From their invoices it is evident that they procured iron rods in various thickness in large quantities but purchased only small numbers of brass and copper rods. The composition of the adhesive would have been kept a secret as was usual during this time—it appears in invoices simply as "powder and doubly-purified liquid for the composition of an insoluble paste for gluing marble." Josef Riederer reports in this volume on attempts to analyze the components of this cement and compares it to recipes from historic publications. The observations made during the recent disassembling of the frieze prove as well that, in the first restoration campaign, iron was used exclusively for doweling. An

Fig. 10. Panel 28: arm of the fallen warrior. Iron dowel with a bronze dowel embedded on top of it to the left. The fragment on the right is turned to reveal the beddings of both dowels with traces of rust. (Photo: Schraudolph)

examination of the panels shows that half have iron as well as bronze dowels. Ten slabs had only bronze dowels, in seven panels iron was used exclusively, and only four panels were in such good condition that no dowels at all had to be used.[43]

When both iron and bronze dowels were found in a relief panel, two basically different restoration phases could be distinguished. Bronze dowels located in holes stained heavily by rust indicated that iron dowels previously occupied these holes. Because they caused damage, the iron dowels were replaced with bronze ones. For example, on panel 39, a thinner bronze dowel sat in a heavily stained larger hole in which an iron dowel previously had secured two halves (fig. 9). This procedure is shown distinctly at the arm of the fallen warrior on panel 28. Here an iron dowel still remains underneath the bronze one, and marble discolored by rust appears below both beddings (fig. 10). Another observation also led to the conclusion of two phases of restoration: in a number of cases empty dowel holes filled with adhesive material were found. Quite often they belong to missing fragments, which had previously been mounted there. The remaining examples, however, clearly belong to a second stage of restoration. For

example, on panel 39 the old dowel broke in the region of the chest of the seated Argive. The empty dowel hole runs exactly along the crack line (fig. 11). The bronze cross-doweling of the fragments can only have been inserted to repair this damage (fig. 12).[44] On panel 18 two empty dowel holes run through the upper part exactly along the crack lines. An old photograph from the workshop of Freres and Possenti shows the original iron doweling, which connected the two parts of the panel on the top. Here the cracks are not yet visible (fig. 13).

By recognizing two separate restoration phases, a clearer picture emerges of the different methods employed. During the first phase, iron rods, dowels, or clamps were used exclusively. On seven of the frieze panels, iron clamps were fastened on the outside of the reliefs, along either the side or the back (fig. 14). These panels are preserved to almost full height, and they were found either already broken or cracked. Their original condition can best be assessed from studying the very detailed dated drawings made by Humann at Pergamon (see Kästner, vol. 1, p. 20, figs. 2–5).[45]

Fourteen relief panels had lower sections missing that were filled in with cement additions. Large bricks with prominent, wide holes filled with cement were used for this restoration (fig. 15). The front of the bricks was smoothed with plaster and the marble fragments were lowered onto these bases with square iron posts and anchored in place with cement (fig. 16). Long-term effects of cement on marble were unknown at the time. This method was therefore in accordance with the latest state of the art. Mixtures of mortar were invented during this period. In 1867 Stanislaus Sorel in Paris reported on a magnesium cement, which comes quite close to what has been found when analyzing our samples (see Riederer in this volume).[46]

Four fragments that became detached from the frieze received a brick-cement support as their background and were fastened to it by means of horizontal dowels from the rear, as for example the Dionysos panel 31 (cat. no. 9). In all four cases these dowels are made of bronze. This is therefore

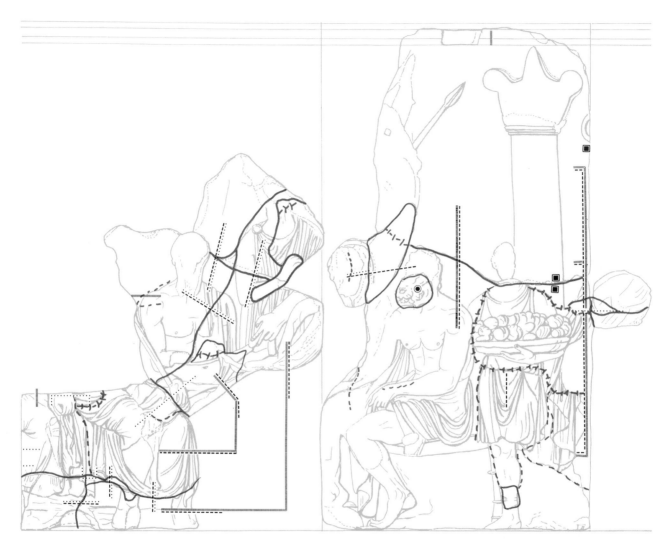

Fig. 11. Panels 39–40: schematic drawing of the old and new
dowels.

- - - - - - - - - - - - steel dowel

|||||||||||||||||||||||||||||||||||| iron dowel

• • • • • • • • • • • • • • • • • bronze dowel

⊙ bronze dowel inside of steel dowel

◼ iron dowel inside of steel dowel

━━━━━━━━━ fracture lines

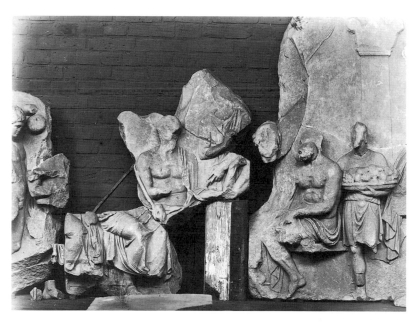

Fig. 12. Panels 39–40 in the workshop after the first restoration in the 19th century. The upper and middle fragments of panel 39 do not yet show fractures.

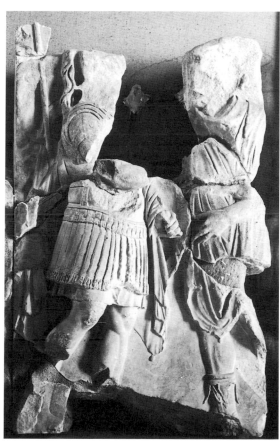

Fig. 13. Panel 18 after the first restoration in the 19th century with an iron dowel running across the upper part. This dowel later caused fractures. Above and to the left a fragment is now missing. Below and to the left the cement filling on top of the iron dowel, which was later exposed, is carefully smoothed (see fig. 5).

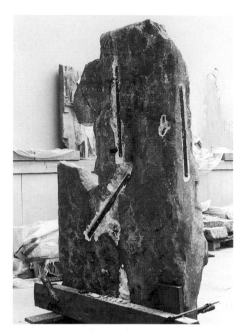

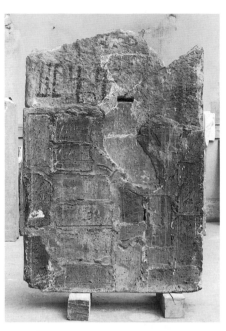

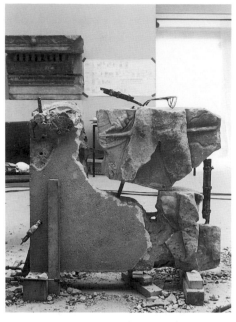

Fig. 14. Panel 34: massive iron clamps embedded in gypsum in the back and in the joint edge. (Photo: Schraudolph)

Fig. 15. Panel 47: the back with ancient dowel hole and brick and cement addition. (Photo: Schraudolph)

Fig. 16. Panel 30 after exposing the dowels: the marble fragments were attached to the brick and the cement additions by rectangular iron dowels. (Photo: Schraudolph)

the second restoration phase. However, the first phase is hard to recognize among these panels—for example, on panel 32 (the nude adolescent boy climbing up a ship ladder; figs. 6 and 17), a rectangular iron rod ran through the entire cement panel from top to bottom serving as an additional support. The bricks of this panel included the stamp MULD[E]N/WERK.[47] The upper and lower part of the boy's body were connected with a round iron rod. All fragments were mounted to the background with one or two bronze dowels. Their anchoring in the panel showed extraordinarily distinct traces of a second treatment. Apparently, large holes had been cut into the cement and were filled with gypsum and fragmented bricks (fig. 18); it seems that the anchoring had been corrected. Remnants of the original doweling are still found in the marble. Three thin, sawn-off pins are stuck in the back and head of the figure. In addition, in this special case, two sculp-

tural additions had been made using cement. The left half of the buttocks and the left knee are additions.

After examining all the panels with iron and bronze rods, the following picture of the second restoration phase emerges: all the iron clamps, though very susceptible to rust in combination with the hygroscopic gypsum (see figs. 8a–b), were not replaced, perhaps because bronze rods of equal diameter would have been difficult to obtain. Square iron dowels remained in the brick-cement additions as well. Their corrosion was much less invasive because the thick cement panels shielded the dowels from humid air. Therefore, during the second restoration phase, the relief panels were not completely disassembled, and only sections whose dowels had caused considerable damage were mended.

Adhesive materials were difficult to date. Cement and gypsum were applied equally as adhesives in both restoration

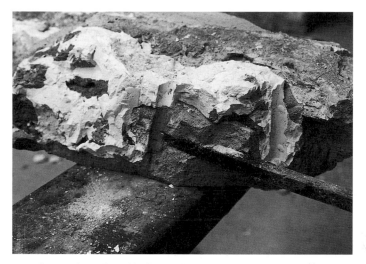

Fig. 18. Panel 32: dowel holes in the supplementary panel filled with gypsum and fragmented bricks. (Photo: Schraudolph)

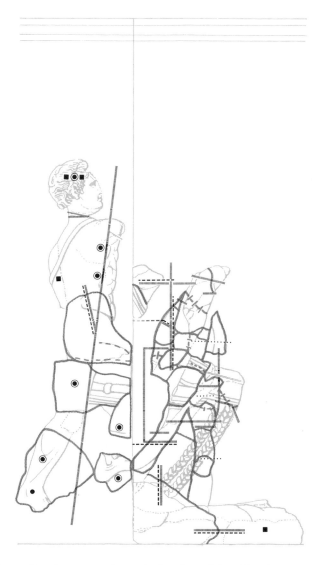

Fig. 17. Panels 32–33: schematic drawing of the old and new dowels.

| | |
|---|---|
| ---------------- | steel dowel |
| ‖‖‖‖‖‖‖‖‖‖‖‖‖‖‖‖‖‖‖‖‖ ■ | iron dowel |
| •••••••••••••••••• ● | bronze dowel |
| ═══════════ | dowel hole |
| ◉ | bronze dowel inside of steel dowel |
| ───────── | fracture lines |

campaigns. It is possible, however, to determine that gypsum was used as the adhesive for the later gluings, and we can state that gypsum, contrary to cement, has been in use for this purpose up to the present time. Cement was tempered with marble powder according to the different types of use (see the analysis by Riederer in this volume); pulverized marble—that is, marble dust—was mixed with cement to anchor the dowels; coarser-grained marble powder was used to glue breaks; and for the filling of larger gaps, marble particles were added to the cement. Mortar was also mixed with sand, and still other mortars were dense and hard without any additives. Before larger surfaces were glued, they were sometimes worked with a rough chisel in order to allow for better adhesion.[48] Only in a few cases were organic adhesives used. Achim Unger of the Rathgen-Forschungslabor (Rathgen Research Laboratory) analyzed them using FTIR-spectrometry.[49] Later restorations utilized polyester resin as an adhesive, which has only been known since the 1950s. Its use is evident on only six fragments.[50]

The question remains of the exact date of the two phases of restoration. Large-scale interventions such as those

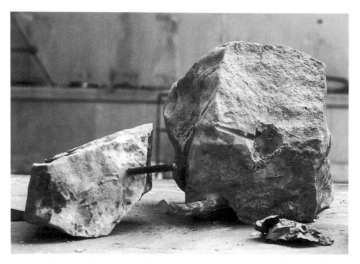

Fig. 19. Panel 18: fragments with widened end of an empty dowel hole. In front the remnants of a newspaper found in the hole. (Photo: Schraudolph)

Fig. 20. The restored newspaper advertisement of a compulsory auction from an empty dowel hole in panel 18 (see fig. 19).

that took place during the second phase could have been undertaken only when the frieze was not on exhibition. Therefore this phase can be dated to the years after the closing of the first Pergamon Museum in 1908 and before its reopening in 1930. It is known that during this time the frieze panels were stored in poorly insulated, walled-in colonnades, and high humidity probably contributed to the increasing corrosion process of the iron rods. According to administrative files on the construction of the new Pergamon Museum, the relief panels were transported to the new building between January and February 1926 in order to shield them from ongoing construction work.[51] The panels then underwent a surface cleaning.

Following the cleaning of the Gigantomachy frieze, the Telephos frieze was cleaned in only four days, according to the reports of the construction supervisors, which do not mention any involvement of staff from the Antikensammlung. Presumably on this occasion damage was ascertained and repair work was started, but nothing of this is on record. During the recent restoration work, a small piece of newspaper was discovered in an empty dowel hole in panel 18 (figs. 19–20). It carried a small advertisement for a compulsory auction of tools to take place on Saturday, 3 July. The year was not mentioned, but an almost identical advertisement was placed in the *Berliner Lokalanzeiger* of 30 June 1926 (fig. 21). Since 3 July was a Saturday in 1926 and since the economy was strained at this time, it is likely that the second phase of restoration took place in 1926. At this time the final placement of both friezes was still undetermined, as Wilhelm von Massow, curator of ancient architecture, provided director Theodor Wiegand in July 1927 with extensive installation proposals for the panels in the new Pergamon Museum. Plans for an interior access stairway to the raised Telephos Hall were dropped in April 1928 since there had been no accidents on the large staircase of the altar during construction. It was only in September 1929 that von Massow recommended the placement of fragments of the sacrificial altar along the re-

maining wall of the Telephos Hall.[52] Therefore, sufficient time remained before the opening of the museum in 1930 for an intensive restoration of the panels.

World War II and Its Aftermath

The fate of the frieze panels from the outbreak of World War II until their return after the war is described extensively in Heilmeyer's essay in volume I. During this time, the possibility of the panels sustaining extensive damage was great. Initially, they were secured with sandbags placed a couple of feet away. When it was noticed that the bags were wet and had started to rot, they were replaced with wood planking and dry sand.[53] Between May and September 1945 the frieze panels were stored in the slaughterhouse at Eldenaer Strasse in Prenzlauer Berg—an unsuitable location for such a purpose. The building had broken windows and a leaky roof. Soviet soldiers then put the panels onto forty railroad cars, with "light freight" stored on top for shipment to Russia. At the Russian border the cargo was transferred onto other railroad cars because of the different gauge of the Russian tracks. On 13 October 1945 the panels arrived in Leningrad, where they were stored in the Hermitage.[54] All had been marked with large inventory numbers, some on the cement additions, but others on the original surface of the reliefs. In August 1957 molds were fabricated of each panel and castings were made.[55] Traces of this procedure are still partially visible, as the material separating the original and mold layers was inadequate. The reliefs therefore were marred by scratches from the mold joints and the marble was partially discolored. The latter can particularly be seen at the joining edges of the panels when only half of the slab's thickness was reproduced. On 7 August 1958 the friezes were exhibited in Leningrad before being returned to Berlin the same year.[56]

· The third restoration, mentioned above, seems to have been carried out in Berlin at this time. Again, nothing is on record. In view of the short time between the arrival of the monuments in fall 1958 and their exhibition at the

Fig. 21. *Berlin Lokalanzeiger* of 30 June 1926, no. 303 (44th year, supplement no. 5) with advertisements of similar compulsory auctions.

Antikensammlung in the Pergamon Museum on 4 October 1959, no major restoration could have occurred (fig. 22). According to a January 1959 operation plan submitted by director Carl Blümel, the mounting of the frieze panels was planned to start in the first quarter of 1959.[57] Before that time, a few selected reliefs of the Telephos and the Gigantomachy friezes were temporarily exhibited in the last two halls of the north wing. During this time, the restorers Adolf Fahrnholz (from 1936), trained modeler and sculptor, and Christine Brussig (from May 1953), trained stonemason, worked for the Antikensammlung.[58] An order book for materials for the restorers lists brass and bronze rods exclusively and marble powder.[59] The small bronze dowels on the rear of each panel must have been put in place at this time. A wire was wrapped around each to fasten the panels to the wall.

It must be assumed that repeated transport of the panels since 1941 had weakened the small exterior fragments especially so that they had to be reattached. A number of these fragments were lost. Most of the dowels remained in the reliefs until the restoration of 1994; others that had been glued and had become detached can be detected only in archival photographs. The fact that some fragments were lost earlier cannot be ruled out because no complete photographic series dates from the time of the second installation until immediately before World War II. The missing fragments originally attached by dowels must represent more recent losses, as the remaining dowels, with the exception of two, are made of bronze. In all, 23 fragments are missing today, of which 15 were doweled, 4 glued, and 4 freshly broken off.[60] Panels 12 and 20 (cat. nos. 5 and 7) are typical examples of these problems. The doweled fragment of the chest of the small cult statue of Athena (panel 20) apparently had broken off; a small piece remained glued and, with the bronze dowel, is the only existing evidence. The lion's paw on the Herakles panel (fig. 23) must have been detached since 1932 and was either lost or removed because it is already missing in photographs of that time.[61] Visible in the lower left-hand corner of the panel is a cement addition that was noted as missing after World War II. Only one of the 22 fragments—a piece with garment drapery doweled on the edge of panel 39—was known to have been taken during a robbery in June 1962 between 4:30 and 7 p.m., before the museum closed. A guard noticed the loss the following morning; remnants of crumbling plaster were still on the floor. A bronze dowel remained in the panel.[62] In addition, fragments from the unworked backs of some panels are missing.[63]

Former directors Elisabeth Rohde and Huberta Heres reported that before the new installation in 1959 the relief panels were washed. The soap, Mersolat, a yellow-brownish paste based on an alkyl sulfonate with sodium chloride, had been developed for this purpose by the Academy of Sciences at the request of Blümel.[64] During the recent restoration, when the panels were cleaned with water a rich foam was observed on the surface, which can only be due to remnants of this soap-cleaning method of 1958–59. In subsequent years the frieze was cleaned by spraying it with water and brushing. It is possible that moisture that had penetrated into the frieze by these measures has contributed to the development of the damage. From 1974 until her death in December 1992, the stone restorer Christel Teller was responsible for the sculptures belonging to the Antikensammlung. In recent times Teller used gypsum exclusively as an adhesive. In the 1970s the restorers Klaus Kropinski, Jörg Rössler, and Gerhard Fiedler from the central laboratories of the Staatliche Museen also at times worked for the Antikensammlung. No treatment notes exist from this period, with the exception of a photographic series in 1985 documenting damage to the Gigantomachy frieze.

Restoration Work, 1994–95

The latest restoration, supervised by Silvano Bertolin, had as its goal the reduction of stress and the removal of any causes of damage without affecting the original surface of the marble. Each panel had to be disassembled into its fragments

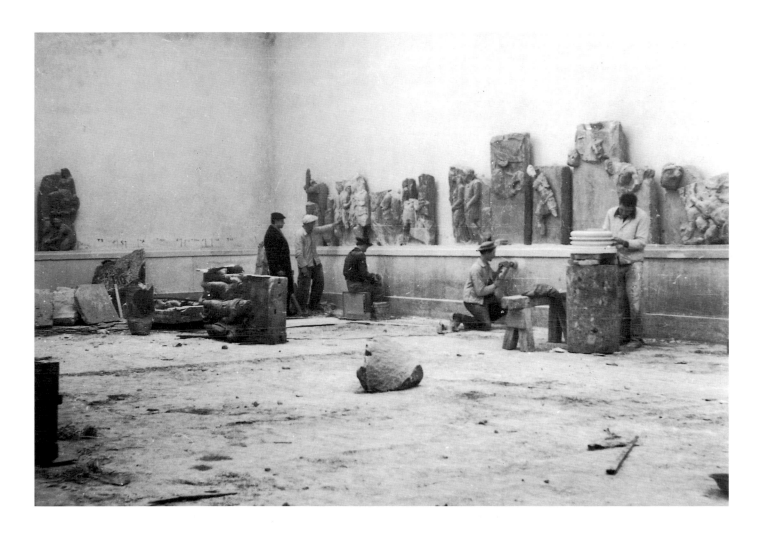

Fig. 22. The Telephos Hall during mounting of the Telephos frieze in 1959. Workmen restore the pedestal and construct a base for the outer colonnades. Panel 10 (cat. no. 4) lies on its joint edge ready for positioning.

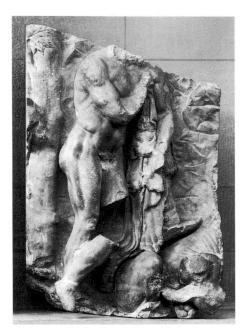

Fig. 23. Panel 12 (cat. no. 5): positioning in the first Pergamon Museum. Underneath the infant Telephos one can see the paw of the lion missing today.

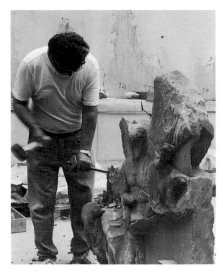

Fig. 24. Panel 39: the cement supplement is hewn off using a chisel. (Photo: Schraudolph)

(as far as the danger of new fractures did not prohibit that manipulation), work that to a large extent was mechanical (fig. 24).

The glue was softened with applications of water or sometimes by submerging the panels into vats of filtered water, but only if the condition of the old dowels allowed it. Very tenacious glue joins required up to two days for opening. Gentle hammer blows in a constant rhythm from two directions into the break brought about the final separation (fig. 25). Dowels were situated so deep in some marble panels that electromagnetic instruments could not locate them. It was particularly difficult to separate pieces held together by these dowels because they were so firmly placed that the removal of filler material did not sufficiently open the join. Most difficult to open were old gypsum adhesive joins combined with rectangular iron bars.[65] In such cases, because the dowels could not be seen, drilling with fine needles from the rear of the glue join was necessary to locate and cut the dowels (fig. 26).

All relief sections underwent water cleaning for a period of one to four days; all adhesive materials were removed from broken surfaces with scalpels and ultrasonic cleaners. The relief surfaces were then washed with water and soft brushes. Ordinary tap water was used, purified with a filter to remove minerals, especially dirt and rust. Contact with any chemical was avoided. Because of this careful treatment, the patina of the surface remains unaffected. Only late contaminations, masking the surface with a dark gray veil, were removed. Stains in the marble caused by corroding metal, iron as well as bronze, remained unchanged; however, the process of corrosion was stopped so that no further damage will occur. For example, on panel 16 (cat. no. 6) the fragment of the head with the Phrygian cap was discolored by rust (figs. 27a–b). This fragment, as well as the torso of the armored Telephos, had been attached with iron bars too massive for the purpose. Luckily, the four-sided bars embedded in gypsum had not caused any further damage.

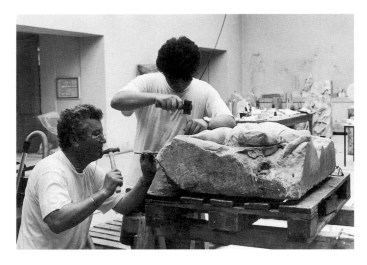

Fig. 25. Panel 25 (cat. no. 8): a cement glue join is opened by rhythmical blows with fine scalpels from two sides. (Photo: Schraudolph)

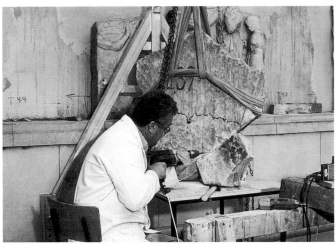

Fig. 26. Panel 42 (cat. no. 11): the dowels of the lower fragment are cut through by drilling in the groove of the fracture from the back. (Photo: Schraudolph)

Fig. 27a. Panel 16 (cat. no. 6): the fragment of the head with Phrygian cap when taken off the relief. The marble was burst apart by the rusting dowel (Photo: Schraudolph)

Fig. 27b. Panel 16 (cat. no. 6): after cleaning and reassembly. (Photo: Schraudolph)

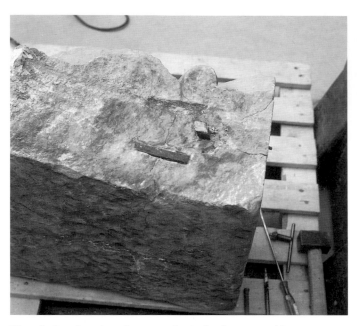

Fig. 28. Panel 39 (see figs. 11 and 12): the fragmented lower part seen from above with the corroding bronze clamps, causing cracks, which appeared underneath the cement supplement. (Photo: Schraudolph)

Fig. 29. Panel 11: soil with small roots had already made its way into a fissure at the site of Pergamon. (Photo: Laurentius)

Bronze dowels had a less damaging effect on the marble. Yet even these sometimes corroded, breaking marble sections. For example, cracks in the lower block of panel 39 were held together by bronze clamps that in turn caused other cracks (fig. 28), which needed to be opened during the recent restoration. Such measures were unavoidable in a number of cases, where cracks extended deep into the marble so that the piece was held together only in small sections. Some of these cracks broke apart during dismantling. This was the case with thirty fragments, ten of which broke into three or more small sections. In nineteen cases, dirt lodged in the cracks caused by the dowels. On panel 11 soil and small roots were found in a crack, dating probably from the time before the excavation at Pergamon (fig. 29). Only in one instance did a crack carry over to the neighboring fragment during the cleaning, causing a small new fracture.[66] In view

of the danger of discoloration, chemical treatment of the relief surface with an impregnating resin—Paraloid, for example—was not attempted.

During a second phase of the recent work, the cleaned fragments were reassembled. Silvano Bertolin searched among the more than five hundred fragments in storage to find additional pieces belonging to the relief panels. Because his predecessors had been efficient about this he made only a few discoveries of unimportant fragments, which probably had been put unmarked in storage when loose. On the other hand, there were fragments that had previously been incorporated into the frieze that had to be removed. For example, the shoulder fragment of the right-hand female figure on panel 4, contrary to the statement of Antonio Freres, has no fracture surface that fits neighboring pieces.[67] Unfortunately, nothing is known of the excavation details of this panel. In 1910 Winnefeld had already doubted that this fragment belonged to the panel because of anatomical reasons.[68] The shoulder starts at a point too high in relationship to the body, and the neck, also situated too high, does not fit the neck of the carved body below. There is also no explanation for the large gap of the break. This fragment had to be eliminated from the reassembly. Another case of such an elimination is the body of an Amazon in the battle scene on panel 23 that only appears

to fit well. It is slanted too far to the front. The Amazon, unmistakable by the typical bent battleax, turned completely to the back, as the rest of her curly hair and the onset of the shoulder below the ax clearly show. The torso cannot have fitted there but must have come from another figure of an Amazon. A correction had to be made for the placement of the lower leg of the Amazon's opponent on panel 24. As all the figures of the frieze show the same leg length, the fragment should be placed 15 centimeters higher. Thus, the warrior stood on an elevation that is not preserved.

For the reassembly, an epoxy resin was used (AKePox by AKEMI). If necessary, the addition of Aerosil rendered it more viscous. The surfaces of the breaks were pretreated with an acrylic resin (5% Paraloid B72 in acetone) in order to prevent the epoxy penetrating into the stone. This treatment allowed for some reversibility of the repair. The liquified adhesive greatly improved the fit of the fractures. The new dowels were made of a refined steel that is rust- and acidproof (V4a), and their surfaces were notched or roughened for better adhesion. Only in rare cases was a deepening of the old dowel hole required (for example, figs. 11 and 30).[69] Marble dust or drilling cores obtained through further doweling were collected for mineralogical examination (see Cramer, Germann, and Winkler in this volume), as for example from panel 16 (cat. no. 6), where the upper dowel hole of the armored Telephos was extended. Other dowel holes remained empty because glue repairs of the fragments were sufficient. A disproportionate number of old to new dowels exists for panel 33 (fig. 6; see Heres, p. 86, fig. 5b). Before the recent restoration, this relatively small block of marble was reinforced with fourteen iron and three bronze rods, but for the new assembly five steel dowels were enough. Occasionally, new dowel holes needed to be drilled, especially for previously clamped relief panels that required an interior support. Thus, panel 11 received three (fig. 31), panel 34 two additional dowels.[70] In panel 5 (cat. no. 2) a dangerous large crack crosses the marble that if opened would cause more harm. Its

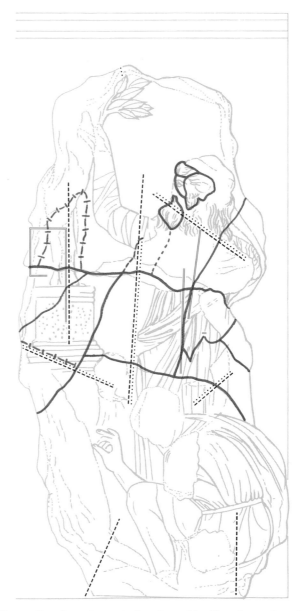

Fig. 30. Panel 1: schematic drawing with old and new dowels.

— — — — — — — steel dowel
· · · · · · · · · · · · · · bronze dowel
══════════ dowel hole
────────── fracture lines

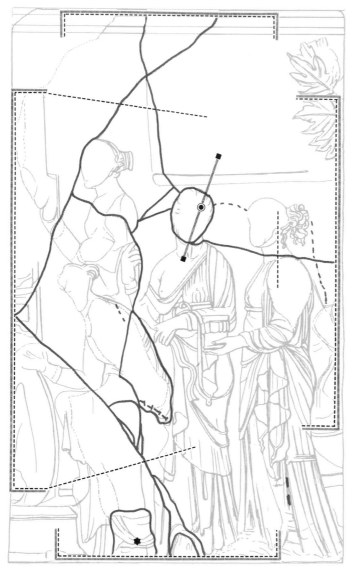

Fig. 31. Panel 11: schematic drawing with old and new dowels.

---------------- ✶ steel dowel

||||||||||||||||||||||||||||||||||| ■ iron dowel

◉ bronze dowel inside of steel dowel

—————————— fracture lines

progress needed to be stopped with a new diagonal dowel extending inward from an exterior clamp hole (fig. 32).[71]

During the third phase of the recent restoration, the old brick and cement supports were replaced with limestone blocks from the Auresina region in Friuli, Italy. This limestone was often used in ancient Aquileia and therefore is also known as "Roman stone." For this part of the work, the irregularly broken surfaces of the marble to be supported were copied with a silicone rubber mold, and the plaster casts obtained from the mold served as models for the chiseled stone supports. Yet it was difficult to fit the stone additions to the original panels. When possible they were not attached with adhesive but screwed down onto a bed of 30 percent lightweight polyester resin and 70 percent stone dust. Thus, at any time it will be possible to separate the original panel from the limestone support. Where additional support was necessary, in some cases glue was added.[72] The outer surface of the support stones was rasped in order to reinforce the character of the stone without giving the support too much prominence.

The final stages of the work concerned the filling of glued fractures and larger gaps between fragments. For this purpose, marble dust was added to acrylic resin, and for bigger areas plaster of paris was used, which was covered with a layer of marble dust with acrylic resin. In the case of panel 33, Bertolin filled the little gaps around the knee by using marble dust and acrylic resin. One of the few pieces from the Telephos frieze that is not in Berlin is a fragment from panel 38, a head from the welcoming scene in Argos (cat. no. 10). It is kept in the museum at Bergama, Turkey.[73] The general director of the administration of ancient art at Ankara, Rüstem Duyuran, allowed a cast to be made in 1962, which indeed fit the broken area on panel 38 exactly. Since the plaster reproduction of this head had become unsightly, Bertolin modeled a new reproduction.

For their new installation in Berlin, after their return from exhibition, the relief panels will be attached to the wall

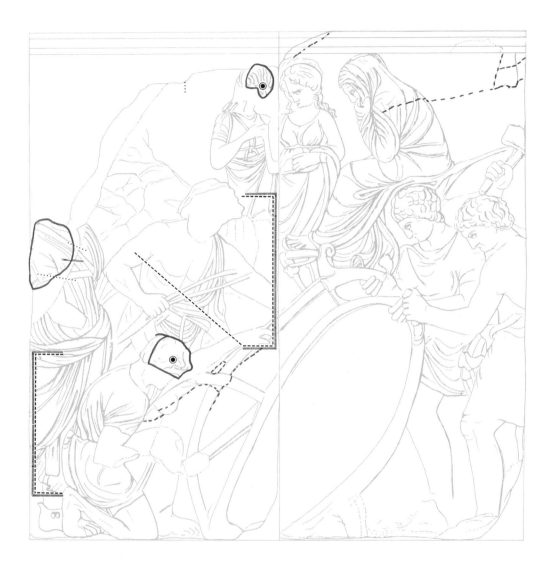

Fig. 32. Panels 5 and 6 (cat. nos. 2 and 3): schematic drawing
with old and new dowels.

----------------- steel dowel

|||||||||||||||||||||||||||||||||| iron dowel

..................... bronze dowel

============= dowel hole

◉ bronze dowel inside of steel dowel

━━━━━━━━━━━ fracture lines

with dowels in order to stabilize their weight. The new placement of the panels will conform to the consensus of the staff of the Antikensammlung. It was agreed that the frieze could not have exceeded the measurements of the walls of the interior court. (In his essay in this volume Heilmeyer summarizes the long and arduous discussions that resulted in the new arrangement.) The Telephos frieze has now been integrated into the Great Altar as a total work of art *(Gesamtkunstwerk)* and is more complete than had been previously assumed. For the first time it will be possible to place the corner panels into the inner corners of the court and the Telephos frieze will appear even closer to its original state.

CHARACTERISTICS OF THE TELEPHOS FRIEZE MARBLE

THOMAS CRAMER, KLAUS GERMANN,
AND F. JOHANN WINKLER

The occurrence of decorative marble is widespread throughout the Mediterranean area. The popularity of marble in buildings and for sculptures is based on qualities that are contingent upon marble's mineralogical composition. It is a compact crystalline rock of high strength that is polishable and does not put up too much resistance to the artist's tool. The varieties of white marble, which consist mainly of calcium carbonate (the mineral calcite), allow light to travel far into its crystals, which frequently reach a size measurable in millimeters. The reflected light endows the marble with an impression of vivid warmth. Admixtures, especially of minute grains of organic substances, are occasionally the cause for the typical banding of marble, and ferrous minerals tend to produce a golden yellow patina on weathered surfaces. These two features are also characteristics of certain parts of the Telephos frieze.

Geologically, marble emerged from calcareous shell remains of marine organisms. After these sediments were buried to greater depths in the earth, under conditions of high pressure and temperature, the originally small calcite crystals grew to such an extent that it is difficult to distinguish any of the original sediment structures. These transformations are called *metamorphism*. Orogenic processes and erosion of the covering sediments then caused the marble to rise to the surface again, where it could be quarried.

Many of the marble deposits mined in ancient times are today exhausted. For over a century an effort has been made to trace the provenance of the marble used for classical buildings and sculptures—that is, to locate the ancient quarries and deposits. Among other things, this research is conducted for the sake of reconstructing trade relations and routes or, for instance, tracing developments in ancient architecture. The late nineteenth-century German geologist Richard Lepsius, a pioneer in this field, was able to distinguish a number of different types of marble by sight and also with the polarizing light microscope.[1] Archaeologists still use his classifications to characterize "classical" marble. From his time on various mineralogical, chemical, and physical methods have been employed more or less successfully to define traits that are typical of the origins of marble used in architecture and art. Since marble even of different provenance can be quite similar in certain properties, it is now generally acknowledged that only combinations of traits indicate place of origin. Most revealing have been those features that derive their distinct qualities directly from the evolution of the marble, which are complex and often very dissimilar in detail. Such differences in evolution are, for example, created by varying depositional conditions in the sea or a varying extent of metamorphic alteration.

AN ANALYSIS OF THE MARBLE FROM THE TELEPHOS FRIEZE

The restoration of the Telephos frieze in 1995–96 offered the first opportunity to observe and to collect samples of this monument, in order to identify the marble with geoscientific methods and perhaps to determine its provenance.

While drilling new dowel holes or deepening existing ones, suitable drill cuttings were collected of up to 22 millimeters in diameter as well as marble powder for mineralogical-

petrological analysis. Some debris also was made available for further analysis. During the restoration, systematic observations already had been made using a magnifying glass in order to collect information on the degree of weathering, crystal size, coloring, layering and banding, and the marble's mineralogical composition. Subsequent quantitative analyses of mineralogical and geochemical characteristics conducted in the laboratory are yet to be done. Chemical and X-ray diffraction analyses confirm the assumption that the marble of the frieze consists almost exclusively of the mineral calcite ($CaCO_3$). Whereas approximately 1 percent of magnesium can be detected, the mineral dolomite (Ca Mg $[CO_3]_2$) cannot be traced. Of other minerals often found in marble, such as quartz and mica, there are only traces; this is also expressed in the very low content of silicone oxide (SiO_2) and aluminum oxide (Al_2O_3). While pulverizing the samples in a mill, we noticed a distinct, unpleasant smell, which nearly all samples gave off. This characteristic is also observed in other marbles from ancient times, and further analyses should reveal the cause. In polished sections very small opaque inclusions were identified as pyrite (FeS_2), which to some extent has oxidized to hematite (goethite), and also as organic substances similar to graphite. It is not improbable that these two components, along with other inclusions, cause the typical smell of the Pergamene marble.

The fabric and mineral composition of the marble were analyzed under a polarizing light microscope in 0.03-millimeter-thick polished sections. In polarized light a fascinating, diversified picture appears (fig. 1), that at first sight does not at all coincide with the rather uniform view by the naked eye. Single calcite grains of up to 4 millimeters in diameter are irregularly surrounded by smaller grains of less than 0.5 millimeter. As the average grain size is about 0.5 millimeter, the marble can be classified as fine to medium. The grain boundaries are not smooth but irregular and often sutured or indented. Coarse-grained recrystallized calcites were broken up by tectonic deformation. There are also other indi-

Fig. 1. Microphoto of a marble of the Telephos frieze. L. 2.1 mm. The different sizes of crystals, cleavage, and twin lamellae of the calcite are easily identifiable. Thin section of a drill-cutting of panel 16 (cat. no. 6) can be seen. Photo taken in polarized light with Nicols crossed.

cations of mechanical stress: nearly all the grains show up fissures along the rhombohedric cleavage and also include in part very thin, in other parts very wide, groups of twin lamellae. Up to three directions of these twin lamellae are found intertwined. In some areas they pass through the grain uninterrupted and complete; in other areas they are only outlined or bent. Undulatory extinction, subgrains, and anomalous biaxial optical character are further indications of the specific ordeal the original limestone went through before becoming Pergamene marble.

One of the most important auxiliary tools for the assignment of marble provenance is isotopic analysis of carbon and oxygen. The biggest advantage of this method lies in the minor amount of sample required for the procedure: only a few 10-milligram grains of marble are dissolved in phosphoric acid, the freed carbon dioxide is captured, and the varyingly heavy carbon- and oxygen-isotope components are then measured by a mass spectrometer.

In comparison, the isotopic pattern of the Telephos frieze marble (fig. 2) proves relatively unhomogeneous. This

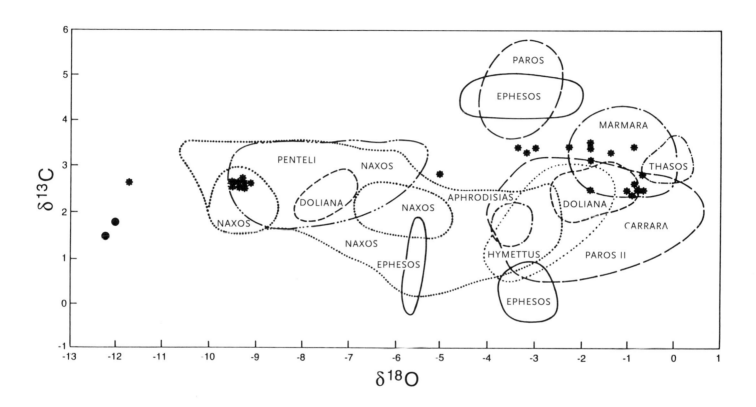

Fig. 2. Different marbles of the Telephos frieze in the carbon/
oxygen isotope diagram of the ancient Mediterranean marble
exploitation areas after Herz ("The Oxygen and Carbon Isoto-
pic Data Base for Classical Marble") supplemented for Paros
and Naxos after analysis by Germann et al. ("Provenance Char-
acteristics of Cycladic [Paros and Naxos] Marbles: A Multivari-
ate Geological Approach"). Stars: marble from the Telephos
frieze; filled circles: marble from Akkaia, north of Pergamon.

does not apply so much to the carbon isotopes as to the oxygen isotopes. The values for carbon isotopes, which are defined as deviations from a calcium carbonate standard, vary only insignificantly between +2.4 and +3.5 and therefore lie at the upper limit of the range, which is seen as normal for a lot of "ancient" marble, whereas the behavior of the oxygen isotopes differs completely. One can clearly discern two clusters of isotope combinations. In the marble samples from panels 1, 5, and 8 they are tightly packed and have sharp boundaries at -9.5; in the samples from panels 11, 34, 39, and 44 they extend between -1 and -3.5, and as low as -5. One single marble sample from panel 1 has extremely light oxygen at -11.7. This is surpassed by only two samples, which, however, are not from the frieze but from a marble deposit in the vicinity of Pergamon, from where they were taken in the last century.[2] Comparing the two isotopic marble groups under the microscope one finds that the samples with the lighter oxygen are distinguished by stronger tectonic deformation of the calcite fabric.

What preliminary conclusions can be reached from the isotope composition? Based on the isotope diagram for the classical Mediterranean marble districts (see fig. 2), some of the Pergamene marble fits into the Naxos field with a very minor scattering. The marble of the frieze, therefore, has some isotopic similarity to the marbles of the central Cyclades on the one hand and to the marbles of the Marmara region on the other. The similarity is also mirrored by some fabric characteristics, which can be identified with the help of the microscope. The extensive correspondence of all samples in respect to the carbon isotopy, which reacts less sensitively to metamorphism, could imply a common or at least a very similar parent rock for the different marbles. But what should we make of the strong divergence between the oxygen isotopes?

The isotopic composition of oxygen in marble is largely determined by the temperature during metamorphic alteration (to put it simply, the higher the temperature, the lighter the oxygen) and by interactions between carbonate rock and fluids of all kinds. If a carbonate rock is submitted to such fluids at any point during its evolution, to a certain extent it can take over those fluids' oxygen isotopy. The tendency of the oxygen isotopy to shift to lighter values during processes of weathering or soil storage of pieces of marble is known. But the differences of isotope ratios of oxygen observed here are much too pronounced to be explained with such recent interactions with surface or groundwater alone. Assuming that a relatively homogeneous parent rock existed, what remains is the interpretation that regions especially receptive to fluids during metamorphism and orogenic deformation could therefore have enabled the isotope ratios to shift to lighter values. As the marbles of Naxos demonstrate (see fig. 2), large temperature differences during metamorphism aid the development of a very large span of oxygen-isotope compositions, even in a comparatively small area.

But this does not end our search for the provenance of the marble. So far no reliable indications exist for assuming that a sufficient amount of marble was available in the vicinity of Pergamon. Although various smaller marble deposits in the surrounding area are known, evidence of larger ancient quarries is lacking. Apart from the many Western Anatolian districts supplying marble, which were already active in ancient times, for logistical reasons it is primarily the eastern Aegean islands of Lesbos, Psara, and Oinousai that come into question as the sources of marble used in Pergamon. Although thick marble sequences of up to three hundred meters in this region are known, no research of ancient quarries or on specific marble characteristics has been undertaken as yet. In order to attain a sufficiently satisfactory provenance determination it therefore is necessary to conduct a geologic exploration of this terrain to localize marble deposits and stone quarries, in addition to performing further laboratory analyses of the marble of the altar.

ARTIFICIAL STONE FILLS IN THE TELEPHOS FRIEZE

JOSEF RIEDERER

At the time of the original assembly of the Telephos frieze in Berlin and in following restorations, the losses in the frieze were filled with an artificial stone. Qualitative analyses were carried out to determine the nature of these fills: X-ray fluorescence spectroscopy was employed for chemical analysis; X-ray diffraction for the detection of mineral phases; thin-section microscopic analysis for the determination of the nature, grain size, and quantity of additives; and microchemical analysis for the identification of organic substances. Material analyses were of particular interest for the restoration documentation of the frieze, as artificial stone fills were commonplace in the nineteenth century. Therefore the result of these analyses could give solid evidence for the type of fill materials used for the restoration of a highly prominent archaeological monument.

Until the nineteenth century, hydrated lime and gypsum were the only mineral binding agents employed for the production of mortars or fills. Substances containing casein, such as milk, were added to the lime mortars in order to improve their durability. In the nineteenth century an additional two mineral-binding agents were invented to improve the quality of synthetic stone—cement and water glass (sodium silicate or sometimes potassium silicate). Magnesia mortars with burnt magnesite (MgO) and magnesium chloride (MgCl2) as binders were also developed at this time, in lieu of caustic (CaO), or hydrated, lime (Ca[OH]2). Moreover, it was discovered that the addition of salts such as alum and borax improved the quality of fill materials as well. And finally, it was discovered at the same time that very durable fill materials of great strength could be created by adding glycerol to lead combinations. Additives with resins, such as dammer, mastic, or shellac, also were employed for creating synthetic stone fills, whereas fills based on glue were more rarely applied in stone restoration. Smelting fills, in which fragments were bound by low-smelting glass at a high temperature, were uncommon.

Thus, at the time of the reconstruction of the Telephos frieze, the following basic types of fill materials were available:

INORGANIC ARTIFICIAL STONE

Lime mortar
Lime mortar with hydraulic components
Cement mortar
Gypsum mortar
Magnesia mortar
Water-glass fills
Fills containing chloride
Sulphur-based fills

ARTIFICIAL STONE WITH ORGANIC ADDITIVES

Lime-casein mortar
Casein fills with inorganic additives
Gypsum mortar with organic additives
Oil-based fills
Resin- and wax-based fills
Glue-based fills
Smelting fills

These basic types of fills expanded into a great number of variations, as diverse loading materials could be added to the binding agent. Sands, marble dust, brick dust, glass powder, burnt bones, clay, fluorite, barium sulphate, sodium carbonate, and numerous other combinations of this kind were common. Further variations were caused by the use of different types of organic additives to the lime-casein mortars. In addition to milk, pure casein, egg white, and blood, gum arabic or rye flour was frequently added. Moreover brandy, garlic cloves, and snail saliva were recommended in nineteenth-century literature. A search on that literature turned up over two hundred recipes for stone fills. These fills were either mixed by restorers themselves, based on their experience, or else were bought ready for use.

X-ray diffraction analysis of the fills in the Telephos frieze revealed hydrous magnesium hydrogen chloride ($Mg_3[OH]_5Cl \cdot 4H_2O$) and calcite to be the main components of the great majority of the fills. Microscopic analysis of thin polished sections proved that calcite in the form of marble dust could be found solely as an additive. Therefore the prevailing stone fills in the Telephos frieze can be identified as a magnesia mortar with marble dust. Such mortars were prepared by mixing magnesium oxide with magnesium chloride and an appropriate additive. Nineteenth-century recipes recommend the addition of magnesite, magnesium sulphate, calcium sulphate, barium chloride, magnesium fluoride, lead hydroxide, and water glass for the improvement of this mortar. None of these additives could be traced by chemical analyses. Lime and magnesium oxichloride were also recommended as additives, but as the former is too similar to marble dust and the latter too similar to the magnesium chloride in pure magnesia mortar, these two additives cannot be analytically discerned as independent combinations. Chemical analysis of the mortars could distinguish the main components—magnesium, calcium, chloride, and also isolated increased proportions of lead and zinc. Thus, the proposed addition of lead hydroxide in the recipes cannot be completely ruled out, although it is more probable that lead white and zinc white were added in order to increase the whiteness of the fills. Organic substances could not be detected at all in the magnesia mortars. This result coincides with the nineteenth-century recipes, which do not suggest mixtures of magnesium combinations with organic components.

With the aid of thin-section microscopy, magnesia mortars could be subdivided, as grain size and grain-size dispersion is subject to distinct deviations. Of the eighteen microscopically analyzed fill samples, sixteen consist of a magnesia mortar. Of these sixteen samples of magnesia mortar, eleven contain marble dust as an additive. These eleven samples with marble components could be subdivided into six samples with medium-sized marble particles and larger marble inclusions, three samples with fine- to medium-sized marble particles, and two samples with larger-grained marble inclusions. Aside from the eleven samples with marble components, four magnesia mortars are found, which are entirely compact and do not contain any larger-grained components. One mortar contains quartz sand as well as marble dust.

The two remaining fills, which do not consist of magnesia mortar, are different kinds of lime mortars. One of these fill materials contains medium-sized marble particles and larger marble inclusions; the other is a lime mortar with a minor cement portion and quartz sand as an additive.

Consequently, the following types of fill materials can be distinguished (see Table 1):

The magnesia mortars are very similar in their compounds; the different grain sizes are based primarily on the intended purpose.

The microscopic data of the thin polished sections can be stated quantitatively (see Table 2):

In summary, the conclusion reached after analyzing the fills from the Telephos frieze is that the prevailing portions

| GROUP | MORTAR GROUP | ADDITIVE | NUMBER OF SAMPLES |
|---|---|---|---|
| a_1 | magnesia mortar | medium-grained and larger marble particles | 6 |
| a_2 | magnesia mortar | fine- to medium-grained marble particles | 3 |
| a_3 | magnesia mortar | larger-grained marble particles | 2 |
| a_4 | magnesia mortar | without marble admixture | 4 |
| a_5 | magnesia mortar | marble dust and quartz sand | 1 |
| b | lime mortar | medium-grained and larger marble particles | 1 |
| c | lime-cement mortar | quartz sand | 1 |

Table 1.

| MATERIAL GROUP | SAMPLE | NO. OF GRAINS | GRAIN SIZE | | SCREEN CURVE | | | | MIXTURE PROPORTION | MAX. PORE SIZE |
|---|---|---|---|---|---|---|---|---|---|---|
| | | n/mm^2 | mm | max. mm | <0.1 mm | 0.1–0.2 mm | 0.2–0.4 mm | >0.4 mm | % | mm |
| a_1 | 19 | 50 | 0.2 | >1 | 25 | 22 | 1 | 2 | 70 | 0.5 |
| a_1 | 20 | 40 | 0.2 | >1 | 20 | 16 | 2 | 2 | 65 | 0.4 |
| a_1 | 26 | 55 | 0.2 | >1 | 30 | 22 | 1 | 3 | 75 | 0.6 |
| a_1 | 28 | 50 | 0.2 | >1 | 25 | 23 | 1 | 1 | 70 | 0.6 |
| a_1 | 29 | 45 | 0.2 | >1 | 20 | 16 | 2 | 2 | 60 | 0.4 |
| a_1 | 30 | 50 | 0.2 | >1 | 25 | 21 | 2 | 2 | 70 | 0.6 |
| a_2 | 17 | 100 | 0.2 | 0.4 | 50 | 45 | 5 | - | 80 | 0.4 |
| a_2 | 31 | 120 | 0.2 | 0.5 | 60 | 55 | 5 | - | 80 | 0.5 |
| a_2 | 32 | 120 | 0.2 | 0.5 | 60 | 55 | 5 | - | 80 | 0.5 |
| a_3 | 15 | 60 | 0.2 | 1 | 35 | 15 | 8 | 2 | 70 | 0.6 |
| a_3 | 16 | 60 | 0.2 | 1 | 35 | 15 | 8 | 2 | 70 | 0.6 |
| a_4 | 18 | 500 | 0.01 | 0.02 | 500 | - | - | - | - | - |
| a_4 | 21 | 700 | 0.01 | 0.02 | 700 | - | - | - | - | - |
| a_4 | 23 | 600 | 0.01 | 0.02 | 600 | - | - | - | - | 0.8 |
| a_4 | 24 | 500 | 0.01 | 0.02 | 500 | - | - | - | - | - |
| a_5 | 25 | 160 | 0.1 | 0.3 | 155 | 4 | 1 | - | 50 | - |
| b | 27 | 50 | 0.2 | >1 | 30 | 14 | 3 | 3 | 75 | 0.6 |
| c | 22 | 6 | 0.3 | 1 | 1 | 1 | 2 | 2 | 40 | 0.8 |

Table 2.

consist of magnesia mortars, which are largely mixed with marble dust. Depending on the intended purpose, the grain size of the marble dust varied so that all grades of grain sizes occur, ranging from compact mortars to mortars with marble particles of up to 1 millimeter. Pure lime mortars are more rare, and only in one case could a cement mortar be detected.

ABBREVIATIONS

AA
Archäologischer Anzeiger

AbhBerl
Abhandlungen der Deutschen Akademie der Wissenschaften zu Berlin

AbhMainz
Abhandlungen der Geistes- und Sozialwissenschaftlichen Klasse. Akademie der Wissenschaften und der Literatur in Mainz

ABV
Beazley, J. D. Attic Black-figure Vase-painters (Oxford, 1956)

AJA
American Journal of Archaeology: The Journal of the Archaeological Institute of America

AM
Mitteilungen des Deutschen Archäologischen Instituts, Athenische Abteilung

AM-BH
Mitteilungen des Deutschen Archäologischen Instituts, Athenische Abteilung. Beiheft

AnatSt
Anatolian Studies: Journal of the British Institute of Archaeology at Ankara

ANSMN
American Numismatic Society Museum Notes

AntK
Antike Kunst

AntK-BH
Antike Kunst. Beiheft

AntW
Antike Welt. Zeitschrift für Archäologie und Kulturgeschichte

Archaeology
Archaeology: An Official Publication of the Archaeological Institute of America

ARV²
Beazley, J. D. Attic Red-figure Vase-painters, 2d ed. (Oxford, 1963)

AvP
Altertümer von Pergamon (from 1885)

BCH
Bulletin de correspondance hellénique

BdA
Bolletino d'arte

BICS
Bulletin of the Institute of Classical Studies of the University of London

Bjb
Bonner Jahrbücher des Rheinischen Landesmuseums in Bonn und des Vereins von Altertumsfreunden im Rheinlande

BSA
Annual of the British School at Athens

BullCom
Bullettino della Commissione archeologica comunale di Roma

CAH
Cambridge Ancient History

Chiron
Chiron. Mitteilungen der Kommission für alte Geschichte und Epigraphik des Deutschen Archäologischen Instituts

DiskAB
Diskussionen zur Archäologischen Bauforschung

EAA
Enciclopedia dell'arte antica, classica e orientale (Rome, 1958–66)

FdD
Fouilles de Delphes, école française d'Athènes

FGH
Jacoby, Felix. Die Fragmente der griechischen Historiker (Berlin-Leiden, 1923–58)

FuB
Forschungen und Berichte. Staatliche Museen zu Berlin

GGA
Göttingische gelehrten Anzeiger

Gnomon
Gnomon. Kritische Zeitschrift für die gesamte klassische Altertumswissenschaft

Hesperia
 Hesperia: Journal of the American School of Classical Studies at Athens

IstForsch
 Istanbuler Forschungen

IstMitt
 Mitteilungen des Deutschen Archäologischen Instituts, Abteilung Istanbul

IstMitt-BH
 Istanbuler Mitteilungen. Beiheft

IvP
 Die Inschriften von Pergamon (Berlin, 1890–1969) = *AvP*, vol. 8

JdI
 Jahrbuch des Deutschen Archäologischen Instituts

JdI-EH
 Jahrbuch des Deutschen Archäologischen Instituts. Ergänzungsheft

JKF
 Jahrbuch für kleinasiatische Forschung

JPKS
 Jahrbuch der preussischen Kunstsammlungen

JSav
 Journal des savants

KölnJb
 Kölner Jahrbuch für Vor- und Frühgeschichte

KUB
 Keilschrifturkunden aus Boghazköi

LIMC
 Lexikon Iconographicum Mythologiae Classicae (Zurich and Munich, from 1974)

MarbWPr
 Marburger Winckelmann-Programm

MVAG
 Mitteilungen der Vorderasiatisch-Aegyptischen Gesellschaft

Oikumene
 Oikumene. Studia ad historiam antiquam classicam et orientalem spectantia (Budapest: Akadémie Kiadó)

ÖJh
 Jahreshefte des Österreichischen archäologischen Instituts in Wien

PECS
 Princeton Encyclopedia of Classical Sites, ed. R. Stillwell et al. (Princeton, 1976)

PergForsch
 Pergamenische Forschungen

POxy
 Oxyrhynchus Papyri, ed. B. P. Grenfell and A. S. Hunt (London, from 1898)

PP
 La parola del passato. Rivista di studi antichi

RA
 Revue archéologique

RE
 Paulys Real-Encyclopädie der klassischen Altertumswissenschaft, ed. G. Wissowa et al. (from 1894)

REA
 Revue des études anciennes

REG
 Revue des études grecques

RM
 Mitteilungen des Deutschen Archäologischen Instituts, Römische Abteilung

RM-EH
 Mitteilungen des Deutschen Archäologischen Instituts, Römische Abteilung. Ergänzungsheft

SBBerl: Phil.-hist. Klasse
 Sitzungsberichte der Deutschen Akademie der Wissenschaften zu Berlin, Philosophisch-historische Klasse

VDI
 Vestnik drevnej istorii

Xenia
 Xenia. Semestrale di antichità

ZbK
 Zeitschrift für bildende Kunst

ZPE
 Zeitschrift für Papyrologie und Epigraphik

GLOSSARY

abacus the uppermost element of a capital; molded in the Ionic and Corinthian orders, plain in the Doric order

acropolis in a Greek city, a fortified place on a commanding height

acroterion (pl. **acroteria**) an ornamental finial or figure on a pediment

aedicula a small shrine, chapel, or house

agora an assembly or place of assembly, especially a marketplace; often the commercial and political center of a city

andron (pl. **andrones**) men's apartments in a house, especially the banqueting hall

anepigraphic without title or inscription

anta (pl. **antae**) a pilaster or pier partially projecting from the lateral wall on either side of a door or in a corner or serving as engaged column; such columns are said to be **in antis**

anthemion a lotus-palmette design in a continuous pattern

apophyge the concave curve where the end of a column spreads into its base or capital

apse a semicircular or polygonal projection of a building or a recess in a wall

apsidal describing a building containing an apse

architrave the lowest element of an entablature, a lintel or a beam resting as a span on the top of capitals or two columns; epistyle

ashlar regular masonry of squared, hewn, or dressed stone with horizontal courses and vertical joints

astynomos (pl. **astynomoi**) a Greek magistrate in charge of public safety, streets, and buildings

balteus a raised band that encircles the center of the return side of an Ionic capital

basileion (pl. **basileia**) a palace or royal dwelling; in the plural, a royal district

bathron a base or pedestal

boss an ornamental projecting piece or block used in architecture

bucranium (pl. **bucrania**) a bull's head or an ox skull carved in frontal view, either in a panel or combined with swags or festoons

calathus a basket, narrow at the base, for holding wool or fruit or carried in procession in honor of Demeter as a symbol of abundance and fruitfulness; the capital of a column

cavetto (pl. **cavetti**) a concave molding with a curve of about 90 degrees, adopted from the typical Egyptian cornice

cella the enclosed chamber or the inmost part of a temple

chiton a tunic or loose garment of varying length, worn by Greek men and women

chlamys a short mantle or cloak, clasped at the shoulder, worn by Greek men

coffer a decorative sunken panel in a vault, ceiling, dome, or even cornice

colonnade a series of columns set at regular intervals, usually supporting a roof or series of arches

Corinthian the order of architecture invented supposedly at Corinth as a substitute for the Ionic; characterized by a bell-type capital decorated with volutes and acanthus leaves

cornice a horizontal molding projecting along the top of a wall or building; the top part of an entablature

corona the top projection of a cornice with a vertical face

cushion the part of a capital that projects outward; the top stone of a pier that supports an arch

cyma recta a wavelike molding of double curvature in which the concave part at the top protrudes

cyma reversa a wavelike molding of double curvature in which the convex part protrudes

dentil a series of small rectangular blocks, projecting like teeth, as from under the molding of a cornice

diastyle characterized by widely spaced columns

dipteros a temple or porch front surrounded by two rows of columns; a double peristyle

Doric the order of architecture that evolved in the Dorian and western regions of Greece and spread throughout the Greek world; characterized by fluted columns with plain capitals, triglyphs, and metopes

dowel a peg or pin of wood, lead, iron, or bronze to secure blocks to each other or to a hole on the surface

echinus a convex, circular molding under the abacus of a Doric column; a similar molding with egg-and-dart pattern under the cushion and between the volutes of an Ionic capital

egg-and-dart a decorative molding used in the Ionic ovolo profile, consisting of an egg-shaped form alternating with a dart- (or arrow-) shaped pattern in a continuous design

entablature a horizontal structure supported by columns, consisting of architrave (supporting member), frieze (decorative element), and cornice (crowning and projecting portion)

epistyle *see* **architrave**

ethnikon a group of people living together, an indication of nationality

eustyle characterized by well-spaced columns

exedra (pl. **exedrae**) a semicircular seat, open recess, or bay where conversations were held

exergue the space on a coin or medal below or around the images or designs, often used for the date, place, etc.; or the inscription in this space

fascia the flat horizontal planes into which the architrave is subdivided

fillet a narrow, flat molding separating other moldings; a narrow band between flutes of Ionic columns

flange an external or internal rim or rib for strength, guiding, or attachment to another piece

flute a long, rounded, vertical groove in the shaft of a column

frieze the decorative element of the entablature; any horizontal band carved with relief sculpture

geison the Greek term for the cornice or corona

gorge a band or fillet around the shaft under the capital; cavetto

guttae the small cylindrical drops under the triglyphs or mutules in the Doric entablature

gymnasium a school for physical training; a school

heroon a shrine of a hero

in antis *see* **anta**

insula (pl. **insulae**) a block of apartments used as separate dwellings

Ionic the order of architecture that evolved in the Ionian (Asia Minor) and eastern Greek regions and spread throughout the Greek world; characterized by ornamental scrolls (spiral volutes) on the capitals

isodomic walls built in equal courses

joggle a joint made between two surfaces of building material by cutting a notch or tooth in one and making a projection in the other to fit into it, to prevent slipping; a dowel for joining two adjacent blocks of masonry

kline (pl. **klinai**) a couch, used at meals or for a bed

krepis the foundation or basement of a building or altar

Lesbian cyma another name for the cyma reversa

lewis a wedge-shaped iron tool used for lifting heavy stones by inserting its dovetailed ends into a dovetailed opening in the top of the block

merlon the projecting part of a battlement or parapet

metope in Doric architecture, the interstice between the triglyphs, sometimes carved in relief

mouseion a philosophical school and library

mutule a flat block projecting beneath the soffit and supporting the corona of a Doric cornice

naiskos a shrine; diminutive of **naos**

naos the cella of a temple

nymphaion a sanctuary of the Nymphs; a chamber, sometimes subterranean, with flowers, plants, and a fountain or running water

oikos (pl. **oikoi**) a house or dwelling place; room, chamber, or hall; household, domestic establishment

omphalos the center or middle point, later the round stone in Apollo's temple at Delphi, regarded as the center of the world; keystone of an arched vault; tomb or vault

opisthodomos a chamber or porch in the rear of a temple, sometimes used as a treasury

orthostat the vertical stone or shaft forming the lower course of a wall

ovolo a convex molding, in cross section a quarter-round with the maximum projection at the top

palaestra a public place for physical training, in wrestling, boxing, and athletics, requiring a small space

peplos a large, one-piece upper garment or mantle, draped about the body, worn by Greek women

peribolos an enclosure; a temple precinct

peripatos a (covered) walk

peripteros a building surrounded by a single row of columns

peristasis (pl. **peristases**) same as peristyle; a colonnade or portico surrounding a building; in Pergamene architecture, the open space surrounding terrace houses to prevent mudslides

peristyle an inner court or building enclosed by a colonnade; a row of columns forming an enclosure or supporting a roof

phyle the largest political subdivision in the ancient Greek state

pilaster an engaged or a semidetached rectangular column or pier

plinth the square block forming the base of a column or pedestal; a course of brick or stone along the base of a wall

polos a tall, cylindrical headdress

polyglossia having many tongues, voices, or languages

portico a porch or covered walk, consisting of a roof supported by columns, often at the entrance to a building

prodomus the porch of a house

pronaos the front porch of a temple or cella

propylon a gateway or portico before a building or group of buildings; entrance to the temenos of a temple

prostas another term for prodomus or pronaos

prostyle a temple fronted by a portico whose columns extend in a line across the front

prothesis the laying out of the dead

prytancion a building for the meeting of the senate committee

pseudodipteral a dipteral temple without the inner row of columns

pseudo-isodomic masonry of squared stone (ashlar) built in irregular, i.e., alternating low and high, courses

pyknostyle characterized by very closely spaced columns

pyxis a vase or jar with a cover used as a container

rabbet a groove or cut made in the edge of a board for another piece to be fitted into to form a joint

regula in the Doric order, a smooth stone band under the taenia below each triglyph

ressaut any projection from the plane of a wall or surface

risalite the entire architectural projection of a building or structure

rosette a circular floral ornament with petals

scotia a deep, concave, and sometimes semicircular molding, especially at the base of a column

sima the gutter of a building, on the gables or flanks

socle a projecting footing of a wall column or pedestal

soffit the exposed underside of an architrave, an arch, or a cornice

spira an element resembling coils in form, such as the base of Ionic, Corinthian, and other columns

stele (pl. **stelai**) an upright stone slab or pillar carved with reliefs or inscriptions

stoa in Greek architecture, a building or colonnade having its roof supported by columns in the front and a wall at the back; portico

stud an ornamental projecting knob or the like used in architecture; any upright piece or support used in a building

stylis a mast used to carry a flag at the stern; a naval standard in the form of a pole with crossbar

stylobate a continuous base or platform for a row of columns

stylopinakion (pl. **stylopinakia**) a pillar with figures on it

systolos characterized by columns two diameters apart

systyle characterized by fairly closely spaced columns

taenia a band between the frieze and the architrave of a Doric entablature; ribbon headband

temenos a sacred precinct

thyrsos a staff wreathed in ivy and vine leaves and tipped with a pinecone, carried by the devotees of Dionysos

torus a large convex molding, fluted horizontally, used at the upper part of the base of an Ionic or a similar column

trachyte a fine-grained, light-colored, extensive, igneous rock

trapeza a table; a table dedicated to the gods for offerings

trigylph in a Doric frieze, a rectangular, projecting block separating the metopes, marked by two vertical grooves and two chamfers

trochilus the Greek term for scotia

truss an architectural bracket or ornamental block placed under a projecting cornice

tympanum the recessed triangular space enclosed by the cornices of the pediment, often enriched with sculpture

via the incline between the mutules in the soffit of the Doric cornice

volute the scroll, either spiral or floral in design, set under the abacus of an Ionic or a Corinthian capital

ENDNOTES

SCHULTZ, "THE COINAGE OF PERGAMON UNTIL THE END OF THE ATTALID DYNASTY (133 B.C.)"

Works Cited and Further Reading

GENERAL

Boehringer, Christof. "Münzen." In *Pergamon. Ausstellung in Erinnerung an Erich Boehringer*. Offenbach: Giese-Druck, 1972.

von Fritze, Hans. *Die Münzen von Pergamon*. Berlin: Königliche Akademie der Wissenschaften, 1910.

Mørkholm, Otto. "Some Pergamene Coins in Copenhagen." In *Studies in Honor of Leo Mildenberg*. Edited by A. Houghton et al., 181–92. Wetteren: Editions Numismatique Romain, 1984.

PERGAMON AS A MINT OF LYSIMACHOS AND OF THE SELEUCIDS

Newell, Edward T. *The Pergamene Mint under Philetaerus*. New York: The American Numismatic Society, 1936.

———. *The Coinage of the Western Seleucid Mints from Seleucus I to Antiochus III*. (New York: The American Numismatic Society, 1941).

Thompson, Margaret. "The Mints of Lysimachus." In *Essays in Greek Coinage Presented to Stanley Robinson*, 163–82. Oxford: Clarendon Press, 1968.

THE ATTALID SILVER COINAGE DOWN TO THE PEACE TREATY OF APAMEA (188 B.C.)

Imhoof-Blumer, Friedrich. *Die Münzen der Dynastie von Pergamon*. Berlin: Königliche Akademie der Wissenschaften, 1884.

Kleiner, Fred S. "The Alexander Tetradrachms of Pergamum and Rhodes." *ANSMN* 17 (1971): 95–125.

Le Rider, Georges. "Les Tétradrachmes attalides au portrait de Philétaire." In *Florilegium Numismaticum. Studia in honorem U. Westermark edita*, 233–45. Stockholm: Svenska Numismatiska Föreningen, 1992.

Price, Martin Jessop. *The Coinage in the Name of Alexander the Great and Philip Arrhidaeus. A British Museum Catalogue*. Zurich: The Swiss Numismatic Society, and London: The British Museum Press, 1991.

Westermark, Ulla. *Das Bildnis des Philetairos von Pergamon. Corpus der Münzprägung*. Stockholm, Göteborg, and Uppsala: Almquist and Wicksell, 1960.

SOME MORE IMPORTANT COIN HOARDS CONTAINING ATTALID TETRADRACHMS

Boehringer, Christof. "Hellenistischer Münzschatz aus Trapezunt 1970." *Schweizerische numismatische Rundschau. Revue Suisse de Numismatique* 54 (1975): 37–64.

Davesne, Alain, and Georges Le Rider. *Le Trésor de Meydancikkale (Cilicie Trachée, 1980)*. Paris: Editions Recherches sur les Civilisations, 1989.

Olcay, Nekriman, and Henry Seyrig. *Le Trésor de Mektepini en Phrygie*. Paris: Librarie Orientaliste Paul Geuthner, 1965.

MUNICIPAL AND ATTALID BRONZE COINAGE DOWN TO THE PEACE TREATY OF APAMEA (188 B.C.)

Westermark, Ulla. "Bronze Coins of Pergamon." *Numismatica e antichità classiche. Quaderni ticinesi* 20 (1991): 147–59.

THE ATTALID SILVER COINAGE AFTER THE PEACE TREATY OF APAMEA (188 B.C.)

Bauslaugh, Robert A. "The Unique Portrait Tetradrachm of Eumenes II." *ANSMN* 27 (1982): 39–51.

———. "Cistophoric Countermarks and the Monetary System of Eumenes II." *Numismatic Chronicle* 150 (1990): 39–66.

Drew-Bear, Thomas, and Georges Le Rider. "Monnayage cistophorique des Apaméens, des Praipénisseis et des Corpéni sous les Attalides. Questions de géographie historique." *BCH* 115 (1991): 361–76.

Harl, Kenneth W. "Livy and the Date of the Introduction of the Cistophoric Tetradrachma." *Classical Antiquity* 10 (1991): 268–97.

Kleiner, Fred S. "Further Reflections on the Early Cistophoric Coinage." *ANSMN* 25 (1980): 45–52.

Kleiner, Fred S., and Sydney P. Noe. *The Early Cistophoric Coinage*. New York: The American Numismatic Society, 1977.

Le Rider, Georges. "Un Tétradrachme d'Athéna Niképhoros." *Revue numismatique,* 6th ser., 15 (1973): 66–79.

———. "La Politique monétaire du royaume de Pergame après 188." *JSav* (1989): 163–89.

———. "Un Groupe de cistophores de l'époque attalide." *BCH* 114 (1990): 683–701.

Mattingly, Harold B. "The Portrait Coin of Eumenes II of Pergamon." In *Actes du XIe Congrès International de Numismatique,* Brussels, 8–13 September 1991, vol. 1, 281–82. Louvain-la-Neuve: Séminaire de Numismatique Marcel Hoc, 1993.

Mørkholm, Otto. "Some Reflections on the Early Cistophoric Coinage." *ANSMN* 24 (1979): 47–61.

Nicolet Pierre, Hélène. "Monnaies de Pergame." In *Kraay-Mørkholm Essays: Numismatic Studies in Memory of C. M. Kraay and O. Mørkholm,* 203–16. Louvain-la-Neuve: Institut Supérieur d'Archéologie et d'Histoire de l'Art, 1989.

Seyrig, Henry. "Monnaies hellénistisques, V: Questions cistophoriques." *Revue numismatique,* 6th ser., 5 (1963): 22–31.

Westermark, Ulla. "The Portrait Coin of Eumenes II of Pergamon." In *Lagom. Festschrift für Peter Berghuus zum 60. Geburtstag am 20. November 1979,* 19–23. Münster: Dombrowski, 1981.

THE COINAGE OF THE USURPER ARISTONIKOS

Adams, John Paul. "Aristonikos and the Cistophoroi." *Historia* 29 (1980): 302–14.

Kampmann, Michel. "Aristonicos à Thyatire." *Revue numismatique,* 6th ser., 20 (1978): 38–42.

Robinson, E. S. G. "Cistophori in the Name of Eumenes." *Numismatic Chronicle,* 6th ser., 14 (1954): 1–8.

HOEPFNER, "THE ARCHITECTURE OF PERGAMON"

1. Rostovtzeff, *Hellenistic World.*

2. The excavators of Pergamon, Carl Humann, Alexander Conze, Wilhelm Dörpfeld, and Theodor Wiegand, together with their colleagues, published the buildings of the city in detailed preliminary reports and numerous volumes of the *Altertümer von Pergamon.* But a new study that does the monuments proper justice has not yet been started.

3. Xenophon *Hellenica* 3.1.6 and *Anabasis* 7.

4. Conze, in *Stadt und Landschaft, AvP,* vol. 1, no. 2, called this "Räubereivorgänge." Hansen, *Attalids,* 9, compares the fate of the Gongylids, slightly exaggerated, with that of Themistokles who, after his flight, was offered the rule of the city of Magnesia by the Persian king.

5. Schalles, "Kulturpolitik," 5ff., thinks that Pergamon was influenced by Greek culture already by the time of the Diadochi, and that the temple of Athena is of that time. But Strabo (13, 622, 4) calls Pergamon at the time of Philetairos not a city but *heryma,* which means "fortified place." See also Radt, *Pergamon,* 20ff.

6. Kawerau, in Schazmann, *Gymnasion, AvP,* vol. 6, 11f.

7. Günther Garbrecht, "Die Wasserversorgung des antiken Pergamon," in *Die Wasserversorgung antiker Städte. Pergamon, Recht/Verwaltung. Brunnen/ Nymphäen. Bauelemente* (Mainz am Rheim: Philipp von Zabern, 1987), 28, is of the opinion that the tower and the cistern were connected to the pressure pipeline, which could, however, only be traced as far as the arsenal below.

8. Schrammen, *Der grosse Altar, AvP,* vol. 3, no. 1, 174f., after Richard Bohn, thinks that the remains on the highest point of Pergamon are of the altar that Pausanias (*Puriegeta* 5.13.8) compares to another ash altar at Olympia. Indications of ash or traces of mortar, which would point to a cistern, were not found: "Aber erst das sorgfältige Reinigen und Auskratzen aller Felsspalten liess die Spuren eines rechteckigen, etwa 18 m im Geviert messenden Raumes erkennen, zu dem auf der Westseite eine Treppe hinaufführte."

9. Although Kawerau interpreted it as a residential tower, Wiegand disagreed and called it a fortification tower, in Schazmann, *Paläste, AvP,* vol. 5, 11–12. But it remains unclear why the tower was erected on the inside of the city wall. Perhaps later the tower served as a treasury vault and archives.

10. Lothar Haselberger, "Der Paläopyrgos von Naussa auf Paros," *AA* (1978): 345–75; Hans Lohmann, "Ein Turmgehöft klassischer Zeit in Thimari (Attika)," *AM* 108 (1993): 101–49, and "Das Kastro von H. Giorgios ('Ereneia')," *MarbWPr* 1988 (1990): 65 n. 160, with extensive objections to the older theory that in many instances the towers were signal- or watchtowers corresponding to a system of such towers. Most of them were private dwellings or defense towers. On towers in rural areas, see W. Kendrick Pritchett, *The Greek State at War,* pt. 5 (Berkeley and Los Angeles: University of California Press, 1991), 352–58.

11. See R. Weil, "Von den griechischen Inseln," *AM* 2 (1877): 62, on inscriptions and country residences on Tenos.

12. The remarkable tower of Hagia Marina, 11 m long on a side, has four stories and merlons. The entrance door was placed 2 m above ground for protection and could only be reached with a ladder; Gabriel Welter, "Von griechischen Inseln: Keos I," *AA* (1954): 48–93. E. Schaubert made exact drawings (Schaubert's estate, now in the Byzantine Museum in Athens). I am indebted for this information to A. Pagageorgiou.

13. Robert Koldewey, *Die antiken Baureste der Insel Lesbos* (Berlin: Reimer Verlag, 1890), 22–27, pl. 27, 62, emphasizes that the towers on Eresian territory are not a series of watchtowers but rather are towers belonging to farms. The tower near Agra (pl. 27) measures 11.04 m on a side, and the tower near Sigri with inside partitioning, 8.36 m.

14. W. Hoffmann, in *RE* 19, no. 2, 2158, s.v. "Philetairos," referring to Strabo 13, 623 and Pausanias 1.10.4, calls the motive for Philetairos's breach of trust his fear of being persecuted as a friend of Agathokles. This could be a later Pergamene way of reading the text. If one believes that Philetairos had his

own plans for Pergamon, it is more likely that he was looking for an opportunity to become independent.

15. Schalles, "Kulturpolitik," 6ff., expresses strong doubts about the farsighted politics of Philetairos.

16. Ernst Fabricius and Adolf Trendelenburg, "Pergamon," in *Denkmäler des klassischen Altertums zur Erklärung des Lebens der Griechen und Römer in Religion, Kunst und Sitte*, vol. 2, ed. Karl August Baumeister (Munich and Leipzig: R. Oldenbourg, 1887), 1209.

17. Wolfram Hoepfner, "Von Alexandria über Pergamon nach Nikopolis. Städtebau und Stadtbilder hellenistischer Zeit," in *Akten des 13. Internationalen Kongresses für Klassischen Archäologie*, Berlin 1988 (Mainz: Verlag Philipp von Zabern, 1990), 282ff.

18. Hierapolis (modern Pamukkale) was probably founded by Eumenes II, and Attalaia (modern Antalya), presumably by Attalos II; *PECS*, 390f., s.v. "Hierapolis" (G. E. Bean); and 111, s.v. "Attalaia" (G. E. Bean); contra Schalles, "Kulturpolitik," 31f.

19. Alfred Philippson, in Conze, *Stadt und Landschaft*, AvP, vol. 1, nos. 1–2, 43ff. and 149ff.

20. According to Vitruvius 2.8.10, Maussolos had his palace built mostly of marble from the Prokonnesos. On those quarries, see N. Asgary, in *Proceedings of the Tenth International Congress of Classical Archaeology, Ankara-Izmir 1973*, 2 vols. (1978), 1:467ff.; *EAA* 4:869 (Ward-Perkins).

21. From the seal inscription *basilike* on the bricks we may conclude that the king had his own brickyards; see Fränkel, *Inschriften, IvP*, 395ff.

22. See Hoepfner and Ernst-Ludwig Schwandner, "Himera," in *Haus und Stadt im klassischen Griechenland*, vol. 1 of *Wohnen in der klassischen Polis* (Munich: Deutscher Kunstverlag, 1994), 13–16, on the houses at Himera. Vitruvius 1.1.10 and 7.4.1 calls these protective alleys between houses the *ambitus*.

23. Günther Klaffenbach, "Die Astynomeninschrift von Pergamon," *AbhBerl* 6 (1953): 6, astynomoi inscription col. 3. No one was to be prevented from building a peristasis.

24. The library of Celsus at Ephesos has 1-meter-wide alleys next to the walls with niches that were used for servicing; they were always understood to keep away dampness. In libraries these seem particularly appropriate. F. J. Hueber, in *Proceedings* (as in n. 20), 2:983, maintains, on the contrary, that these alleys collected the rainwater from the roof of the library and led it into channels under the floor. Thus, the library would have been virtually surrounded by water.

25. Henner von Hesberg, "Platzanlagen und Hallenbauten in der Zeit des frühen Hellenismus," in *Proceedings of the Thirteenth International Congress of Classical Archaeology*, Berlin 1988 (1990), 231ff.; J. J. Coulton, *The Architectural Development of the Greek Stoa* (Oxford: Clarendon Press, 1976), 55ff.; R. E. Wycherly, *How the Greeks Built Cities* (London: Macmillan, 1949), 50–86.

26. Pergamene stoas at Aigai, Assos, Herakleia on Latmos, Alinda, Alabanda, and Aspendos have been compiled by Hans Lauter, "Die hellenistische Agora von Aspendos," *BJb* 170 (1970): 77ff. For the best research on the large stoas at Assos see Joseph T. Clarke, Francis H. Bacon, and Robert Koldewey, *Expedition of the AIA: Investigations at Assos* (London: Quatritch, Southeran; Boston: The Heintzemann Press, 1902), 23, 27, 33–51, and at Aigai see Bohn, "Altertümer von Aegae," *JdI-EH* 2 (1889): 30ff.

27. Manolis Korres, "Vorfertigung und Ferntransport eines athenischen Grossbaus," in *Bauplanung und Bautheorie in der Antike*, Colloquium Berlin 1983, *DiskAB*, vol. 4 (Berlin: Wasmuth Kommanditgesellschaft, 1983), 201–7.

28. In the older reconstruction drawings of Pergamene buildings this layer of gravel has never been specifically marked; the total area is only hatched in gray. Since many mosaics from the upper stories are known from Delos and other locations the underlay of gravel is considered standard. It still plays a part in today's civil engineering. Furthermore, in most reconstructions the location of the small beams that protected the precious large beams from getting wet has been omitted. See Coulton (as in n. 25), 191, figs. 14 and 15, with a cross section of stoas at Pergamon and Assos.

29. For the development of the coffers, many convincing examples on Rhodes of preserved wooden ceilings from the Middle Ages can be studied: Hoepfner, "Zum Problem griechischer Holz- und Kassettendecken," in *Bautechnik der Antike*, Colloquium Berlin, 15–17 February 1990, *DiskAB*, vol. 5, ed. Adolf Hoffman, Schwandner, Hoepfner, and Gunnar Brands (Mainz: Verlag Philipp von Zabern, 1991), 90–98.

30. Manfred Klinkott, "Die 'ambulationes pensiles' in der pergamenischen Stadtbaukunst," *IstMitt* 39 (1989): 273–80, does not name a peristasis in connection with stoas (although they are clearly attested for Assos and Aigai). He is of the opinion that the stoas on the downslope are heavy enough to prevent the terrace from sliding down!

31. Georges Roux, "La Terrasse d'Attale I," in *Topographie et architecture, FdD* 2 (1987): plans 3, 10.

32. In the stoa of Eumenes that the Pergamenes gave to Athens there are vaulted chambers instead of a peristasis at the back of the building as protection against pressure of the soil; see John Travlos, *Pictorial Dictionary of Ancient Athens* (London: Thames and Hudson, 1971), 523–26, figs. 660–64.

33. Klaffenbach (as in n. 23), 5ff.

34. In the astynomoi inscription the complications resulting from common walls are regulated by law: W. Kolbe, "Die Inschriften," in "Die Arbeiten zu Pergamon, 1900–1901," *AM* 27 (1902): 66ff.; Klaffenbach (as in n. 23), col. 3, 6ff.

35. Dörpfeld, "Die Bauwerke," in "Arbeiten zu Pergamon" (as in n. 34), 14ff.

36. Brigitte Hintzen-Bohlen, "Die Prometheus-Gruppe im Athenaheiligtum zu Pergamon. Ein Beitrag zu Kunst und Repräsentation der Attaliden," *IstMitt* 40 (1990): 145–56.

37. Hoepfner, "Siegestempel und Siegesaltäre," 113.

38. Emplacements for catapults were constructed on Rhodes in connection with the land wall ca. 300 B.C.; see Melina Filimonos, in Hoepfner and Schwandner (as in n. 22), 64ff.

39. Bohn, *Theater-terrasse, AvP*, vol. 4, 12.

40. Klaus Rheidt, "Die obere Agora. Zur Entwicklung des hellenistischen Stadtzentrums von Pergamon," *IstMitt* 42 (1992): 235ff., puts forth the theory that in earlier times the agora was located directly below the citadel wall in the place where the Great Altar later stood. Under Eumenes II a sanctuary of Zeus located farther down was remodeled into an agora district. However, such relocations of agorai and remodelings of sanctuaries into market places would have been unprecedented in Greek cultural history. But the evidence also speaks against this theory: where do we find an agora on very steep terrain on which houses also stood? And a market hall that Rheidt would like to see in the long rectangular building below the Athena precinct would also have been located on steeply sloping terrain! Unfortunately, this building and the entire slope with additional monuments have never been thoroughly investigated and published. Would it not be more convincing to consider the phase of the large rectangular building of the late 3d century B.C. at the place of the agora, which Rheidt had investigated, to be simply an older phase of the agora? It would be an important, although not unexpected, conclusion if a continuous use of the agora could be proven. Accordingly, the agora of the city of Philetairos would have only been a small area densely surrounded by houses (see the trench by Rheidt). This area might have been changed to a rectangular shape. See also Radt, *Pergamon*, 114ff.

41. Schazmann, *Gymnasion, AvP*, vol. 6, 11.

42. Kolbe (as in n. 34), 76.

43. Kolbe, 74.

44. Ohlemutz, *Kulte und Heiligtümer*, 4ff.; Schalles, "Kulturpolitik," 6ff., after a thorough investigation reaches a dating for the Athena temple in the 4th century B.C. Such a rich vocabulary of forms exists from the middle of the 4th century B.C. that a linear development of architecture can no longer readily be seen, as was the case in the classical period. The small size of the building and the number of columns do not substantiate Ohlemutz's dating. The building technique might be important, but the wooden clamps he mentions are also found on later Hellenistic buildings, for example on the Ptolemaic dedication at Olympia from the 270s B.C. See Hoepfner, *Zwei Ptolemaierbauten; des Ptolemaierweihgeschenk in Olympia und ein Bauvorhaben in Alexandria* (Berlin: Mann, 1971), 22ff. The historic arguments put forth by Schalles are, in my opinion, not convincing. Why should the boy Herakles, who was killed in 309 B.C. at the age of thirteen, or his Persian mother, Barsine, who both lived in Pergamon as inconspicuously as possible, build a peripteral temple for Athena?

45. In the precise drawing by Bohn, *Heiligtum der Athena, AvP*, vol. 2, pl. 3, the temple deviates by three degrees from the old city wall. Kähler, *Der grosse Fries*, 151 n. 3, makes the strange assertion that the temple is parallel to the citadel wall and must have been built at the same time as the citadel wall, or

the temple had already existed and the wall had to be aligned accordingly. See also Schalles, "Kulturpolitik," 19. Parallel to the wall and therefore incorrect is the temple drawn in Hans Schleif's plan, as seen in Kähler, "Pergamon," after 64.

46. This incompleteness is no argument for the erection of a temple in the 4th century B.C.; see Schalles, "Kulturpolitik," 22. On blocked-out Hellenistic columns as objects of art see Lauter, "Künstliche Unfertigkeit hellenistische Bossensäulen," *JdI* 98 (1983): 287–310. Here such a column at Kamiros should be mentioned, which, although of smaller dimensions, is similar to the Rhodian columns discussed by Lauter. The fragment is located in a late building near the agora.

47. Hoepfner, "Zum Mausoleum von Belevi," *AA* (1993): 122–23.

48. Peter Robert Franke and Max Hirmer, *Die griechische Münze* (Munich: Hirmer, 1964), 149.

49. Burkhardt Wesenberg, *Kapitelle und Basen. Beobachtungen zur Entstehung des griechischen Säulenformen* (Düsseldorf: Rheinland-Verlag, 1971), 74ff.; Philip P. Betancourt, *The Aeolic Style in Architecture: A Survey of Its Development in Palestine, the Halikarnassos Peninsula, and Greece, 1000–500 B.C.* (Princeton, N.J.: Princeton University Press, 1977).

50. Clarke, Bacon, and Koldewey (as in n. 26), 139ff.

51. Marble architecture as early as the archaic period attached importance to close-fitting joints, and it was certainly the intention of the architects to give temples and treasuries the appearance of a large sculpture without joints. Clamps and dowels were therefore hidden within the architectural members. To show clamps, as at Pergamon, is quite unusual. It should also be mentioned that on the temple of Athena there are horizontal casting channels in the contact surface of the column drums that were visible on the outside of the columns as small lead-filled triangles. This shows a lack of awareness of the building practices of the classical period. Owing to mere carelessness, such visible ends of casting channels become common elsewhere in the 2d century B.C. They made it quite easy for robbers in later periods to detect clamps and dowels; compare the columns of the Olympieion at Athens.

52. Bohtz, *Demeter-Heiligtum, AvP*, vol. 13.

53. Frank Rumscheid, "Die unbekannte Säulenbasis des Demeter-Tempels von Pergamon," *IstMitt* 42 (1992): 347–50.

54. Schalles, "Kulturpolitik," 24.

55. Ziegenaus, *Asklepieion. Teil 1, AvP*, vol. 11, no. 1, pl. 34b–c.

56. Alexander Conze and Georg Schazmann, "Mamurt-Kaleh. Ein Tempel der Göttermutter unweit Pergamon," *JdI-EH* (1911): 5–44.

57. Conze and Schazmann, 19, incorrectly reconstructed the building as a temple in antis, although the side face of the anta is much thinner than the column.

58. Wiegand, *Paläste, AvP*, vol. 5, no. 1, Foreword.

59. Hoepfner and B. Funck, independent of each other, make their contributions in *Basileia. Die Paläste der hellenistischen Könige,* Symposium Berlin 1992, ed. Hoepfner and Brands (Mainz: Verlag Philipp von Zabern, 1996).

60. The rooms located very high behind the north stoa of the Trajaneum are thought to be Hellenistic; they could hardly have been isolated. Investigations of the older layers of reconstruction work on the Trajaneum have been carried out for many years. Based on the information given by Wulf Raeck, Wolfgang Radt, in his latest report, "Pergamon. Vorbericht über die Kampagne 1992," *AA* (1993): 376, states that even the exposure of large areas has yielded no connection with the Hellenistic palaces to the east of the Trajaneum. These walls of the basileia lay much higher than expected, either on or slightly below the level of the stoa and the road, and thus were razed when the large terrace was built. However, 25 m to the south a parallel wall was uncovered (see Radt, 374, fig. 32), which might be the boundary of the basileia building as a supporting wall on the slope.

61. Radt, *Pergamon,* 90, is reminded of old prostas houses.

62. Hoepfner, in Hoepfner and Brands (as in n. 59); I. Nielson, "From Periphery to Centre: Italic Palaces," in *Centre and Periphery in the Hellenistic World,* Symposium Lolland, Denmark 1992, ed. Per Bilde et al. (Aarhus: Aarhus University Press, 1993), 216, distinguishes between building complex V "for official purposes" and building complex IV, "residential." However, it is not true that complex IV is less luxurious than V, where the mosaics and stucco are of the highest quality.

63. The mosaic is now in the Antikensammlung Berlin; Irmgard Kriseleit, *Antike Mosaiken. Aus den Bestanden der Antikensammlung im Pergamonmuseum* (Berlin: Staatliche Museen zu Berlin der DDR, 1985), 8ff., with color figs. 61ff.

64. It is certainly not a coincidence that Augustus's peristyle has the same width (22 m) as the peristyle in the royal andron at Pergamon. Gianfilippo Caretonni, *Das Haus des Augustus auf dem Palatin* (Mainz: Verlag Philipp von Zabern, 1983), 10, plan 2; Nielson (as in no. 62), 212ff.; Paul Zanker, *Augustus und die Macht der Bilder* (Munich: C. H. Beck, 1987), 110ff., 255ff., points out the symbolic meaning of the citations found on the architecture of the Augustan period.

65. Arnold Schober attributed these relief panels—found in the area of andron V and the terrace of the temple of Athena—to the propylon of the district of Athena, "Zur Datierung eumenischer Bauten," *ÖJh* 32 (1940): 160–68. Several subjects could hardly have been fitted on the small gate with only a few panels. Besides, a gate is not an appropriate place for such dignified reliefs.

66. Both are royal monuments, and it is wrong to assign to the Great Altar the function of an altar of Zeus located in a market.

67. Conze, *SBBerl: Phil.-hist. Klasse* (1884): 1259ff.; Bohn, *Heiligtum der Athena, AvP,* vol. 2, 56ff.

68. Karl F. O. Dziatzko, ed., "Beiträge zur Theorie und Praxis des Buch- und Bibliothekswesens Nendeln," *Sammlung bibliothekswissenschaftlicher Arbeiten*

10 (Wiesbaden: Otto Harrasowitz, 1886; Liechtenstein: Kraus Reprint), 38ff.; and *RE* 3, no. 1, 414–15, s.v. "Bibliotheken."

69. Chr. Callmer, "Antike Bibliotheken," in *Acta Instituti Romani regni Sueciae,* 10. Opusc. archaeol. 3 (1994): 145ff.; also Horst Blanck, *Das Buch in der Antike* (Munich: C. H. Beck, 1992), 185–86.

70. It must be remembered that the columns of the classical period were not doweled onto the stylobate; this allowed them to slide a little during earthquakes and thus be prevented from breaking.

71. Bohn, *Heiligtum der Athena, AvP,* vol. 2, 69–70.

72. The proposal by Brent Götze, "Antike Bibliotheken," *JdI* 52 (1937): 225–47, is unintelligible.

73. Otfried Deubner, "Expolitio. Inkrustation und Wandmalerei," *RM* 54 (1939): 21, with fig. 4.

74. Caretonni (as in n. 64), 32ff.

75. Bohn, *Heiligtum der Athena, AvP,* vol. 2.

76. Bohn's text and drawings show the peristasis; in later reconstructions it was omitted.

77. The complex and extravagant coffered ceiling of the Erechtheum can be reconstructed from the evidence in inscriptions. See Lacey Davis Caskey, "The Inscriptions," in *The Erechtheum, Measured, Drawn, and Restored by Gorham Phillips Stevens,* ed. James Morton Paton (Cambridge, Mass.: Harvard University Press, 1927), 354ff.

78. Gennaro Pesce, *Il Palazzo delle colonne in Tolemaide de Cirenaica* (Rome: "L'Erma" di Bretschneider, 1950), 27, pl. X.

79. The term *oikos* seems to refer to the entire residential building. In sanctuaries the oikos may be seen in connection with banqueting rooms, as at Hellenistic Delos. See Maire-Christine Hellmann, *Recherches sur le vocabulaire de l'architecture grecque d'après les inscriptions de Délos* (Athens: Ecole française d'Athènes; Paris: Diffusion de Boccard, 1982), 302.

80. Schazmann, *Gymnasion, AvP,* vol. 6, 11.

81. Glanville Downey, *A History of Antioch in Syria: From Seleucus to the Arab Conquest* (Princeton, N.J.: Princeton University Press, 1961), 95–107.

82. Hoepfner (as in n. 44), 55ff. A large project to construct stoas and presumably a temple in the basileia at Alexandria was begun in the first quarter of the 2d century B.C. but was not completed.

83. Schazmann, *Gymnasion, AvP,* vol. 6, 69ff., pls. 23ff.

84. Schwandner, "Beobachtungen zu hellenistischer Tempelarchitektur von Pergamon," in *Hermogenes und die hochhellenistische Architektur,* Colloquium Berlin, 28–29 July 1988, ed. Hoepfner and Schwandner (Mainz: Verlag Philipp von Zabern, 1990), 85ff.

85. Hoepfner, "Zum Entwurf des Athena-Tempels in Ilion," *AM* 84 (1969): 165–81.

86. Schwandner (as in n. 84), 92.

87. M. Kreeb, "Hermogenes. Quellen und Datierungsprobleme," in Hoepfner and Schwandner (as in n. 84), 110.

88. The space is not large enough to assume three steps including the stylobate. On the two steps of the temple of Athena at Troy see Heiner Knell, "Der Athenatempel in Ilion. Eine Korrecktor zur Grundrisskonstruktion," *AA* (1973): 131–33. There the depth of the steps is 40 cm. Other Doric buildings have steps that are less deep, for instance on the limestone temple at Delphi they measure 29 cm and 32 cm. See Jean-Pierre Michaud, "Le Temple en Calcaire," in *Topographie und Architecture, FdD* 2 (1977): 21ff.

89. Ohlemutz, *Kulte und Heiligtümer*, 114f., 120, with references to coins.

90. Ohlemutz, 114f., with references to the excavation reports of Hugo Hepding, "Die Inschriften," in "Die Arbeiten zu Pergamon, 1908–1909," *AM* 35 (1910): 309f., and Albert Ippel, "Die Inschriften," in "Die Arbeiten zu Pergamon, 1910–1911," *AM* 37 (1912): 302.

91. Ohlemutz, 113. It is strange that Ohlemutz did not draw a connection between temple R and Dionysos.

92. Vitruvius describes this process slightly differently. Hermogenes had finished elements for a Doric building remodeled to be used in a temple of the Ionic order. However, it seems very unlikely that Hermogenes had not known beforehand that buildings of the Ionic order could be constructed more easily. Here we are dealing with an anecdotal distortion of the actual procedure. In reality Hermogenes seems to have erected the temple of Dionysos in the gymnasium in the order that now seemed to him more advantageous (not more beautiful), although the temple previously had been of the Doric order.

93. Dörpfeld and Emil Reisch, *Das griechische Theater. Beiträge zur Geschichte des Dionysos-Theaters in Athen und anderer griechischer Theater* (Athens: Barth & von Hirst, 1896), 20f., reconstructs the Dionysos temple of the classical period at Athens with four facade columns and two additional columns between the corner columns and antae. He emphasizes, however, that the ground plan is not really confirmed. Temple L at Epidauros, probably of the 3d century B.C., must be considered an exceptional form because it is a peripteros in which the columns are projected onto the walls of the cella and create a deep porch. See Georges Roux, *L'Architecture de l'Argolide au IVe et IIIe siècles avant J.-C.* (Paris: E. de Boccard, 1961), 223ff.

94. Klaus Tuchelt, "Bemerkungen zum Tempelbezirk von Antiochia ad Pisidiam," in *Beiträge zur Altertumskunde Kleinasiens. Festschrift für Kurt Bittel*, ed. R. M. Boehmer and H. Hauptmann (Mainz: Verlag Philipp von Zabern, 1983), 501–22.

95. Bohn, *Theater-terrasse, AvP*, vol. 4, 41ff., on the remodeled building of the imperial period 54ff., pls. 25ff.

96. Nikolaos Ch. Stampolidis, "Hermogenes, sein Werk und seine Schule vom Ende des 3. bis zum Ende 1. Jhs. v. Chr.," in Hoepfner and Schwandner (as in n. 84), 119, cannot detect a correspondence between Hermogeneian and Pergamene architecture.

97. Probably the even wider eustyle was also erected by Hermogenes, where the ratio of the diameter to the intercolumniation is 1:2.25 or 4:9. The temple of Dionysos at Teos, which Hermogenes designed and described in a book, was supposed to be such an eustyle. See Hoepfner, "Bauten und Bedeutung des Hermogenes," in Hoepfner and Schwandner (as in n. 84), 12–16.

98. On Palestrina see Friedrich Rakob, "Die Rotunde in Palestrina," *RM* 97 (1990): 61–92.

99. Hoepfner (as in n. 97), 24–27.

100. Ziegenaus and de Luca, *Asklepieion, AvP*, vol. 11, no. 2, 8ff. The fragments of the Ionic marble temple were found to the east in a filling of the 2d century B.C. and are tentatively attributed to the temple of Asklepios on the rock ledge in the middle of the sanctuary and in the later court. Ziegenaus dates the graceful marble architecture to the time of Philetairos. However, the building decoration is, without a doubt, only from the time of Eumenes. It is quite likely that this temple (its ground plan not being at all certain [see fig. 9, this essay]), replaces an older temple that was destroyed by Philip V in 201 B.C. Of the latter building only fragments of a garland frieze were found; see Ziegenaus and de Luca, *Asklepieion, AvP*, vol. 11, no. 1, 79ff., pl. 34c; Michael Pfrommer, "Zum Fries des Dionysostempels von Milet," *IstMitt* 39 (1989): 438, dates the Ionic marble temple to the later part of the 3d century and also points out a relationship to the buildings of Hermogenes at Magnesia and Teos.

101. On the capitals from Magnesia see Hoepfner, "Zum ionischen Kapitell bei Hermogenes und Vitruv," *AM* 83 (1968): 213–34; Orhan Bingöl, "Vitruvsche Volute am Artemis-Tempel von Hermogenes in Magnesia," *IstMitt* 43 (1993): 399ff. So far the capitals of temple R at Pergamon have been reconstructed only cursorily in a drawing and with little reference to the fragments; see Schazmann, *Gymnasion, AvP*, vol. 6, pl. 26.

102. In this Hermogenes differs from the architect Pytheos, who designed his buildings with a low entablature and without a frieze, as is seen on the temple of Athena at Priene and on the Mausoleum at Halikarnassos.

103. Bingöl, "Überlegungen zum ionischen Gebälk," *IstMitt* 40 (1991), 101, 108.

104. Pliny *Naturalis historia* 34.84; among them Isogonos, Phyromachos, Stratonikos, and Antigonos.

105. Ohlemutz, *Kulte und Heiligtümer*, 90ff.; H. von Prott, "Dionysos Kathegemon," in "Die Arbeiten zu Pergamon, 1900–1901," *AM* 27 (1902): 161–88.

106. On panel 12 Herakles finds his son Telephos, who is being suckled by a lioness. See depictions of Herakles and Telephos in Bauchhenss-Thüriedl, *Mythos*, cat. nos. 24–46. On a wall painting of the youthful Dionysos at Pergamon see Erika Simon, "Zum Fries der Mysterienvilla bei Pompeji," *JdI* 76 (1961): 144ff.

107. Prott (as in n. 105), 161–88.

108. Ohlemutz, *Kulte und Heiligtümer*, 115f.

109. Kristian K. Jeppesen, "Tot Operum Opus. Ergebnisse der Dänischen Forschungen zum Maussolleion von Halikarnass seit 1966," *JdI* 107 (1992):

59–60; Hoepfner and Schwandner (as in n. 22), 226–34; a new reconstruction is being attempted by Hoepfner.

110. Hoepfner (as in n. 47), 111–23.

111. Hoepfner, "Zu den grossen Altären," 603ff.

112. Joseph Coleman Carter, *The Sculpture of the Sanctuary of Athena Polias at Priene* (London: Society of Antiquaries of London in association with British Museum Publications, 1983), 181ff.

113. On the discovery and excavation see Eduard Schulte, ed., *Carl Humann der Entdecker des Weltwunders von Pergamon in Zeugnissen seiner Zeit, 1839–1896. Schriften der Hermann-Bröckelschen-Stiftung Carl Humann zum Gedächtnis,* 3 (Dortmund: Ardey Verlag, 1971); Friedrich Karl Dörner and Eleonore Dörner, *Von Pergamon zum Nemrud Dag. Die archäologischen Entdeckungen Carl Humanns. Schriften der Hermann-Bröckelschen-Stiftung Carl Humann zum Gedächtnis,* 8 (Mainz: Verlag Philipp von Zabern, 1989), 50ff; Kunze, *Kunstepoche,* and Rohde, *Pergamon,* 13ff., with bibliography, 162ff.

114. The length of the figural frieze of the Parthenon is 208 m.

115. Schrammen, *Der grosse Altar, AvP,* vol. 3, no. 1, 83ff; Hoepfner (as in n. 17), 282.

116. Hoepfner, "Zu den grossen Altären," 620.

117. Michael Pfanner, "Bemerkungen zum grossen Fries von Pergamon," *AA* (1979): 57.

118. Hoepfner, "Siegestempel und Siegesaltäre," 111ff.

119. The assumption of Schrader, in "Anordnung," 97ff., that the Telephos frieze was located not only on the walls of the court but also on the outside of the monument can be discarded since Greek architects always distinguished between inside and outside. Bauchhenss-Thüriedl, *Mythos,* correctly proposes a distribution of the panels only in the area of the court. Contra this proposal see Heres, "Fragmente vom Telephosfries," 191ff., and in Kunze, *Kunstepoche,* 55ff.

120. Hoepfner and Schwandner (as in n. 84), 91, figs. 6, 7. That the leaf points of the cyma of the temple touch the beads and not the reels of the string of beads is certainly an intentional variation.

121. Pytheos, who designed the temple of Athena at Priene and the Mausoleum at Halikarnassos, was the first architect to make the Ionic order the base of a gridded architecture. Doubtless, Hermogenes relied on him. See Hoepfner, in Hopefner and Schwandner (as in n. 84), 27. The grids on the temples of Dionysos at Pergamon could be determined by means of the ground plans in *Theater-terrasse* and *Gymnasion, AvP,* vol. 4, and vol. 6. That the Great Altar adheres to a grid ground plan is shown in Hoepfner, in *Die griechische Polis. Architektur und Politik,* eds. Hoepfner and Gerhard Zimmer (Tübingen: E. Wasmuth, 1993), 111ff.; contra Kunze in Andreae, *Phyromachos,* 133.

122. Capitals with a proportion of the volutes 1:2:3 were first designed by Pytheos in the middle of the 4th century B.C.; see Hoepfner and Schwandner, "Das Maussolleion und die Säulenordnungen des Architekten Pytheos," in *Haus und Stadt* (as in n. 22), 230–33. At the end of the 3d and beginning of the 2d century B.C., Hermogenes used these proportions on his capitals and may thus be called Hermogeneian; see Hoepfner (as in n. 101), 229ff. Vitruvius used these sources for the construction of his Ionic capitals.

123. Salis, "Altar," 10ff., gathered from an artist's signature that Menekrates, son of Menekrates, designed the altar, because Ausonius in *Mosella* (A.D. 371) poetically named the most famous architects, listing as the last a certain Menekrates. Since Pliny *Naturalis historia* 36.34 states that a Menekrates from Rhodes had adopted the artists of the Farnese Bull, Salis assumed that the older Menekrates of Pergamon was the adoptive father; this would fit well chronologically. Contra E. Fabricius, in *RE* 15, no. 1, 803, no. 39, s.v. "Menekrates." On the question of the attribution to particular artists see Andreae's essay in this volume.

HOEPFNER, "MODEL OF THE PERGAMON ALTAR (1:20)"

1. This older model is illustrated in Schmidt, *Der grosse Altar,* pls. 68–71.

2. Hoepfner, "Bauliche Details," 189ff., in reference to the excavator Richard Bohn; contra Schrammen, *Der grosse Altar, AvP,* vol. 3, no. 1, 15ff.

3. Hoepfner, "Zu den grossen Altären," 631ff. The foot used on the altar is the old Ionic foot of 35 cm, as already assumed by Kähler, "Pergamon," 22–24.

4. The columns in the Pergamon Museum have an additional square ashlar-shaped plinth below the round plinth, which gives a curious stilted impression. This, obviously, is a reconstruction error resulting from the assumption of a short open staircase without pedestal; Hoepfner, "Zu den grossen Altären," 622ff.

5. Hoepfner and Ernst-Ludwig Schwandner, *Haus und Stadt im klassischen Griechenland* (Munich: Deutscher Kunstverlag, 1994), 204ff.

6. Schrammen completed the volutes of the capitals incorrectly so that they did not conform to the basic proportion of 1:2:3 (which he did not know). Anton Bammer, "Zu den Kapitellen des Altares von Pergamon," *FuB* 16 (1974): 183–90, compared the capitals, which he had also completed incorrectly, to the much older ones on the altar of the Artemision in Ephesos. However, the similarity is restricted to the outer shaping of the cushion on some of the Pergamene pieces.

7. Hoepfner, "Zum ionischen Kapitell bei Hermogenes und Vitruv," *AM* 83 (1968): 213–34.

8. Similarly "wiry" are the capitals worked in Alexandria; Hoepfner, *Zwei Ptolemaierbauten. Des Ptolemaierweihgeschenk in Olympia und ein Bauvorhaben in Alexandria* (Berlin: Mann, 1971), 76ff.

9. Executed in this way by Armin von Gerkan during the reconstruction in Berlin.

10. According to Winter, *Skulpturen, AvP,* vol. 7, no. 1, 90–118, nos. 57–91, all statues and fragments were found in the area of the Great Altar or slightly below. Not a single one came from the Athena terrace, which, therefore, can definitely be eliminated as the site where they were erected.

11. The female statues were neither anchored nor embedded (the same as the figures on the roof), as no traces of cuttings were found. Since the surface of these statues is well preserved, contrary to the surface of the roof figures, they cannot have stood in the open air on a freestanding base.

12. See Hoepfner, "Zu den grossen Altären," 627 n. 37; my thanks are due to Paul Zanker, who made this observation in a discussion after my lecture in 1988 at the Archaeological Institute, University of Munich.

13. With no reference points, one cannot assume that a long bathron ran along the wall as it was reconstructed for the altar in the Pergamon Museum. Given a length of 99 m, some fragments of the coping panels would have to exist.

14. Schrammen assumed a larger clear span for the east side because two architraves were found close to the corner, which are 2.5 cm longer. However, it is basically wrong to determine the exact clear span from individual architrave beams. The vertical joints of adjoining architraves were not to be seen (as was the case with the horizontal joints of the column drums) and, therefore, were seldom located exactly above the center of the column. We already encounter deviations of several centimeters in the classical period; see Hoepfner, "Siegestempel und Siegesaltäre," 113 n. 16. In the Hellenistic period in Pergamon these deviations can reach 6 cm, as on the temple in Mamurt Kale.

15. A crowning block of the wall that leads from a small wall to one that is 5 cm wider has survived; see Schrammen, *Der grosse Altar, AvP*, vol. 3, no. 1, 40a.

16. Attalos II even sent three painters to Delphi to restore the stoa his father had dedicated; see Christian Habicht, "Athens and the Attalids in the Second Century B.C.," *Hesperia* 59 (1990): 573 n. 67.

17. Hoepfner, "Bauliche Details," 202.

18. Schrammen, *Der grosse Altar, AvP*, vol. 3, no. 1, 41, with figure.

19. Schrammen, *Der grosse Altar, AvP*, vol. 3, no. 1, 41, top.

20. The block attributed by Schrammen, *Der grosse Altar, AvP*, vol. 3, no. 1, 44, a and b, to the larger outer corner belongs here.

21. My thanks are due to W. J. Brunner for taking exact measurements of the cornice blocks at the site in 1988 and to G. Seidensticker for the final drawing in Berlin.

22. In the recent detailed compilation by Beatrice Palma, "Il Piccolo Donario pergameno," *Xenia* 1 (1981): 45–84, pieces are listed that do not belong to the group. The scale of the figures alone cannot be a criterion for the attribution. I am of the same opinion as Tonio Hölscher, "Die Geschlagenen und Ausgelieferten in der Kunst des Hellenismus," *AntK* 28 (1985): 120–36, who states that the group consisted solely of defeated and not battling enemies.

23. The previous reconstruction proposal, Hoepfner, "Zu den grossen Altären," 625, fig. 24, is now obsolete.

24. My thanks are due to J. Bouzek, who pointed this out during a lecture at Karls University in Prague.

25. Karl Lehmann, "Samothrace: Fifth Preliminary Report," *Hesperia* 21 (1952): 20, and "Samothrace—Seventh Campaign of Excavations," *Archaeology* 6 (1953): 35. For a recent interpretation, see Andrew Stewart, "Narration and Allusion in the Hellenistic Baroque," in Holliday, *Narrative and Event*.

26. Winter, *Skulpturen, AvP*, vol. 7, no. 2, 169, states that it is "völlig gesichert" that the griffins as well as the horses belong to the roof decoration.

27. According to Winter, *Skulpturen, AvP*, vol. 7, no. 1, nos. 166, 167, the Tritons were found at the north rim of the altar.

28. Two centaurs are placed before the entrance to the museum in Bergama (modern Pergamon). Because of the size, material, and technique—there are two large dowel holes where the two halves are joined—they can be identified as belonging to the group on the roof of the Pergamon Altar, although the label states that they came from the Asklepieion. Max Kunze, in Andreae, *Phyromachos*, 123ff., pl. 85, has discovered two centaurs in the excavation storage in Bergama that were previously thought to be horses. He emphasizes the sepulchral character of the roof decoration of the Great Altar.

KÄSTNER, "THE ARCHITECTURE OF THE GREAT ALTAR AND THE TELEPHOS FRIEZE"

1. Schrammen, *Der grosse Altar, AvP*, vol. 3, no. 1; Wilhelm Dörpfeld, "Der Wiederaufbau des pergamenischen Altars" (manuscript, 1919); Armin von Gerkan, "Zur Aufstellung der Architekturen im Museumneubau" (manuscript, 1926?); Kähler, *Der grosse Fries*; Mehmet Cetin Şahin, *Die Entwicklung der griechischen Monumentaltäre* (Bonn: Rudolf Habelt Verlag, 1972), 67–72, 99–113. Summarizing the earlier state of research: Volker Kästner, "Der Pergamonaltar als Bauwerk," in Kunze, *Kunstepoche*, 22–33.

2. Gerkan, "Aufbau," 64–68.

3. The apsidal building was either interpreted as a sanctuary of Zeus (see Arthur Bernard Cook, *Zeus*, vol. 1 [Cambridge: Cambridge University Press, 1914], 120; vol. 2 [1920], 953–54), or compared with similar buildings in the sanctuary of the Kabeiroi on Samothrake (see Gerda Bruns, "Umbaute Götterfelsen als kultische Zentren in Kulträumen und Altären," *JdI* 75 [1960]: 100–111). Stähler, in "Zur architektonischen Gestalt," thought it was a direct predecessor of the altar in the form of a cult area for the hero Telephos. Wolfram Hoepfner has recently suggested an interpretation of the round building as a nymphaion (see Hoepfner in this volume). The most recent examinations of the foundation grid, in 1994, have yielded no further evidence for the interpretation of the older buildings, see Wolfgang Radt, the section "Die Arbeiten am Pergamonaltar," in "Pergamon. Vorbericht über die kampagne 1994," *AA* (1995): 575–88.

4. Humann, in Conze, "Ausgrabungen," 148, stated conclusively after uncovering the entire northern court: "An einigen Stellen erscheint der Fels abgetragen, an anderen sind die Vertiefungen ausgefüllt, um ein Planum zu schaffen, welches ungepflastert gewesen zu sein scheint; wenigstens hat sich nirgends eine Spur davon gefunden."

5. Rheidt dates the systematic destruction of ancient buildings in Pergamon as early as the activity of John of Ephesos in the A.D. 530s. *Stadtgrabung, AvP*, vol. 15, no. 2, 170–72.

6. Manolis Korres, "Vorfertigung und Ferntransport eines athenischen Grossbaus," in *Bauplanung und Bautheorie in der Antike*, Colloquium Berlin 1983, *DiskAB*, vol. 4 (Berlin: Wasmuth Kommanditgesellschaft, 1983), 201–7.

7. This type of base, preserved in several examples with masons' marks, had already been sketched by Richard Bohn but is not mentioned in the publications of the excavations.

8. The fluted leaves with their half-round ends, which are still preserved on a capital fragment in Berlin (inv. Pe.1.149), resemble the flutes of Ionic columns. Another fragment (Berlin, inv. Pe.1.154) can be recognized as a re-modeling of an Asiatic A-type capital into one of the B type.

9. The capitals with diagonal volutes occur first in the interior of the temple of Apollo at Bassai, later elsewhere on the Peloponnesos and the Greek mainland and, about 400 B.C., on the Nereid monument at Xanthos in Asia Minor. In Pergamon they are also used as anta capitals in the upper story of the propylon of the sanctuary of Athena (somewhat older than or contemporary with the altar construction) and on the exedra of Pyrrhos in the Upper Gymnasium (end 2d century B.C.). The bottom of the diagonal volutes are decorated with palmettes.

10. Marks that indicate the columns were to be placed at an interval of 1.44 m were also observed on the upper cornices of the Gigantomachy frieze on the east side (see Schrammen, *Der grosse Altar, AvP*, vol. 3, no. 1, 28–30, 37).

11. On the northeast corner were found the geison of the colonnade, a fragment of a corner slab of the capping blocks, and the matching corners of the external wall architrave. From the southeast corner we have the complete wall capping blocks with masons' marks KB-ΛB as well as its adjoining slab on the south side (ΛB-MB), a fragment of the matching corner of the wall architrave. From the same find spot originate a corner architrave and a normal architrave of the colonnade with an axial spacing of 1.44 m. The number of coffer fragments that can be attributed to these corners has been considerably increased through current examinations.

12. Schrammen, *Der grosse Altar, AvP*, vol. 3, no. 1, 44, fig. c; Kawerau and Wiegand, *Paläste, AvP*, vol. 5, no. 1, 32–33, pl. 16.1. Two other reused fragments, which remain unpublished, still lie in the cellar of the stadium and on the way from the agora to the gymnasium.

13. Schrader, "Anordnung," *JdI* 15 (1900): 108, fig. 9.

14. Winnefeld, *Friese, AvP*, vol. 3, no. 2, 209–14.

15. The cuttings widening to dovetails in the lower part, meant to be used with a lewis, were originally cut into the middle of the upper panel surface to different depths. When the reliefs were being sculpted, the cuttings were only partially completed, to keep them away from the relief face. Similar situations can be seen on the panels of the Gigantomachy frieze as well.

16. The arrangement of the wall as described is a preliminary result of a new examination of the dressed blocks used for the altar, which is not yet concluded. Schrammen, *Der grosse Altar, AvP*, vol. 3, no. 1, 61–63, only enumerated different sizes of ashlars and mentioned the masons' marks. But he had already noticed that the structure of the separately built anta pillars was different from that of the court wall proper. The base molding that Schrammen ascribed to the wall structure, which includes a fourth panel with an outer corner, must be separated from the court wall and given to a smaller, exedra-like building—probably the altar inside the court: Schrammen, *AvP*, vol. 3, no. 1, 62, figs. a–c.

17. Bohn, *Heiligtum der Athena, AvP*, vol. 2, 72, 75.

18. Decisive for this comparison is not so much the external architectural appearance of the monuments but the fact that the sacrificial places were supplied with an enclosure for the ashes of the sacrificed animals, a hearth in its most general sense (see Hans Schleif, "Der Zeusaltar in Olympia," *JdI* 49 [1934]: 139–56). As Pausanias does not give a more detailed description of the Pergamene altar, one should suppose that he referred to a generally known building comparable to the Samian altar of Hera.

19. See Salis, "Altar," 9.

20. For altars with canopies, see Heinz Cüppers, "Vorformen des Ciboriums," *BJb* 163 (1963): 21–27; H. Plommer and F. Salviat, "The Altar of Hera Akraia at Perachora," *BSA* 61 (1966): 207–15; Gerhard Kuhn, "Untersuchungen zur Funktion der Säulenhalle in archaischer und klassischer Zeit," *JdI* 100 (1985): 233–41; on Delos, with further evidence. D. W. Rupp suspects the tetrastylon around or the canopy above a part of the altar to be a Corinthian invention of the sixth century B.C.: "The Altars of Southern Greece: A Typological Analysis," in *L'Espace sacrificiel. Actes du colloque tenu à la Maison de l'Orient*, Lyon, 4–7 June 1988 (Lyon: Bibliothèque Salomon-Reinach, Institut d'Archéologie Classique, 1991), 305. The canopy visible on the coin in Berlin resembles pergola structures, as for example on a wall painting from Boscoreale or the fragment of the Nile mosaic from Praeneste in Berlin: Irmgard Kriseleit, *Antike Mosaiken. Aus den Bestanden der Antikensammlung im Pergamonmuseum* (Berlin: Staatliche Museen zu Berlin der DDR, 1985), 38–41, no. 11.

21. Schrader, "Opferstätte," 612–25; Schrammen, *Der grosse Altar, AvP*, vol. 3, no. 1, 67–75.

22. See Gerkan (as in n. 1).

23. Nikolaos Chr. Stampolidis, *Ο βωμός τοῦ Διονύσου στήν Κῶ* (Athens: Εκδόση τοῦ Ταμείου Αρχαιολογικῶν Πορῶν καὶ Απαλλοτριωσεῶν, 1981), and "Der 'Nymphenaltar' in Knidos und der Bildhauer Theon aus Antiochia," *AA* (1984): 113–27 (see also n. 30).

24. Naomi J. Norman, "The Temple of Athena Alea at Tegea," *AJA* 88 (1984): 190–91, pl. 30, figs. 8a–b.

25. Hans Möbius, "Attische Architekturstudien, II. Zur Ornamentik des Erechtheions," in *Studia Varia* (Wiesbaden: Franz Steiner Verlag, 1967), 83–91.

26. Rumscheid, *Kleinasiatischen Bauornamentik*, 36–39, 98–107.

27. Marble altars for burnt sacrifices needed a special covering of fire-resistant material. Covers of fireproof stone, metal, and coverings of packed earth are known or deduced. The latter had to be renewed several times and

could, like the metal covers, extend to the lateral wings as well. See Erich Pernice, *Die hellenistische Kunst in Pompeji, 5. Hellenistische Tische, Zisternen-mündungen, Beckenuntersätze, Altäre und Truhen* (Berlin and Leipzig: Walter de Gruyter, 1932), 55–70; Olaf Dräger, "Religionem Significare," *RM-EH* 33 (1994): 23–28; and A. Ohnesorg in *L'Espace sacrificiel* (as in n. 20), 316.

28. Fränkel, *Inschriften, IvP,* 106–7, no. 169; Schrammen, "Die Architectur-fragmente," in Winter, *Skulpturen, AvP,* vol. 7, no. 1, 381, no. 24.

29. There are still problems concerning the details of the arrangement of the plinths (?) doweled with the crown molding, which demand further research. With the molding fragments known so far one can propose, for example, a regular grouping for sculptures or canopy supports only by supplying the projecting wings with another angle at the front sides. See, for example, the suggestion for the restoration of the altar of Poseidon at Teos by Lauter, *Architektur des Hellenismus,* fig. 72.

30. For divergent solutions for the crowning of the altar placed inside the court, see Stampolidis, "Altar, Krateutes and Acroteria," in *L'Espace sacrificiel* (as in n. 20), 290–96 (acroteria with Tritons), and Hoepfner, "Model of the Pergamon Altar (1:20)," in this volume.

HERES, "THE MYTH OF TELEPHOS IN PERGAMON"

1. Fränkel, *Inschriften, IvP,* no. 156; Kertész, "Telephos-Mythos," 203–6, with further reading; Schalles, "Kulturpolitik," 110–11; Scheer, *Mythische Vorväter,* 110–52.

2. See, e.g., for the Antigonids, Ulrich Sinn, *Die homerischen Becher. Hellenistische Reliefkeramik aus Makedonien* (Berlin: Mann, 1979), 59–60.

3. Robert, "Telephos-Frieses"; Schrader, "Anordnung" and "Opferstätte"; and Winnefeld, *Friese, AvP,* vol. 3, no. 2.

4. Bauchhenss-Thüriedl, *Mythos.*

5. *LIMC* 7: 856–57, 861–62, s.v. "Telephos" (Huberta Heres and Matthias Strauss).

6. Schober, *Kunst,* 99, and Kertész, "Telephos-Mythos," 211, presume that the model was a courtly epic. Bauchhenss-Thüriedl, *Mythos,* 71, following Robert, "Telephos-Frieses," presumes a "pergamenische Dichtung." An opposite view is that of Hesberg, "Bildsyntax," 342 n. 129: "die Gestaltung der Bildfolge kann deshalb allein den ausführenden Bildhauern zu verdanken sein," which is certainly not possible.

7. See Winnefeld, *Friese, AvP,* vol. 3, no. 2, 157–97; Bauchhenss-Thüriedl, *Mythos,* 40–74; Schefold and Jung, *Urkönige,* 207–12; *LIMC* 7: 857–61, s.v. "Telephos" (Heres and Strauss).

8. Gerhard Neumann, *Gesten und Gebärden* (Berlin: Walter de Gruyter, 1965), 41 with n. 134.

9. Robert, "Telephos-Frieses," parts III through VI, 59.

10. Bauchhenss-Thüriedl, *Mythos,* 47–48.

11. Katherine Dohan Morrow, *Greek Footware and the Dating of Sculpture* (Madison: University of Wisconsin Press, 1985), 109–10, figs. 88–89; Hans-Ruprecht Goette, "Mulleus, Embas, Calceus," *JdI* 103 (1988): 441–42.

12. Heres, "Fragmente vom Telephosfries," 199–200, fig. 3: inv. TF 107.

13. Ohlemutz, *Kulte und Heiligtümer,* 16, 20–21; Schalles, "Kulturpolitik," 15 n. 81.

14. Panels 32–33, enclosing the fragments of a warrior running onto a ship, have been related until now to the flight of the Greeks after the battle in the Kaikos river valley (see *LIMC* 7: 860, s.v. "Telephos" [Heres and Strauss]). New considerations about the arrangements of the panels (see Heilmeyer in this volume) assume that the panels have to be connected with 13–14b.

15. Schalles, "Kulturpolitik," 68–123; Tonio Hölscher, "Die Geschlagenen und Ausgelieferten in der Kunst des Hellenismus," *AntK* 28 (1985): 120–36.

16. Philostratos *Heroikos* 2.14–18; *LIMC* 5: no. 2, s.v. "Hiera" (Erika Simon).

17. Ohlemutz, *Kulte und Heiligtümer,* 90–106, 115; Helmut Müller, "Ein neues hellenistisches Weihepigramm aus Pergamon," *Chiron* 19 (1989): 539–53.

18. *LIMC* 7: 856–57, s.v. "Telephos" (Heres and Strauss).

19. Strauss, "Telephos. Voruntersuchungen zum Verständnis des Telephos-frieses von Pergamon" (Ph.D. diss., University of Freiburg, 1988).

20. See Stewart in vol. 1.

21. Most recently: Osada, *Stilentwicklung,* 39–63, with further reading.

22. *LIMC* 3: nos. 8–15, s.v. "Auge" (Bauchhenss-Thüriedl). Silver bowl from Rogozen: Brian Shefton, "The Auge Bowl," in *The Rogozen Treasure: Papers of the Anglo-Bulgarian Conference,* London, 12 March 1987, ed. B. F. Cook (London: British Museum Publications, 1989), 82–90.

23. Theun-Matthias Schmidt, "Der späte Beginn und der vorzeitige Abbruch der Arbeiten am Pergamonaltar," in Andreae, *Phyromachos,* 148–50.

24. Diethelm Krull, *Der Herakles vom Typ Farnese* (Frankfurt am Main: Peter Lang, 1985), 374 with nn. 611–12.

25. *LIMC* 7: 19, s.v. "Telephos" (Heres and Strauss); Hesberg, "Bildsyntax," 328–30, fig. 12; Françoise Gury, "La Découverte de Telèphe à Herculaneum," *KölnJb* 24 (1991): 97–103.

26. Neumann (as in n. 8), 13.

27. An inscription on the epistyle of the temple testifies to the representation of Auge, Telephos, and Aleos on the metopes: *LIMC* 7: no. 3, s.v. "Telephos" (Heres and Strauss).

28. Angelos Delivorrias, "La Bataille du Caique au fronton ouest de Tegée," *BCH* 97 (1973): 111–35. Andrew Stewart, *Skopas of Paros* (Park Ridge, N.J.: Noyes Press, 1971), 53–57.

29. For the Corinthian helmet: Hermann Pflug, "Antike Helme. Sammlung Lipperheide und andere Bestände des Antikenmuseums Berlin," *Römisch-Germanisches Zentralmuseum Maïnz,* Monograph 14 (1988), 65–106.

30. Petros Dintsis, *Hellenistische Helme*, 2 vols. (Rome: Giorgio Bretschneider, 1986), 87 (the helmet of the Telephos frieze can be added to the compilation of material concerning the Corinthian helmet in the Hellenistic period); 78f., cat. no. 133, pl. 32.10 (konos helmet); 113ff., 118, cat. no. 234, pl. 59.3 (pseudo-Attic helmet).

31. Hildegund Gropengiesser, "Ein Achilleus-Becher in Mannheim," in *Tainia. Roland Hampe zum 70. Geburtstag dargebracht*, ed. Tonio Hölscher and Erika Simon (Mainz: Verlag Philipp von Zabern, 1980), 322–27.

32. *LIMC* 7: 826, s.v. "Telephos" (Heres and Strauss).

33. *LIMC* 7: no. 64, s.v. "Telephos" (Heres and Strauss): Telephos seizes Orestes by the foot, so that he hangs upside down.

34. For contrast as a representational device in the Hellenistic narrative see Hesberg, "Bildsyntax," 377.

35. *LIMC* 3: nos. 41–63, s.v. "Danae" (Jean-Jacques Maffre).

36. *LIMC* 3: no. 26, s.v. "Auge" (Bauchhenss-Thüriedl).

37. *LIMC* 7: nos. 18–35, 37–38, s.v. "Telephos" (Heres and Strauss).

38. Salis, "Altar."

39. Neumann (as in n. 8), 136–42.

40. Hesberg, "Bildsyntax," 312–15.

41. Neumann (as in n. 8), 49–58; Marion Meyer, "Die griechischen Urkundenreliefs," *AM-BH* 13 (1989): 140–41.

42. Angela Bernadette Spiess, *Der Kriegerabschied auf attischen Vasen der archaischen Zeit* (Frankfurt am Main: Peter Lang, 1992), 24–26, 41–44, 165–68.

43. Homer *Iliad* 19.1–36; Schefold and Jung, *Urkönige*, 210.

44. Johannes Bergemann, "Die bürgerliche Identität der Athener im Spiegel der attischen Grabreliefs," in *Griechische Klassik. Tagung des Deutschen Archäologenverbandes und der Mommsengesellschaft*, Blaubeuren 1991 (Nuremberg: Hans Carl, 1994), 283–93.

45. Neumann (as in n. 8), 49–50.

46. Nikolaus Himmelmann, "Archäologisches zum Problem der griechischen Sklaverei," *AbhMainz* 13 (1971): 13–18.

47. Meyer (as in n. 41), A 88 pl. 28.1; Ulrich Hausmann, *Kunst und Heiltum* (Potsdam: Stichnote, 1948), 171, no. 73. This comparison was already noted by Salis, "Altar," 139.

48. Winnefeld, *Friese, AvP*, vol. 3, no. 2, 189. Salis, "Altar," considers the object to be an urn.

49. Salis, "Altar," 124–25.

50. Helmut Kyrieleis, "Throne und Klinen," *JdI-EH* 24 (1969): 134; Burkhard Fehr, *Orientalische und griechische Gelage* (Bonn: Bouvier Verlag Herbert Grundmann, 1971), 26; Klaus Stemmer, *Sitzmöbel und Sitzweisen in der Antike, z.B. Stühle. Ein Streifzug durch die Kulturgeschichte des Sitzens* (Giessen: Anabas-Verlag Günter Kämpf Kommanditgesellschaft, 1982), 229–31.

51. Kyrieleis (as in n. 50), 131–34 (type A); Stephan Steingräber, *Etruskische Möbel* (Rome: Giorgio Bretschneider, 1979), 111 (*diphros* 1 b).

52. As an example for the arrangement of figures on the relief ground with large spaces in between, see the Hephaisteion at Athens, east frieze: Florens Felten, *Griechische tektonische Friese archaischer und klassischer Zeit* (Waldsassen: Stiftland-Verlag Kommanditgesellschaft, 1984), 60–62, pl. 45. For figures crowded closer together with overlapping extremities on the friezes with fighting scenes at the temple of Athena Nike at Athens, see Felten, 118–31, pl. 47; Osada, *Stilentwicklung*, 36–37.

53. Salis, "Altar," 129–34; *LIMC* 1: nos. 90, 381, 435a, s.v. "Amazones" (Pierre Devambez and Aliki Kauffmann-Samaras); for the group of the mounted Persian turning around and being attacked by two Greeks in the south frieze of the temple of Athena Nike, see Felten (as in n. 52), pl. 47.2, panel a.

54. For the fallen under the team of Hera and at the feet of Aphrodite: Winnefeld, *Friese, AvP*, vol. 3, no. 2, pls. 10 and 14.

55. For the iconographic tradition of the recovery group see Barbara Schmidt-Dounas, "Metopen von Ilion," *IstMitt* 41 (1991): 383–87, pl. 48.

56. E.g., *Iliad* 5.152–64 (stealing of the weapons); 5.663–69 (saving of the bodies of Sarpedon and Tlepolemos); fight over the body of Patroklos in book 17 of the *Iliad*.

57. Donna C. Kurtz and John Boardman, *Thanatos. Tod und Jenseits bei den Griechen* (Mainz: Verlag Philipp von Zabern, 1985), 63–68; 88, fig. 17; 90, fig. 21; 171–72, fig. 50; 180–81; white ground lekythos, e.g., Berlin F. 2684: *Die Antikensammlung Berlin* (Berlin and Mainz: Verlag Philipp von Zabern, 1992), figs. 22–23 (Max Kunze); Ingeborg Scheibler, *Griechische Malerei der Antike* (Munich: C. H. Beck, 1994), 131–32 with nn. 227–28 (representations of the prothesis in Campanian wall painting of the 4th century).

58. Ernst Pfuhl and Hans Möbius, *Die ostgriechischen Grabreliefs*, 2 vols. (Mainz: Verlag Philipp von Zabern, 1977 and 1979), 166, 495, nos. 686c, 835c, 1647b.

59. Sabine Faust, "Fulcra. Figürlicher und ornamentaler Schmuck an antiken Betten," *RM-EH* 24 (1989): 23–25, 29, with further reading.

60. Gisela M. A. Richter, *The Furniture of the Greeks, Etruscans, and Romans* (London: Phaidon Press, 1966), 61, fig. 326; Kyrieleis (as in n. 50), 162–73 (furniture leg type B); Anastasia Pekridou, "Das Alketasgrab in Termessos," *IstMitt-BH* 32 (1986): 75–78, with further reading.

61. Behn, "Schiffe."

62. *LIMC* 2: nos. 79, 117, s.v. "Athena" (Pierre Demargne). For the cult image of Pergamon see Schalles, "Kulturpolitik," 13–15; Scheer, *Mythische Vorväter*, 106–7. The description of the cult image in Tatjana Brahms, *Archaismus. Untersuchungen zu Funktion und Bedeutung archaistischer Kunst in der Klassik und im Hellenismus* (Frankfurt am Main: Peter Lang, 1994), 96–98, with further reading, is incorrect and her results are therefore wrong.

63. Margrit Jacob-Felsch, *Die Entwicklung griechischer Statuenbasen und die Aufstellung der Statuen* (Waldsassen: Stiftland-Verlag Kommanditgesellschaft, 1969), 42–43, 68, pillar base type B. Comparable is the base in vol. I, cat. no. 29.

64. Jacob-Felsch (as in n. 63), 91, and plate showing the types of round bases.

65. See the judgments of Salis, "Altar," 102–49. See Hübner, "Applikenkeramik von Pergamon," section on "Figuralreliefs" for the iconology of Pergamene art.

66. *LIMC* 7: 856, 861–62, s.v. "Telephos" (Heres and Strauss).

67. Radt, *Pergamon*, 307–9; Hansen, *Attalids*, 409–18.

68. Winter, *Skulpturen, AvP*, vol. 7, no. 1, no. 357, supplement 39.

69. Sinn (as in n. 2), 52–69; Gropengiesser (as in n. 31), 307–32.

70. Brückner, "Wann ist der Altar von Pergamon errichtet worden?"; Kertész, "Telephos-Mythos," 209–15, with further reading; Kunze, "Neue Beobachtungen zum Pergamonaltar," in Andreae, *Phyromachos*, 135–38; Schmidt (as in n. 23), 141–62. For the beginning of the construction of the altar after 180 B.C., as suggested by Kähler, *Der grosse Fries*, 143–49, see Radt, *Pergamon*, 190, and Hoepfner, "Zu den grossen Altären," 633–34. For the pottery from the altar foundation see most recently Hübner, "Calices Pergami und die Scherbenfunde aus dem Grossen Altar," in *Epistemonike Synantese gia ten Hellenistike Keramike. Chronologemena synolaergasteria*, Thessalonike, 24–27 September 1991 (Athens: He en Athenais Archaiologike Hetaireia, 1994), 282–93.

71. Osada, *Stilentwicklung*, 34, with earlier bibliography; Carroll-Spillecke, *Landscape Depictions*, 18–24, 29, 54–55, 63, 108.

72. Osada, *Stilentwicklung*, 39–63.

73. Heres, "Reliefgestaltung."

74. Rostovtzeff, *Hellenistic World*, 1:563–64.

75. Hausmann, *Griechische Weihreliefs* (Berlin: Walter de Gruyter, 1960), 61–62, fig. 31; Carroll-Spillecke, *Landscape Depictions*, 57–59; Wegener, *Funktion*, 139–56.

76. Hesberg, "Bildsyntax," 355.

77. *LIMC* 6: no. 31, s.v. "Meleagros" (Susan Woodford).

78. Helga Rauscher, *Anisokephalia* (Vienna: Notring, 1971), 2:454; Jürgen Borchardt, "Zur Darstellung von Objekten in der Entfernung," in *Tainia* (as in n. 31), 248 n. 7.

79. See n. 47.

80. See the examples given by Osada, *Stilentwicklung*, 45–46.

81. Heres, "Reliefgestaltung," 104.

82. *LIMC* 6: no. 48, s.v. "Odysseus" (Odette Touchefeu-Meynier); see Heres, "Reliefgestaltung," 105.

83. Doris Pinkwart, *Das Relief des Archelaos von Priene und die "Musen des Philiskos"* (Kallmünz: Michael Lassleben, 1965), 118–24.

84. Adolf H. Borbein, "Eine Stele in Rhodos," *MarbWPr 1968* (1969): 84–85.

85. Heres, "Reliefgestaltung," 107–11. Jörg-Peter Niemeier, *Kopien und Nachahmungen im Hellenismus* (Bonn: Dr. Rudolf Habelt Gesellschaft mit beschränkter Haftung, 1985); Pollitt, *Art in the Hellenistic Age*, 164–68; Caterina Maderna Lauter, "Polyklet in hellenistischer und römischer Zeit," in *Polyklet. Der Bildhauer der griechischen Klassik*, exh. cat., Frankfurt am Main, Liebieghaus (Mainz: Verlag Philipp von Zabern, 1990), 298–327, with further reading in n. 1.

86. See for the following Stähler, *Das Unklassische*, 10–49; qualifying this Pinkwart, review, 201–11, and *Relief des Archelaos* (as in n. 83), 108–18.

87. Stähler, *Das Unklassische*, 50–75; Heres, "Reliefgestaltung," 113–14.

88. For the rendering of the bodies in the middle of the 2d century B.C. see, among others, Jörg Schäfer, "Kentauren aus dem Asklepieion von Pergamon," *PergForsch* 1 (1972): 180–86; Hilde Hiller, "Statuette eines Jünglings aus dem Marmorsaal," in Rheidt, *Stadtgrabung, AvP*, vol. 15, no. 1, 151–54.

89. For heads in the second century see Gerhild Hübner, "Der Porträtkopf," in Rheidt, *Stadtgrabung, AvP*, vol. 15, no. 1, *Stadtgrabung*, 129–32. Philip Brize, "Späthellenistischer Frauenkopf aus Pergamon," *IstMitt* 40 (1990): 187–89.

90. For the characterization of the heads of the Telephos frieze, see Pinkwart, in *Pergamon*, nos. 14–16, and *Relief des Archelaos* (as in n. 83), 124–25; Heres, "Fragmente vom Telephosfries," in Kunze, *Kunstepoche*, 50–52, with further reading.

STEWART, "TELEPHOS/TELEPINU AND DIONYSOS: A DISTANT LIGHT ON AN ANCIENT MYTH"

I thank Anthony Bulloch, Philip Damon, Renée Dreyfus, Crawford Greenewalt, Mark Griffith, Gary Holland, and the students in my Pergamon seminar (David Berkey, Jorge Bravo, Ambrosia Cervini, Celina Gray, Richard Neer, Elizabeth Paulette, Kristin Seaman, and Sarah Stroup) for their kind help with preparing and polishing this essay; all mistakes and indiscretions are, as usual, my own.

1. See Bauchhenss-Thüriedl, *Mythos*, 1–13; Hansen, *Attalids*, 5–6, summarizing earlier attempts to extract a kernel of historical fact from them; Matthias Strauss, "Telephos. Voruntersuchungen zum Verständnis des Telephosfrieses von Pergamon" (Ph.D. diss., University of Freiburg, 1988; non vidi), and "Frühe Bilder des Kindes Telephos," *IstMitt* 40 (1990): 79–100; and Strauss, in *LIMC* 7: s.v. "Telephos" (Huberta Heres and Matthias Strauss); his promised *Studien zur Ikonographie und Geschichte des Mythos von Telephos*, announced in the *Lexikon* as "in press," has, to my knowledge, yet to appear. The dates given are for the final composition of the *Kypria, Little Iliad*, and *Catalogue of Women* according to Martin West, *The Hesiodic Catalogue of Women* (Oxford: Clarendon Press, 1985), 130–37; Malcolm Davies, *The Epic Cycle* (Bristol: Bristol Classical Press, 1989), 3–5; and Gregory Nagy, *Pindar's Homer: The Lyric Possession of an Epic Past* (Baltimore and London: Johns

Hopkins University Press, 1990), 70–81; as argued in the text, the mythological raw material out of which they were woven was much older.

2. According to the scholiast, Priam bribed Eurypylos's mother, Astyoche, with the promise of a golden vine to persuade him to enter the war.

3. Aristotle *Rhetoric* 1.12, 1372b31; others, West (see n. 1); challenged by Strauss (as in n. 1), 93–94 and 100, but the ancient tradition is unanimous, and Aristotle was better placed to know the truth than we. See further below.

4. Bauchhenss-Thüriedl, *Mythos,* pl. 1 (part); *LIMC* 3: no. 7, pl. 283 (part), s.v. "Diomedes I" (John Boardman and C. E. Vafopoulou).

5. *LIMC* 1: no. 468, pl. 106, s.v. "Achilleus" (Anneliese Kossatz-Deissmann); John Boardman, *Athenian Red-Figure Vases: The Archaic Period* (New York and Toronto: Oxford University Press, 1975), fig. 50.

6. Nagy (as in n. 1), 72; for Telephos, the *Cycle,* and Homer, see Wolfgang Kullmann, *Die Quellen der "Ilias,"* Hermes Einzelschrift 14 (Wiesbaden: Steiner Verlag, 1960), 50 and 189–203.

7. West (as in n. 1), 154–55.

8. Paul Friedländer, "Herakles. Sagengeschichtliche Untersuchungen," *Philologische Untersuchungen* 19 (1907): 161 n. 1, after Herodotos 6.64–70, 7.101–5; etc.; and Xenophon *Hellenica* 3.1.6.

9. Horned deer: Sophokles fr. 89 Radt; Strauss (as in n. 1), pl. 17, 4–5; *LIMC* 7: nos. 6–7, pls. 594–95, s.v. "Telephos" (Heres and Strauss). For an authoritative discussion of the Telephos frieze as a colonizing narrative I am indebted to an unpublished seminar paper by Jorge Bravo.

10. For Aischylos's *Telephos,* see frr. 238–40 Radt; for Sophokles' trilogy *Telepheia,* frr. 77–91, 206–22, and 409–18 Radt; and for Euripides' *Telephos* and *Auge,* Denys L. Page, *Select Papyri ii: Literary Papyri: Poetry* (Cambridge, Mass., and London: Loeb Classical Library, 1950), nos. 3 and 17, with frr. 696, 700, 705, 716, 724, and 727N², and *POxy* 2460 *(Telephos); Strabo 13, 615 (Auge);* see in general Dana F. Sutton, *The Lost Sophocles* (Lanham, N.Y., and London: University Press of America, 1984), 3, 13–15, 46–49, 78–80, and 126–27; and T. B. L. Webster, *The Tragedies of Euripides* (London: Methuen, 1967), 43–48 and 238–41; also Ludwig Koenen, "Eine Hypothesis zur Auge des Euripides und tegeatische Plynterien," *ZPE* 4 (1969): 7–19; Pindar, *Olympian Ode* 9.73; *Isthmian Odes* 5.41 and 8.50.

11. Alkidamas *Odysseus* 14; on this text see especially Pierre Brulé, "Héraclès et Augé. A propos d'origine rituelles du mythe," *Les Femmes et le féminin,* in *Actes du Colloque de Grenoble,* 22–23 October 1992, Institut historique belge de Rome. Etudes de philologie, d'archéologie et d'histoire ancien, no. 31, 35–49. Vases and mirrors, some perhaps inspired by Euripides' *Telephos:* Bauchhenss-Thüriedl, *Mythos,* pls. 2–3; *LIMC* 3: nos. 9–11, pl. 47, s.v. "Auge" (Christa Bauchhenss-Thüriedl) ; *LIMC* 7: nos. 53–66, pls. 599–600, s.v. "Telephos" (Heres and Strauss); Andrew Stewart, "Reflections," in *Sexuality in Ancient Art,* ed. Natalie Kampen (New York and Cambridge: Cambridge University Press, 1996), 136–54, figs. 55–57; see Webster (as in n. 10), 302–3, and Arthur D. Trendall and T. B. L. Webster, *Illustrations of Greek Drama* (London: Phaidon Press, 1971), 103–4. Skopas: Pausanias 8.45.7; Stewart,

Skopas of Paros (Park Ridge, N.J.: Noyes Press, 1977), pls. 13–22 and 53; and Stewart, *Greek Sculpture,* figs. 542–55.

12. Lykophron *Alexandra* 205–15, 1245–49; inscription, J. Daux and R. Bousquet, "Télèphe, Dionysos Sphaléotas et les Attalides I," *RA* 19, no. 1 (1942–43): 113–25 and "Télèphe, Dionysos Sphaléotas et les Attalides II," *RA* 20, no. 2 (1942–43): 19–40. "Vine-clad plain of Mysia": Pindar *Isthmian Ode* 8.49–52.

13. Apollodoros *Epitome* 3.17, also Schol. B ad *Iliadem* 1.59; Dares Phrygios *De excidio Troiae Historia* 16. Others: Seneca *Troades* 215; Pausanias 1.4.6, 8.45.7, 9.5.14; Philostratos *Heroikos* 2.14–18, pp. 155–60, ed. Kayser; *Anth. Pal.* 16.110; Hyginus *Fabulae* 99–101; Quintus Smyrnaeus *Posthomerica* 4.41–42, 173–77; 7.379–80; 14.130; Dictys Cretensis *Bellum Troianum* 2.1–7; Jordanis *Getica* 9.59–60; Tzetzes *Antehomerica* 268–85, *ad Lycophronem* 1249, and *Chiliades* 12.951; Eustathius *ad Iliadem* 1.59; Schol. ad Lycophronem 206 and 211. Survey, Bauchhenss-Thüriedl, *Mythos,* 1–13.

14. Page (as in n. 10), no. 17, lines 11–13.

15. Telepinu: my thanks to Professor Philip Damon for alerting me to this connection, which seems to have escaped most Hellenists. First suggested in 1917 by B. Hrozny, *Die Sprache der Hethiter,* Boghaz-Koï Studien, 1–2 (Leipzig: J. C. Hinrichs, 1917), 3 n. 2, it was argued in detail in 1927 by Paul Kretschmer, "Der Name der Lykier und andere kleinasiatische Völkernamen," *JKF* 1 (1927): 18–24; for repercussions in English-language scholarship, see Hansen, *Attalids,* 6. For the texts, see *KUB* 17 and 18 (1921–44), and Hans Otten, "Die Überlieferungen des Telipinu-Mythos," *MVAG* 46, no. 1 (1942); and for translation and commentaries, James B. Pritchard, *Ancient Near Eastern Texts Relating to the Old Testament* (Princeton, N.J.: Princeton University Press, 1969), 126–28, 205, 354, 356, 358, and 396–97; O. R. Gurney, *The Hittites* (Harmondsworth: Penguin Books, 1964), 184–89; Hans Güterbock, in *Mythologies of the Ancient World,* 2d ed., ed. S. N. Kramer (Chicago: Quadrangle Books; Garden City, N.Y.: Anchor Books, 1989), 144–80; G. Kellerman, in *Kanissuwar. A Tribute to H. G. Güterbock on his Seventy-fifth Birthday,* ed. H. A. Hoffner and G. M. Beckman (Chicago: University of Chicago Press, 1986), 115–23; Franca Pecchioli Daddi and Anna Maria Pulvani, *La Mitologia ittita* (Brescia: Paideia Editrice, 1990), 71–89; and Volkert Haas, *Geschichte der hethitischen Religion* (Leiden and New York: Brill, 1994), 442–45, 707–18, etc. On the Hellenist side, the connection was resurrected by G. L. Huxley, "Hittites in Homer," *PP* 14 (1959): 281–82, but with no citation of any earlier scholarship; he prefers the manuscript variant *Kheteioi* (Χήτειοι) for the *Keteioi* (Κήτειοι) of Eurypylos's followers in T1, which would make them Hatti, i.e., Hittites. Though unaware of this MS variant, W. E. Gladstone had already suggested in 1876 that the Keteioi were Hittites, in *Homeric Synchronism* (New York: Harper, 1876), 70–76; but in the new Oxford edition of the *Odyssey,* Heubeck and Hoekstra note that Alcaeus fr. 413 Lobel-Page proves that "Keteios" is in fact a genuine Mysian ethnic; indeed, Gladstone had already realized that Strabo 13, 616 lists the Keteios as one of the tributaries of the Kaikos, and Kretschmer, 8, added a river god with this name on a bronze coin of Pergamon (Head, *Historia Nummorum²,* 536). So in T1, "Keteioi" (Κήτειοι) should be preferred. Lykia: Menaichmos ap. Stephanos Byzantinus, s.v. "Telephios demos"; see Euripides *Telephos* fr.

700N² and Pausanias 9.41.1; see Kretschmer, 13. For the Roman imperial coins see *LIMC* 7: nos. 17, 31, 35, and 36, s.v. "Telephos" (Heres and Strauss); Ben Damsky is currently preparing a study of these and presented his preliminary results at an American Numismatic Society regional conference in Berkeley on 4 May 1996. On Tarhun(t), see Kretschmer, 12–13; see Gurney, 138; Haas, 31, 309, and 338–39; and on Tarchon and Tarquinia see Lykophron *Alexandra* 1245–49, where his brother Tyrsenos (i.e., "the Etruscan") also founds Caere.

16. Walter Burkert, *Structure and History in Greek Mythology and Ritual* (Berkeley and Los Angeles: University of California Press, 1979), 123–32.

17. For references, see Hansen, *Attalids*, 6 n. 18

18. Burkert, *Greek Religion* (German ed. 1977; Cambridge, Mass.: Harvard University Press, 1985), 147.

19. Burkert (as in n. 18), 202–3; Gregory Nagy, *The Best of the Achaeans* (Baltimore and London: Johns Hopkins University Press, 1979), 121.

20. Polarity between Apollo and Dionysos: see, e.g., Plutarch *Moralia* 338E–339C, with commentaries and further sources in W. F. Otto, *Dionysos, Myth and Cult* (Frankfurt am Main: V. Klostermann, 1933; Dallas: Spring Publications, 1965, reprint 1981), ch. 18; Burkert (as in n. 18), 162–63, 223–25; Stewart, "Dionysos at Delphi: The Pediments of the Sixth Temple of Apollo and Religious Reform in the Age of Alexander," in *Macedonia and Greece in Late Classical and Early Hellenistic Times,* Studies in the History of Art, 10, ed. Eugene Borza and Beryl Barr-Sharrar (Washington, D.C.: National Gallery of Art, 1982), 205–28. Dionysos Sphaleotas and his sanctuary: Daux and Bousquet (as in n. 12), passim, and their brief report of the excavation of the Sphaleotas sanctuary in *BCH* 75 (1951): 138–39.

21. Oracle to Aleos: Alkidamas *Odysseus* 14 (=H. W. Parke and D. E. W. Wormell, *The Delphic Oracle* [Oxford: Oxford University Press, 1956], ii, no. 324); see especially Brulé (as in n. 11) on its significance. First oracle to Telephos: Schol. Vat. to Euripides' *Rhesus* 250 (=*FGH* 327 fr. 17); *Souda* and Photius s.v. "Eschaton Myson" and *Appendix Proverbiorum* 2.85: Diodoros 4.33.11; Apollodoros 2.9.1; see, ii, nos. 308 and 451. Second oracle to Telephos: Menaichmos in Steph. Byz. s.v. "Telephios demos" and (by implication) Euripides *Telephos* fr. 700N² and Pausanias 9.41.1 refer the question to the Lykian Apollo of Patara, whereas Libanios *Declamationes* 5.9 and the scholia to Aristophanes' *Clouds* 919 and Demosthenes 18.72 prefer Delphi. Other sources are nonspecific: see Parke and Wormell, ii, no. 198, Apollo cults at Argos: Sophokles *Electra* 6; see Bauchhenss-Thüriedl, *Mythos,* 26–32, 87–88, nos. 53 and 57, and pls. 2–3; *LIMC* 1: nos. 13 and 18, pls. 192–93, s.v. "Agamemnon" (Odette Touchefeu). Oracle to Achaians: the appearance of Kalchas in Apollodoros 3.19–20, on a cup in Boston (*ARV²* 817 no. 2), and on a Paestan calyx-krater in San Antonio (*LIMC* 7: no. 51, pl. 866, s.v. "Telephos" [Heres and Strauss]; *LIMC* 5: no. 4, pl. 601, s.v. "Kalchas" [Vincenzo Saladino]) makes it almost certain that this was Apollo's. Unfortunately, the fragment of Euripides' *Telephos* preserved in *POxy* 2460 fr. 9 (see Eric Handley and John Rea, *BICS* supplement 5 [1957]: 6, 37–38) and the presumed résumé of Euripides' plot by Hyginus, *Fabulae* 101, are both unhelpful on this score.

22. See Nagy (as in n. 19), 209, with 179–80 on the immortal connotations of gold.

23. Florence 4209: *ABV* 76: John Boardman, *Athenian Black Figure Vases* (London: Thames and Hudson, 1974), fig. 46; see Stewart, "Stesichoros and the François Vase," in *Ancient Greek Art and Iconography,* ed. W. G. Moon (Madison: University of Wisconsin Press, 1983), 53–74, and with Albert Henrichs, "Myth Visualized: Dionysos and His Circle in Sixth-Century Attic Vase-Painting," in *Papers on the Amasis Painter and His World,* ed. Marion True (Malibu: J. Paul Getty Museum, 1987), 94–95, for a reply to criticisms of my thesis and a sensible intermediate position on the issue.

24. Achilles-Apollo: Burkert (as in n. 18), 202–3; Nagy (as in n. 19), 59–65 and 118–44. Neoptolemos: Nagy (as in n. 19), 118–41, with full references.

25. Upbringing: see Bauchhenss-Thüriedl, *Mythos,* 36 and 50–54 for discussion and references, with cat. nos. 25 (Herculaneum painting) and 43 (relief); *LIMC* 2: no. 1, pl. 437, s.v. "Arkadia" (Erika Simon); *LIMC* 7: no. 37, pl. 598, s.v. "Telephos" (Heres and Strauss).

26. See Ohlemutz, *Kulte und Heiligtümer,* 90–122, on the cult.

27. Telephos and Herakles: Pausanias 10.28.8; also (for what it is worth) Jordanis *Getica* 9.59. As one might expect, hymns sung to the healing god Asklepios at Pergamon began with an invocation to Telephos, but they omitted Eurypylos because he had killed Asklepios's son, Machaon, at Troy: Pausanias 3.26.9–10; see Ohlemutz, *Kulte und Heiligtümer,* 165 n. 126, 231. A votive relief from just outside the Asklepieion, inscribed with Telephos's name, confirms his ties with the sanctuary: de Luca, *Asklepieion, AvP,* vol. II, no. 4, pl. 59 (above); Bauchhenss-Thüriedl, *Mythos,* 69–70 and pl. 10, 2; *LIMC* 7: no. 91, pl. 602, s.v. "Telephos" (Heres and Strauss).

28. Nagy (as in n. 19), 339–44; see esp. *Iliad* 9.410–16; spectacularly confirmed by the new early classical sarcophagus (as yet unpublished) with a representation of Polyxena's sacrifice at Achilles' tomb, found near Çanakkale on the Hellespont and now in the local museum. Taking up a suggestion of Hans Schrader's, Bauchhenss-Thüriedl, *Mythos,* 36 and 51, suggests that Telephos may have omitted to thank Dionysos for his rescue when a baby and so provoked the god's wrath; but even if this is correct, it can only be an after-the-fact explanation: see further below.

29. Pindar *Olympian Ode* 9.70–73; see Apollodoros *Epitome* 3.17.

30. On this see Nagy (as in n. 19), 176–77.

31. *Iliad* 9.410–16.

32. See Nagy (as in n. 19), 174–77 with especially *Iliad* 9.412–13; *Odyssey* 24.93–94.

33. So Nagy (as in n. 19), 40–41 and 266–68.

34. Omitted sacrifice: for a parallel see the story of Artemis, Oineus, and the Kalydonian Boar, *Iliad* 9.529–46. For Apollo's cults in the Troad see *Iliad* 1.39 and 10.430, with J. M. Cook, *The Troad* (Oxford: Oxford University Press, 1973), 117–19, 228–31. Thymbra was where Achilles killed Apollo's favorite, Troilos, and was himself killed by Paris or Apollo: schol. to *Iliad* 24.257; Apollodoros *Epitome* 3.32; Servius ad *Aen.* 3.85.

35. Bronze Age contacts: Hansen, *Attalids*, 4–5; Christopher Mee, "Aegean Trade and Settlement in Anatolia in the 2nd Millennium B.C.," *AnatSt* 28 (1978): 121–56, and "A Mycenaean Thalassocracy in the Eastern Aegean?" in *Problems in Greek Prehistory*, ed. Elizabeth B. French and Kenneth A. Wardle (Bedminster: Bristol Classical Press, 1988), 301–6. Later colonization: Herodotus 1.149; Strabo, 13, 614. See J. M. Cook, *CAH* 3d ed., 2, no. 2 (1975): 779–80; see Anthony M. Snodgrass, *The Dark Age of Greece* (Edinburgh: Edinburgh University Press, 1971), 67 and 134–35 on the Pitane pottery, which he dates to ca. 1050–900 B.C.; Hansen, *Attalids*, 6–8, discusses attempts to reconcile the legends, the history, and the archaeology; see also R. Stillwell, ed., *The Princeton Encyclopedia of Classical Sites* (Princeton, N.J.: Princeton University Press, 1976), 715, for further references.

36. On Tudhaliyas, see most recently F. Cornelius, "Telephos. Eine Episode der hethitischen Geschichte in griechischer Sicht," in *Festschrift Heinrich Otten: 27 Dez. 1973*, ed. Erich Neu and Christel Ruster (Wiesbaden: Harrassowitz, 1973), 53–57, and (independently) L. A. Gindin and V. L. Tsymbursky, "The Ancient Greek Version of the Historical Event Reflected in a Hittite Text," *VDI* 176 (1986): 81–87. For the traditional reconstruction of Tudhaliyas's relationships with the Ahhiyawa, see Gurney (as in n. 15), 51–52; for critiques and retranslations of the crucial document (Heinrich Otten, "Mythische und Magische Texte in hethitischer Sprache," *KUB* 33 [1943]: 13), which would void this theory, see Hans Güterbock, "The Hittites and the Aegean World: Part I. The Ahhiyawa Problem Reconsidered," *AJA* 87 (1983): 137–38; D. F. Easton, "Hittite History and the Trojan War," in *The Trojan War: Its Historicity and Context*, ed. Lin Foxhall and John K. Davies (Bristol: Bristol Classical Texts, 1984), 29.

37. On this sense of Moira see Nagy (as in n. 19), 128–35, 268, and 285.

ANDREAE, "DATING AND SIGNIFICANCE OF THE TELEPHOS FRIEZE IN RELATION TO THE OTHER DEDICATIONS OF THE ATTALIDS OF PERGAMON"

Further Reading

Allen, R. E. *The Attalid Kingdom: A Constitutional History*. Oxford: Clarendon Press, 1983.

Andreae, Bernard. *Laokoon und die Kunst von Pergamon. Die Hybris der Giganten*. Frankfurt am Main: Fischer, 1991.

———. "Der Lorbeerkranz des Asklepios und die Attaliden von Pergamon." *RM* 100 (1993): 83–106.

Bauslaugh, Robert A. "The Unique Portrait Tetradrachm of Eumenes II." *ANSMN* 27 (1982): 39–51.

Cardinali, Giuseppe. *Il regno di Pergamo. Ricerche di storia e di diritto pubblico*. Rome: Ermanno Loescher & Co., 1906.

de Chaisemartin, Nathalie. "Eumène II de Pergame. Du type monétaire aux portrait plastique." *REA* 95 (1993): 225–34.

Chamoux, François. "Pergame et les Galates." *REG* 101 (1988): 492–500.

Donatas, Georgios. "Ein plastisches Attaliden-Paar auf der Akropolis." In *Kanon: Festschrift Ernst Berger. AntK-BH* 1 (1988): 222–31.

Green, Peter. *Alexander to Actium: The Hellenistic Age*. London: Thames and Hudson, 1990.

Habicht, Christian. "The Attalid Monarchy at Its Peak." *CAH* 8 (1989): 324–34.

Hansen, Esther V. *The Attalids of Pergamon*. 2d ed. Cornell Studies in Classical Philology, no. 36. Itahca, N.Y., and London: Cornell University Press, 1971.

Hopp, Joachim. *Untersuchungen zur Geschichte der letzten Attaliden*. Munich: Beck, 1977.

McShane, Roger B. *The Foreign Policy of the Attalids of Pergamon*. Urbana: University of Illinois Press, 1964.

Onians, John. *Art and Thought in the Hellenistic Age: The Greek World View, 350–50 B.C.* London: Thames and Hudson, 1979.

Rohde, Elisabeth. *Pergamon. Burgberg und Altar*. 7th ed. Berlin: Henschel Verlag, Kunst und Gesellschaft, 1982.

Staehelin, Felix. *Geschichte der kleinasiatischen Galater*. Leipzig: Teubner, 1907.

WULF, "TOPOGRAPHICAL PLAN OF ROMAN PERGAMON (1:2500)"

Ulrike Wulf, "Der Stadtplan von Pergamon," *IstMitt* 44 (1994): 135–75, with a thorough description and further reading.

SCHRAUDOLPH, "RESTORATION OF THE TELEPHOS FRIEZE"

This essay is a shortened version of the German original, which will be published elsewhere.

1. Eugenio La Rocca, *Ara Pacis Augustae in occasione del restauro della fronte orientale* (Rome: "L'Erma" di Brettschneider, 1983).

2. Eugenio La Rocca, *L'Auriga dell'Esquilino* (Rome: "L'Erma" di Brettschneider, 1987).

3. Marina Mattei, *Il Galato Capitolino* (Rome: "L'Erma" di Brettschneider, 1987).

4. *Il Toro Farnese. La "montagna di marmo" tra Roma e Napoli* (Naples: Gaetano Macchiaroli, 1991).

5. *BullCom* 15 (1993): 175–263, with an introduction on 174.

6. Lorenzo Lazzarini and Marisa Laurenzi Tabasso, *Il Restauro della pietra* (Padua: CEDAM, 1986).

7. "Materiali Lapidei. Problemi relativi allo studio del degrado e della conservazione, I. II," *BdA*, supplement 41 (1987).

8. *Fourth International Meeting on the Restoration of the Acropolis Monuments: English Summaries* (Athens: Ministry of Culture and Sciences, 1994). The

first international meeting of this kind took place in 1977. The second and third meetings took place in 1983 and 1989: *Parthenon: Second International Meeting for the Restoration of the Acropolis Monuments: Proceedings,* Athens, 12–14 September 1983 (Athens: Ministry of Culture and Sciences, 1985); and *Third International Meeting for the Restoration of the Acropolis Monuments: Proceedings,* Athens, 31 March–2 April 1989 (Athens: Ministry of Culture and Sciences, 1990).

9. Hans Rupprecht Goette, "Restaurierungen und Forschungen auf der Akropolis von Athen. Ein Forschungsbericht," *AntW* 22 (1991): 165–76.

10. Richard Economakis, ed., *Acropolis Restoration: The CCAM Interventions* (London: Academy Editions, 1994).

11. Michael Maass, "Nachträgliche Überlegungen zur Restaurierung der Ägineten," *AM* 93 (1984): 165–97, with extensive references; also in general, to literature on this topic.

12. As late as the first half of the 19th century, ancient statues were often reconstructed to their original form. Only in the late nineteenth century did an aesthetic feeling develop for sculptural fragments. Nevertheless, on a trial basis reconstruction of the figures in six panels of the Gigantomachy frieze was attempted by the sculptor Alexander Tondeur. The pieces were used for the 1:1 reconstruction of the Pergamon Altar on the occasion of the jubilee exhibition of the Akademie der Künste: Adolf Trendelenburg, *Die Gigantomachie des pergamenischen Altars. Skizzen zur Wiederherstellung derselben, entworfen von Alexander Tondeur* (Berlin: Verlag von Ernst Wasmuth, 1884). For the scholarly discussion on this matter in the beginning of the 20th century, see Georg Dehio and Alois Riegl, *Konservieren, nicht restaurieren. Streitschriften zur Denkmalpflege um 1900* (Braunschweig: Friedrich Vieweg und Sohn VerlagsgesellschaftmbH, 1988), with a preface by Marion Wohlleben.

13. See also Schrader, "Anordnung," 111; contra Robert, "Telephos-Frieze," parts III through VI, 98, 104.

14. Winnefeld, *Friese, AvP,* vol. 3, no. 2, 2–5; see Conze, "Ausgrabungen," 129–56.

15. Schulte, "Pergamonaltar," 27–218.

16. "Situation der Arbeiten am 1. Mai 1879," Archive of the Antikensammlung, Staatliche Museen zu Berlin. Scale 1:200. Also Schulte, "Pergamonaltar," 190: "23. März 1880: In der Byzantinischen Mauer häuften sich die Funde, die, wie die Fundkarte zeigt, fast in einer Linie lagen," and 214: "Im Januar 80 . . . ; am 17. hatte ich die Karte fertig gezeichnet und konnte sie nach Berlin senden."

17. Winnefeld, *Friese, AvP,* vol. 3, no. 2, addition 1.

18. Archive of the Antikensammlung, Staatliche Museen zu Berlin, published in Schulte, "Pergamonaltar," 219–51; however, in the publication the drawings of panels 23 and 45 are missing.

19. Robert, "Telephos-Frieze," parts III through VI, 99.

20. Panels 6, 8, 12, 16, 18, 23?, 48, 49, 50, and 51 (cat. nos. 3, 5–6, and 12).

21. In this respect it seems doubtful whether panel 23, heavily stained, really originated in the Byzantine wall, as Robert, "Telephos-Frieze," parts III through VI, 99, mentions. His information seems to be based on a note by Humann penciled on the original drawing, which was made in April 1881. Another note by a different hand, scribbled below the first one a few days later, reads: "war von Humann schon im Oktober als Telephosrelief mitgeteilt." According to this, the panel was found in October 1880.

22. This can be learned from an inventory of a box in the archive of the Antikensammlung, Staatliche Museen zu Berlin, inv. 65 (entry no. 498).

23. Parts of panels 24 and 27, panels 28, 30, 32, 33, 43, and 47 in the southeast; parts of panels 27 and 39, panels 10–11, 20, 25, 34–36, 38, 40, and 46 (cat. nos. 4, 7, 8, and 10) in the northeast and east respectively. Panel 7 also marginally pertains to this case; according to Humann's diary of 29 October 1883, it was found at the eastern wall of the altar peribolos. Schulte, "Pergamonaltar," 218, quotes an "erweitertes Tagebüchlein" of Humann, from which we learn that he drew this piece on 19 November. The original drawing has been preserved. The diary quoted is, probably, one that is now in private hands (Hans Dietrich Humann zu Bredeney). Oddly, Winnefeld mentions the south side of the market as the find spot without reference to a source.

24. Schrader, "Anordnung," 111.

25. Schulte, "Pergamonaltar," 178.

26. Panels 34 (partly), 36, 39, and 40 (partly).

27. Panels 2, 5, 8–9, 30, 42, and 45 (cat. nos. 2 and 11).

28. For example, PM 579 of 1934.

29. I thank Klaus Germann, professor of geology (deposit research) at the Technische Universität Berlin, for kindly providing the information.

30. No information is known for the following pieces: panels 4, 13, 14a–b, 31, 37, and 41 (cat. no. 9).

31. Panels 1 and 3 (cat. no. 1), and parts of panel 39.

32. Panel 17.

33. Parts of panel 47.

34. In the case of panels 9, 30, and 42 (cat. no. 11).

35. Winnefeld, *Friese, AvP,* vol. 3, no. 2, 167, made this observation. In his general chapter, "Technisches," 213, however, he states that there is a rectangular dowel in this location.

36. On ancient gluings in archaic and classical times, see Sheila Adam, *The Technique of Greek Sculpture in the Archaic and Classical Periods* (Oxford: Thames and Hudson, 1966), 80–82; recently on this topic, see Amanda Claridge, "Ancient Techniques of Making Joints in Marble Statuary," in *Marble: Art Historical and Scientific Perspectives on Ancient Sculpture* (Malibu: J. Paul Getty Museum, 1990), 153–54.

37. Winnefeld, *Friese, AvP,* vol. 3, no. 2, 209.

38. The complete documentation with drawings, photographs, and the detailed results of the restoration stored in a database are in the archive of the Antikensammlung, Staatliche Museen zu Berlin.

39. Schulte, "Ausgrabung," 69. The minutes are in the Deutsches Zentralarchiv in Merseburg.

40. General administration. Proofs *(Zusammenstellungen)* 1881/82 in the central archive of the Staatliche Museen zu Berlin (GV 510).

41. General administration. Proofs *(Extraordinarien)* 1 April 1882/83 in the central archive of the Staatliche Museen zu Berlin (GV 518).

42. Archive of the Antikensammlung, Staatliche Museen zu Berlin (no. 165). Freres and Possenti are named as authors. The handwriting, however, correlates throughout to the wage receipts of Possenti. In each case he documents the number of fragments of one box and refers, in somewhat awkward German, to single pieces that have aroused his special attention. About 100 boxes resulted from the third campaign of excavation and often contained fragments of the Gigantomachy frieze, which indicates that work concerning this frieze was still unfinished at that time.

43. An exception is panel 34, where a small clamp made from pure copper was found.

44. The Telephos frieze panels, apparently, were described soon after their restoration in a small collection of anonymous notes kept in the archive of the Antikensammlung, Staatliche Museen zu Berlin, which, from a comparison of handwriting, appears to have been written by the archaeologist Paul Wolters. In these notes the panels are numbered following the Roman numerals assigned by Humann. Panel 39, at that time, consisted of not more than three fragments, according to the description and a small drawing on page 13. Today the number of fragments has increased to sixteen.

45. Schulte, "Pergamonaltar," 218–51.

46. Wilhelm Hinz, ed., *Silicat-Lexikon. Nichtmetallisch-anorganische Werkstoffe* (Berlin: Akademie-Verlag, 1985), s.v. "Magnesiumoxichlorid 'zement.'" Thanks are due to Achim Unger of the Rathgen-Forschungslabor for this reference.

47. Volker Kästner indicated that the bricks, according to this stamp, may have come from Saxonia, from the region of the river Mulde.

48. Panels 1, 14b, 18, 23, 34, and 38. Traces of this procedure were found on the back of the richly decorated ship fragments (panel 14b). They are caused by the original reconstruction with the now missing fragment of the back.

49. The results of the analysis were recorded in the Antikensammlung together with the documentation of the restoration. A complete, precise identification of the glues was not possible. By comparison, the three samples examined came closest to the following glues: granular skin glue, fish-bladder glue, and rabbit-skin glue. On panel 47 and especially in the oracle scene of panel 1 (fig. 30, this essay), organic glue had been used in the second phase.

50. The determinations are due to Silvano Bertolin for the following panels: 2, 22, 28, 33, 38, and 50 (cat. no. 10). Only panels 38 and 50 were analyzed by Unger, according to which an acrylic adhesive was used.

51. "Einrichtung der Architektursäle 1925–29," vol. 2, Staatliche Museen zu Berlin, Zentralarchiv, I/BV 513, letter of Regierungs- und Baurat Wille to the general administration.

From a letter written by Prof. Rathgen of the chemical laboratory, Staatliche Museen zu Berlin, 19 January 1926, to the director of the Antikensammlung, Theodor Wiegand: "Die weisslichen Ausschläge auf den pergamenischen Marmorreliefs bestehen aus Gips und anderen leichter löslichen, schwefelsauren Salzen. Ich halte für unbedenklich, wenn sie in frostfreiem Raum mit lauwarmen Wasser beseitigt werden, nachdem vorher der Staub mittels Staubaufsaugers gründlich entfernt worden ist." Based on this, Wiegand advised the supervision of the construction: "Eilt: Die Friese sind hiernach zu reinigen, doch darf die Patina nicht abgewaschen werden. Es wird daher nötig sein, die Antikenabteilung zu zuziehen."

52. Staatliche Museen zu Berlin, Zentralarchiv, I/BV 513, 66a–b.

53. Carl Weickert reports this concerning the Gigantomachy frieze, and so we assume that the Telephos frieze was treated in the same way: "Bericht über die Bergungsmassnahmen der Antikenabteilung und weiterhin über diejenigen der Gesamtheit der Staatlichen Museen," Berlin C 2, 1 October 1945, 8–9 (unpublished manuscript, Archive of the Deutsches Archäologisches Institut and of the Antikensammlung).

54. Konstantin Akinscha, Grigori Koslow, and Clemens Toussaint, *Operation Beutekunst. Die Verlagerung deutscher Kulturgüter in die Sowjetunion nach 1945* (Nuremberg: Germanisches Nationalmuseum, 1995), 36, 61.

55. Akinscha, Koslow, and Toussaint (as in n. 54), 46.

56. Akinscha, Koslow, and Toussaint (as in n. 54), 51.

57. Files of the Antikensammlung to the main administration, Staatliche Museen zu Berlin, Zentralarchiv, VA 4910 and VA 4831.

58. Elisabeth Rohde, "Die Berliner Antikensammlung. Erlebt und mitgestaltet, 1945–1980," *FuB* 20 (1980): 43–71. We learn from a letter concerning awards written by Rohde to the general administration in October 1959 that Adolf Fahrnholz should be honored: "für die Restaurierung der Gipsabgüsse an der Nord- und Südwand des Pergamon-Altars, für die Befestigung vieler grösserer und kleinerer Bruchstücke an den Marmorfriesen des Pergamon-Altars und für das Waschen der Friesplatten."

59. See n. 57.

60. Fragments of panels 2, 12, 18 (two fragments), 20, 22, 24 (two fragments), 27, 28 (three fragments), 30 (two fragments), 37 (two fragments), 39 (two fragments), 40 (two fragments), and 47 (two fragments) (cat. nos. 5 and 7).

61. A photograph taken by the photographer Horlemann was listed in 1933 in the photo archive of the Antikensammlung, Staatliche Museen zu Berlin. It was published in 1932 in the guide to the Pergamon Museum by Massow, *Führer durch das Pergamonmuseum,* fig. 41. In the guidebook by Bruns, *Der Grosse Altar von Pergamon,* published when the frieze had not yet returned to Berlin, a photograph (fig. 43) shows the paw is missing.

62. Notice in file dated 14 June 1962, directed to the general administration; see n. 57. During the same year, but before the robbery, the plaster copy of the head was fitted on panel 38 (cat. no. 10) under the direction of Heinz Luschey and Huberta Heres. The fragment is still visible in a photograph taken at that time; see Rohde, *Griechische und römische Kunst in den Staatlichen Museen zu Berlin* (Berlin: Henschel Verlag, 1968), fig. 34. The glass negative series dated that same year was taken after the theft; in that picture, only the bronze dowel is visible.

63. On panels 4, 14b, and 50.

64. *Chemikalien-Nachweiskatalog. ZC Information VEB Chemieanlagenbaukombinat Leipzig-Grimma* (Berlin and Johannisthal: VEB Zentrale Informationsverarbeitung Chemie, 1987), 15, nos. 98–99.

65. See panels 17 and 42 (cat. no. 11).

66. See fig. 11, new fracture above the navel of the seated man.

67. Winnefeld, *Friese, AvP*, vol. 3, no. 2, 161.

68. Winnefeld, *Friese, AvP*, vol. 3, no. 2, 161.

69. An extension was necessary in the case of panels 1, 2, 8, 11, 16, 23–24, 27, and 39–40 (cat. no. 6).

70. More examples of this kind: panels 8, 40, and 44.

71. Due to similar reasons panel 50 received a safety dowel.

72. The additions to panels 1, 2, 18, and 50 were glued with epoxy resin, and panel 33 by Paraloid (10%). Panel 14b was glued without using a dowel.

73. See Luschey, "Funde." A photograph of the original is unpublished.

CRAMER, GERMANN, AND WINKLER, "CHARACTERISTICS OF THE TELEPHOS FRIEZE MARBLE"

1. G. Richard Lepsius, "Griechische Marmorstudien," *Abhandlungen der Königlichen Akademie der Wissenschaften zu Berlin, philosophisch-historische Abhandlungen* (1890): 1–135.

2. These samples were collected in 1898 by Carl Schuchhardt and have been kept in storage at the Antikensammlung, Staatliche Museen zu Berlin: Alexander Conze and Schuchhardt, "Die Arbeiten zu Pergamon, 1886–1898," *AM* 24 (1899): 148–51. Schuchhardt did not consider these samples to be identical with the marble of the Telephos frieze; he matched them to the marble of architecture fragments of the altar. The restorers Freres and Possenti also saw similarities to the marble of the Pergamene sculptures that are not from the altar area.

Further Reading

Germann, Klaus, G. Gruben, H. Knoll, V. Valis, and F. Johann Winkler. "Provenance Characteristics of Cycladic (Paros and Naxos) Marbles: A Multivariate Geological Approach." In *Classical Marble: Geochemistry, Technology, Trade.* Edited by Norman Herz and Marc Waelkens, 251–62. Dordrecht: Kluwer Academic Publishers, 1988.

Herz, Norman. "The Oxygen and Carbon Isotopic Data Base for Classical Marble." In *Classical Marble: Geochemistry, Technology, Trade.* Edited by Norman Herz and Marc Waelkens, 305–14. Dordrecht: Kluwer Academic Publishers, 1988.

SELECTED BIBLIOGRAPHY

Allen, R. E. *The Attalid Kingdom: A Constitutional History*. Oxford: Clarendon Press, 1983.

Andreae, Bernard. *Die Antikensammlung Berlin*. Berlin and Mainz: Verlag Philipp von Zabern, 1992.

———, ed. *Phyromachos-Probleme: Mit einem Anhang zur Datierung des grossen Altares von Pergamon*. RM-EH 31 (1990).

Bauchhenss-Thüriedl, Christa. *Der Mythos von Telephos in der antiken Bildkunst*. Beiträge zur Archäologie, no. 3. Würzburg: Konrad Triltsch Verlag, 1971.

Behn, Friedrich. "Die Schiffe des Telephosfrieses." *JdI* 22 (1907): 240–48.

Belov, Gregorij D. *Altar' Zevsa v Pergame* (in Russian). Leningrad: Publication of the Hermitage, 1959.

Bieber, Margarete. *The Sculpture of the Hellenistic Age*. Rev. ed. New York: Columbia University Press, 1961.

Bielefeld, Erwin. "Zum Problem der kontinuierenden Darstellungsweise." *AA* (1956): 29–34.

von Blanckenhagen, Peter H. "Narration in Hellenistic and Roman Art." *AJA* 61 (1957): 78–83.

Boehringer, E., and F. Krauss, eds. *Das Temenos für den Herrscherkult*. AvP. Vol. 9. Berlin and Leipzig: Verlag von Walter de Gruyter & Co., 1937.

Bohn, Richard. *Das Heiligtum der Athena Polias Nikephoros*. AvP. Vol. 2. Berlin: Verlag von W. Spemann, 1885.

———. *Theater-terrasse*. AvP. Vol. 4. Berlin: Verlag von W. Spemann, 1896.

Bohtz, Carl Helmut. *Das Demeter-Heiligtum*. AvP. Vol. 13. Berlin: Walter de Gruyter & Co., 1981.

Brückner, Alfred. "Wann ist der Altar von Pergamon errichtet worden?" *AA* (1904): 218–25.

Bruns, Gerda. *Der Grosse Altar von Pergamon*. Berlin: Gebrüder Mann, 1949.

Bulle, Heinrich. Review of *Die Meister des grossen Frieses von Pergamon*, by Carl Schuchhardt. *Gnomon* 2 (1926): 326–36.

Carroll-Spillecke, M. P. *Landscape Depictions in Greek Relief Sculpture*. Frankfurt am Main: Lang, 1985.

Conze, Alexander, et al. "Die Ausgrabungen zu Pergamon und ihrer Ergebnisse." *JPKS* 1 (1880): 127–224.

———. *Stadt und Landschaft*. AvP. Vol. 1, nos. 1–3. Berlin: Verlag von Georg Reimer, 1912–13.

Filgis, Meinrad, and Wolfgang Radt. *Die Stadtgrabung. Teil 1. Das Heroon*. AvP. Vol. 15, no. 1. Berlin: Walter de Gruyter & Co., 1986.

Fränkel, Max, ed. *Die Inschriften von Pergamon. I: Bis zum Ende der Königszeit*. AvP. Vol. 8, no. 1. Berlin: Verlag von W. Spemann, 1890.

———, ed. *Die Inschriften von Pergamon. II: Römische Zeit—Inschriften auf Thon*. AvP. Vol. 8, nos. 1–2. Berlin: Verlag von W. Spemann, 1895.

Froning, Heide. "Anfänge der kontinuierenden Bilderzählung in der griechischen Kunst." *JdI* 103 (1988): 169–99.

von Gerkan, Armin. "Überlegungen zum Aufbau des Zeusaltares." In "Pergamon. Gesammelte Aufsätze." Edited by Erich Boehringer. *PergForsch* 1 (1972): 64–66.

Green, Peter. *Alexander to Actium: The Hellenistic Age*. London: Thames and Hudson, 1990.

Gruen, Erich S. *The Hellenistic Age and the Coming of Rome*. Berkeley and Los Angeles: University of California Press, 1984.

Hansen, Esther V. *The Attalids of Pergamon*. 2d ed. Cornell Studies in Classical Philology, no. 36. Ithaca, N.Y., and London: Cornell University Press, 1971.

Heres-von Littrow, Huberta. "Untersuchungen zur Reliefgestaltung des Telephosfrieses." *FuB* 12 (1970): 103–21.

———. "Fragmente vom Telephosfries." *FuB* 16 (1975): 191–208.

von Hesberg, Henner. "Bildsyntax und Erzählweise in der hellenistischen Flächenkunst." *JdI* 103 (1988): 309–65.

Hoepfner, Wolfram. "Zu den grossen Altären von Magnesia und Pergamon." *AA* (1989): 601–34.

———. "Bauliche Details am Pergamonaltar." *AA* (1991): 189–202.

———. "Siegestempel und Siegesaltäre. Der Pergamonaltar als Siegesmonument." In *Die griechische Polis. Architektur und Politik*. Edited by Wolfram Hoepfner and Gerhard Zimmer. Tübingen: Ernst Wasmuth Verlag, 1993.

Holliday, Peter J., ed. *Narrative and Event in Ancient Art*. Cambridge: Cambridge University Press, 1993.

Hübner, Gerhild. "Die Applikenkeramik von Pergamon. Eine Bildersprache im Dienst des Herrscherkultes." *PergForsch* 7 (1993).

Kähler, Heinz. "Die Datierung des Altars von Pergamon." *Funde und Forschungen* 15 (1939): 294–96.

———. *Der grosse Fries von Pergamon*. Berlin: Gebrüder Mann, 1948.

———. "Pergamon." *Bilderhefte Antiker Kunst* 9 (1949).

Kawerau, Georg, and Theodor Wiegand. *Die Paläste der Hochburg*. AvP. Vol. 5, no. 1. Berlin and Leipzig: Druck und Verlag von Walter de Gruyter & Co., 1930.

Kekulé-von Stradonitz, Reinhard. *Die griechische Skulptur*. Berlin: Verlag von Georg Reimer, 1906.

Kertész, I. "Der Telephos-Mythos und der Telephos-Fries." *Oikumene* 3 (1982): 203–15.

Klein, Wilhelm. *Vom antiken Rokoko*. Vienna: Hölzel, 1921.

Kleiner, Gerhard. Review of *Der grosse Fries von Pergamon*, by Heinz Kähler. *Gnomon* 22 (1950): 278–89.

Knell, Heiner. *Mythos und Polis. Bildprogramme griechischer Bauskulptur*. Darmstadt: Wissenschaftliche Buchgesellschaft, 1990.

Kunze, Max, ed. *"Wir haben eine ganze Kunstepoche gefunden!" Ein Jahrhundert Forschungen zum Pergamonaltar*. Exh. cat. Berlin: Staatliche Museen zu Berlin, 1986.

Lauter, Hans. *Die Architektur des Hellenismus*. Darmstadt: Wissenschaftliche Buchgesellschaft, 1986.

von Littrow, Huberta. "Der Telephosfries, seine entwicklungsgeschichtliche Stellung, Fragen der Komposition und der Ausführung." Ph.D. diss., Humboldt University, 1969.

de Luca, Gioia. *Das Asklepieion. Via Tecta und Hallenstrasse. Die Funde*. AvP. Vol. 11, no. 4. Berlin: Walter de Gruyter & Co., 1984.

Luschey, Heinz. "Funde zu dem Grossen Fries von Pergamon." 116./117. *Winckelmannsprogram der Archäologischen Gesellschaft zu Berlin*. Berlin: Verlag Walter de Gruyter & Co., 1962.

von Massow, Wilhelm. *Führer durch das Pergamonmuseum*. Berlin: Reichsdruckerei, 1932.

McShane, Roger B. *The Foreign Policy of the Attalids of Pergamon*. Urbana: University of Illinois Press, 1964.

Müller, Helmut. "Ein neues hellenistisches Weihepigramm aus Pergamon." *Chiron* 19 (1989): 539–53.

Müller, Werner. *Der Pergamon-Altar*. Leipzig: Seemann, 1964.

Niemeier, Jörg-Peter. *Kopien und Nachahmungen im Hellenismus*. Bonn: Dr. Rudolf Habelt Gesellschaft mit beschränkter Haftung, 1985.

Ohlemutz, Erwin. *Die Kulte und Heiligtümer der Götter in Pergamon*. Würzburg and Aumühle: Triltsch, 1940.

Onians, John. *Art and Thought in the Hellenistic Age: The Greek World View, 350–50 B.C.* London: Thames and Hudson, 1979.

Osada, Toshihiro. *Stilentwicklung hellenistischer Friese*. Frankfurt am Main: Lang, 1993.

Pergamon: Ausstellung 22 April–4 Juni 1972, Ingelheim am Rhein, in Erinnerung an Erich Boehringer. Offenbach: Giesedruck, 1972.

Pinkwart, Doris. Review of *Das Unklassische im Telephosfries*, by Klaus Stähler. *GGA* (1968).

Pollitt, J. J. *Art in the Hellenistic Age*. Cambridge: Cambridge University Press, 1986.

Price, Martin Jessop, and Bluma L. Trell. *Coins and Their Cities: Architecture on the Ancient Coins of Greece, Rome, and Palestine*. London: V. C. Vecchi and Sons; Detroit: Wayne State University Press, 1977.

Radt, Wolfgang. *Pergamon. Geschichte und Bauten, Funde und Erforschung einer antiken Metropole*. Cologne: DuMont, 1988.

Rheidt, Klaus. *Die Stadtgrabung. Teil 2. Die byzantinische Wohnstadt*. AvP. Vol. 15, no. 2. Berlin and New York: Walter de Gruyter, 1991.

Robert, Carl. "Beiträge zur Erklärung des pergamenischen Telephos-Frieses." Parts I and II. *JdI* 2 (1887): 244–59.

———. "Beiträge zur Erklärung des pergamenischen Telephos-Frieses." Parts III through VI. *JdI* 3 (1888): 87–105.

Rohde, Elisabeth. *Pergamon. Burgberg und Altar*. Berlin: Henschel Verlag, Kunst und Gesellschaft, 1961. 7th ed. Berlin: Henschel Verlag, Kunst und Gesellschaft, 1982.

———. *Griechische und römische Kunst in den Staatlichen Museen zu Berlin*. Berlin: Henschel Verlag, 1968.

Rostovtzeff, Michael. *Social and Economic History of the Hellenistic World*. 3 vols. Oxford: Clarendon Press, 1941.

Rumscheid, Frank. *Untersuchungen zur kleinasiatischen Bauornamentik des Hellenismus*. Mainz: Verlag Philipp von Zabern, 1994.

von Salis, Arnold. "Der Altar von Pergamon." In *Ein Beitrag zur Erklärung des hellenistischen Barock-Stils in Kleinasien*, 93–149. Berlin: Verlag von Georg Reimer, 1912.

Schalles, Hans-Joachim. "Untersuchungen zur Kulturpolitik der pergamenischen Herrscher im dritten Jahrhundert vor Christus" *IstForsch* 36 (1985): 1–174.

———. *Der Pergamonaltar zwischen Bewertung und Verwertbarkeit*. Frankfurt am Main: Fischer Taschenbuch Verlag, 1986.

———. "Rezeptionsgeschichtliche Nachlese zum Pergamonaltar." In *Modus in Rebus. Gedenkschrift für Wolfgang Schindler*, 188–200. Berlin: Gebrüder Mann, 1995.

Schazmann, Georg. *Das Gymnasion: Der Tempelbezirk der Hera Basileia*. AvP. Vol. 6. Berlin and Leipzig: Druck und Verlag von Walter de Gruyter & Co., 1923.

Scheer, Tanja Susanne. *Mythische Vorväter. Zur Bedeutung griechischer Hero-enmythen im Selbstverständnis kleinasiatischer Städte.* Munich: Maris, 1993.

Schefold, Karl, and Franz Jung. *Die Urkönige. Perseus, Bellerophon, Herakles und Theseus in der klassischen und hellenistischen Kunst.* Munich: Hirmer Verlag, 1989.

Schmidt, Evamaria. *Der grosse Altar von Pergamon.* Leipzig: Seemann, 1961.

Schober, Arnold. *Die Kunst von Pergamon.* Vienna, Innsbruck, and Wiesbaden: Margarete Friedrich Rohrer Verlag, 1951.

Schrader, Hans. "Die Opferstätte des pergamenischen Altars." *Sitzungsberichte der Königlich Preussischen Akademie der Wissenschaften, Philosophisch-historische Klasse* 6 (July 1899): 612–25.

———. "Die Anordnung und Deutung des pergamenischen Telephosfrieses." *JdI* 15 (1900): 97–135.

Schrammen, Jakob. *Der grosse Altar. Der obere Markt. AvP.* Vol. 3, no. 1. Berlin: Verlag von Georg Reimer, 1906.

Schulte, Eduard. "Der Pergamonaltar: Entdeckt, beschrieben und gezeichnet von Carl Humann." In vol. 1 of *Schriften der Hermann Bröckelschen-Stiftung Carl Humann zum Gedächtnis.* Dortmund: Ardey Verlag, 1959.

———. "Chronik der Ausgrabung von Pergamon, 1871–1886." In vol. 2 of *Schriften der Hermann Bröckelschen-Stiftung Carl Humann zum Gedächtnis.* Dortmund: Ardey Verlag, n.d.

Smith, R. R. R. *Hellenistic Royal Portraits.* Oxford: Clarendon Press, 1988.

———. *Hellenistic Sculpture: A Handbook.* London: Thames and Hudson, 1991.

Stähler, Klaus. *Das Unklassische im Telephosfries.* Münster: Aschendorff, 1966.

———. "Überlegungen zur architektonischen Gestalt des Pergamonaltäres." In *Studien zur Religion und Kultur Kleinasiens. Festschrift für F. K. Dörner,* 838–67. Edited by S. Sahin et al. Leiden: E. J. Brill, 1978.

Stewart, Andrew. *Greek Sculpture: An Exploration.* New Haven, Conn., and London: Yale University Press, 1990.

Wegener, Silke. *Funktion und Bedeutung landschaftlicher Elemente in der griechischen Reliefkunst archaischer bis hellenistischer Zeit.* Frankfurt am Main: Lang, 1985.

Winnefeld, Hermann. *Königliche Museen zu Berlin. Beschreibung der Pergamenischen Bildwerke.* Berlin: W. Spemann, 1885.

———. "Das Pergamonmuseum." *AA* (1902): 1–4.

———. *Führer durch das Pergamon-Museum.* Berlin: Reichsdruckerei, 1902.

———. "Das Pergamon-Museum in Berlin." *ZbK* 13 (1902): 95–100.

———. *Die Friese des grossen Altars. AvP.* Vol. 3, no. 2. Berlin: Verlag von Georg Reimer, 1910.

Winter, Franz. *Die Skulpturen mit Ausnahme der Altarrelief. AvP.* Vol. 7, nos. 1–2. Berlin: Verlag von Georg Reimer, 1908.

Wulf, Ulrike. "Der Stadtplan von Pergamon." *IstMitt* 44 (1994): 135–75.

Ziegenaus, Oskar, and Gioia de Luca. *Das Asklepieion. Teil 1: Der südliche Temenosbezirk in hellenistischer und frührömischer Zeit. AvP.* Vol. 11, no. 1. Berlin: Walter de Gruyter & Co., 1968.

———. *Das Asklepieion. Teil 2. Der nördliche Temenosbezirk in hellenistischer und frührömischer Zeit. AvP.* Vol. 11, no. 2. Berlin: Walter de Gruyter & Co., 1975.

Published in 1997 by the Fine Arts Museums of San Francisco.

Produced through the Publications Department of the Fine Arts Museums of San Francisco. Ann Heath Karlstrom, Director of Publications and Graphic Design; Karen Kevorkian, Editor. Copyedited by Fronia W. Simpson, Bennington, Vermont. Designed by Susan E. Kelly and Ed Marquand. Produced by Marquand Books, Inc., Seattle, Washington. Printed at C & C Offset Printing Co., Hong Kong.

Text set in Scala with display type in Scala Sans and Legacy Serif. Greek text set in Symbol.